GARI
MELCHERS

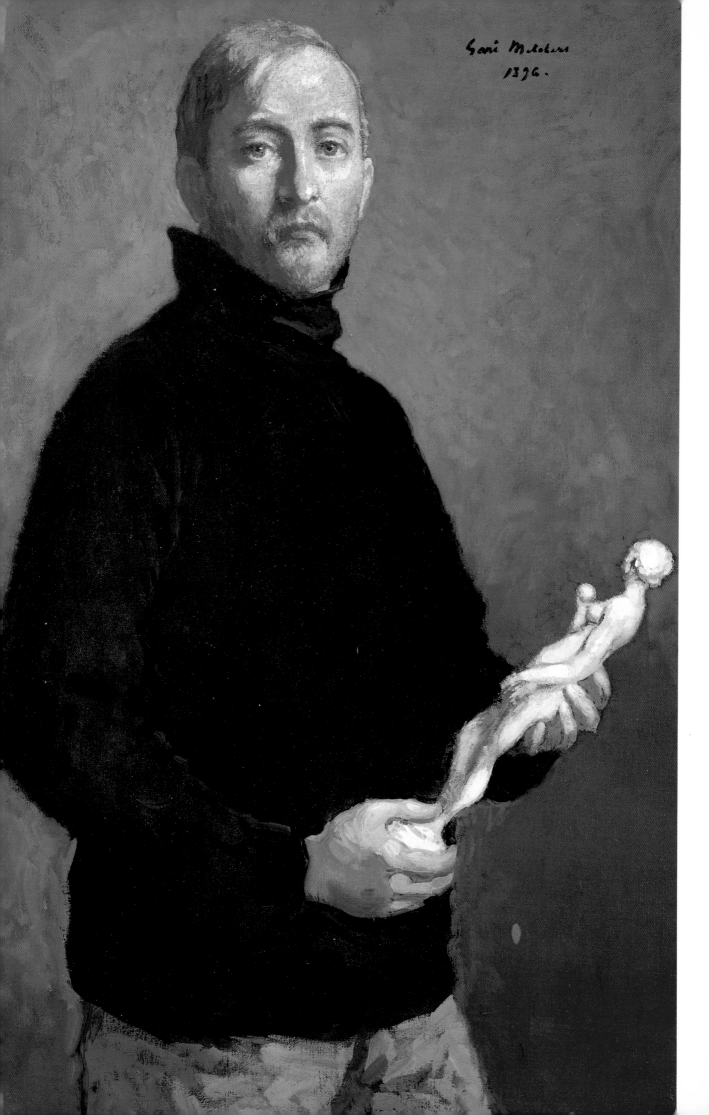

GARI MELCHERS

—•●•—

A

RETROSPECTIVE

EXHIBITION

ORGANIZED BY DIANE LESKO

CATALOGUE EDITED BY DIANE LESKO
AND ESTHER PERSSON

MUSEUM OF FINE ARTS
ST. PETERSBURG, FLORIDA

This publication has been made possible through the generous support of the following contributors:

The Stroh Foundation and members of the Stroh family
Detroit, Michigan

Mary Washington College
Fredericksburg, Virginia

Mr. and Mrs. Robert G. Beck
Newport News, Virginia

The Museum of Fine Arts is recognized by the state of Florida as a Major Cultural Institution and receives major funding from the state of Florida through the Florida Department of State, the Florida Arts Council, and the Division of Cultural Affairs.

EXHIBITION TOUR

Museum of Fine Arts
St. Petersburg, Florida
March 11–May 6, 1990

Telfair Academy of Arts and Sciences, Inc.
Savannah, Georgia
June 5–August 5, 1990

National Academy of Design
New York, New York
September 11–November 4, 1990

The Detroit Institute of Arts
Detroit, Michigan
December 8, 1990–February 17, 1991

Virginia Museum of Fine Arts
Richmond, Virginia
April 8–June 2, 1991

Library of Congress Catalogue Card Number: 89–63393
ISBN 1-878390-00-7

Front cover: *In Holland,* 1887, oil on canvas, Belmont, The Gari Melchers Memorial Gallery (pl. 3; cat. no. 12)
Back cover: *Skaters,* c. 1893, oil on canvas, Pennsylvania Academy of the Fine Arts, Joseph E. Temple Fund (pl. 8; cat. no. 23)
Frontispiece: *Self-Portrait,* 1896, oil on canvas, Belmont, The Gari Melchers Memorial Gallery (pl. 11; cat. no. 27)

Produced by Marquand Books, Inc., Seattle
Managing editor: Suzanne Kotz
Typeset by Centerpoint/Type Gallery, Inc., Seattle
Printed and bound in Japan by Toppan Printing Co., Ltd.

CONTENTS

DIRECTORS' STATEMENTS 6

ACKNOWLEDGMENTS 8

LENDERS TO THE EXHIBITION 10

GARI MELCHERS AND INTERNATIONALISM
DIANE LESKO 11

PLATES 19

THE STUDENT YEARS: DÜSSELDORF AND PARIS
GEORGE MESMAN 49

THE HOLLAND YEARS
ANNETTE STOTT 55

GARI MELCHERS AND THE BELGIAN ART WORLD: 1882–1908
JENNIFER A. MARTIN BIENENSTOCK 75

GARI MELCHERS IN NEW YORK
JOSEPH G. DREISS 111

MELCHERS AND THE TELFAIR ACADEMY:
THE EVOLUTION OF A COLLECTION
FEAY SHELLMAN COLEMAN 125

BELMONT, THE GARI MELCHERS MEMORIAL GALLERY
RICHARD S. REID 151

EGMOND REMEMBERS GARI MELCHERS
RONALD VAN VLEUTEN 159

CATALOGUE OF THE EXHIBITION
JOANNA D. CATRON 165

CHRONOLOGY 236

SELECTED BIBLIOGRAPHY 238

Directors' Statements

At the turn of the century Gari Melchers achieved fame not only in his own country but in Holland, France, and Germany. The Museum of Fine Arts, St. Petersburg, has been privileged to organize this retrospective exhibition of the artist, whose work and international reputation are so deserving of renewed attention.

After opening at the Museum of Fine Arts, the exhibition travels to four museums that have strong connections to Melchers: the Telfair Academy of Arts and Sciences in Savannah, where Melchers served actively for more than twenty years as a fine arts adviser; the National Academy of Design, New York, with which Melchers was affiliated first as an associate and later as an academician; the Detroit Institute of Arts, which possesses a valuable cross-section of Melchers's art; and the Virginia Museum of Fine Arts, Richmond, which, even though still in the planning phase at the time of Melchers's death, was aided by his years of service to the Virginia Arts Commission (and by his widow's continuing support to that organization and as a trustee of the museum). That these museums have chosen to participate in this tribute speaks not only for their recognition of Melchers's art but for his long-standing commitment to America's cultural institutions.

With our co-organizers at Belmont, The Gari Melchers Memorial Gallery, we extend our thanks and appreciation to the many institutions and individuals who have enthusiastically assisted our efforts. In particular, the museum's board and I offer thanks to Dr. Diane Lesko, curator of collections at the Museum of Fine Arts, for her excellent work. She handled the enormous tasks of organizing the exhibition and acting as chief editor of the catalogue with consummate skill. We are proud of the contribution that this exhibition and catalogue make to the further enhancement of Melchers's place in the history of art, both in the United States and in Europe.

Michael Milkovich
Director
Museum of Fine Arts

In 1938 the Virginia Museum of Fine Arts sponsored a comprehensive exhibition of the works of Gari Melchers. The memorial retrospective, commemorating Melchers's services to the state of Virginia, opened on the second anniversary of the museum he helped to establish. Now, fifty-two years later, a second exhibition pays tribute to one of America's foremost artists. This retrospective will rekindle our knowledge of a painter who became internationally famous in the days of John Singer Sargent and James McNeill Whistler. Works spanning more than half a century—from the artist's early years in Detroit to his final years at Belmont, his eighteenth-century home overlooking the falls of the Rappahannock River— reflect the painter's pursuit of truth in art. Long overdue, this exhibition affords an enriching opportunity to reevaluate the artistic contributions of Gari Melchers.

The impetus behind the project lies with the Museum of Fine Arts, St. Petersburg. Michael Milkovich, director, and Dr. Diane Lesko, curator of collections, deserve immense credit for their research and organization of the exhibition. On behalf of Belmont, I extend my deepest appreciation to the museum.

I am grateful for the support of Mary Washington College, Belmont's parent institution. Virginia Lewis Dalton, rector of the Board of Visitors, and William M. Anderson, Jr., president, enthusiastically endorsed this important exhibition and catalogue. Special appreciation is extended to Peter Stroh, the members of the Stroh family, and the Stroh Foundation for their contributions to all phases of the project. Finally, I want to thank Mr. and Mrs. Robert G. Beck for their gift toward the publication of the catalogue. Thanks to the support of these individuals and institutions, Belmont, The Gari Melchers Memorial Gallery, is today a vital and cherished home for art.

Peter Dun Grover
Director
Belmont, The Gari Melchers Memorial Gallery

ACKNOWLEDGMENTS

This exhibition and catalogue would not have been possible without the whole-hearted support of the staff of Belmont, The Gari Melchers Memorial Gallery. Peter Dun Grover, director, and Joanna D. Catron, assistant director—who wrote the catalogue entries—have worked tirelessly and with great enthusiasm through-out the protracted process of organization and implementation. The former director of Belmont, Richard S. Reid, has written Belmont's history for the cata-logue and has helped with vital information and advice. Catherine L. Fishback, administrative assistant, sped necessary information our way.

Belmont has a strong ally in its governing institution, Mary Washington College, Fredericksburg, Virginia. The support of its president, William M. Anderson, Jr., and of its Board of Visitors, headed by Virginia Lewis Dalton, has resulted in crucial monetary assistance for the exhibition catalogue. There has been staff involvement as well: Dr. Joseph G. Dreiss, chair of the Art Depart-ment, who has previously published on Melchers, has contributed an essay to the catalogue and has assisted with plans since the exhibition's inception. In Virginia, we are also grateful to Mr. and Mrs. Robert G. Beck, the Honorable and Mrs. J. Granger Macfarlane, and Mr. and Mrs. Daniel Chichester.

In Detroit the Stroh family and the Stroh Foundation have supported our efforts and contributed significantly to the exhibition catalogue. There were strong ties between Melchers and the Strohs: Gari was born in Detroit in 1860, and in 1883 his sister, Hedwig, married Julius Stroh, a son of the founder of the Stroh Brewery. Melchers's portrait of Julius Stroh, painted in 1909 and included in the exhibition, attests to their years of friendship.

Staff members at each museum participating in the exhibition's tour deserve special thanks: at the Virginia Museum of Fine Arts, Paul Perrot, director; Richard Woodward, deputy director; William Rasmussen, curator of American art to 1900; and Bruce Young, registrar; at the Detroit Institute of Arts, Samuel Sachs II, director; Nancy Rivard Shaw, curator of American art; and Judith Dressel, registrar; at the National Academy of Design, John Dobkin, director; Barbara Krulik, assistant director; and Abigail Booth Gerdts, curator of painting and sculpture; and at the Telfair Academy of Arts and Sciences, Gregory Allgire Smith, director; Elizabeth Scott Shatto, curator/registrar; and Feay Shellman Coleman, research curator. Other staff members at these museums also deserve our gratitude for professional courtesies extended.

Lenders to the exhibition include the tour museums, Belmont, six additional institutions, and private collectors. We thank them for their assistance with loans, photography, and research. In addition, other institutions opened their storage rooms and files and willingly supplied information and photographs. Margaret M. Mills, executive director, showed me a number of Melchers's drawings from the permanent collection of the American Academy and Institute of Arts and Letters (Melchers was elected to the institute in 1898 and to the academy in 1916). Ann H. Murray, director of the Watson Gallery at Wheaton College, Norton, Massachusetts, sent photographs and a published discussion of a Melchers painting, *Audrey, The Shepherd Lass*, in the gallery's collection. At the University of Michigan Museum of Art, curator Hilarie Faberman helped with the loan and shipment of a Melchers mural study from a private Michigan collection, and Joyce L. Watson sent her 1982 master's thesis, "Melchers' Portraits at Michigan: Three Examples of American *Juste Milieu*," from the University of Michigan's Department of the History of Art. A number of museums lent photographs and sent information from their files; many of them are listed with the illustrations reproduced within the essays. Without this assistance the catalogue could not have taken its present form.

Seven catalogue essays discuss Melchers's art and life from a variety of viewpoints. While these tributes are independent studies, they form a coherent whole and enable us to appreciate the strength, diversity, and innovation found in Melchers's oeuvre. We are indebted to the authors for their foresight and their scholarship.

The organization of this exhibition and the production of the catalogue have involved the entire staff of the Museum of Fine Arts. Their names are listed in the back of this catalogue and all deserve praise. I am particularly grateful to Michael Milkovich, director, for enthusiastically endorsing this project and for offering advice throughout its implementation. Finally, special recognition is extended to Carol Allen, exhibitions assistant, and Margarita Laughlin, registrar; their professionalism, dedication, and energy inspire us all.

Diane Lesko
Curator of Collections
Museum of Fine Arts

LENDERS TO THE EXHIBITION

Mr. and Mrs. Robert G. Beck, Newport News, Virginia

Belmont, The Gari Melchers Memorial Gallery, Fredericksburg, Virginia

Mr. and Mrs. J. Bretan

The Butler Institute of American Art, Youngstown, Ohio

The Corcoran Gallery of Art, Washington, D.C.

The Detroit Institute of Arts

Mr. and Mrs. Peter Heydon, Ann Arbor, Michigan

The Minneapolis Institute of Arts

National Academy of Design, New York

National Gallery of Art, Washington, D.C.

National Museum of American Art, Smithsonian Institution, Washington, D.C.

Pennsylvania Academy of the Fine Arts, Philadelphia

Private collection

Private collection, Falmouth, Virginia

Mrs. John W. Stroh, Grosse Pointe Farms, Michigan

Mr. and Mrs. Peter W. Stroh, Grosse Pointe Farms, Michigan

The Stroh Companies, Inc., Detroit, Michigan

Telfair Academy of Arts and Sciences, Inc., Savannah, Georgia

Virginia Museum of Fine Arts, Richmond

Gari Melchers and Internationalism

Diane Lesko

▼

The art of Gari Melchers spans more than a half century. From his student years in the late 1870s to his death in 1932, he produced hundreds of paintings in studios in Holland, France, Germany, and America. Because of Melchers's long-standing ties with Europe, and his success there, he has been categorized as an expatriate artist. Yet he was committed to his career in America, and he crossed the Atlantic continually while living on both continents. That Melchers was a celebrated painter is clear from his long exhibition history, the many awards and medals he won, and the number of his works purchased by museums and collectors. That he was loved and admired, and that his friendships included Americans and Europeans from all walks of life, is evident from reminiscences, biographies, and letters.

The international scope of Melchers's art is confirmed by this retrospective exhibition and catalogue. Throughout his lifetime Melchers believed in a viable academic tradition, and in surveying the whole of his oeuvre, the diversity of styles and of subjects—genre scenes, religious motifs, landscapes, portraits, nudes, and still lifes—is remarkable. At the beginning of his career he painted the peasants of Brittany and Holland in realistic depictions based upon his Düsseldorf training, the Hague School artists, and the Paris Salon. In the late 1880s and the 1890s his art was influenced by Symbolism, and in the early years of the twentieth century he turned to Impressionism for inspiration. Occasionally he reverted to the past and painted in styles formulated in his earlier years.

This diversity makes Melchers's art difficult to classify. He cannot be called strictly an American Impressionist, nor should he be identified solely with his Dutch genre pictures, monumental and important as they are. Although Melchers painted a number of impressive leisure scenes, this interest was never overriding. And despite over 150 portraits—many of celebrated personalities like Theodore Roosevelt (fig. 56) and Andrew Mellon (National Gallery of Art, Washington, D.C.)—Melchers is not known primarily for his portraiture.

Consistent in Melchers's art is a direct, honest, and unassuming attitude that transcends all subjects and stylistic considerations. There is a distinct lack of affectation, and sentiment, when present, never deteriorates into sentimentality. It is

said that above the door of Melchers's studio in Egmond aan Zee the Dutch words *waar en klaar* were written. As descriptive adjectives, "true and clear" capture the essence of Melchers's philosophy both in terms of his art and his life: conceptualizations are rooted in reality, and obfuscation is eschewed for clarity.

The basis for this outlook can be found in Melchers's childhood and home life within Detroit's German immigrant community and in his early instruction, both from his German-born artist father and at the academy in Düsseldorf. There he was instilled by Eduard von Gebhardt with sound academic principles and a commitment to solid images that conveyed spiritual strength. These same tenets were upheld by a number of European artists, including Fritz von Uhde, Wilhelm Leibl, and Jules Bastien-Lepage, all of whom produced variations on the themes of peasant life and contemporary religious attitudes. Melchers would continue these investigations and combine the secular with the sacred in a variety of ways, as did his good friend George Hitchcock and others of their generation.[1]

After graduation Melchers entered the Académie Julian in Paris and subsequently was accepted at the Ecole des Beaux-Arts. His early success with *The Letter* (pl. 1; cat. no. 6) in the 1882 Salon was the beginning of a quarter century of association with Paris through Salon entries, gold medals, and participation on juries. In 1889 Melchers was awarded a grand prize medal in the American painting section at the Exposition Universelle, an honor bestowed only upon Melchers and John Singer Sargent.[2] In 1904 Melchers was made chevalier of the Legion of Honor and in 1908 a member of the Institute of France. During these years he kept a studio in Paris; besides the paintings that originated there, he also worked on canvases that he had begun in Holland.

The acclaim that Melchers received in France was matched in Germany and America; he was also honored in Belgium, Austria, and Holland. Americans abroad have often been ridiculed for their provincialism; it is therefore a telling commentary on Melchers's internationalism that he was identified as a German in Germany and as a Dutchman in Holland.[3]

In 1884 Melchers joined George Hitchcock in establishing a permanent studio in the Egmonds.[4] This decision was propitious for Melchers's development; monumental paintings like *The Sermon*, 1886 (pl. 2; cat. no. 11), and *In Holland*, 1887 (pl. 3; cat. no. 12), which used as models the townfolk of the Egmond area, established Melchers's reputation as a painter of Dutch scenes that celebrate the virtues of an unsophisticated life of hard work and pious reverence. *The Sermon* was exhibited in Paris, Amsterdam, Brussels, Munich, and Chicago—to name the first few showings—and it brought Melchers's art to the attention of a widespread international audience.

With its large scale and nearly life-size figures, *The Sermon* is an impressive painting. The picture's naturalism and its crisp modeling, provocative narrative detail, and brilliant blue background of wooden benches hold the viewer's attention. Moreover, closer inspection reveals that within the folds of dresses and capes of female parishioners are small areas of visual delight: seductive patches of vibrant hues applied with thick, loose brushstrokes.[5]

Like many areas of Holland, the lure of the Egmonds lay in its pristine landscape, picturesque views, sturdy peasants willing to pose, and low cost of living. For many artists and writers Holland was a haven from an increasingly urbanized,

industrialized world. Furthermore, for many Americans, Holland and America were linked through historical, religious, political, and ideological ties.[6] These associations strengthened the interest of American collectors and provided a ready market for American painters living in Holland.

The appeal of a Dutch subject like *Old and Young*, c. 1890 (pl. 5; cat. no. 17), is obvious. Here Melchers succeeds in expressing universal truths through simple means: an old man, whose life on the sea is suggested through the presence of a ship's model, lovingly holds his sleeping grandchild in his lap. A female figure, perhaps meant to be the child's mother, stands in the background behind the model ship. Smaller in scale than the picture's subjects, and partially illuminated by the sunlight that pours through the window, the figure appears as a watchful guardian, protecting the studio's precious inhabitants.[7]

By the early 1890s Egmond had become the summer home to students attracted by the success of Melchers and Hitchcock. Because of this influx Hitchcock established a school at Schuylenburg, the home and studio he and his wife Henriette purchased in 1891. Most students were American, many of whom were on summer break from art schools in Paris. It has been estimated that during Hitchcock's tenure—he left the Egmonds in 1905—he taught three hundred aspiring artists, including some German and British students,[8] as well as Melchers's future wife, Corinne Mackall. In the summer, parasols positioned for plein-air painting dotted the fields like giant flowers, replacing the tulips that bloomed in spring. Although Melchers did not teach on a formal basis, he often painted at Schuylenburg and was active there in art discussions and critiques.

A number of paintings produced in Holland in the late 1880s and the 1890s illustrate Melchers's free brushstroke, thick application of paint, and fascination with strong decorative detail. In *Skaters*, c. 1893 (pl. 8; cat. no. 23), a snowy landscape with a high horizon line, mauve houses, and blue-gray sky becomes a pale foil for the patterned violet cloak of Melchers's pretty model. The skaters are positioned in the foreground and are shown in three-quarter length. She is posed in profile, her young face reflecting the cold through a rosy red cheek. Dressed in neutral colors, he sports a thin mustache, and he has a ruddy complexion. The patterned scarf at his neck serves as a link with her cloak, whose large triangular shape dominates the composition and underscores the solidity of the figures. This beautiful picture with its unsophisticated charm is characteristic of Melchers's oeuvre: despite variations in style and subject matter, his art consistently retains an explicit humility and lack of pretense.

Five years after *The Sermon*, Melchers painted *The Nativity* (pl. 6; cat. no. 19). The free handling of paint and the lustrous color found in the clothing details of *The Sermon* were employed in this picture as a unifying force over the entire canvas surface. A pale golden glow, with its central source the infant Jesus, exudes a warmth that encompasses the three figures and is balanced by an interplay with cool lavender brushstrokes.

Inspired no doubt by the widespread renewed interest in religious questions during the last decades of the century, which fascinated many artists including radicals like Gauguin, van Gogh, and Ensor, *The Nativity* was Melchers's first biblical subject. Other scriptural paintings would follow, such as *The Last Supper* (fig. 8) and *The Supper at Emmaus* (Belmont), but it can be argued that *The Nativity* is

Melchers's most successful religious scene. Its loose, relaxed technique, palpable paint, harmonious color tonality, and simple composition speak for a mystical force that is clearly rooted in the physical. The setting, according to Melchers's note, is a French farm, but its ultimate importance lies in Melchers's portrayal of a universal event that crosses all nationalistic boundaries.

During this same period Melchers was involved with Symbolism, influenced in part by his friendship with Pierre Puvis de Chavannes. There are parallels, for example, between Melchers's sensitive oil study *Christ with Halo* (fig. 43) and Puvis's *Head of St. John the Baptist* (later acquired by Melchers for the Telfair Academy in Savannah). Furthermore, the large murals *Arts of War* (cat. no. 21) and *Arts of Peace*, painted for the Manufactures and Liberal Arts Building of the 1893 Columbian Exposition, were clearly inspired by Puvis's murals. Puvis, thirty-six years older than Melchers, may have been both mentor and father figure. He was dedicated, like Melchers, to maintaining an academic tradition while also developing a Symbolist aesthetic.

Given Melchers's interest in the reality of appearances, he never fully embraced Symbolism, but it appeared in a number of his works that imply the existence of a reality beneath the depiction of everyday experience. As early as 1887 in *Moss and Sand* (pl. 4; cat. no. 13), Melchers's art can be seen as sympathetic to Symbolism. In this night scene a pale moon is barely visible as it rises above a high horizon. A young woman, who has thrown down her rake and bucket, lies against the rise of a dune, her eyes open yet strangely blank, as if lost in reverie. The top of the dune obliquely tilts, sloping downward and to the left, its parallel in a secondary rise immediately beneath it. This configuration creates a subtle rolling motion that suggests the sea's waves. Countering this feeling is a visual pull toward the surface of the picture plane, achieved through the use of bright blue flowers interspersed throughout the landscape. Although the painting's natural beauty is clearly evident, the composition, recumbent figure, and cool coloring imbue the work with a sense of mystery and recall Puvis's 1883 painting *The Dream* (Louvre, Paris).[9]

The Sisters, circa 1895 (pl. 10; cat. no. 26), and *The Butterfly* (fig. 26) are two of Melchers's most obvious Symbolist paintings. In both pictures a flattened landscape serves as a backdrop and foil to the young girls who stand in the immediate foreground; by their size and position, they emphasize the two-dimensional picture plane and the verticality of the canvas. The edge of a green plateau at the top of each work restricts the view of a village, permitting only the rooftops of houses to be seen. A slight change of hue differentiates the middle ground, where white goats graze, but a sense of dimension is countered by the flattened divisions, vertical stacking, and palette of secondary colors. These paintings are discussed by Jennifer Bienenstock, pp. 92–95; here it is enough to note that Melchers's subtle orchestration of color and form presents the viewer with contradictions of depth and flatness, materiality and spirituality, and innocence and experience, revealing Puvis's Symbolist goal "to be, not Nature, but parallel to Nature."[10]

Sainte-Gudule (fig. 25) and *The Communicant* (pl. 13; cat. no. 29) again demonstrate Melchers's representation of the spiritual by the material. The paintings present solitary female figures who fill the canvas, occupying a shallow space in

front of a wall parallel to the picture plane. They sit motionless with prayer books held loosely in their laps and their feet positioned closely together on small ornamental rugs. As emblems of innocence and conduits of divine revelation, they can be identified with the Breton women in Gauguin's Symbolist painting *Vision After the Sermon* (1888, The National Galleries of Scotland, Edinburgh). In addition, these saintly figures, frozen in iconic stasis, relate visually to fifteenth-century hieratic images of Mary and the infant Jesus painted by Jan van Eyck and his Netherlandish followers.[11]

For *The Bride*, 1903 (pl. 15; cat. no. 31), Melchers painted a beautiful devotional image on wood in emulation of Northern painters. Surrounded by a carved gold frame, the luminous colors of the wedding gown and veil glow against a deep blue background. The bride's calm introspection embodies the essence of a sacrament, which can be defined as an outward visible sign of inward spiritual grace.

In contrast, other paintings of solitary figures emphasize physicality rather than spirituality. In *La Brabançonne*, circa 1904 (fig. 16), the woman shown in Dutch costume is Corinne Mackall Melchers. She too occupies a shallow space. Although the Brabançonne wears a pendant cross and stands primly, her hands folded across a voluminous skirt, the celebration of her physical beauty and matronhood is palpably felt. As in *La Brabançonne*, the figure in *The Fencer*, circa 1895 (pl. 9; cat. no. 25), is life-size and fills the canvas. The deep colors, strong value contrasts, and crisp linear form accentuate the fencer's shape and emphasize the mental and physical precision needed for the sport.

In these pictures and others, including the portrait of Henriette Hitchcock titled *The Delft Horse*, c. 1900 (pl. 12; cat. no. 28), the model is seen within a distinctive space characterized by the use of decorative details. However, when Melchers painted his *Self-Portrait* (pl. 11; cat. no. 27) in 1896, he chose to stand against a blank orange wall, his link with the physical world established through symbolic means: he holds a statuette of Eve.

There are few self-portraits of Melchers,[12] but they are consistent with what we know about his personality: he was modest and unaffected by his considerable success in Europe and in America. In the 1896 self-portrait the thirty-six-year-old artist is dressed casually in turtleneck sweater and work pants; his thinning blonde hair falls over a high forehead, and he regards the viewer directly through sensitive blue eyes. Gently cradling the statuette of Eve, Melchers is serious and introspective. The self-portrait seems so simple and direct that the depth of its meaning can easily be overlooked. Despite its allegiance to traditional portraiture, it recalls Gauguin's 1889 *Self-Portrait with Halo* (National Gallery of Art, Washington, D.C.). Although Melchers's painting is rooted in reality, the orange background—as with Gauguin's—negates identification of a specific place. The statuette of Eve substitutes for the apple and serpent of Gauguin's work, suggesting that in 1896 the Creation, Fall, and Redemption remained vital existential considerations. Finally, Melchers's strong physical presence and his association with Eve reflect his concern with the artist's role as creator.

Throughout his career Melchers painted the cycle of human life. Commonplace situations and events—courtship, marriage, the birth of children, and baptism—were seen as milestones worthy of memorializing. Melchers's marriage

would remain childless, but his attraction to the motif of mother and child, which developed in the early 1890s, occupied his attention until the end of his life. Internationally important at the turn of the century, the subject was of interest to artists on both sides of the Atlantic. For Melchers, mother and child paintings held metaphysical meaning: "A mother with a baby in her arms is lovelier than all else. The tenderness of the mother, the wonder of the baby, and the intimacy of their love—that is the most beautiful thing in life."[13] These pictures range from realistic depictions (fig. 15) to overtly religious images of women and children with halos (cat. no. 53 and fig. 20).

One of Melchers's earliest and most appealing treatments of the theme is *Mother and Child with Orange*, 1892 (pl. 7; cat. no. 20). The overall green tonality of the picture envelops the large, solid figures in an atmosphere of softness. The fruit adds a religious connotation, recalling traditional Dutch iconography in which an orange alludes to the Infant as the future Redeemer. Attention is drawn to the fruit through a juxtaposition of hands: the mother's protective hand encompasses the baby's small waist and holds him upright, while his tiny hands appear directly above hers, intent on retaining their precarious hold on the orange.

A source of inspiration for Melchers's interest in the mother and child theme was Mary Cassatt. There are a number of connections between the two artists: they lived and exhibited in Paris during the same years; they shared mutual friends, including Mrs. Potter Palmer; they both worked on murals for the Columbian Exposition. Melchers expressed his appreciation for Cassatt in a 1913 *New York Times* article and in an unpublished draft of the introduction for John Beatty's 1922 book, *The Relation of Art to Nature.*

The affinities between Cassatt's pastel *Mother Rose Nursing Her Child* (Shelburne Museum, Vermont) and Melchers's pastel *Mother and Child* (pl. 18; cat. no. 37) have been noted by Joseph Dreiss; both works were executed on brown paper and with similar color tonalities, and both show the head, shoulders, and breast of a mother nursing her child.[14] Distinctly different, however, are the application of the pastels and the resultant forms. In Cassatt's calm strokes, a light-handed downward motion created the soft volumetric forms of the figures, and both faces are realistically modeled. In Melchers's pastel the strokes are thick and scribbled, extending in all directions. The infant's head is depicted with naturalism, but the mother's face is heavily laden with short choppy highlights of pink, white, and red. In creating the forms Melchers first outlined the shapes with a dark hue; white, pink, and gray were added as an overlay. The surface is electric with motion generated from the pastel strokes, and the mother—whose large figure exudes vigor and vitality—becomes the contemporary personification of a universal earth mother. These stylistic differences significantly alter the spirit of the work from Cassatt's controlled and refined Impressionist vision.

With Melchers's marriage in 1903 came a permanent home and studio in Egmond, but he continued to paint at the Hitchcocks' residence, Schuylenburg, where he had worked for over ten years. During his bachelor years he was interested in genre themes of Dutch working-class life; following his marriage he turned to domestic scenes of bourgeois life, often with Corinne as a model. These paintings reflect an increasingly popular subject painted by scores of American and European artists at the turn of the century: genteel scenes of the upper classes at

leisure.[15] However, what is distinctive about Melchers's paintings of this type is their impressive scale. Rather than the typical small canvas with its sense of intimacy, Melchers painted on large canvases and showed solid, monumental figures, as in the eight-foot-tall *At Home (The Winged Victory)* (fig. 18).

The Open Door (pl. 19; cat. no. 38), another large picture, is one of Melchers's most ambitious compositions. A maid dressed for the outdoors stands in the hallway holding a straw hat and umbrella. She faces forward—as if in conversation with someone in the hall—and she may be ready to announce a visitor to the two women who sit admiring an infant in the drawing room. Reflected in the parlor's mirror is a window in the hall, thus windows, a mirror, and an open door are used to suggest a recession in space and an extension beyond the picture plane. Sunlight, which shines through the tall window next to the mirror, bleaches the color from the garments of the seated women and casts a golden glow upon the patterned rug. Despite an interest in the effects of sunlight, forms retain their basic solidity, as they do in *At Home (The Winged Victory)* and *Penelope* (pl. 21; cat. no. 42).

As with other influences, Melchers's interest in Impressionism was assimilated from international sources; he looked to France, Germany, and America for inspiration. This art has been described as a "lightened palette of academic Impressionism, which, combined with careful drawing, constitutes an international style hailed by contemporary critics."[16] It is interesting to note that in pictures like *Unpretentious Garden* (cat. no. 32) and *Woman Reading by a Window* (cat. no. 33), both painted at Melchers's Egmond home, a conscious effort was made to disintegrate forms and to create an overall shimmering, evanescent surface. However, here Melchers's experimentation excluded architectural detail: the house in *Unpretentious Garden* and the door and windows of the sun porch in *Woman Reading by a Window* are distinctly delineated.

When Melchers painted the urban landscape in New York, where he spent considerable time, his interest in Impressionism was shaped in part by his friendship with Childe Hassam. *Bryant Park (Twilight)* (pl. 20; cat. no. 39) is an impressionistic winter's night scene of mauves and blues. *Snow* (pl. 26; cat. no. 51) was painted at this time, and although the picture was altered slightly and redated 1921, its style reveals that Melchers continued his allegiance to solid form. Despite its Impressionist brushstroke and glowing color, crisp, dark shadows delineate the woman's substantial sculptural shape and imbue her presence with monumental importance.

For Melchers and his wife, and for others who had established roots abroad, the First World War and America's increasing isolationism imposed physical and psychological restrictions. In 1915 they left Europe, and in 1916 they purchased Belmont, an eighteenth-century house and acreage in Falmouth, Virginia. Belmont became their permanent home and replaced the Egmonds in Melchers's oeuvre; he painted the grounds and surrounding area in numerous impressionistic landscapes and genre scenes like *Early Spring Landscape* (pl. 23; cat. no. 45), *House with a Porch* (cat. no. 46), and *Morning Haze* (cat. no. 49). His continued interest in Impressionism was also evident in the portrait of Corinne seated before a window, *Young Woman Sewing* (pl. 25; cat. no. 48), and in the depiction of his friend Charles Lewis Hind, the British author who had married Henriette Hitchcock. In

the Lewis Hind portrait, titled *The Sun Porch* (pl. 27; cat. no. 52), Melchers employed a loose, bravura brushstroke that recalls earlier Holland works, like *The China Closet* (pl. 16; cat. no. 34).

A number of late realistic paintings such as *The Hunters* (pl. 28; cat. no. 54) and *Native of Virginia* (Belmont), both circa 1925, recall Melchers's previous monumental depictions of local residents in Holland. For some viewers the realism in these pictures makes them striking prototypes for the work of Norman Rockwell. Standing alone with her hoe and vegetables beside her, the figure in *Native of Virginia* could be a Dutch peasant, and in *The Hunters* the distant snowy landscape has been noted as evocative of Brueghel's winter scenes.[17]

During the Virginia years Melchers remained in contact with Holland through letters and visits. *The Zeeland Madonna* (fig. 20), painted in 1930, recalls specifically the Dutch picture *The Communicant* (pl. 13; cat. no. 29). In *The Zeeland Madonna* Melchers returns to Symbolism and attempts to restructure its aesthetics. However, this strange picture—with its flattened decorative details and its bright, chalky secondary colors—appears distinctly *retardataire*. What is evident from this work is that, whether successful or not, it demonstrates Melchers's continuing search for artistic viability.[18]

Melchers made his last trip to Holland in the year of his death, 1932. *The Lace Cap* (pl. 30; cat. no. 59), his last picture, was based upon sketches produced during that visit. This vibrant image, filled with bright thick patches of paint, shows a young woman seated before a window reading a note: it recalls Melchers's first success, *The Letter*, and concludes a lengthy, distinguished career.

NOTES

1. For a discussion of Melchers's religious painting within the scope of European precedents and contemporary academic painting, see William H. Gerdts, Introduction to *Gari Melchers: His Works in the Belmont Collection*, by Joseph G. Dreiss (Charlottesville, Va.: University Press of Virginia, 1984), xcii ff.

2. For the exhibition's importance and Melchers's entries, consult Annette Blaugrund et al., *Paris 1889: American Artists at the Universal Exposition* (Philadelphia: Pennsylvania Academy of the Fine Arts; New York: Harry N. Abrams, 1989).

3. For references to Melchers as a Dutchman, see Stott, below, p. 60 and n. 12, and Catron, below, p. 196; for his identification as a German, see Bienenstock, below, p. 79 and n. 16.

4. It has been suggested that Italy was also considered, but a cholera epidemic there deterred him. Reported in Dreiss, *Gari Melchers*, p. 11 and n. 28.

5. For further discussion of the painting see Stott, below, pp. 55–56, and Bienenstock, below, pp. 80–89.

6. Annette Stott, "The Appeal of The Netherlands for Late Nineteenth-Century Americans," chap. 1 in "American Painters Who Worked in The Netherlands, 1880–1914," (Ph.D. diss., Boston University, 1986).

7. Melchers may have used a mannequin for the figure;

its small size, thin body, and crudely painted face distinguish it from the realistic treatment of the old man and child.

8. Stott, "American Painters," p. 141 and n. 32.

9. After reading this introduction, Joanna Catron informed me that a reproduction of this painting appears in Melchers's picture file, an archive that contains over six hundred art postcards and reproductions.

10. Quoted in Edward Lucie-Smith, *Symbolist Art* (New York: Thames and Hudson, 1985), p. 84.

11. A number of van Eyck's paintings are included in Melchers's picture file, among them Dresden's *Madonna and Child Enthroned*.

12. Only five self-portraits are listed in the comprehensive appendix of Melchers's portraits published in Dreiss, *Gari Melchers*, pp. 187–89.

13. Ibid., p. 33.

14. Ibid., p. 35.

15. Consult Ron Pisano, *Idle Hours: Americans at Leisure 1865–1914* (New York: Little, Brown, 1988).

16. In Blaugrund, *Paris 1889*, p. 186.

17. This observation was made by Joanna Catron.

18. While many fine pictures date from the last fifteen years of Melchers's life, there are also less successful works, particularly among the late figure paintings, in which the figures are stiff and the poses contrived.

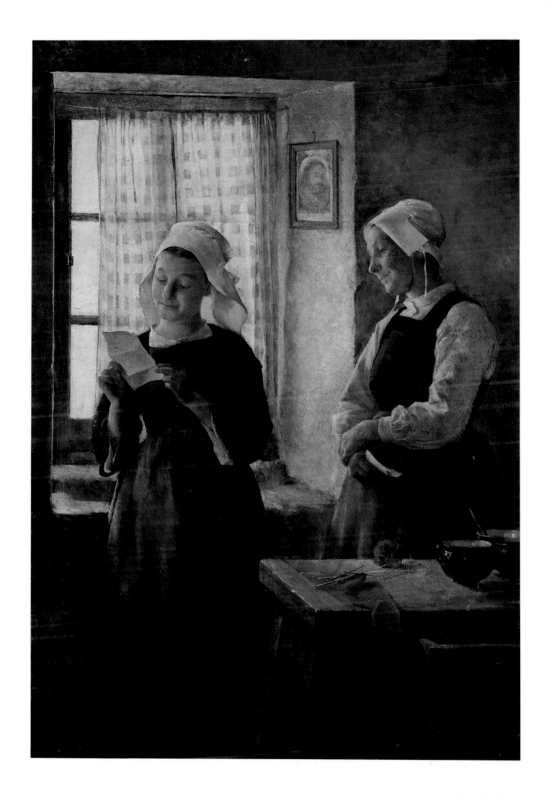

PLATE 1

THE LETTER
1882, oil on canvas, 37 1/4 × 26 3/8 inches
The Corcoran Gallery of Art, Washington, D.C.,
Edward C. and Mary Walker Collection, 1937
(cat. no. 6)

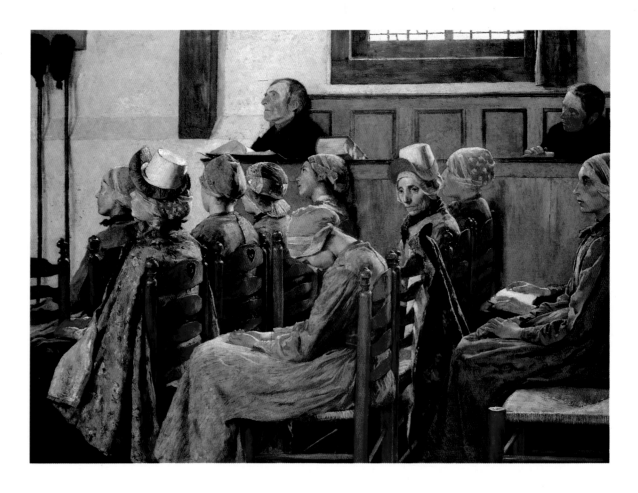

PLATE 2

THE SERMON

1886, oil on canvas, 62 ⁵/₈ × 86 ¹/₂ inches
National Museum of American Art, Smithsonian Institution,
Washington, D.C., bequest of Henry Ward Ranger through
the National Academy of Design
(cat. no. 11)

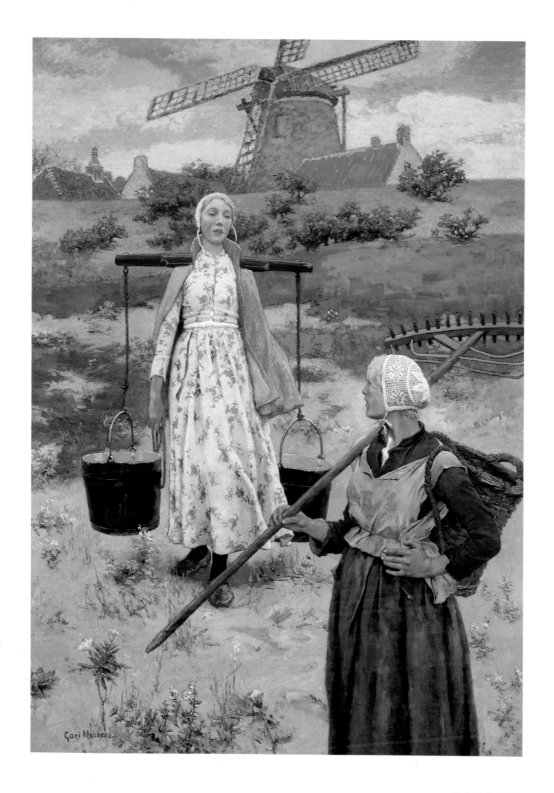

PLATE 3

IN HOLLAND
1887, oil on canvas, 109 × 77 ³/₄ inches
Belmont, The Gari Melchers Memorial Gallery
(cat. no. 12)

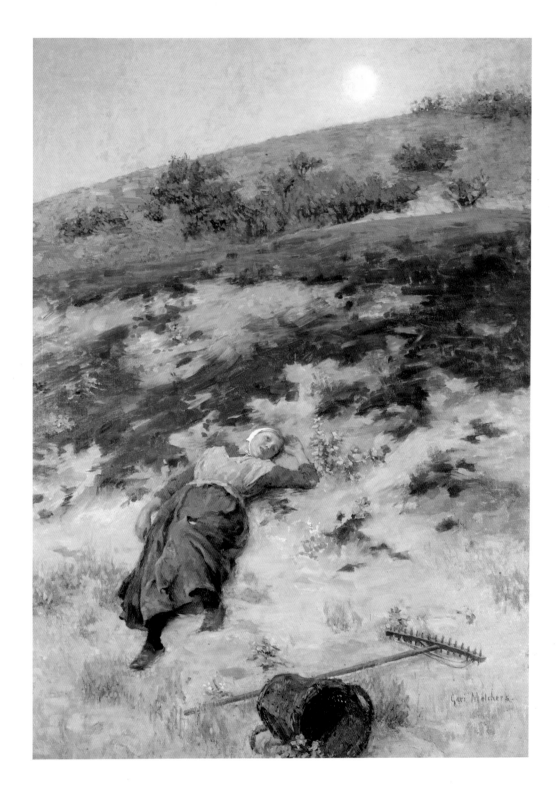

PLATE 4

MOSS AND SAND

1887, oil on canvas, 44 × 33 inches
Belmont, The Gari Melchers Memorial Gallery
(cat. no. 13)

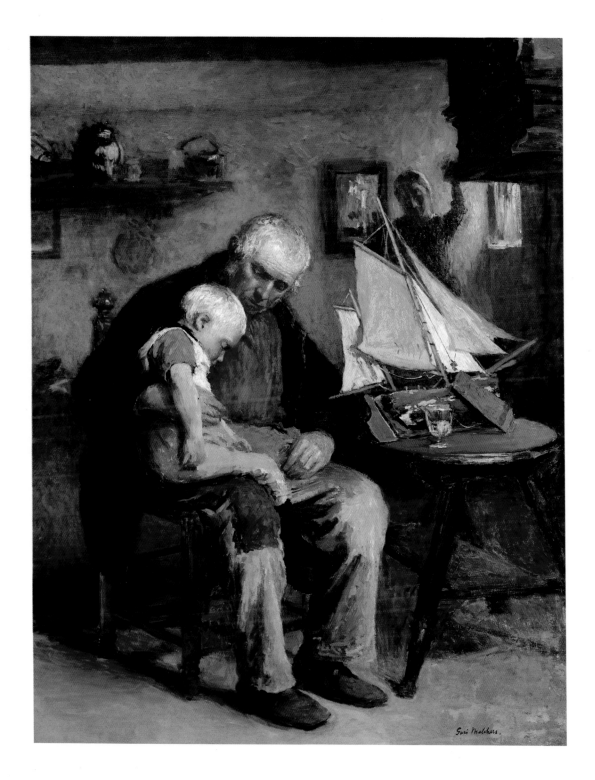

PLATE 5

OLD AND YOUNG

c. 1890, oil on canvas, 43 ³/₈ × 33 ¹/₂ inches
Mr. and Mrs. Robert G. Beck, Newport News, Virginia
(cat. no. 17)

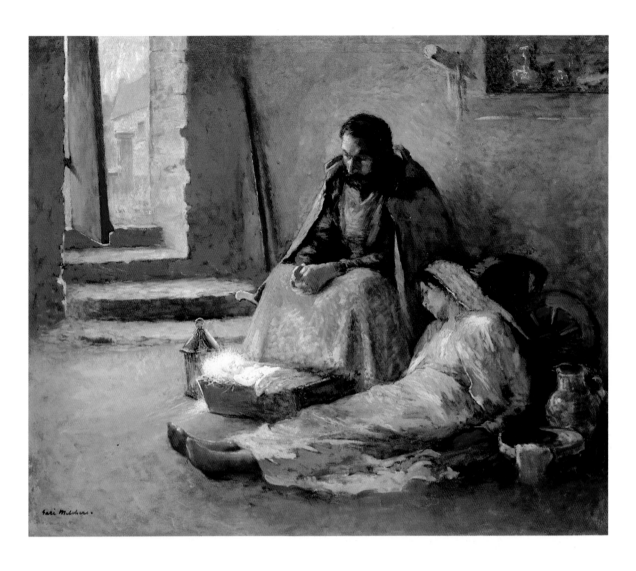

PLATE 6

THE NATIVITY
c. 1891, oil on canvas, 35 $\frac{1}{2}$ × 43 $\frac{1}{2}$ inches
Belmont, The Gari Melchers Memorial Gallery
(cat. no. 19)

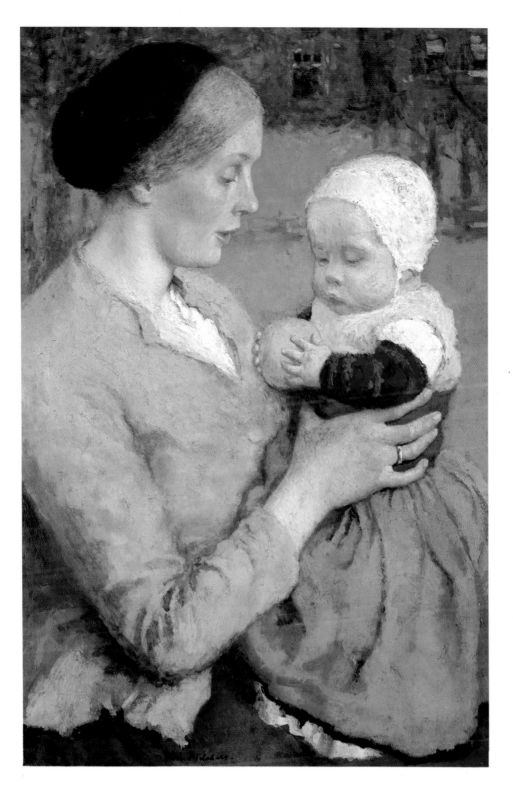

PLATE 7

MOTHER AND CHILD WITH ORANGE
c. 1892, oil on canvas, 29 × 19 ½ inches
Belmont, The Gari Melchers Memorial Gallery
(cat. no. 20)

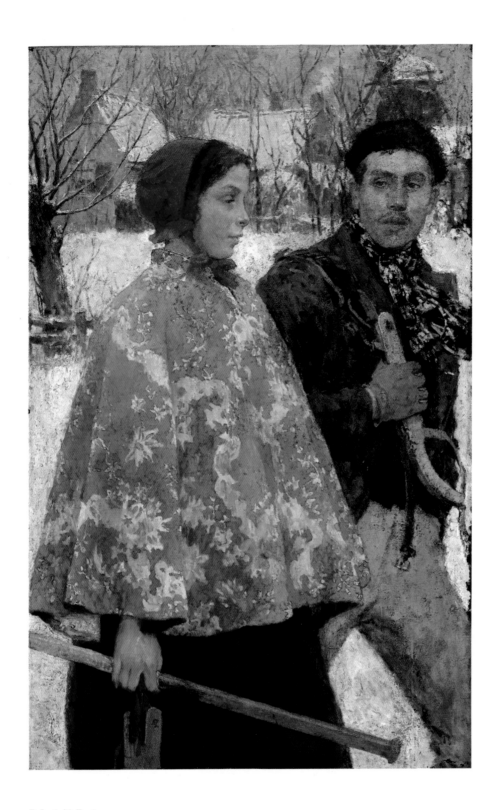

PLATE 8

SKATERS
c. 1893, oil on canvas, 43 3/16 × 27 7/16 inches
Pennsylvania Academy of the Fine Arts, Philadelphia,
Joseph E. Temple Fund
(cat. no. 23)

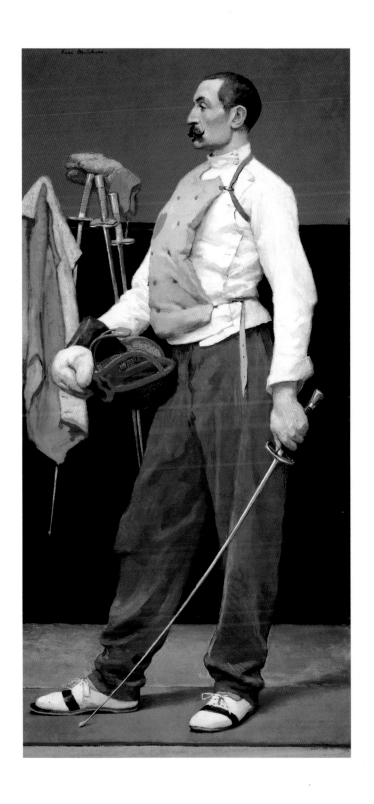

PLATE 9

THE FENCER

c. 1895, oil on canvas, 80 $^7/_8$ × 39 $^1/_4$ inches
Belmont, The Gari Melchers Memorial Gallery
(cat. no. 25)

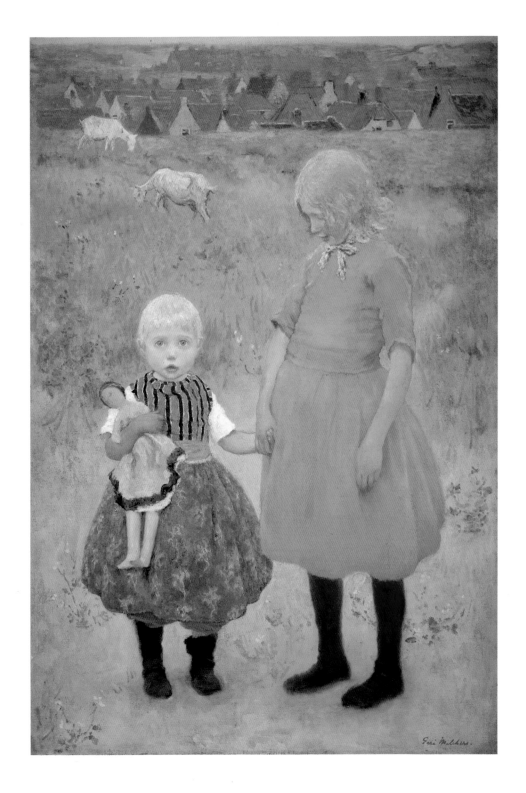

PLATE 10

THE SISTERS

c. 1895, oil on canvas, 59 ¹/₄ × 39 ⁵/₈ inches
National Gallery of Art, Washington, D.C.,
gift of Curt H. Reisinger, 1957
(cat. no. 26)

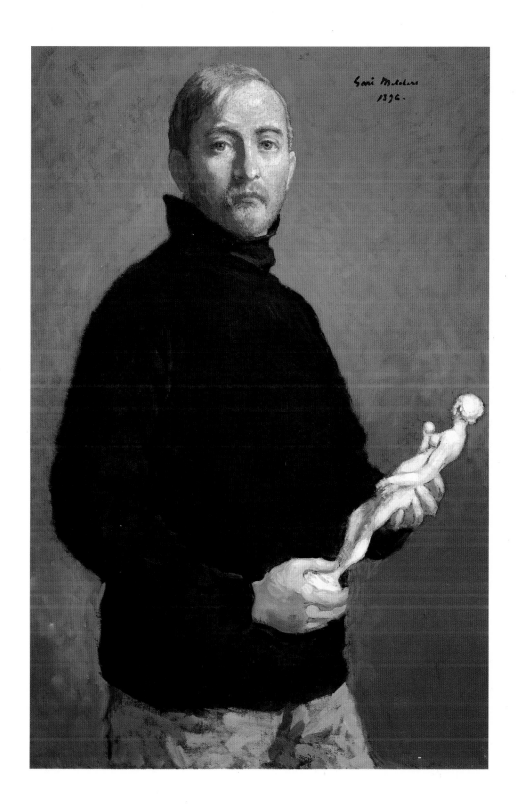

PLATE 11

SELF-PORTRAIT
1896, oil on canvas, 37 7/8 × 26 1/8 inches
Belmont, The Gari Melchers Memorial Gallery
(cat. no. 27)

29

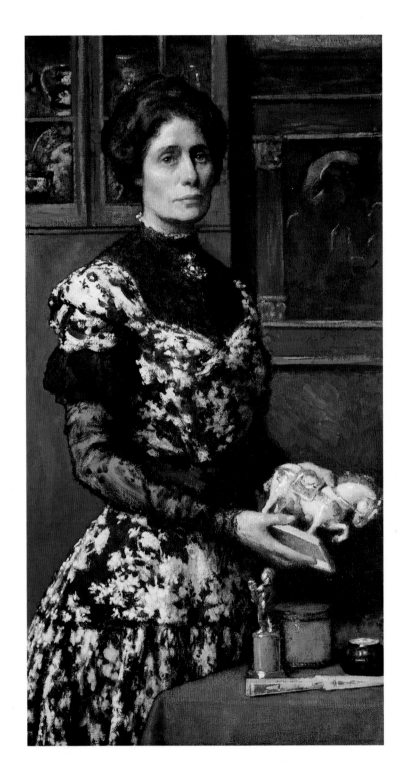

PLATE 12

THE DELFT HORSE
c. 1900, oil on canvas, 44 ¼ × 22 ¼ inches
Belmont, The Gari Melchers Memorial Gallery
(cat. no. 28)

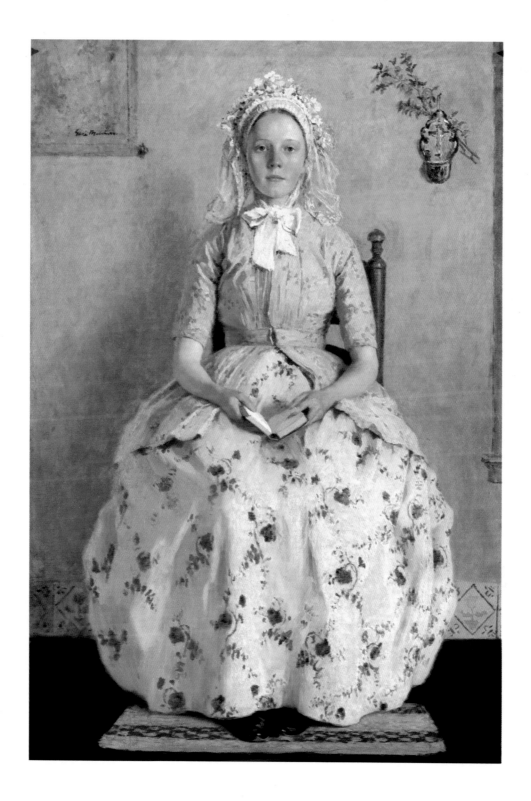

PLATE 13

THE COMMUNICANT

c. 1900, oil on canvas, 63 ¹/₄ × 43 inches
The Detroit Institute of Arts, bequest of
Mr. and Mrs. Charles M. Swift, 1969
(cat. no. 29)

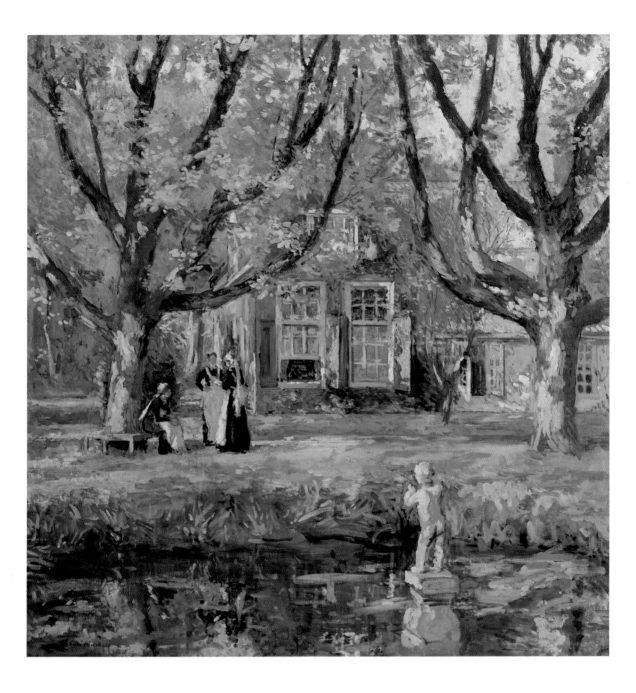

PLATE 14

IN MY GARDEN
c. 1903, oil on canvas, 41 × 40 inches
The Butler Institute of American Art,
Youngstown, Ohio, purchase, 1922
(cat. no. 30)

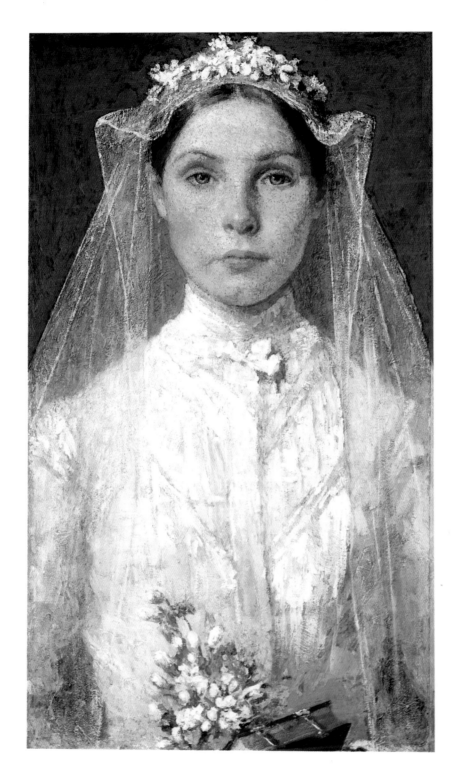

PLATE 15

THE BRIDE

1903, oil on wood panel, 21 $\frac{1}{4}$ × 12 $\frac{1}{8}$ inches
Belmont, The Gari Melchers Memorial Gallery
(cat. no. 31)

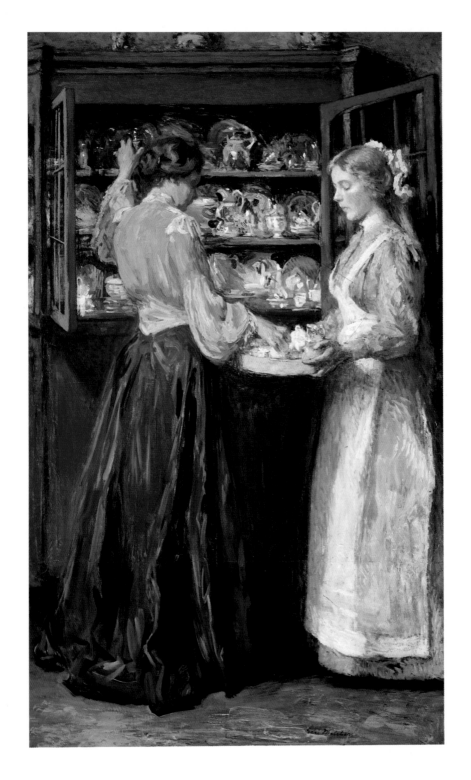

PLATE 16

THE CHINA CLOSET
1904–1905, oil on canvas, 50 × 30 inches
Belmont, The Gari Melchers Memorial Gallery
(cat. no. 34)

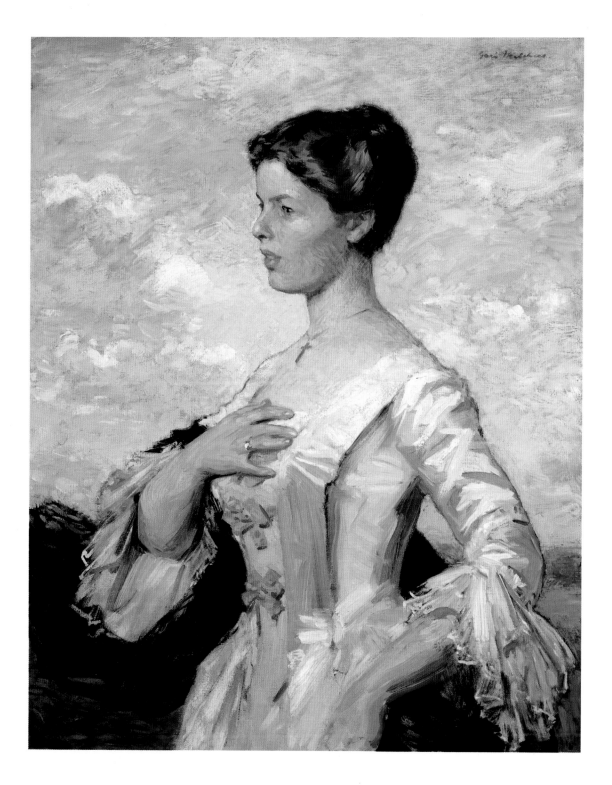

PLATE 17

PORTRAIT OF MRS. GARI MELCHERS
1905, oil on canvas, 35 3/4 × 28 1/2 inches
Belmont, The Gari Melchers Memorial Gallery
(cat. no. 35)

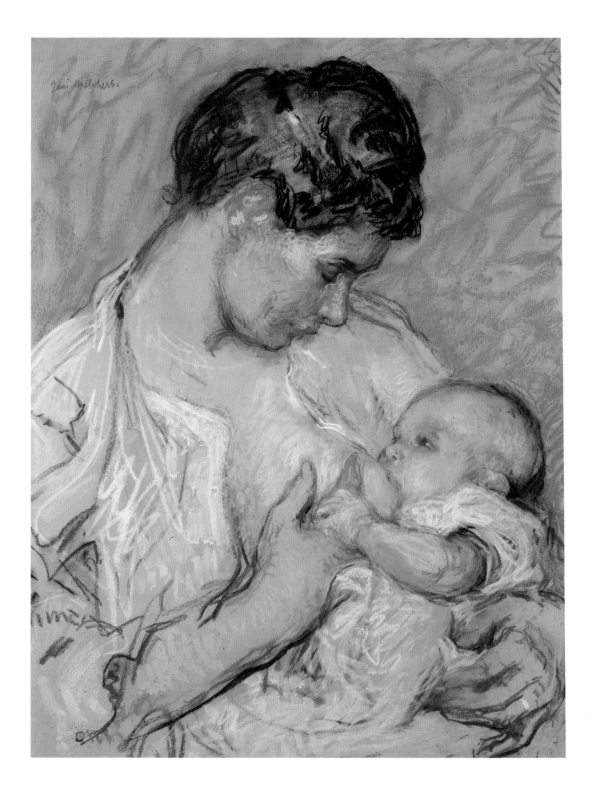

PLATE 18

MOTHER AND CHILD
c. 1905–1908, watercolor, charcoal, and pastel
on paper mounted on board, 24 × 18 ¼ inches
Belmont, The Gari Melchers Memorial Gallery
(cat. no. 37)

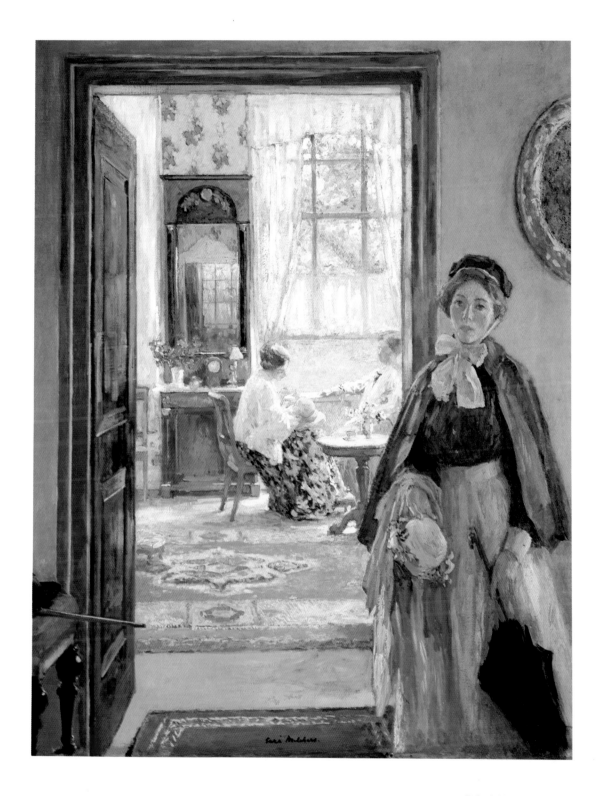

PLATE 19

THE OPEN DOOR
c. 1905–10, oil on canvas, 62 × 48 ⅓ inches
Belmont, The Gari Melchers Memorial Gallery
(cat. no. 38)

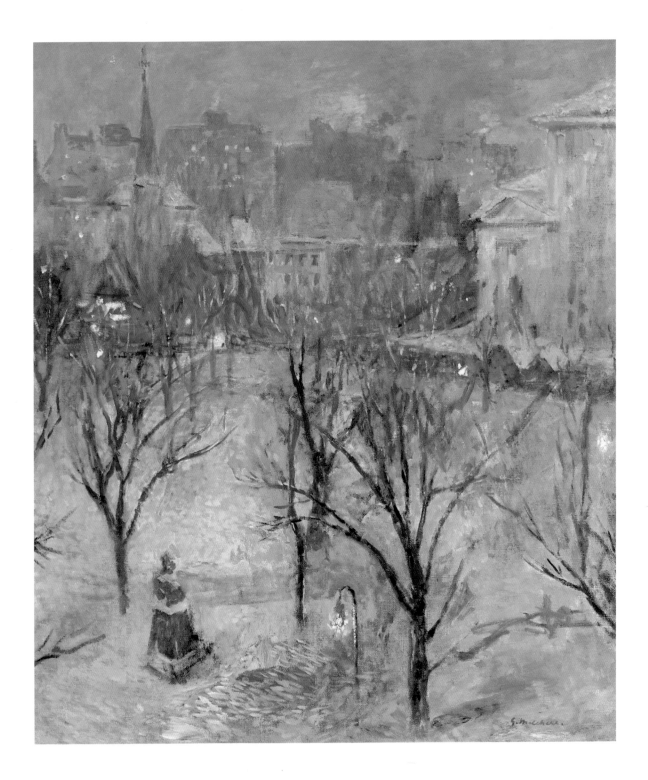

PLATE 20

BRYANT PARK (TWILIGHT)
c. 1906–1907, oil on canvas, 34 1/8 × 29 1/2 inches
Belmont, The Gari Melchers Memorial Gallery
(cat. no. 39)

PLATE 21

PENELOPE
1910, oil on canvas, 54 ½ × 50 ⅞ inches
The Corcoran Gallery of Art, Museum Purchase Gallery Fund, 1911
(cat. no. 42)

PLATE 22

THE WARTBURG, NO. 1
c. 1912, oil tempera on paper mounted
on board, 35 × 25 ¹/₂ inches
Belmont, The Gari Melchers Memorial Gallery
(cat. no. 44)

PLATE 23

EARLY SPRING LANDSCAPE
c. 1918, oil on canvas, 17 3/4 × 21 inches
Belmont, The Gari Melchers Memorial Gallery
(cat. no. 45)

PLATE 24

UNCLE JIM
c. 1919, oil on panel, 19 ¼ × 8 ⅛ inches
Belmont, The Gari Melchers Memorial Gallery
(cat. no. 47)

PLATE 25

YOUNG WOMAN SEWING
1919, oil on canvas, 34 ¼ × 29 ¼ inches
Belmont, The Gari Melchers Memorial Gallery
(cat. no. 48)

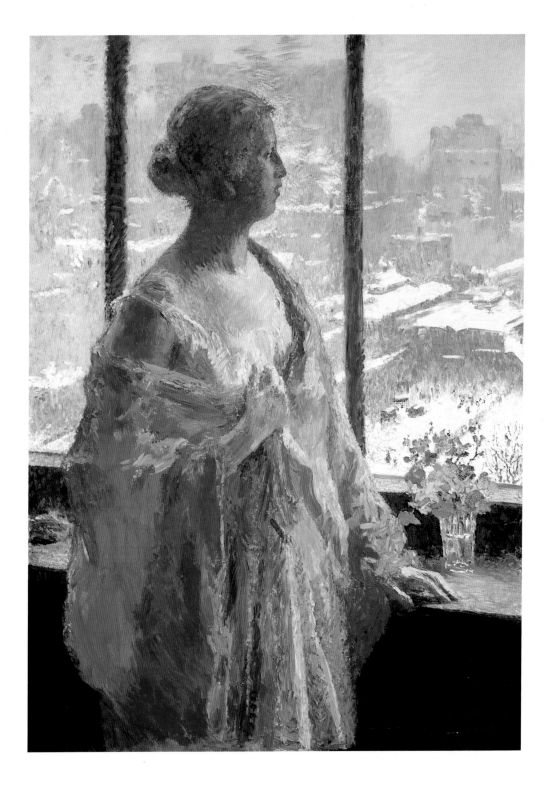

PLATE 26

SNOW
1921, oil on canvas, 43 × 31 ¹/₈ inches
Belmont, The Gari Melchers Memorial Gallery
(cat. no. 51)

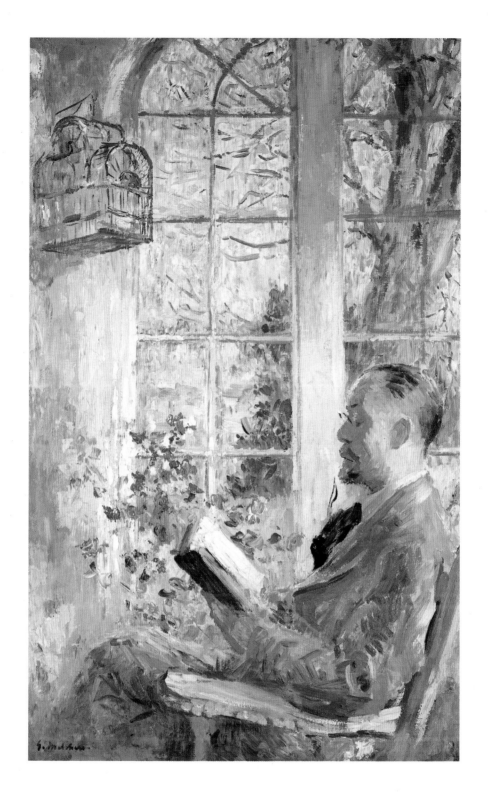

PLATE 27

THE SUN PORCH

c. 1921, oil on canvas, 28 × 18 inches
Belmont, The Gari Melchers Memorial Gallery
(cat. no. 52)

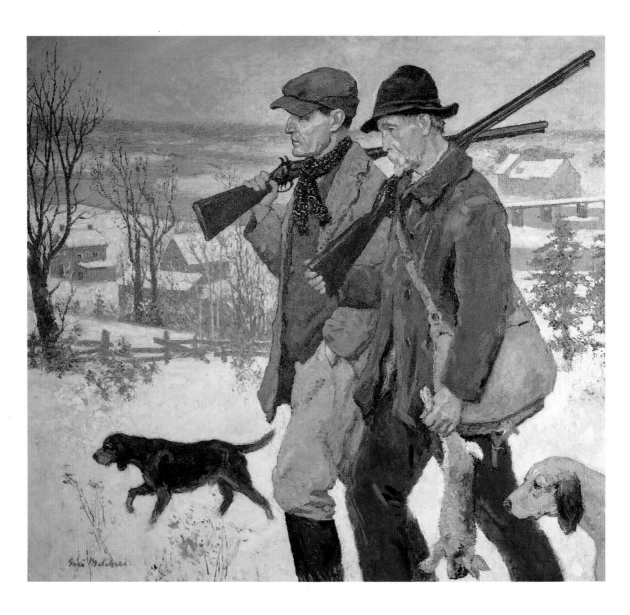

PLATE 28

THE HUNTERS
c. 1925, oil on canvas, 53 3/8 × 59 1/4 inches
Mr. and Mrs. Robert G. Beck, Newport News, Virginia
(cat. no. 54)

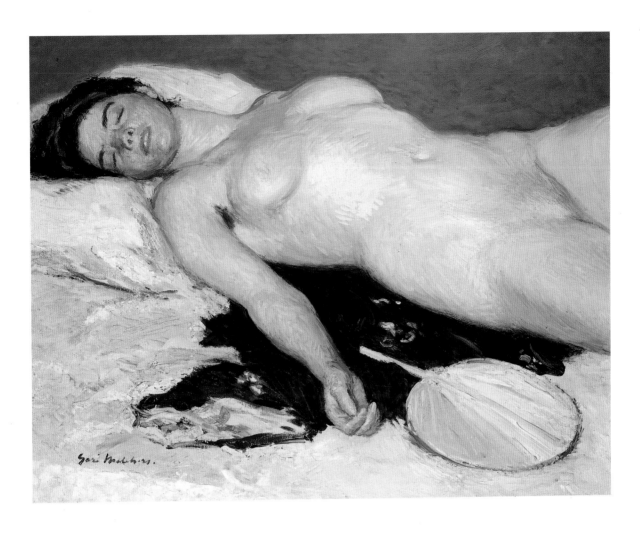

PLATE 29

LASSITUDE

c. 1925–31, oil on canvas, 36 × 29 inches
Belmont, The Gari Melchers Memorial Gallery
(cat. no. 57)

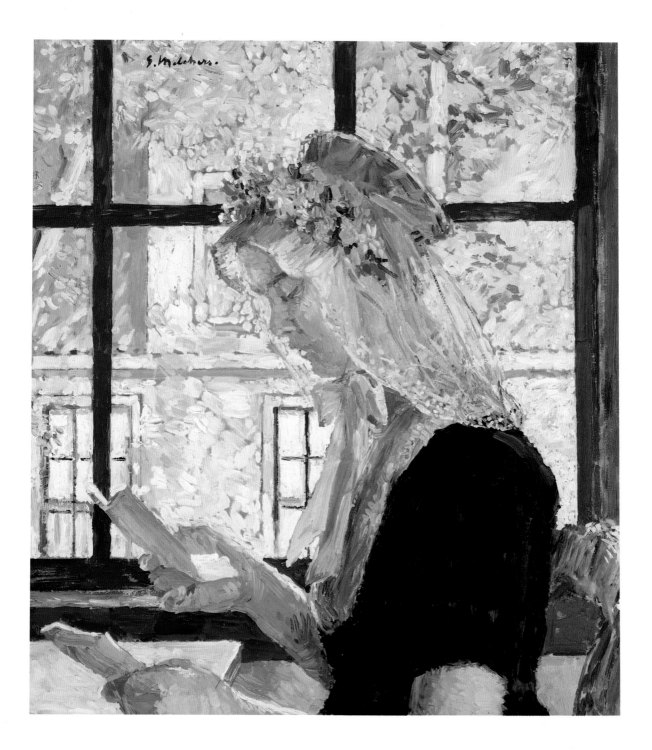

PLATE 30

THE LACE CAP
1932, oil on paper mounted on composition
board, 19 1/4 × 17 1/4 inches
Belmont, The Gari Melchers Memorial Gallery
(cat. no. 59)

The Student Years:
Düsseldorf And Paris

GEORGE MESMAN

▼

Julius Garibaldi (Gari) Melchers was born in Detroit on August 11, 1860. His father, Julius Theodore Melchers, a German emigrant, settled in Detroit in 1855.[1] Julius became known as an art teacher and gained a national reputation as a sculptor whose works ranged from wooden cigar-store Indians to civic monuments. Gari was named for his father and for his godfather, the Italian patriot Giuseppe Garibaldi. Like all other children in his neighborhood, he went to the Barstow School. Unlike his classmates, however, he spent most of his free time at his father's studio and attended Julius's drawing classes on Sunday mornings.[2]

When Melchers turned seventeen, he had to decide between a career in the military and that of an artist. Julius wanted his son to become a soldier and considered sending him to West Point.[3] Gari, however, had already embarked on his life's work. He had participated in the first exhibition of the Detroit Art Association in 1876,[4] and after a visit later that year to the Centennial Exhibition in Philadelphia, Melchers and his father may have discussed the possibility of an art education in Europe. In any case, it was agreed that in 1877 Gari would enroll at the academy in Düsseldorf or Munich. Paris, the European city most favored by American students in the 1870s, was not considered because of opposition by Gari's mother, who characterized Parisian studios as "dens of iniquity."[5] Düsseldorf's academy[6] was chosen, perhaps in part because of family ties: Julius Melchers was a Westphalian and Gari's paternal grandfather, Johann Wilhelm Anton Melchers, still lived in Dortmund, halfway between Soest, Julius's birthplace, and Düsseldorf. Julius's great-uncle, Paulus Melchers, was archbishop of nearby Cologne, and the Düsseldorf *Adressbuch* for 1877 listed Frau Melchers-Layers, who may have been another relative.

A quiet place with few distractions, Düsseldorf was appealing for a number of reasons. An art student could live comfortably in the city for $150 a year; instruction by a private art teacher cost $8.50 per month, and tuition at the academy, officially known as Königliche Preussische Kunstakademie zu Düsseldorf, was $12 annually. The artists formed an important social class in the city and were

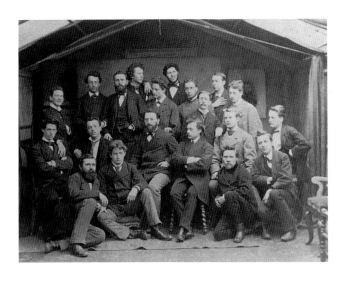

Fig. 1. Düsseldorf Royal Academy of Art, c. 1877. Melchers: first row, second student from left.

respected by its residents, who profited economically and socially from their presence and from the fame they brought Düsseldorf as an art center.[7]

Melchers began his studies with Hugo Crola and Heinrich Lauenstein (fig. 1). In April of 1878 he began working with Peter Janssen, and in June he enrolled in Karl Müller's class in antique casts. In the spring of 1880 Melchers entered the combined class of Eduard von Gebhardt and Julius Roeting to paint in oils.[8]

Although Melchers left no written recollections of his academic training, his friend Julius Rolshoven described their instructors and courses. Crola's students first made drawings after Hans Holbein and then drew from plaster casts; Gebhardt—who often worked nude so that he could study the movements of his body in a large mirror—advised students to carry a sketchbook wherever they went, maintaining that this method developed one's perception of nature.[9] In fact, all academy instructors considered it important for students to supplement their art studies with sketching trips (*studenten Reisen*) around Düsseldorf and along the Rhine.[10] Several of Melchers's sketchbooks from his Düsseldorf days have survived, and it is possible to follow, to a limited extent, his early artistic development.[11]

Few records survive concerning Melchers's trips outside Düsseldorf. In 1878 he traveled to Paris to visit the Exposition Universelle with an academy friend,[12] and in June of 1879 he was in Dortmund where he made a charcoal portrait of his paternal grandfather (Belmont). Melchers received his diploma in July of 1880, but he did not leave the academy until April 1881. He visited Brittany during this period or immediately afterward; a painting signed and dated "81" and titled *The Vegetable Girl* shows a young woman in Breton costume (fig. 2).[13]

While a student in Düsseldorf, Melchers exhibited his works in Detroit. In February 1879 he sent two crayon works, a portrait and a nature study, to Angell's Art Gallery; in October of that year he sent four sketches in ink and three in oil.[14]

Melchers apparently convinced his parents that additional study in Paris was necessary for his artistic development; sometime between April and June of 1881 he left for Paris. The example of fellow students may have fueled his argument: in the early 1880s it had become customary for German painters to study in Paris after completing their education at home. A German student would hope to stay in Paris until he could exhibit his work at the Salon and receive at least an honorable mention.[15]

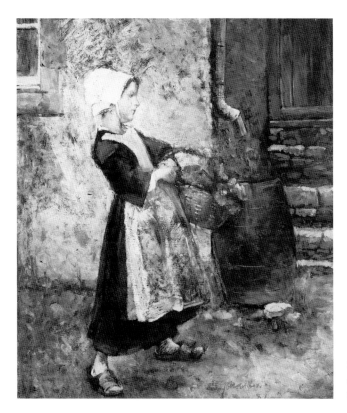

Fig. 2. *The Vegetable Girl*, 1881, oil on canvas, 18³/₄ × 15⁵/₈ inches, location unknown, photo courtesy Christie's.

Three contemporary American observers—Henry Bacon, Phebe D. Natt, and Richard Whiteing—writing about art education in Paris in 1881–82, discussed the advantages of studying there. Arriving from diverse parts of the world, students matured and grew by contact with others;[16] masterpieces of the past and present were accessible to everyone;[17] living was inexpensive and accommodations were plentiful.[18] According to Natt, "Paris, with all its varied attractions, has been and is the paradise of artists."[19]

Melchers entered the Académie Julian, where he worked under the guidance of Gustave Boulanger and Jules Lefebvre,[20] but the objective of every student in Paris, native or foreigner, was to enroll at the prestigious Ecole des Beaux-Arts. French applicants between the ages of fifteen and thirty-five were accepted; for foreigners there was no age limit. Admittance, however, was difficult to gain: the applicant had to present proof of age and talent, as well as a letter of recommendation from his ambassador or consul to the French Minister of Fine Arts. The applicant then became an *aspirant*—a candidate for admission—and was permitted to use the art galleries and libraries and to attend lectures. Next were a series of difficult examinations on topics including anatomy, perspective, and antique drawings; the submission of a study from life; and finally, an oral or written examination in general history.[21] The applicant was also examined for proficiency in French. This stringent testing had been introduced to limit the number of foreign students, especially from America, because, as Lucy H. Hooper wrote, they "threatened to crowd out the embryo painters of France from the already restricted space of the National School of the Fine Arts."[22] On July 4, 1881, Melchers obtained the required letter of recommendation from the American chargé d'affaires. He took the qualifying examinations and was admitted to the painting section of the school.[23]

Less than a year later Melchers achieved his first important success with the acceptance of a painting at the 1882 Salon. *The Letter* (pl. 1; cat. no. 6) shows an interior with two Breton peasant women, one of whom reads a letter. Melchers had chosen a popular subject; his picture was but one of a number dealing with Breton themes selected for the Salon.

The first American public mention of *The Letter* appeared in the *Detroit Free Press* in June of 1883 when the painting was exhibited at the National Academy of Design in New York, where it received favorable notice.[24] In September of that year, *The Letter* was one of eight Melchers paintings shown at the Detroit Art Loan Exhibition.[25] In connection with this exhibition, the *Detroit Free Press* critic wrote, "There is this to say of ... *The Letter*: It shows the artist in serious work with an honest and successful effort to present a plain, finished, picturesque idea ... capital ... admirably drawn and excellently painted."[26]

In correspondence dated May 16, 1882, Julius Melchers congratulated his son on *The Letter* and also discussed Gari's travel plans for a trip to Italy, warning him of "fiery wines," and "females with a temperament where love and hatred dwell in the same breast together."[27] The letter suggested that Gari visit his godfather and namesake, Garibaldi, with the observation that "the old man may even let you paint or draw his portrait; this would be good advertising for the American press."[28] For Julius, travel to Italy had remained an unfulfilled desire:

> Your travel plans—to go with your friend Pauwels—to Naples and surroundings to study there for three months I can only approve of.... That which I yearned for in my youth but which had to remain just a beautiful dream, that is what is now going to be fulfilled for you: you will see and experience sunny Italy.[29]

Melchers spent several weeks at the Trappist monastery at Casamari—fifty-five miles southeast of Rome—where he was "impressed by the quiet asceticism of monastic life."[30] A number of small, contemplative paintings on panel date from this visit, including *Kneeling Monk in a Church* (cat. no. 5). From Casamari he traveled to Atina, a tiny mountain village, where he painted *Woman of Atina* (location unknown). This painting, together with *Pater Noster* (location unknown), was exhibited at the 1883 Salon.

Melchers's return to America in 1883 marked the conclusion of his apprenticeship and student life and the beginning of his professional career.[31] In 1884 he moved to Egmond aan Zee, a village on the Dutch shore of the North Sea. There Melchers would paint many of his most memorable works and achieve worldwide recognition.

George Mesman, a doctoral candidate at City University of New York, is writing his dissertation on Gari Melchers.

1. Julius Theodore Melchers was born in the town of Soest, West Germany, about forty miles northeast of Düsseldorf. Perhaps influenced by the unsettled political situation in Prussia in 1848, he left his hometown, and after a stay in Paris, where he studied sculpture under Jean-Baptiste Carpeaux at the Ecole Nationale de Dessin, he worked in London on the decorations for the Crystal Palace. In 1852 he journeyed to America; he worked in several cities and in 1855 joined relatives in Detroit. Julius married Marie Bangetor on May 5, 1858. The couple had four children: Hedwig (Hettie), Julius Garibaldi, Arthur Carl, and Julie Irma. For a discussion of the Melchers family, see Joseph G. Dreiss, *Gari Melchers: His Works in the Belmont Collection* (Charlottesville, Va.: University Press of Virginia, 1984), pp. 1ff.

2. Bruce M. Donaldson, "An Appreciation of Gari Melchers, 1860–1932," *Michigan Alumnus Quarterly Review*, June 29, 1935, p. 508.

3. Louis L. Richards, "Tabloid Tales of an Old Reporter," *Detroit News Tribune*, June 30, 1931, p. 14. Melchers did join the Pelouze Cadets, who were trained in the elementary duties of a soldier.

4. "The Art Exhibition: Opening of the First Exhibition of the Detroit Art Association," *Detroit Free Press*, February 1, 1876, p. 1. The opening of the exhibition was reported on the front page and described by the art critic as "an extensive and choice display of works of local and foreign artists," but he did not discuss Melchers's entries. Melchers showed several works, including the oil painting *Domestic Quarrel* (c. 1875, location unknown). Entry 185 consisted of "Crayon Drawings," otherwise untitled. Detroit Art Association, *First Exhibition, February 1876*, pp. 3, 4.

5. Bruce M. Donaldson, *Gari Melchers: A Memorial Exhibition of His Works* (Richmond: Virginia Museum of Fine Arts, 1938), p. 14.

6. For the Düsseldorf academy see Wend von Kalnein, *The Düsseldorf Academy and the Americans: An Exhibition of Drawings and Watercolors* (Atlanta: High Museum of Art, 1973), p. 18. Melchers's friend Julius Rolshoven, the son of a German emigrant who settled in Detroit in 1850 as a silversmith, also chose Düsseldorf. In his "Journal," recollections written in the mid-1920s, Rolshoven recalled their journey to Europe with another friend, Minnie Dieterich (probably the daughter of Auguste F. Dieterich, a business partner of Melchers's uncle, Edward [*Detroit City Directory*, 1862–63]). In early August 1877, they traveled to New York and boarded the *Pomerania*. Disembarking in Hamburg two weeks later, Dieterich went to Leipzig and the young men to Düsseldorf (V.D.C., "Julius Rolshoven," *University Art Museum Bulletin*, University of New Mexico, vol. 1 [Winter 1965–66], pp. 6–7). The "Journal" is in the collection of Bruce Weber, Miami.

7. "Foreign Correspondents, Items, etc.," *The Crayon*, vol. 4 (December 1857), pp. 373–74.

8. Melchers was registered in 1877 as Julius G. Melchers. His student card recorded that he was to be trained as a *Figurenmahler* and that he was a good student with much talent and a diligent worker. He received favorable comments from Peter Janssen, but Müller found his work difficult to judge (Student records of the Academy, 1877–81).

9. Rolshoven, "Journal," pp. 30–32.

10. David Edward Cronin, *The Evolution of a Life* (New York: S. W. Green's Son, 1884), pp. 116–17.

11. There are forty-seven sketchbooks, of various sizes, at Belmont, but many remain nearly empty. Throughout his career Melchers often sketched one or two figures in a book and then abandoned it, and he dated only the sketches made during his academy years. These drawings are in charcoal, ink, pencil, or mixed media. No sketches or drawings made after plaster casts or after drawings of the Old Masters have survived.

12. Leslie L. Gross, "Melchers' Art from Detroit and Düsseldorf," in *Gari Melchers (1860–1932): Selections from the Mary Washington College Collection* (Fredericksburg, Va., 1973), p. 9.

13. *The Vegetable Girl* was sold at Christie's in New York on May 31, 1985.

14. "Art Brevities," *Detroit Free Press*, February 2, 1879, and October 16, 1879.

15. Lovis Corinth, "In der Akademie Julian," *Kunst und Künstler*, vol. 3 (September 1904), p. 19.

16. Henry Bacon, *A Parisian Year* (Boston: Roberts Brothers, 1882), p. 54.

17. Phebe D. Natt, "Paris Art Schools," *Lippincott's Magazine*, vol. 27 (March 1881), p. 269.

18. Richard Whiteing, "The American Student at the Beaux-Arts," *The Century Illustrated Monthly*, vol. 23 (December 1881), pp. 259–61.

19. Natt, "Paris Art Schools," p. 276.

20. The Académie Julian, founded in 1868, became the largest and most famous of the private Parisian art schools because of its ability to attract well-known painters and sculptors from the Ecole des Beaux-Arts. Boulanger and Lefebvre were Prix de Rome winners and had received the Legion of Honor. Both won medals at the Salon and were often chosen as Salon jury members. See William Rothenstein, *Men and Memories: Recollections of William Rothenstein 1872–1900* (New York: Coward-McCann, 1931), p. 39.

21. Natt, "Paris Art Schools," pp. 271–72.

22. Lucy H. Hooper, "Art Schools in Paris," *The Cosmopolitan*, vol. 14 (November 1892), pp. 59–60.

23. Belmont archives.

24. "Local Art Brevities," *Detroit Free Press*, June 27, 1883, p. 4.

25. His entries, in addition to *The Letter*, were *Alone, Atina in Italy, The Gladiator, In the Monastery, The Lictor, Theresina,* and *Vespers. Detroit Art Loan: Catalogue of Art Works Exhibited* (Detroit: John F. Eby, 1883), p. 47. Except for *The Letter*, the whereabouts of Melchers's seven other entries at the Detroit Art Loan Exhibition are unknown.

26. "The Great Exhibit: Various Paintings by Detroit Artists Spoken of," *Detroit Free Press*, September 13, 1883, p. 4.

27. For an English translation of the letter, originally in German, see Dreiss, *Gari Melchers*, p. 9.

28. Ibid.

29. Ibid.

30. Christian Brinton, *Modern Artists* (New York: Baker and Taylor, 1908), p. 216.

31. There were two reasons for Melchers's visit in 1883: in June his sister Hettie married Julius Stroh of the Stroh brewing family ("Married," *Detroit Evening News*, June 7, 1883, p. 4), and in September he participated in the Detroit Art Loan Exhibition, announced by the *Detroit Free Press* (September 2, 1883; p. 4) as "the largest and best art exhibition ever held in the West." The Art Loan Exhibition was advertised as representing schools of modern painting as well as works by "ancient" masters. Among the exhibitors mentioned were Rosa Bonheur, Frank Duveneck, Jean-Léon Gérôme, Gabriel Max, Jean-François Millet, and Alfred Emile Stevens.

THE HOLLAND YEARS

A N N E T T E S T O T T

▼

In December of 1884 Gari Melchers and two fellow Americans, George and Henriette Hitchcock, moved into a studio home on a dune in the Dutch fishing village of Egmond aan Zee. The decision to establish roots in Egmond, based on a successful summer and fall of sketching in and around the village, was to prove pivotal for both the artists and Egmond. Holland would provide Gari Melchers with his primary subjects and models for three decades and with themes to which he would return regularly for the rest of his life. George Hitchcock, too, based his life's work on The Netherlands. Together, Melchers and Hitchcock attracted so many other artists to Egmond aan Zee (and the neighboring towns of Egmond Binnen and Egmond aan den Hoef) that by 1900 the region supported a recognized art colony with its own school of painting — the Egmond School.

Before moving into the studio on the Torenduin (tower dune), Melchers and the Hitchcocks apparently lived in a local hotel frequented by artists and sailors. The two men sketched outdoors in the streets and on the beaches, only joining other artist guests to paint in the hotel's main salon in bad weather.[1] Hitchcock concentrated on seascapes, while Melchers painted figure studies of fishermen or peasant farmers and herders.

Once settled in the Torenduin studio, Melchers and Hitchcock had an ideal place to paint the large-scale pictures on which artists relied to attract attention at the Paris Salons and other annual exhibitions throughout Europe. Melchers's first major success of this type came with *The Sermon* in 1886 (pl. 2; cat. no. 11). Painted in the Dutch Reformed Church in Egmond Binnen, it depicts nine women, wearing the simple dress of the region, in various attitudes of attention or indifference to a sermon. Two men sit above and separate from the women. Melchers delineated each detail of the rush seats, numbered wooden chair backs, flowered cloaks, and lace caps in an attempt to convey an honest and accurate impression of the people among whom he lived. His success in his quest for "truth and clarity," his motto, may be judged by the reaction of his contemporaries. *The Sermon* attracted favorable attention at the Paris Salon in the spring of 1886, winning an honorable mention there and a gold medal at the "Exhibition of Living

Fig. 3. Wilhelm Leibl, *Three Women in Church*, 1882, oil on panel, 44½ × 30¼ inches, Berbling Kunsthalle, Hamburg.

Masters" in Amsterdam that fall. When the painting appeared in the 1889 Exposition Universelle in Paris, the critic Theodore Child wrote:

> He paints figures round and solid, with a tendency toward the complete illusion of materiality. In all that concerns realistic work we cannot mention a French artist who is superior to him, for Mr. Melchers is marvellously skilful; in *Le Prêche* [*The Sermon*] and in the large *Communion* picture there are figures and *morceaux* which are simply the last word of realism in painting.[2]

In addition, the painting was reproduced as a fine-art print and in magazines in France, Germany, and the United States, which did much to spread the artist's reputation.

The subject of peasants at a church service had been attempted previously with considerable success by the German painter Wilhelm Leibl. His *Three Women in Church* (fig. 3), painted in Germany in 1882, was well received when exhibited in Munich and Paris. Also related to Melchers's painting is a drawing by Edwin Austin Abbey of an old Dutch man in a church who appears to have fallen asleep while listening to the service. Abbey's illustration was part of a collaborative effort with George Henry Boughton to illustrate Holland for the readers of *Harper's New*

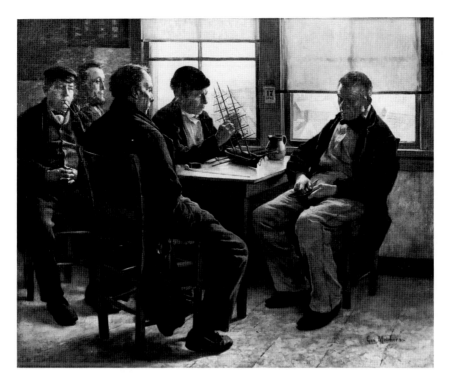

Fig. 4. *The Pilots*, 1887, oil on canvas, 67³/₄ × 83¹/₂ inches,
Frye Art Museum, Seattle.

Monthly Magazine. Published serially between 1883 and 1884, and in book form
in 1885, these drawings became some of the best-known images of Holland
among Americans.[3] Other artists also portrayed European peasants in church to
suggest the natural piety of simple people, and Melchers returned to this popular
subject many times.

The following year, 1887, Melchers sent a large painting of Egmond farm
women, *In Holland* (pl. 3; cat. no. 12), to the Salon. The artist must have been
disappointed at its quiet reception. Most critics failed to notice it, and one who
did declared that people had a right to expect more than this oversized sketch from
an artist who was talented enough to have produced *The Sermon* the year before.[4]
Probably as a result of the unfavorable criticism, Melchers later reworked the
painting, adding a village background and making minor alterations in the cos-
tumes. But in 1888 he scored another hit at the Salon with *The Pilots* (fig. 4).
Child called it one of the two best American pictures in the Salon, and other
reviewers praised the variety of character types and Melchers's technique.

The Pilots, like *The Sermon*, reveals Melchers's intense interest in the ordinary,
everyday lives of working-class people. His facility for the Dutch language allowed
him to live among the Egmonders and to share the small occurrences of their daily
activities. Because his neighbors felt comfortable in his presence, he had ample
opportunity to observe their personal traits and gestures, and these were much
admired when included in his paintings. (Note, for example, the action of the
pilot who tamps tobacco into his pipe with one finger.)

At about this time Melchers painted two pictures of young lovers, *The Sailor
and His Sweetheart* (fig. 5) and *Skaters* (pl. 8; cat. no. 23). In its simple composi-
tion, *The Sailor and His Sweetheart* conveys a wealth of meaning. The woman's hand

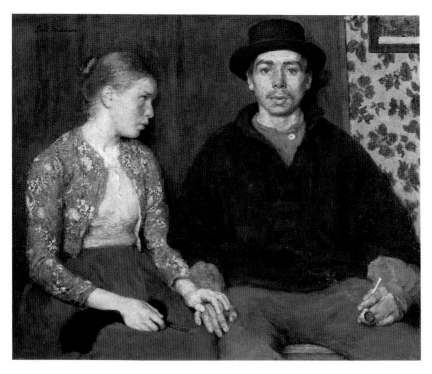

Fig. 5. *The Sailor and His Sweetheart*, c. 1898–99, 33½ × 41⅜ inches,
Freer Gallery of Art, Smithsonian Institution, Washington, D.C.

on his, her upward gaze fixed on her lover's face, the knitting that rests in her lap,
and the Dutchman's ever-present pipe all provide clues to their relationship.
Melchers's contemporaries admired this picture for its successful revelation of two
believable personalities. Francis Ziegler wrote, "The adoring expression of the
country maiden and the stolid contentment of her phlegmatic lover, capitally
rendered, are most amusing."[5] Charles H. Caffin declared:

> The abstract gaze of the fisherman, stolid with much looking on sky and water; the
> personal, straining gaze of the woman, accustomed to wait and watch for her man; his
> rough, bluff self-containedness, the action of her hand as her heart goes out to him —
> it is a bit of sentiment, elemental in its unaffected simplicity and truth.[6]

Melchers and Hitchcock worked together closely, sometimes sharing models
and often exchanging ideas. In an article on the picturesque qualities of Holland,
Hitchcock recommended the celebration of Communion in the Dutch Reformed
tradition, a marriage ceremony, and a church full of lace-capped women as suit-
able subjects for paintings; all had been, or soon would be, painted by Melchers,
and Hitchcock's descriptions correspond exactly to the way Melchers painted
them.[7] Hitchcock vehemently disliked manufactured household goods, factory-
made furniture, and industrial farm equipment. Neither he nor Melchers saw
artistic potential in the mass-produced paraphernalia of modern life; instead, their
paintings celebrate the traditionally picturesque.[8] *In Holland* and *Moss and Sand*
(pl. 4; cat. no. 13) exemplify Melchers's interest in old-fashioned, wooden farm
implements and the traditional farming techniques then common in Holland.

In spite of shared ideas and subjects, the two men developed distinctive per-
sonal styles. Whereas Hitchcock showed an early interest in marine and landscape

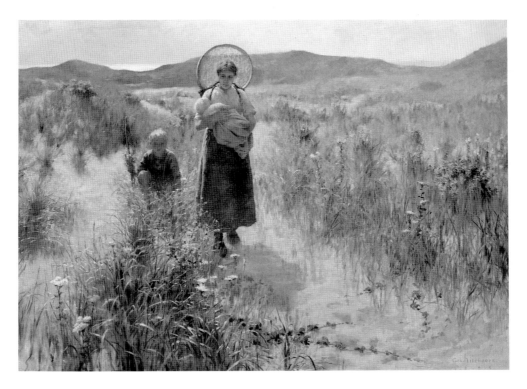

Fig. 6. George Hitchcock, *Maternity*, 1889, 69¹/₂ × 98 inches,
Aberdeen Art Gallery and Museums, Scotland.

painting and a later preference for female figures outdoors, Melchers painted men
as well as women and frequently placed his figures in interiors. Furthermore,
Melchers usually presented a straightforward, factual account of Dutch peasants,
emphasizing their sturdy, honest character, simple clothing, and phlegmatic
nature, while Hitchcock more often endowed them with mystical qualities.
Hitchcock's *Maternity* (fig. 6), for example, reveals an Egmond farm woman
against the side of a dune, similar to Melchers's *In Holland*. But the presence of a
baby and the winnowing basket strapped to her back to create a halo elevate
Hitchcock's peasant to the realm of religious symbolism.[9] Hitchcock's Madonna
contrasts with the stolid materialism of Melchers's peasant women. This is not to
say that Melchers did not sometimes endow Dutch peasant genre with religious
symbolism, but when he did he was more subtle. Many of his paintings of young
Dutch mothers holding their babies recall the Madonna only by virtue of his
audience's familiarity with the subject as rendered by Raphael. On one of the few
occasions when he included an obvious clue—a yellow plate placed on a ledge to
create a halo behind the principal figure in *Young Mother*—Francis Ziegler criti-
cized it as "a piece of trickery that has little to commend it."[10] Perhaps in
response, Melchers painted the plate out of the version of the painting known as
Fairy Story (fig. 7) and placed a small Madonna and Child statuette in the back-
ground instead.

When Melchers did paint religious subjects, he usually posed his models in
biblical robes and gave Jesus a halo to ensure that there was no mistaking his
intent. *The Nativity* (pl. 6; cat. no. 19) depicts Mary, Joseph, and the infant Jesus
in Bethlehem. In *The Last Supper* (fig. 8), only the inclusion of a Delft plate and
wooden milk pail locates the painting in Holland. This significantly differentiates

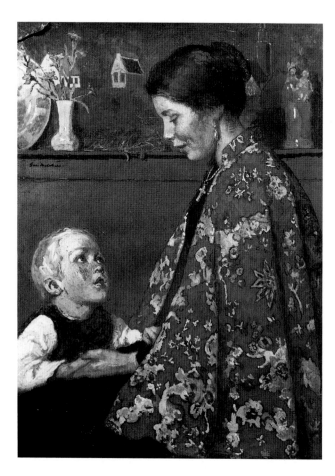

Fig. 7. *Fairy Story*, c. 1899, gouache on buff paper, 35½ × 25½ inches, Annmary Brown Memorial, Brown University, Providence.

Melchers's Dutch peasant Bible subjects from those of the German painter Fritz von Uhde, with which they are usually compared. Von Uhde's success in the 1880s with paintings like *Come Lord Jesus Be Our Guest (His Omnipresence)* (National Museum of Modern Art, Paris) may well have encouraged Melchers to attempt similar subjects, but whereas von Uhde presents Jesus as a holy presence visiting nineteenth-century Dutch peasants, Melchers transformed the peasants into Jesus, John, Judas, and the others.[11]

In the early years of his career, Melchers was often mistaken for a Dutch artist. J. Nilsen Laurvik recalled:

> In the first flush of enthusiasm, I hailed him as a new Dutch painter who had at last succeeded in interpreting the spirit as well as the outward aspect of his people.... The name as well as the point of view revealed in these canvases led me to the easy conclusion that this must surely be the work of a Dutchman.[12]

A writer for *Art Amateur* in 1885 singled out this "exceedingly clever Hollander" for praise and, after eloquently extolling Melchers's watercolor technique, went on to examine the work of "Meinherr's hardly less clever countrymen," the Hague School artists Jacob Kever and George Poggenbeek.[13]

As these incidents suggest, the contemporary Hague School influenced some of Melchers's early Dutch work. The Hague School consisted of Dutch landscape and figure painters bound by a common concern for native Dutch subject matter

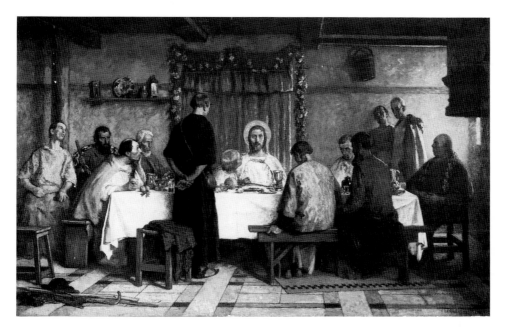

Fig. 8. *The Last Supper* (*Lamplight*), c. 1903, oil on canvas, 39 × 58³/₄ inches, Belmont, The Gari Melchers Memorial Gallery.

and subdued gray or silvery tonalities. Their work received increasing international notice in the 1880s. George Hitchcock had studied with a member of the school, Hendrik Willem Mesdag, before coming to Egmond, and Melchers must have seen their work in Paris exhibitions before closer acquaintance in The Netherlands. In 1885 Melchers and Hitchcock joined Bernardus Blommers, Mesdag, and other artists of the Hague School in an exhibition at Gladwell's Gallery in London (fig. 9). This is the only known instance of such a joint venture, but the artists continued to have contact at larger exhibitions, and Melchers owned works by the Dutch artists Johannes Bosboom, Jozef Israëls, and Anton Mauve.

Melchers shared an interest in the simplicity of Dutch peasant life with the Hague School figure painters Blommers, Israëls, D. A. C. Artz, Matthijs Maris, and J. Albert Neuhuys. For example, his painting *The Sisters* (pl. 10; cat. no. 26) is similar in subject and composition, though not in technique, to Neuhuys's *Going to School* (fig. 10). In each, the foreground is dominated by a girl leading a younger sister by the hand down a path. Both artists captured the tender relationship between the siblings. Melchers's paintings of children and of mothers holding babies may also be related in a general way to Blommers, who specialized in such domestic scenes and became one of America's favorite Dutch painters.

Paintings like Melchers's *The Sick Child* (cat. no. 9) and *Fulfilled* (Belmont) are related to Jozef Israëls's work in their choice of subject, somber palette, and melancholy mood. *The Sick Child* is particularly reminiscent of Israëls's *Alone in the World* (Rijksmuseum H. W. Mesdag, The Hague), which attracted great admiration at the World's Columbian Exposition in Chicago and was considered by many Americans to be Israëls's masterpiece. Although Melchers paid tribute to the father of the Hague School in these renderings of peasant sorrow, and some of his early oil sketches reveal the subtle tonal effects for which the Hague School

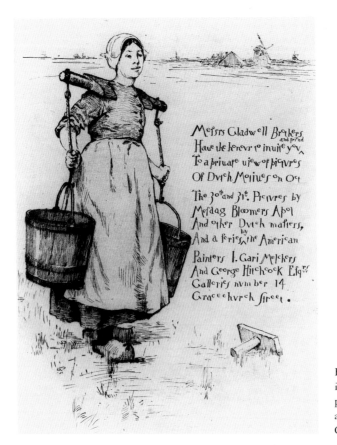

Fig. 9. Artist unknown. Engraved invitation to an exhibition of Dutch pictures by Melchers, Hitchcock, and painters of the Hague School, Gladwell Gallery, London, 1885.

Fig. 10. J. Albert Neuhuys, *Going to School*, c. 1889, oil on panel, 14½ × 10¼ inches, Gemeentemuseum, The Hague.

became famous, his mature work more often reflects his optimistic view of life and his love of light and color.

As early as 1886 Melchers employed strong colors in *The Sermon* (pl. 2; cat. no. 11), and this tendency increased as his style matured. Turquoise, orange, lemon yellow, and pink became favorite hues, which he used in unusual and not always harmonious combinations. A reviewer of Melchers's Egmond pictures noted:

> We find ourselves vexed by his hard outlines, his harsh color, and his inclination to omit all those delicate nuances which in nature blend tone with tone. . . . It is the glory of modern Dutch painting to make much of those very effects which Mr. Melchers ignores. [14]

This opinion notwithstanding, most critics admired Melchers's colorful style, hailing his paintings as a new vision of the Dutch landscape and character. The catalogue for an exhibition by young Dutch artists in 1916 explained: "These younger men of the new movement simply carry forward the discovery made by that open-eyed American painter, Gari Melchers, who long since saw that Holland was not always enveloped in a drab forbidding gray mist." [15] Thus Melchers's relationship with contemporary Dutch painting came full circle. He admired the founders of the Hague School, following their lead in subject matter and gray palette. But from there he developed his own more colorful, optimistic view of Dutch life, one which may have influenced some younger Dutch painters to see their country through his eyes.

When he came to Holland, Melchers was determined to rise in his profession. He used the Egmond studio as a quiet workplace for concentrated periods and sent the pictures produced there to exhibitions throughout Europe and the United States. A sociable person and a good businessman, he soon made sales and acquired regular patrons including Mr. and Mrs. Potter Palmer, Charles Freer, and James Deering. He traveled frequently, always expanding his professional contacts — to Paris for the spring and fall Salons; to London for the Royal Academy exhibition; to Düsseldorf, where he had studied, and Munich; home to Detroit; to Italy; and to Spain. He also established studios in other cities, but Egmond continued to inspire his major pictures.

In the winter of 1889–90 Melchers worked in Chicago, painting portraits in a room set aside for him by the Potter Palmers. During the next few years he was frequently in the United States, and when he returned to Holland he continued to paint in the Torenduin studio, but lodged in one or another pension. A favorite was the Slot van den Hoef, named after the castle ruins in Egmond aan den Hoef. It was run by the Bult family, who became good friends of and models for their artist guests. Meanwhile, Hitchcock had purchased a country estate called Schuylenburg near Egmond aan den Hoef and had built a studio there.

Throughout the 1890s Melchers's paintings became increasingly decorative in nature. By this time he had traveled extensively in The Netherlands. A visit to the art colony at Volendam in the late 1880s produced a few small pictures (cat. no. 16); he made sketches in Dordrecht, South Holland; visited Katwijk in 1890; and traveled throughout the provinces of Zeeland and Brabant. As a result of these

Fig. 11. *Dutch Women in a Church*, c. 1893, oil on canvas, 47½ × 38¼ inches, Stadelsches Kunstinstitut und Stadtische Galerie, Frankfurt am Main.

trips he began to include costumes from other Dutch regions in his paintings. In *Dutch Women in a Church* (fig. 11), he combined the regional Veluwe cap with a North Holland dress on the center figure and placed a worshiper in typical Egmond headdress next to her. Melchers set this scene in the same church in Egmond Binnen as seen in *The Sermon* and recorded individual details just as accurately, but because of the mixture of costumes, the work lacks the veracity of the earlier painting. Like the famous Dutch flower painters who mixed winter, spring, and summer blossoms in one picture, Melchers assembled costumes from various provinces for greater pictorial effect. In many of Melchers's pictures from this period, women wear the elegant *poffer* bonnet of North Brabant.[16] Melchers seems to have preferred its filmy veil, ribbons, and flower wreath to the simpler Egmond lace cap, and in one or two paintings he depicted the entire congregation of the Egmond aan den Hoef chapel in North Brabant costume.

Melchers's introduction of more colorful and decorative costumes complemented his increasing use of high-key pigments and impasto highlights. By the time he painted *Easter Sunday* (fig. 12) in 1910–11, he was applying thick, wet globs of colored paint to approximate light reflections from the church's stained-glass windows. The congregation no longer occupies the center of the picture but is seen as a row of heads in a variety of costumes across the bottom of the painting. Colorful glass windows and a fancy wrought-iron oil lamp fill the upper portion of the painting. *The Sermon* focused on the people, their humble piety, and everyday costume, whereas *Easter Sunday* is more concerned with a decorative and colorful design.

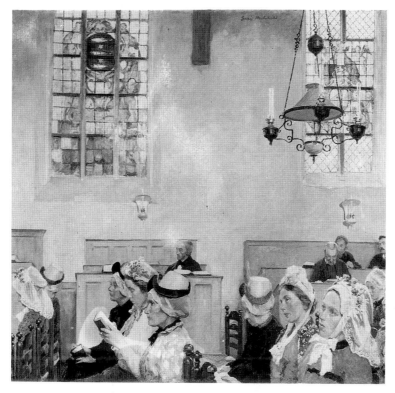

Fig. 12. *Easter Sunday*, 1910–11, oil on canvas, 52 × 56 inches,
The Toledo Museum of Art, gift of Florence Scott Libbey.

Melchers's church subjects often depict special occasions, such as *The Communion* (Cornell University, Ithaca, fig. 29), *The Wedding* (fig. 13), and *The Christening* (Belmont). Melchers painted themes that interested him numerous times, altering background details and focusing on a few figures, or pulling back to reveal the whole scene. This is well illustrated by the wedding series. In *Marriage* (cat. no. 22), a bride is turned to a three-quarter view beside her bridegroom. *The Bride* (pl. 15; cat. no. 31) presents a close-up frontal view of the same woman, his Dutch cook, Anna Dekker. The orange background of the earlier picture is here exchanged for a blue one, and the groom is absent. *The Wedding* reveals the minister in his pulpit and the witnesses as well as the bride and groom. With each painting Melchers experimented with color and composition, even varying his models for the bride and groom. Several other paintings in watercolor and gouache depict related scenes, and similar series exist for other subjects.

One of Melchers's favorite themes was the mother and child. He included this subject as part of a larger composition in *The Family* (National Gallery, Berlin), depicting a young Dutch woman nursing a baby while her proud husband looks on. Melchers set the scene in a typical Dutch home with the curtains of a cupboard bed visible in the background. Other details, including a doll abandoned on the floor, the father's smoking clay pipe, and the foot warmer on which the mother rests her feet, contribute a homey realism to the painting. Melchers clarified the relationships between the four figures through the father's affectionate gaze and proud stance, the mother's tender handling of the baby, and her concerned regard

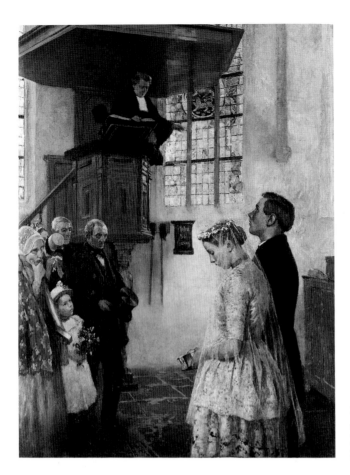

Fig. 13. *The Wedding*, c. 1900, oil on canvas, 45 × 34 inches, © The Detroit Institute of Arts, gift of Edward Chandler Walker.

for the older daughter who clutches the father's leg. A Madonna and Child painting on the wall suggests an interpretation of the contemporary Dutch mother as a modern Madonna.

Melchers exhibited *The Family* in the 1895 Salon of the Société Nationale des Beaux-Arts, along with other canvases including *The Doll*—a picture of the same little blonde girl clutching her doll. From Paris he sent *The Family* to the Art Institute of Chicago and the Pennsylvania Academy of the Fine Arts, where it won a gold medal. Over the next ten to fifteen years he painted a dozen or so mother and child subjects, some with additional figures, but the majority presenting a three-quarter-length view of a woman holding her baby. These bring to mind similar subjects by Mary Cassatt, George de Forest Brush, Elizabeth Nourse, and other artists of the late nineteenth and early twentieth centuries. Some of Melchers's mother and child paintings, like *Madonna* (fig. 14), make obvious reference to Mary and Jesus. The veil and wreath of the Madonna's North Brabant headdress create a halo, and the woman kneeling at her feet, with hands extended in an attitude of prayer, replaces the figure of an angel in similar compositions by Leonardo da Vinci and Botticelli. At the same time, the baby's gesture as it reaches toward the woman's outstretched hands is a natural one and keeps the painting in the real world. Other depictions of the mother and child theme, although modeled by Dutch women, are not particularly Dutch in character (fig. 15). They represent the motherhood in all women.

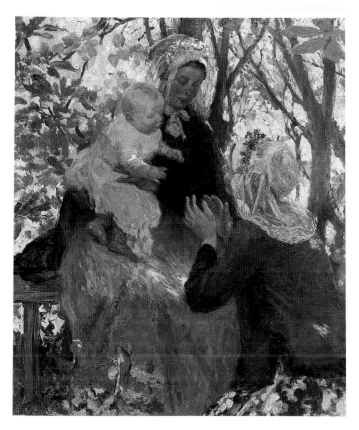

Fig. 14. *Madonna*, c. 1910, oil on canvas, 47¼ × 39⅝ inches,
The Metropolitan Museum of Art, Rogers Fund, 1911 (11.42).

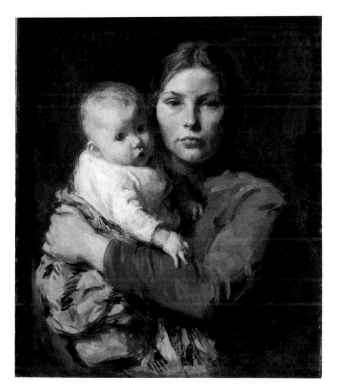

Fig. 15. *Mother and Child*, c. 1906, oil on canvas, 26¼ × 21½ inches,
© 1989, The Art Institute of Chicago, all rights reserved.

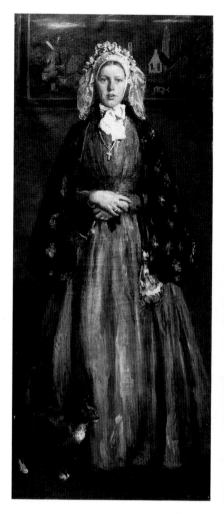

Fig. 16. *La Brabançonne*, c. 1904–1905, oil on canvas, 73 × 31 inches, Annmary Brown Memorial, Brown University, Providence.

Fig. 17. Letitia Crapo Smith, *The First Birthday*, 1902, oil on canvas, 57 × 42½ inches, Flint Institute of Arts, Michigan, gift of Mrs. Jay C. Thompson (67.10).

The theme at the core of Melchers's work is the cycle of human life. He repeatedly explored the milestones of human existence: birth, baptism, young love, marriage, parenthood, and death. *Old and Young* (pl. 5; cat. no. 17), an oil painting of a favorite Egmond model holding a little boy on his lap in the Torenduin studio, summarizes this concern with the stages of life.

During the 1890s Melchers painted a number of decorative pictures of single female figures. In both *Arranging the Tulips* (National Museum of American Art, Washington, D.C.) and *La Brabançonne* (fig. 16), a woman in Dutch garb is seen at full length against a wall parallel to the picture plane. The wall confines the pictorial space, helping to focus attention on the figure. *Fairy Story* (fig. 7) and *The Delft Horse* (pl. 12; cat. no. 28) conform to this compositional pattern as well. Melchers balanced the formal elements of figures, wall, paintings, and furniture to create a complex two-dimensional design. He often placed a mural high in the background, recalling the use of paintings within paintings by seventeenth-century Dutch painters, such as Vermeer, but achieving a flatter effect. Melchers developed this single-figure type at about the same time that Hitchcock began painting single, costumed female figures outdoors set against fields of flowers.

Melchers's interest in formal considerations and the manipulation of interior light balances Hitchcock's concern with color composition and the simulation of bright sunlight. As usual they shared a common interest but carried it in different directions.

A third Egmond artist, the American-born British painter James Jebusa Shannon, painted portraits of both Melchers (Belmont) and Hitchcock (fig. 58) and captured characteristics of each artist's work. He posed Melchers indoors against a backdrop of paintings, creating a narrow pictorial space, a compositional device that relates the portrait to Melchers's own paintings. Shannon posed Hitchcock outside in the sunlight, surrounded by poppies, with a screen of foliage blocking the view into the distance. A stream of light shines on Hitchcock, illuminating the palette he holds in his hands. The flowers, general composition, and light are appropriate symbols for an artist who prided himself as a colorist and was known as the "Painter of Sunlight."

Shortly before 1890 George Hitchcock began teaching pupils at Egmond.[17] Soon a dozen or more art students, mostly Americans, took up residence there each summer. Melchers's relationship to these young artists appears to have been that of a role model. He had no formal arrangement to teach in the school but did occasionally offer criticism, encouragement, or advice. Sometimes he painted outdoors with the students, sharing their models, but more often he worked alone in his studio. Mrs. Mackall, the mother of one of Hitchcock's students and Melchers's future mother-in-law, wrote in 1902 that Melchers lived like a recluse. Her daughter reported that Melchers discouraged visitors to his studio.[18] Despite this determination to guard his solitude, Melchers's fame, and quite possibly his personal invitation, were instrumental in bringing students to the region.

Fellow Detroit artist Letta Crapo Smith probably learned about Egmond through Melchers or his paintings, which he often exhibited in Detroit. She spent several summers in Hitchcock's class, and her paintings reflect both his and Melchers's influence. Her 1903 Salon picture, *The First Birthday* (fig. 17), recalls Melchers's interest in the mother and child theme. Her color scheme, insistence on plein air execution, and attention to detail can be attributed to her instruction in the Egmond School.

Melchers's Dutch images became so well known that when another Egmond pupil, Alice Blair Ring, exhibited her pictures in Cleveland, a local writer reported: "Miss Ring's models, as may be seen from the illustrations, are of the type so often painted by Gari Melchers. Nor is this surprising, since these simple peasant folk, found in Egmond, are the same among whom Gari Melchers has made his home."[19] It is possible that Melchers assumed a more active teaching role in Egmond after 1905 when Hitchcock left. Ring and Florence Upton claimed to have been his pupils, and both women worked in Egmond in that late period.

The annual influx of artists, art students, families chaperoning female pupils, and patrons who came to see Melchers and Hitchcock had an inevitable effect on the Egmonds. As paintings exhibited around the world made their once-isolated town famous, Egmonders began to seek ways to capitalize on the situation. In 1895 Egmond aan Zee established an office of tourism and took steps to

Fig. 18. *At Home (The Winged Victory)*, 1905–10, oil on canvas, 98$\frac{1}{2}$ × 59$\frac{1}{4}$ inches, Belmont, The Gari Melchers Memorial Gallery.

develop the town into a vacation spot. They coordinated building efforts for new hotels and pensions, published a seasonal paper to advertise services, and worked to improve transportation to the area. Pensions and cafes were already established in all three towns, and individuals hired themselves out to the Americans as maids, gardeners, coachmen, and models. About 1901 Mr. Kraakman built a studio building in Egmond aan den Hoef so Hitchcock's students would have a place to work close to their instructor's home. He also established an antiques business and rented costumes and props to the artists. By 1905 Egmond aan Zee had changed from a remote fishing village to a thriving tourist and art center.

Melchers's last decade in Egmond is marked by two events: his marriage to Corinne Mackall in 1903 and the defection of George Hitchcock, who left his wife and Egmond in 1904–1905 to marry one of his students. These events, plus the altered character of the region, contributed to a change in Melchers's art. He began to paint domestic interior scenes of upper-class cosmopolitan ladies, which although painted in Holland, are no longer recognizably Dutch.

Shortly after their marriage, Gari and Corinne Melchers purchased a house in Egmond aan Zee. Melchers sometimes painted there, but after Hitchcock's departure he more often drove out to Schuylenburg to work (pl. 13; cat. no. 29). In 1912 Corinne reported that Melchers painted at Schuylenburg every day from nine until four.[20] Henriette Hitchcock probably encouraged him to make use of the

studio there, and a number of his paintings are set in the house itself. *Penelope* (pl. 21; cat. no. 42) is a fine example of the domestic interiors he painted during this time. Corinne Melchers posed for Penelope, and Henriette Hitchcock's Dutch maid, Kierie Blok, posed for the maid. The painting's title refers to Odysseus' faithful wife, who devised a ruse to keep suitors away until her husband returned. Having told them she could not marry anyone until she finished her weaving, she wove by day and unraveled her work at night. In Melchers's painting, Penelope sits at a tambour frame while her maid sorts colorful skeins of embroidery thread. The flowered wallpaper and distinctive fireplace, seen in *The Morning Room* (Belmont) and *At Home (The Winged Victory)* (fig. 18), identify the setting as Schuylenburg.

Each of the paintings describes a blissfully peaceful existence, where women occupy themselves with quiet tasks in the elegant comfort of their surroundings. They may be compared to similar domestic interiors by the Boston School artists Edmund Tarbell, William Paxton, and Philip Hale and are part of a popular trend depicting women as beautiful, decorative objects in equally decorative settings.[21] While it may seem ironic that Melchers set these scenes in a home where a troubled marriage had just ended in divorce, the paintings replace his friends' tribulations with depictions of domestic bliss. That Melchers had recently embarked, at the age of forty-three, on a happy, traditional marriage, undoubtedly contributed to his interest in such subjects.

During these years another American expatriate, Florence Kate Upton, also worked at Schuylenburg. She studied with Hitchcock in the first few years of the century and befriended Mrs. Hitchcock, with whom she visited and traveled after Hitchcock's departure. Upton's friend Adeline D. Piper described the period:

> I would I could dwell at length on the life at Egmond Hoef. The visits to Schuil en Berg [*sic*], the home of the Hitchcocks', where so many temperaments met and discussed art, or wandered in their old world garden. The informal dinners in the vivid blue dining room of the Gari Melchers, the candle light revealing the treasures of old Delft and copper, and the lily-lined garden showing eerily in the long soft twilights. The expeditions in the capacious Dutch cart when we gathered priceless bits of porcelain ... I remember all the pictures that were painted by [Upton] in those years in North Holland.[22]

Upton had painted female figures outdoors while studying with Hitchcock, but she began to do interior genre scenes under Melchers's influence. Two versions of *The Yellow Room* (fig. 19) show an Egmond woman named Harmijntji and a little girl in a farmhouse interior with a fireplace as distinctive as the one at Schuylenburg. Like Melchers, Upton posed her figures near a window to capture the effect of natural, filtered light. She exhibited the first version of the picture at an international exposition in Nantes and at the Société Nationale des Beaux-Arts in Paris, and it won her the title of Sociétaire and a medal of honor. Like Melchers, she painted several pictures at Schuylenburg, including some portraits of Mrs. Hitchcock.

Because of the war in Europe, Melchers and Corinne returned to the United States in 1915. At first it was to be a temporary absence from Holland and Germany (where Melchers had been teaching since 1909), and they kept the house in

Fig. 19. Florence Kate Upton, *The Yellow Room*,
c. 1905, dimensions and location unknown.

Egmond and corresponded with Egmond friends. But they never resumed residence and finally sold the house to a Dutch artist.

Although Melchers's direct association with Egmond came to an end in 1915, the years in Holland remained an important influence on his art. He continued to paint Dutch subjects in his new studio at Belmont in Fredericksburg, Virginia. Brief visits to Holland in 1922, 1930, and 1932 may have inspired some of these late Dutch works, which differ significantly from the paintings he made while living in Egmond. With an ocean between himself and his models, he began to transform the Dutch figures into iconic images. *Zeeland Madonna* (fig. 20) portrays a woman in a rigid frontal pose wearing a costume loosely based on that of Walcheren Island in the province of Zeeland. Her inexplicable placement on a chair on the Veere quay, with her feet on a stool, adds to the strangeness of the image. Melchers converted her beautiful white Zeeland bonnet into a flat halo of gold leaf and white cloth. The vivid, rather discordant purple, green, and yellow colors contribute to an overall decorative effect. Melchers's reliance on photographs for costumes and background may partially explain the flatness and lack of vitality of the forms; however, similar stiff frontal poses in *The Brabant Bride* (Belmont) and *The Communicant* (pl. 13; cat. no. 29) suggest a continuing interest in the painted image as an icon.

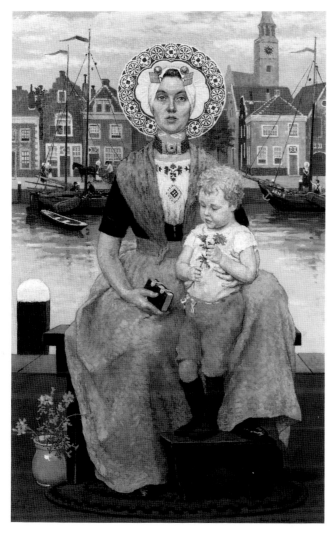

Fig. 20. *Zeeland Madonna*, 1930, oil on canvas, 67 × 43¼ inches,
Belmont, The Gari Melchers Memorial Gallery.

The last painting Melchers completed before his death in 1932 was a Dutch
subject, *The Lace Cap* (pl. 30; cat. no. 59). This picture of a woman wearing the
Brabant costume concluded a forty-eight year period during which Melchers had
created a permanent visual record of the life, environment, customs, and
appearance of contemporary Holland. The venture that started in Egmond in
1884 had resulted in a distinguished lifetime career, and for over a century his
paintings have brought Holland into homes across America.

*Dr. Annette Stott is Assistant Professor of Art History, Winthrop College, Rock Hill, South
Carolina. She is the author of articles dealing with late nineteenth-century American art
and is currently a Mellon Faculty Fellow at Harvard University, where she is writing a
book about Dutch-American painting.*

1. An article, "Beeldende Kunst te Egmond aan Zee," in the regional newspaper, *In en Om Kennemerland* (January 1, 1905), describes fourteen panels in the artists' salon of the Zeezicht Hotel. A few panels were saved when the hotel was destroyed and are now in the Egmond museum, but none by Melchers or Hitchcock has been identified.

2. Theodore Child, "American Artists at the Paris Exhibition," *Harper's New Monthly Magazine*, vol. 79 (September 1889), p. 510.

3. George Henry Boughton, "Artist Strolls in Holland," *Harper's New Monthly Magazine*, vol. 66 (March 1883), p. 530. George Henry Boughton, *Sketching Rambles in Holland* (New York: Harper and Brothers, 1885).

4. Paul Leroi, "Salon de 1887," *L'Art*, vol. 43 (1887), p. 20.

5. Francis Ziegler, "Sixty-ninth Annual Exhibition of the Pennsylvania Academy of the Fine Arts," *Brush and Pencil*, vol. 5 (1900), p. 267.

6. Charles H. Caffin, *The Story of American Painting* (New York: Frederick A. Stokes, 1907; del. ed., Garden City, N.Y.: Garden City Publishing, 1937), p. 354.

7. George Hitchcock, "The Picturesque Quality of Holland: Figures and Costumes," *Scribner's Magazine*, vol. 10 (November 1891), p. 627.

8. For a discussion of artists' antimodern sentiments that includes Hitchcock and Melchers, among others, see Annette Stott, "Dutch Utopia: Paintings by Antimodern American Artists of the Nineteenth Century," *Smithsonian Studies in American Art*, vol. 3 (Spring 1989), pp. 47–61.

9. Other examples of Hitchcock's tendency to make strong religious or mystical statements of his Egmond subjects include *Blessed Mother* (Cleveland Museum of Art), *The Annunciation* (Art Institute of Chicago), and *Dutch Interior, Mother and Children* (Belmont).

10. Ziegler, "Sixty-ninth Annual Exhibition," p. 267.

11. The men who posed for Melchers's two versions of *The Last Supper* took their roles seriously. If Melchers planned to select his models on the basis of physical appearance, he soon found he had to accommodate the Egmonders' sense of appropriateness as well. For example, one refused to pose as Judas, declaring that he would not betray the Lord for seven stuivers, the modeling fee. It may be the models' intense feeling for the subject that caused the painting to take on the appearance of a *tableau vivant*. See also van Vleuten, below, p. 163.

12. J. Nilsen Laurvik, "Gari Melchers," in John D. Trask, ed., *Catalogue De Luxe of the Department of Fine Arts, Panama-Pacific Exposition*, vol. 1 (San Francisco: Paul Elder, 1915), p. 34.

13. "American Water Color Society Exhibition," *Art Amateur*, March 1885, p. 80.

14. "American Painting," *Art Amateur*, August 1893, p. 56.

15. G. E. de Vries, *The Netherlands Art Exhibition* (San Francisco: G. E. de Vries, 1916), p. 6.

16. The woman on the far right in the foreground of *Easter Sunday* (fig. 12) provides a good example of the *poffer* bonnet.

17. I am greatly indebted to Annette Blaugrund for sending me an article, "Hitchcock Elopes," *New York Herald Tribune* (June 25, 1889), describing one of Hitchcock's early affairs with a student. The article is important in establishing that Hitchcock taught students in Egmond as early as 1888.

18. Mrs. Mackall, letter to "Mollie," August 25, 1902, Belmont archives.

19. "Art: Miss Alice Blair Ring," *Town Topics*, October 29, 1910, p. 12. I am grateful to Connie Constant for bringing this article to my notice.

20. Corinne Melchers, letter to "My Dearest Uncle," February 28, 1912, Belmont archives.

21. It is significant that these paintings of tranquil domesticity began to appear in large numbers at a time when more and more American women were leaving sheltered home environments to attend college and make careers, and increasing numbers were divorcing or choosing not to marry. I believe the preoccupation of American figure painters with harmonious interior genre subjects at this time can be interpreted as part of a broader conservative move to reinforce traditional concepts of female identity. For further reading on this subject see *Domestic Bliss: Family Life in American Painting 1840–1910* (Yonkers, N.Y.: Hudson River Museum, 1986) and *The Bostonians: Painters of an Elegant Age 1870–1930* (Boston: Museum of Fine Arts, 1986).

22. Adeline D. Piper, "Florence K. Upton, Painter," *Magazine of Art*, vol. 14 (September 1923), p. 490.

GARI MELCHERS AND THE BELGIAN ART WORLD 1882–1908

JENNIFER A. MARTIN BIENENSTOCK

▼

From the closing decades of the nineteenth century until the outbreak of World War I, American artists played a lively role in the Belgian art world, though few were as consistently involved as Gari Melchers. For twenty-six years he was a regular participant in Belgium's domestic and international exhibitions. This crucial aspect of his cosmopolitan career, however, has only recently been recognized and has yet to receive adequate art historical consideration.[1]

Gari Melchers debuted in the Belgian art arena in August of 1882, only four months after his first entry in the Paris Salon. His association with Belgium ended in 1908 with his appointment to full professor at the Weimar Grand Ducal Academy of Fine Arts. He exhibited both individually and collectively, although a distinction will be drawn between his participation in large-scale American displays and his individual contributions to the Triennial exhibitions. The latter were official Salons that alternated between Brussels, Antwerp, and Ghent until 1898; thereafter, the cycle became quadrennial with the addition of Liège.[2] If the collective American displays acknowledged the growing importance of America in the international art arena, the Triennials demonstrated a specific interest in Gari Melchers.

The appeal of this expatriate American painter was twofold. First, he enjoyed an enormously successful international reputation. One eulogizer wrote at his death in 1932 that "the years of his life as an artist, as one glances back across them, are seen glittering with medals and honors."[3] Second, Melchers adopted a widely acceptable *juste milieu* or academic progressivist style, articulately defined

by his contemporary, the American author Edward Alden Jewell:

> Although classifiable as an academician, Gari Melchers was too alert and adventurous
> to stand altogether at odds with what we loosely term "modern art." In no sense actu-
> ally a modernist, he yet argued in paint a sympathetic appreciation of the fact that
> living art can never afford to shut the door upon fresh search and significant discovery.[4]

BELGIAN SALONS

Gari Melchers's *juste milieu* style, coupled with his international prestige, was
wholly compatible with the reforming spirit embraced by Belgium's Triennial
exhibitions, particularly in Brussels and in Ghent, at the turn of the century.
Belgium's official Salons confronted competition from avant-garde organizations,
such as Les XX and La Libre Esthétique. In addition, its decentralized art world
sustained inveterate rivalries between Antwerp, Brussels, and Ghent, and heated
debate over artistic centralization threatened the very survival of the Triennial sys-
tem. Consequently, Belgium's Salons sought to revitalize and improve the quality
of their expositions by attracting moderately progressive artists of national and
international renown. It is against this background that Gari Melchers's contribu-
tions to Belgium's Triennial exhibitions should be considered—with one exception.

Melchers's *The Letter* (pl. 1; cat. no. 6), shown at the Antwerp Triennial of
1882, predated not only his conversion to academic progressivism, but also his rise
to international prominence. The picture was, however, consistent with Antwerp's
long-standing admiration for the Düsseldorf style, which Melchers acquired dur-
ing his study at Düsseldorf's Royal Academy of Art between 1877 and 1881. In
addition, a less biased attitude toward foreign exhibitors, fostered by serious artis-
tic rivalry between Brussels and Antwerp, also accounted for Melchers's contri-
bution to this Triennial.

Chronic discord between these two cities was rooted, at least in part, in the
traditionally hierarchical nature of the decentralized system. Antwerp promoted
itself as the "métropole des arts," leaving Brussels to content itself as "la capitale
politique." By the late 1870s, however, Antwerp's prestige was waning in the
face of rising provincialism and "virulent resistance" to "innovative currents
announced in the important European centers."[5] Brussels, consistent with the
centralizing policies of the Belgian government, became increasingly dissatisfied
with its subordinate role.

In 1880 Brussels openly challenged Antwerp's artistic supremacy by
mounting a retrospective exhibition of Belgian art for the Exposition Nationale,
organized to celebrate the fiftieth anniversary of Belgian independence from The
Netherlands. The import of the retrospective exhibition was explained by the art
critic of the *Journal d'Anvers*, who acknowledged that Antwerp's "royauté" had
been substantially challenged; many of Belgium's leading contemporary painters,
he was forced to admit, were of Brussels origin. Furthermore, he lamented that
Rubens—synonymous with Antwerp's artistic identity—was now claimed by the
whole country. Consequently, he urged Antwerp to retaliate: "Nos fêtes artisti-
ques," he maintained, "doivent être les plus importantes du pays."[6]

In 1882, thus, Antwerp seized the opportunity provided by its Triennial to organize an impressive exhibition designed to reclaim its role as the "métropole des arts." It may be distinguished from Antwerp's previous Triennials by its enormous size (940 artists and almost 1,600 works), and by its tolerance for artistic innovation, which was most conspicuously evinced by the exhibition of Edouard Manet's Impressionist *Un Bar aux Folies-Bergère* (1882, Courtauld Institute Galleries, London).

More germane to the participation of Gari Melchers was the heightened diversity of foreign exhibitors, which included primarily German, but also Dutch, French, Italian, Hungarian, English, and American artists. Antwerp's exhibitions had traditionally manifested an overwhelming preference for Germanic painting, particularly from Düsseldorf. In 1882, however, French representation was significantly increased, although one journalist noted that Antwerp had failed to attract many prominent French artists because they had been refused in past years.[7]

The foreign exhibitors included four American expatriates: Frank M. Boggs, Sarah P. Dodson, William P. Dana, and Gari Melchers. Despite their modest number, they were the largest group of American artists to exhibit in Belgium since the 1860s. And in some striking ways, Melchers's background was closely akin to that of his American co-exhibitors. None had participated in the Belgian art forum before. They were all resident in Paris; moreover, they had all exhibited at the Paris Salon of 1882. Antwerp's Triennials in previous years, it should be noted, had rarely attracted Belgium's occasional American exhibitors, who preferred to show in Brussels or Ghent. Given Antwerp's evident intention to enlarge the French contingent at its Triennial exhibition, it remains uncertain to what extent their presence reflected their American nationality or—more to the point, perhaps—their Franco-American identity. Unlike his fellow expatriates, however, who had more or less established reputations and enjoyed varying degrees of success in the Parisian art arena (Boggs's *Place de la Bastille*, for example, had been purchased from the recent Paris Salon for the Luxembourg Museum), Melchers had only just debuted in the Paris Salon of 1882 with *The Letter*.

Nevertheless, the evident similarities between the American exhibitors strongly suggest that their participation was orchestrated by the Triennial's organizing committee, the Royal Society for the Encouragement of Fine Arts in Antwerp. Surviving documentation is meager, but it is clear that Boggs was invited. In an undated letter to the Royal Society, he wrote: "J'ai accepté en empressement votre invitation de vous envoie [*sic*] deux tableaux."[8] Melchers's letter dated June 30, 1882, is less explicit:

> Explication de mon envoi pour le Salon d'Anvers [Antwerp] 1882
>
> | nom | Gari Julius Melchers |
> | adresse | chez Mr. Ligabue (Encadreur) |
> | | Rue d'Enfer 97 à Paris |
> | | ou M. Melchers à Atina (près de Naples) |
> | | Italie |
> | Titre du Tableau | *La Lettre* (Intérieur Brettonne) [*sic*] |
> | Prix | douze cent francs (1200 fr)[9] |

His decisive tone, however, implies that he too was responding to an invitation. Besides, there is little reason to suspect that the young and virtually unknown Gari Melchers would have actively sought to further his reputation outside of Paris at this early date.

Whatever the precise circumstances of Gari Melchers's entry to the Antwerp Triennial of 1882, *The Letter* was wholly compatible with Antwerp's preference for sentimental Realism informed by a general admiration for Dutch seventeenth-century painting. A Belgian art historian, Herwig Todts, recently defined the main qualities that characterized Antwerp painting, to a greater or lesser degree, in the late-nineteenth century:

> De eis om de werkelijkheid tastbaar weer te geven trachte men te vervullen door een trefzekere uitvoering; een accentrijke tekening (uitvoerig of tenminste selectief in de detaillering) en koleriet, het benadrukken van de fysische présence en de bijna sensuele aantrekkelijkheid van materies en vormen (veelal door clair obscur en een geraffineerde belichting), en het steevast kiezen voor typische motieven en karakteristieke houdingen, gebaren en gelaatsuitdrukkingen. [10]

Antwerp painters such as Evert-Jan Boks, Louis Van Engelen, Aloïs Boudry, Edward Farasyn, Henry Luyten, and Gerard Portielje enjoyed enormous popularity in the 1880s and 1890s for their meticulously painted, anecdotal depictions of everyday life in Antwerp and its environs. It was precisely this preference for Realist painting that accounted for Antwerp's strong ties to Düsseldorf which were, it may be recalled, consistently manifested at Antwerp's Triennials throughout this period (this bond is evident too in the present collection of Antwerp's Koninklijk Museum voor Schone Kunsten). More important, these shared ideals determined Antwerp's attraction to Gari Melchers's *The Letter.*

THE LETTER

A sentimental genre painting executed in Picardy, *The Letter* depicts a young peasant girl who has interrupted her chores to read a letter before a well-lighted window. Her more mature companion conveys a sense of satisfaction at the evident happiness inspired by the missive. Light-hearted episodes, the painting implies, momentarily relieve the serious industriousness and religiosity (indicated by the devotional picture of Christ) of peasant existence. The painting's rich tonalities and precise drawing strongly reflect Melchers's training in Düsseldorf, where he studied with Eduard von Gebhardt and Peter Janssen. But his attraction to the mundane, in particular, indicates his assimilation of Gebhardt's preference for the prosaic. [11] Works such as Gebhardt's *The Reformer* (1877, Städtliche Museum, Leipzig, 1899) typify the German's gentrified approach to history painting. (In fact, Gebhardt's inclination toward historical subjects tempered by realism may be compared with a similar attitude in the late work of the Antwerp painter Nicaise De Keyser.)[12] The Germanic nature of Melchers's *The Letter* has been further characterized by Michael Quick: "This early work still reflects the deep chiaroscuro and Old Master tones of his German training, and the action of light entering the

interior through the window was a matter of general interest in academic circles both in Düsseldorf and Munich at this time."[13]

A strong dependence on the Dutch genre tradition also characterized these two German art centers in the late 1870s.[14] Consequently, Melchers's *The Letter* relies more on a knowledge of Dutch seventeenth-century prototypes than on a familiarity with nineteenth-century Breton life. The subject immediately recalls works by Terborch, Vermeer, or Metsu. Vermeer's *The Love Letter* (c. 1670, Rijksmuseum, Amsterdam), for example, depicts a maid delivering a letter to her mistress, and such depictions of two women distinguished by station are not unusual in other Dutch seventeenth-century treatments of this theme. Melchers, however, reinterprets this distinction as one of age rather than of position. His composition is also indebted to Dutch Old Master painting: the figures are pinned behind a table, great emphasis is placed upon the still-life objects, the mood is introspective, and finally, the focused illumination is used to draw particular attention to the crucial story-telling elements in the painting.[15] *The Letter*'s sense of immediacy, however, is conveyed by the appropriation of more contemporary Realist devices such as the open drawer and insistent foreground.

The style of the painting, coupled with the Germanic origin of Melchers's surname, may explain one Belgian critic's assumption that Melchers was of German nationality.[16] In fact, Melchers's true nationality went unrecognized, and his painting elicited very little critical comment. Gustave Lagye of the conservative *La Fédération artistique* described the painting admiringly: "... la *Lettre*, joli intérieur breton, lumineux et fin, meublé de deux joyeux types de jeunes filles."[17] The critic of the *Revue artistique*, surprisingly, found Melchers's draughtsmanship deficient.[18]

Despite the fact that the painting elicited slight interest, the significance of the Antwerp exhibition for Melchers may have been its welcome affirmation of his talent. Arthur Hoeber, who befriended him in the early 1880s, remembered that after the summer of 1882 Melchers "obtained a grip on himself."[19] Although Hoeber, with considerable hindsight, attributed his friend's newly found confidence to an Italian trip taken in the summer of 1882, one might conjecture that the Antwerp Triennial also played a contributing role. Furthermore, the Antwerp exhibition offered him a wholly unexpected, if premature, opportunity to further his reputation. "From the beginning," Melchers once recounted, "I have had my path made smooth for me."[20] The Antwerp Triennial of 1882 epitomized his good fortune.

THE BRUSSELS TRIENNIALS

Celebrity and a widely acceptable *juste milieu* style, rather than good fortune, determined Melchers's participation in the Brussels Triennials of 1887 and 1890. In these years the exhibition organizers were obliged to revitalize and upgrade the quality of their Salons by attracting moderately progressive artists of national and international renown. These reforms followed the extensive criticism, in the early 1880s, of the Triennials' injudicious selection policies and of their intolerance to

artistic innovation, which led one critic to dub prior Salons "vénérables nécropoles."[21] In addition, the new liberality indicated a circumspect acceptance of the avant-garde tendencies championed by Les XX, founded in 1883 in opposition to the official Brussels Salons.[22] By the mid-1880s, concluded Charlotte Wilking in her study of Belgian Triennials, "het 3-jaarlijkse Salon te Brussel was verplicht met deze progressieve stroming rekening te houden."[23]

Indicative of its more fair-minded attitude, the Triennial of 1887 suppressed all medals, which had been seen by many Belgian artists as "an increasing source of difficulties, of competitions, of rivalries, and of injustices."[24] This decision was met with enthusiasm by *L'Art moderne*, Belgium's leading avant-garde journal, which had been campaigning for the abolition of medals since 1885.[25]

A further concession to the avant-garde was the nomination of Edmond Picard, a leading supporter of Les XX, to the organizing committees of the 1887 and 1890 Triennials. In part the result of Picard's influence, the Triennial of 1887 manifested an increased tolerance for cautiously progressive paintings, particularly of "modern life" subjects executed *en plein air*. Avant-garde critics were delighted. Max Waller of *La Jeune Belgique* wrote, "Depuis Les XX, voici l'exposition la plus intéressante que nous ayons eue depuis longtemps."[26] An unspecified writer for *L'Art moderne* declared, "Il n'y a plus d'injustices d'écoles: chacun respecte ... l'art de son voisin. La règle suivie a été: 'Les bonnes oeuvres de toutes les écoles.' "[27]

In fact, the reforming spirit of 1887 was significantly more hesitant than that of 1890. A. J. Wauters of *La Gazette* noted that in 1887 the works of *vingtistes* such as Jan Toorop, James Ensor, Willem Vogel, and Willy Finch were absent; a painting by Paul Besnard had been rejected; and Jacques Blanche's entry poorly hung.[28] By 1890, however, the works of many *vingtistes* were included, notably those of James M. Whistler, Willy Schlobach, Guillaume Van Strydonck, and Rodolphe Wytsman.[29] "Vingtistes," observed *La Nation,* were shown "à côté des académiques," and "les jeunes à côté des poncifs."[30] Nevertheless, the Triennial of 1890 stopped short of works "du pointillé et de la virgule."[31]

Artistic tolerance was accompanied by a more rigorous selection policy "to avoid the invasion of the Salon by mediocre works."[32] Moreover, the list of foreign *invités*, reported *L'Art moderne*, received "coupes sombres."[33] A survey of the foreign exhibitors in the Triennials of 1887 and 1890 reveals a judicious selection of celebrated *juste milieu* and progressive artists such as Max Liebermann, Fritz von Uhde, Eugène Carrière, Henri Fantin-Latour, John Everett Millais, George Hitchcock, Jean Béraud, Henri Gervex, James M. Whistler, Charles Sprague Pearce, Paul Gabriel, and Gari Melchers. Many of the foreigners were recruited in Paris—given Brussels's francophile tendencies—a procedure adopted even for the Brussels Triennial of 1884, when *La Féderation artistique* noted that the organizers were making official trips to the Parisian ateliers to solicit foreign works for their exhibition.[34]

THE SERMON

Whether Gari Melchers was formally invited to the Brussels Triennial of 1887 can only be a matter of speculation, since there is little surviving documentation.[35]

Nevertheless, it is a distinct possibility. *The Sermon* (pl. 2; cat. no. 11), which he exhibited in Brussels, had earned him recent and widespread acclaim: an honorable mention at the Paris Salon of 1886, his first official recognition and, later that year, a first-class gold medal in Amsterdam. Furthermore, Melchers had a powerful Belgian ally, the Paris-based art critic Léon Gauchez, who had founded France's prestigious art journal *L'Art* in 1875. Gauchez (writing under various pen names, but most often reviewing the Parisian Salon under the name of Paul Leroi) began to take a pronounced interest in Gari Melchers after viewing *The Sermon* at the Paris Salon of 1886. He wrote extensive and admiring reviews in *L'Art* and in *The Magazine of Art*; published full-page illustrations of preparatory drawings for *The Sermon*; lambasted the Société des Artistes Français for having awarded Melchers an honorable mention rather than a medal; and urged the French government to purchase the painting for the Luxembourg Museum.[36] Thus, the critic may have facilitated Melchers's entrance to the Brussels Triennial of 1887 not only by his enthusiastic critical support but also by his known friendship with Charles Buls, president of the Triennial's *commission directrice*, and with Jean-François Portaels, also on the organizing committee.[37]

No doubt in preparation for his participation, Melchers visited Brussels in October 1886, taking up residence at 120 rue Royale Ste-Marie, a fashionable Brussels address at the time.[38] It is unlikely that Melchers, visiting from Paris, would have rented such an apartment for his short stay in Brussels. One wonders, thus, whether the owner of the building might have been Léon Gauchez, particularly since Melchers resided at the same address in September of 1887, concurrent with the Brussels Triennial, which opened on the first of that month.[39] This possibility seems even more plausible since Melchers and Gauchez seem to have met in the summer of 1886. Gauchez, in a letter to Melchers dated June 10, 1886, wrote, "Il n'est pas impossible que ce soit moi qui aille vous rendre visite cet été si vous ne quittez pas Egmond. La Hollande entre des pays que j'aime le plus à revisiter."[40]

Holland held a similar fascination for the American; he once wrote to Gauchez: "La Hollande m'attire entre tous les pays."[41] In 1884 Melchers settled in the fishing village of Egmond aan Zee together with George Hitchcock, whom he described as "un confrère qui partage ma passion pour ce pays."[42] In the Dutch Reformed Church of Egmond Binnen, Melchers painted *The Sermon*, a representation of local townspeople at worship.

The painting reveals Melchers's conversion to Naturalism in its direct confrontation with modern life, no longer filtered through Dutch seventeenth-century prototypes. His commitment to his *coin de terre* in Egmond demonstrated his allegiance to the philosophy of French Naturalists like Jules Breton and Jules Bastien-Lepage. Melchers's conviction that "pour bien faire une chose il faut la connaître à fond" recalled Bastien-Lepage's devotion to his village in Lorraine where he could paint "people and landscapes of my home as they really are."[43] Thus, Melchers's portrayal of the spiritual life of Egmond villagers should be considered in relation to similar works by other European Naturalists: Alphonse Legros's *The Sermon* (1871, National Gallery of Scotland, Edinburgh); Willem Leibl's *Three Women in Church* (fig. 3); Jules Breton's *La Plantation d'un calvaire*

(1858, Musée des Beaux-Arts, Lille); Hubert von Herkomer's *The Last Muster: Sunday at Chelsea Hospital* (fig. 22); and Léon Lhermitte's *Nine Peasant Women Seated in Church* (1867, Victoria and Albert Museum, London).[44]

With regard to the Triennial exhibition of 1887, *The Sermon* concorded with the new tolerance for Naturalist canvases, most of which were hung in room 4: Max Liebermann's *Les Fileuses de Laren* (1887, Staatliche Museum, Berlin); Léon Frédéric's *Les Ages du paysan* (1885–87, Royal Museums of Fine Arts, Brussels); George Hitchcock's *La Culture des tulips* (1887, unlocated); Emile Claus's *Le Vieux Jardinier* (1887, Musée d'Art Moderne, Liège) or his *Pique-Nique* (1887, coll. Royal Palace, Brussels); and Charles Sprague Pearce's *Sainte-Geneviève* (1887, private collection, Philadelphia). A. J. Wauters of *La Gazette* saw such Naturalist subjects, once the cause of violent protest, as marking the step forward taken by this Triennial.[45]

Like many Naturalists in the 1880s, Melchers began to respond to Impressionism. While maintaining an allegiance to accurate drawing, rigorous structure, and solid form, *The Sermon* incorporated several Impressionist features: a chalky pastel palette, arbitrary cropping, and an interest in the effect of brilliant sunlight. As *La Fédération artistique* astutely observed, *The Sermon* "a pris au XX certains procédés sans épouser leurs outrances et leurs exagérations."[46] The Belgian journal grasped the essence of the *juste milieu* compromise as defined by the American art historian Albert Boime: "modernism combined with traditionalism by modifying the disquieting features of Impressionism."[47]

If Melchers's academic progressivism and rustic subject allied him to European Naturalism, his emphasis on sentimental narrative in *The Sermon* denoted his continuing adherence to specifically Germanic ideals. In fact, it was precisely this sentimental narrative that captured the imagination of Léon Gauchez, who deplored the general lack of sentiment in French Naturalist painting. "One soon sickens," he wrote in 1886, "of all its pretentious emptiness; we have sickened of it already." What Gauchez admired in *The Sermon* was, evidently, its unmistakably Düsseldorfian sentiment, which coincided with the Belgian's conviction that "painting is an art, an interpretation by means of a creative idea, and never a stupidly exact copy."[48]

It is also the sentiment that distinguishes *The Sermon* from Leibl's *Three Women in Church* (fig. 3), a painting cited more than once as a close prototype for Melchers's.[49] Certainly Leibl's work is a thematic antecedent, since both paintings treat religious genre. However, Leibl's *Three Women in Church* is virtually devoid of narrative concerns. "No reference is made in this incredibly veristic canvas," remarked Linda Nochlin, "to the objects of worship at all, but simply to the three worshippers, their costumes and appearance and their fervid concentration."[50] In contrast, Melchers "concentrates less on the devotional content," observed Lois Fink, "than on the anecdotal detail of the young woman who has fallen asleep in church, which steals the scene."[51]

The assumption that the young girl has fallen asleep during the sermon, and that the old lady seated next to her disapprovingly regards her impropriety, has

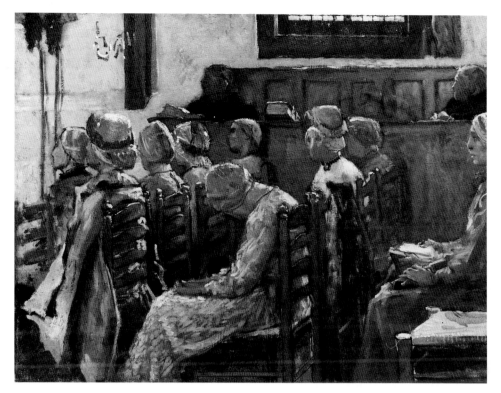

Fig. 21. Study for *The Sermon*, 1885, oil on canvas, 16¹/₄ × 21 inches,
Belmont, The Gari Melchers Memorial Gallery.

largely prevailed since the exhibition of *The Sermon* in Paris in 1886. It originated
with Léon Gauchez: "Le sommeil auquel s'est invinciblement abandonée la plus
jeune des fidèles, à la muette indignation d'une maigre matrone."[52] *L'Art* was
closely followed even in America, where the *Art Amateur* called it "unique . . .
among art publications in the number, value and timely interest of its articles."[53]
The following review in the Philadelphia *Daily Evening Telegraph* can only be a poor
translation of Gauchez's commentary: ". . . a girl whose youth has succumbed to
sleep, much to the indignation of the cross old woman, her neighbor."[54]

But there were other, if less well known interpretations. Arthur Hoeber saw
the painting as a study of the stages of life; J. Brenchley (Mrs. George Hitchcock)
viewed the work as recording various responses to the sermon: ". . . conveying ever-
lasting truth to some, to others ennui and failing, in the case of one old woman, to
convey any truth at all." The New York *Star* in 1890 reported that the young girl
was bowed in prayer, while the old woman watched her with "tenderness."[55]

These varied and incompatible explanations underscore the enigmatic nature
of *The Sermon.* They also open the door to a new, perhaps more appropriate, inter-
pretation. Annette Stott recently observed that the young girl and three other
figures wear unadorned gauze mourning caps. In Egmond, "where many of the
inhabitants were related through bloodlines or marriage," postulated Stott, "a
death . . . touched several households." Thus, the old woman "expresses sympathy
and perhaps curiosity, rather than reproof."[56]

Gari Melchers's intention in *The Sermon*, therefore, may have been to portray

Fig. 22. Hubert von Herkomer, *The Last Muster: Sunday at Chelsea Hospital*, 1875, oil on canvas, 84 × 62 inches, Lady Lever Art Gallery, Port Sunlight, England.

the role played by religion and the community in rural areas at moments of great personal loss. This pathos is imparted, on the one hand, by the heroic size of *The Sermon*, which belies the more light-hearted narrative suggested by Léon Gauchez. On the other hand, it is most convincingly argued by examining Melchers's process toward that narrative. The main problem he needed to resolve was how to convey his narrative intention without relying on his audience to identify the caps, which no one outside of Egmond could have been expected to do. A comparison of the oil study for *The Sermon* (fig. 21) with the finished version reveals that at the outset Melchers relied on the caps as the key. The study allied four women in mourning caps to four empty seats, signifying the departed loved ones, in the men's pew. Apparently realizing that this would fail to transmit his meaning, Melchers made decisive changes. In the finished oil painting he reduced the empty places in the pew to three, now allying the sense of absence and loss not to the four caps but to the three empty chairs, which even in the oil study played a subordinate role. In order to accent the now crucial third chair to the far left of the composition, he changed the color behind the offertory bags from beige to blue. He also eliminated the oil lamp so that the vertical lines formed by the poles would lead the eye unconstrainedly to the empty chair. In addition, Melchers moved the unopened book on the raised enclosed pew slightly to the left. As a result, the contrast between the unused book and the open one, held by the adjacent man, became more telling.

The solemnity of *The Sermon* deeply moved many Belgian critics, who

Fig. 23. Hubert von Herkomer, *Sunday at Chelsea Hospital*, 1871, wood engraving, 16 × 11½ inches, Rijksmuseum Vincent van Gogh/Vincent van Gogh Foundation, Amsterdam.

declined to interpret the precise narrative but avoided the explanation offered by Gauchez. Achille Chainaye of *La Réforme* wrote:

> De ce groupe de femmes assises et recueillies dans cette pauvre église de village se dégage une profonde émotion. L'attitude des personnages est "simplifiée" selon les principes de certains sculptures.... Tout, dans l'exécution de cette toile, concourt à l'émotion.[57]

An unidentified critic for the *Journal des beaux-arts et de la littérature* reported, "Il est difficile d'être sobre: M. Gari Melchers a su l'être dans son *Prêche.*"[58]

This anonymous critic, in fact, recognized the most probable source for *The Sermon* as Hubert von Herkomer's *The Last Muster: Sunday at Chelsea Hospital* (fig. 22), awarded the grand medal of honor at the Paris Exposition Universelle of 1878. The painting could not have failed to impress the eighteen-year-old Melchers, who visited the exhibition with several of his friends.[59] The similarities between Herkomer's *The Last Muster* and Melchers's *The Sermon* are striking.[60] Each picture shows worshipers listening to a sermon by an unseen preacher, while the interaction of two centrally placed figures evokes the paintings' poignant meaning. Furthermore, Herkomer's bowed pensioner reappears as Melchers's mourning young woman, whose upturned cupped hands relate more closely to the pensioner in Herkomer's wood engraving for *The Last Muster*, which first appeared in *The Graphic* in 1871 (fig. 23).[61]

In contrast to Herkomer, who depicts an old man's realization that his companion is dead rather than asleep, Melchers concentrates on the responses of the

bereaved. The hands of Herkomer's pensioner suggest the life that is no more; those of Melchers's young woman denote profound sorrow or, perhaps, the concept that man's salvation lies in the hands of God. Finally the allusion to Herkomer is consistent with Melchers's interest around 1886 in the theme of death and salvation as indicated by *The Sick Child* (cat. no. 9), where a black crucifix and scarf suggest inevitable death, and by *Fulfilled* (c. 1885, Belmont), which shows the corpse of an old Dutch woman bearing a large black crucifix.

Melchers's emotionally charged painting received extensive and laudatory reviews in the Belgian press, and his presence in Brussels assured a general awareness of his American nationality. *La Flandre libérale* anticipated that the painting would be "l'un des succès du Salon"; *La Gazette* commented, "une des oeuvres originales et retenantes du Salon"; the *Journal des beaux-arts et de la littérature* stated it was "une large et excellente note hollandaise qui nous donne espoir pour plus tard."[62] *La Chronique* admired *The Sermon*'s qualities of light and air, while *La Réforme* found Melchers's portraits of the two men seated in the pew of "une vérité frappante."[63] Max Sulzberger of *L'Etoile belge* praised Melchers's outstanding skills of observation but thought his pastel colors false. "C'est de l'art appris par coeur," he wrote, "qui ne coule pas de source"; the *Journal des arts* agreed.[64]

Despite occasional, if conservative, criticism of Melchers's Impressionist-derived colors, *The Sermon* was so well received that Melchers told a prospective buyer, John G. Johnson, that the Brussels Museum might purchase it. In passing through Brussels, Johnson, a leading collector in Philadelphia, had admired *The Sermon*. On September 14, 1887, he wrote to Melchers:

> I am sorry you did not see your way to an acceptance of my offer, but agree with you that it would not be advisable for you to do so as long as there is a reasonable chance to sell it. Certainly it would be an advantage to have it placed in the Brussels Museum. I do not put much trust in the Belgians—they are Home Protectionists. They may, and probably will, award you a medal. I doubt if they will go further.[65]

Johnson was evidently unaware that all medals had been suppressed, but he was largely correct in characterizing the Belgians as "Home Protectionists." As late as 1895, *L'Art moderne* noted that of all Belgian museums only "le Musée de Peinture Moderne de Bruxelles ne contenait, jusqu'ici, aucune oeuvre étrangère."[66] Although Melchers failed to sell *The Sermon* in Belgium, he succeeded in enriching his international reputation. The Brussels Triennial of 1887, in turn, profited from his acclaim.

It is probable, therefore, that he was invited three years later to participate in the Brussels Triennial of 1890; as in 1887, though, there is no surviving documentation of the fact. Nevertheless, in addition to the contact already established with Brussels, Melchers's prominence in the European art arena had significantly increased in the intervening years. By 1890 Melchers had, in his own words, "won all the medals I could win in Europe."[67] Indeed, the year following its exhibition in Brussels, *The Sermon* earned him a first-class gold medal in Munich. Moreover, he was awarded a third-class gold medal for *The Pilots* (fig. 4) at the Paris Salon of 1888; and at the Paris Exposition Universelle of 1889 he won the grand prize for American Painting, an honor shared only with John Singer Sargent.

Melchers's entry to the Triennial of 1890 was *In Holland* (pl. 3; cat. no. 12), exhibited under a variant title, *Dans les dunes.* The painting was first shown at the Paris Salon of 1887, and in December of that year at the American Art Association in New York City. In 1888 it was exhibited at the Saint Botolph Club in Boston. *In Holland* depicts two Egmond farm girls on their way to work; but it is important to point out that its present appearance is not as it was between 1887 and 1890. At some later date, the windmill and houses in the background were added; the originally steep slope of the horizon line was modified; and the cap and shoes of the peasant girl with the buckets were altered. The original composition, however, is preserved in Melchers's etching (fig. 24), reproduced in the Paris Salon catalogue of 1887 (Belmont).

The choice of *In Holland* for the Brussels Triennial of 1890 was consistent with the more progressive spirit of both the painting and the exhibition. In 1890, it may be recalled, the *commission directrice* admitted the works of such avant-garde painters as James M. Whistler and Rodolphe Wytsman. As the *Journal de Bruxelles* noted:

> Les membres du jury ont très sagement ouvert toutes grandes les portes du sanctuaire officiel à de tout jeunes néophastes et surtout à certains schismatiques dont on feignait jusqu'ici d'ignorer le talent et qu'on excommuniait à tour du bras avec des indignations d'une orthodoxie admirable. Les jeunes et les barbares ont donc été reçus.[68]

The tenor of the Triennial was further characterized by *La Revue belge:* "Le Salon actuel est l'apothéose de la brosse, non pour la largeur comme au temps de Rubens, mais pour l'épaisseur, pour l'empâtement et la vigueur du maniement."[69] *In Holland*, consistent with this tolerance for vigorous brushwork, was more painterly than *The Sermon.* Furthermore, the narrative content which so distinguished the latter painting was abandoned in favor of decorative concerns.

In many ways, *In Holland* reflects a strong response to Jules Bastien-Lepage, one of the most influential of the French Naturalists, who was at the height of his fame in the early 1880s before his untimely death in 1884.[70] Melchers's interest in the work of Bastien-Lepage was recorded by three of his contemporaries: Christian Brinton, J. Brenchley, and E. V. Lucas. In fact, the latter stated that Melchers personally knew Bastien-Lepage.[71]

The unusual vertical format of *In Holland* recalls decorative figural panels exhibited by Bastien-Lepage in Paris in the fall of 1882 and described by the *Art Amateur* as, "panels for dining rooms, with flat landscape backgrounds, painted in the large fashion of color and form of Bastien-Lepage, who, realist as he is, has peculiar qualities for decorative work."[72]

The decorative verticality of Melchers's painting is coupled with an equally decorative composition and color scheme. Melchers's two figures—one carrying a rake and a wicker basket, the other, milk pails and a coiled length of rope—are seen against a steeply rising plain, with an exaggeratedly high horizon line. The effect, as in Bastien-Lepage's *Pauvre Fauvette* (1881, Glasgow Art Gallery and

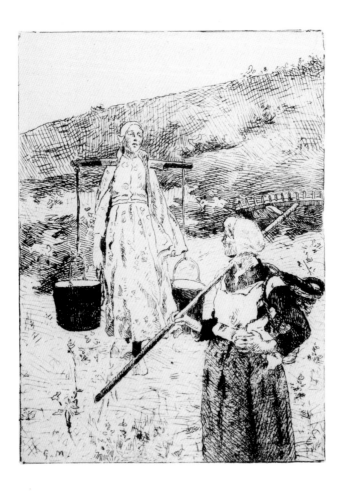

Fig. 24. *In Holland*, 1887, etching,
8 × 5⅞ inches, Belmont, The
Gari Melchers Memorial Gallery.

Museum), is to heighten not only the encounter between the spectator and the fig-
ures, but also that between the figures and the landscape which surrounds them.
Hence, Melchers invokes the peasants' dependence on the land, "made explicit,"
wrote Joseph Dreiss, "by the inclusion of farm implements."[73] Such a visually
supportive relationship was closely associated with Bastien-Lepage, and late
nineteenth-century French critics often referred to it by the theatrical term
mise-en-scène.[74] It is significant, thus, that Georges Verdavainne of *La Fédération
artistique* characterized Melchers's *In Holland* as "un peu théâtrale."[75]

The staged quality of Melchers's figures as well as his decorative flat composi-
tion recall works by other admirers of Bastien-Lepage: H. H. La Thangue's *In the
Dauphine* (c. 1885, unlocated); George Clausen's *In the Orchard* (1881, Salford Art
Gallery, England); or Frank Fowler's *Twilight* (1881, unlocated). Like these artists,
Melchers picked up Bastien-Lepage's coarse handling of paint, emphasis on fore-
ground weeds, reliance on softly diffused gray light, and generally muted
tonalities.

The latter quality is particularly apparent in Melchers's treatment of the
landscape, but his incorporation of bold color accents denotes a specific response to
the Frenchman's work of around 1882. In *The London Bootblack* (1882, Musée des
Arts Décoratifs, Paris), Bastien-Lepage utilized a "novel arrangement of hues,"
consisting primarily of bright red with touches of luminous blue. For Bastien-

Lepage, the pervasive red tonalities "denoted London," consistent with his Naturalist inclinations to capture specificity of place.[76] Likewise, Gari Melchers emphasized the brilliant blue milk pails whose color was typical for Egmond, where villagers thought it would repel flies.[77] Furthermore, bright blue was thoroughly associated with the work of Bastien-Lepage and his admirers. La Thangue's *In the Dauphine* was described as "broad and systematic in touch, high bluish and open-air-like in color," and Charles Sprague Pearce's *Sainte-Geneviève*, exhibited in Brussels in 1887, was characterized by Max Waller of *La Jeune Belgique* as being dominated by the "bleus éclatants de Bastien-Lepage."[78]

Recent considerations of *In Holland* have asserted that Melchers brightened his color scheme after 1890, but reviews of the painting in Brussels and in New York confirm that the vivid decorative coloring was already present.[79] The bold lilac jacket was noted by *The Nation* when the painting was exhibited in New York in 1887.[80] In 1890, *L'Etoile belge* commented on "les relations de tons amusants de ses bleus, de ses jaunes et de ses verts"; and *L'Indépendance belge* observed, "Ce bleu criard, qui crève les yeux est le clou planté dans la toile de M. Melchers pour accrocher l'attention des visiteurs de l'exposition."[81]

But if Melchers admired the decorative Naturalism of Bastien-Lepage, he did not draw on the Frenchman's penchant for imbuing peasant subjects with a psychological intensity invoked by vacant, staring eyes. Although E. V. Lucas asserted that Melchers admired Bastien-Lepage's "superimposition of pathos and poetry upon the soil," *In Holland* suggests it was the poetry rather than the pathos that Melchers emulated.[82] Thus, one Belgian critic noted the "poésie saline" of *In Holland*; and an unidentified writer for *L'Etoile belge* expressed the widely held opinion that Melchers, "supplée à la pauvreté de son sujet, en charmant l'oeil. Ses figures sont bien campées, mais voilà tout." Consequently, *Le Soir* expressed its disappointment, as did *L'Artiste*, which commented that *In Holland* was "à mille coudées au-dessous du chef-d'oeuvre du Salon dernier, le *Prêche*.[83]

After 1890, Melchers ceased to exhibit in the Brussels Triennials. His absence may reflect, to some extent, the generally poor reception accorded *In Holland*. Yet there are three other factors to be considered. First, in the early 1890s Melchers largely devoted his energies to two sets of murals: the World's Columbian Exposition murals of 1893, and the Library of Congress murals of 1895. Second, the Brussels Triennial of 1893 experienced a seeming reversion to conservatism, as judged by the participation of more orthodox, academic American painters such as Henry Mosler and Charles Sprague Pearce (it is noteworthy that the latter had participated in the exhibition of 1887, but not in the more thoroughgoing progressive show of 1890). Third, the Brussels Triennial of 1896 was waived while the city prepared for its first international exposition the following year.

THE GHENT TRIENNIALS

Meanwhile, in the mid-1890s, Ghent's Triennials superseded those of Brussels in their endorsement of internationalism and artistic liberality. At the Ghent Salons

of 1899 and 1902, Melchers was one of a prominent contingent of foreigners consisting of American, Spanish, Dutch, Swiss, English, Italian, Russian, Norwegian, and German artists. Even before 1895, Ghent's Triennials were well known for their hospitality to foreigners but particularly toward French artists, academic as well as avant-garde. French exhibitors between 1880 and 1895 included Claude Monet, Camille Pissarro, Alfred Sisley, Luigi Loir, Jules Bastien-Lepage, Léon Bonnat, Léon Lhermitte, Alfred Roll, Jean-Léon Gérôme, Eugène Carrière, Henri Fantin-Latour, William Bouguereau, and Jean-Paul Laurens. This tradition, noted *Le Petit Bleu*, rendered the Salons of Ghent, "célèbres dans la peinture française autant que dans la peinture belge.... On a pu suivre parfaitement à ces expositions triennales l'histoire de l'art français contemporain."[84]

By the turn of the century, however, this partiality was abandoned in favor of a considerably more catholic internationalism. In 1899, *Le Petit Bleu* dubbed the Ghent exhibition, "le Salon des étrangers."[85] Likewise in 1902, Gustave Van Zype of *La Gazette* characterized Ghent's Salons as those which "nous révèle le plus d'artistes étrangers."[86] With respect to the American participants, specifically, the Quadrennial of 1899 hosted fourteen expatriates; in 1902, the Quadrennial included seven expatriates plus the New York–based William Merritt Chase, who exhibited *Le Livre japonais* (c. 1900, Jordan-Volpe Gallery, New York, 1988). Consistent with Ghent's traditionally francophile tendencies, most of these expatriates resided in France.[87]

Like most other foreigners, they were actively solicited by Ghent's organizing committee, the Royal Society for the Encouragement of Fine Arts in Ghent. Primary responsibility for contacting foreigners appears to have fallen to two members of Ghent's *commission directrice*: Fernand Scribe, a leading collector in Ghent and secretary of the society, and Jean Delvin, a painter and founding member of Les XX. Unfortunately, no letters have survived among the papers of the society for the exhibitions of 1899 and 1902; still, newspaper coverage and related documents reveal their aggressive methods of solicitation. In 1895, for example, Scribe wrote to Delvin that he visited forty Parisian ateliers, and succeeded in obtaining commitments from the Americans William Dannat and John Humphreys Johnston for one or more paintings.[88] In 1899, *Le XXᵉ Siècle* noted that the members of the society, "n'hésitent pas à multiplier les démarches personnelles à Paris, à Londres, en Ecosse pour s'assurer d'éminents et captivants concours."[89] An undated letter from Scribe to Delvin, written from Paris, asked for "règlement" and invitations — which were issued in German, Dutch, French, and English — to be forwarded, since Scribe hesitated to present himself "chez les artistes que je méconnais" without any official credentials.[90]

Contact with Gari Melchers, specifically, was established at least by the late 1880s: invitation lists compiled by Ghent's Royal Society indicate that he was invited for the Triennials of 1889, 1892, and 1895.[91] His absence in 1889 may be explained by the fact that he reserved all his work for the Paris Exposition Universelle. His preoccupation with the Columbian Exposition murals in 1893 and with the Library of Congress murals in 1895 may explain his absence from the latter two Triennials.

Melchers's presence in the Quadrennials of 1899 and 1902 was clearly based on his alliance with the progressive Parisian Salon, the Société Nationale des Beaux-Arts, founded in 1890; Delvin regularly compiled lists of prospective exhibitors based on his visits to the exhibitions of the Société Nationale, held on the Champ-de-Mars.[92] In 1909, for example, he designated works by Elizabeth Nourse, Walter Gay, Hendrik Mesdag, Florence Upton, and Giovanni Boldini.[93] The preponderance of these exhibitors was so marked that *Le Petit Bleu* reported in 1899: "On retrouve ici le Champ-de-Mars de cette année."[94] In 1902 the conservative Ghent critic Karel Lybaert observed that, "een kenner, die onze tentoonstelling bezoekt, zou denken in de tentoonstelling van de 'Champ-de-Mars' te Parijs te zijn."[95] Ghent's predilection for progressive artists was such that one critic remarked: "Le Salon de Gand est un Salon d'avant-garde." And Lybaert estimated that in the Salon of 1902, Jules Joseph Lefebvre was the sole representative of "classical art."[96] To a large extent, these Salons promoted the works of *juste milieu* and avant-garde painters associated with Impressionism or Symbolism, including Emile Claus, Jean-François Raffaelli, Fernand Khnopff, Georges Lemmen, John White Alexander, John H. Johnston, Alexander Harrison, George Hitchcock, Gari Melchers, and members of the Glasgow School.

In addition to their artistic liberality, these Salons were also progressive in their hanging methods. In 1899, *L'Etoile belge* reported that canvases were hung according to "leurs colorations et leurs tendances"; in 1902, Frédéric de Smet noted that tapestries were installed to harmonize coloristically with groups of paintings, classed as in 1899 by color and by artistic affinity.[97]

This progressive stance was prompted, in part, by the Royal Society's earnest commitment to the elevation of public taste. But it was also fostered by renewed debate over artistic centralization. The issue dates back to around 1862 when Belgium's Minister of Fine Arts initiated the discussion of an annual Brussels Salon—it was met with energetic resistance, and the minister soon resigned.[98] By the turn of the century, the arguments for and against a single Salon forcefully reappeared. In 1906 *La Presse* asked if Ghent's progressive exhibitions did not serve as a good argument against centralization. The newspaper cited the sentiments of Ferdinand Van der Haeghen, librarian at the University of Ghent and vice-president of the Royal Society, who insisted on "le caractère constamment éclectique des Salons de Gand et des efforts déployés par la société gantoise pour faire connaître les talents encore ignorés." He hoped, the article continued, that current attempts at centralization would fail as lamentably as those of the 1860s.[99]

In response to this threat, Ghent's Royal Society provided many incentives for celebrated and progressive artists such as Gari Melchers to exhibit in the "City of Artevelde." It arranged the transport of paintings—at its own expense—either from the artists' studios or from the Parisian Salons. Works submitted by foreign artists were not subject to jurying.[100] The society boasted, in letters to prospective exhibitors, of its profitable exhibitions; after 1892, each Salon yielded between two and three hundred thousand Belgian francs.[101] Furthermore,

Ghent's museum (unlike that of Brussels) regularly purchased foreign works, and the Belgian government, which seriously began purchasing foreign paintings in the mid-1890s, frequently resorted to Ghent's Salons for its acquisitions. [102] Finally, the vital and eclectic nature of these Salons attracted considerable international attention. In 1899 Léonce Benedite, curator of France's Luxembourg Museum, honored Ghent's Quadrennial by his presence. In 1902 the participation of a significant number of Glasgow artists prompted extensive coverage by the British press, and in 1906, a writer for the American publication *The Nation* remarked: "For the third time I have come to see the international exhibition ... that Ghent holds every three years, and for the third time I wonder to find so large and important a show in so comparatively small a town." [103]

THE SISTERS

Melchers, thus, was assured not only of enhancing his international reputation but also of augmenting his possibilities for patronage. In 1899 he sent two Symbolist-inspired works, *The Sisters* (pl. 10; cat. 26) and *Sainte-Gudule* (fig. 25). [104] They were shown, according to Ghent's hanging methods, alongside other paintings of similar hue such as John White Alexander's *The Green Girl* (c. 1897, Graham Gallery, New York, 1985) and Emile Claus's *A Sunny Day* (1899, Museum voor Schone Kunsten, Ghent). [105] Melchers must have been cognizant of Ghent's policy, since his choice of these two works manifested a thoughtful selection determined by coloristic and stylistic harmony. Indeed, *L'Art moderne* characterized them as "deux claires compositions mi-decoratives, mi-documentaires ... constituent un ensemble homogène." [106]

The Sisters was first exhibited under a variant title, *The Doll*, at the Société Nationale des Beaux-Arts in 1895. [107] It depicts two golden-haired children holding hands on the dunes of Egmond. The younger child clutches her doll and stares out at the spectator with perfect innocence and trust, while her older sister assumes a protective, motherly stance.

The subject of Melchers's painting enjoyed enormous popularity in the late nineteenth century, as evidenced by the spate of similarly titled works by European and American artists such as Walter MacEwen, William Stott, Matthijs Maris, Henri Fantin-Latour, Berthe Morisot, Abbott Thayer, Frank Benson, Mary Cassatt, James Tissot, and Edwin Austin Abbey. In contrast to Tissot's *The Two Sisters* (1864, coll. Lady Sophia Murphy, England) or Fantin-Latour's *The Two Sisters* (1859, St. Louis Art Museum), Melchers's painting does not probe profound differences of character. Instead, Melchers's *The Sisters* treats the theme of childhood innocence as did Maris's *The Sisters* (1875, coll. Burrell, Glasgow). For all its seeming attention to details of rural Dutch life, Melchers's painting relies on a Symbolist rather than on a Naturalist aesthetic, if not of the most bizarre type. Although Charles Meltzer reproduced *The Sisters* as the frontispiece for his 1913 article entitled "Gari Melchers: A Painter of Realities," the work has far more to do with the aspect of Symbolism described by Robert Goldwater as "forces hidden behind the surface of the commonplace." [108] *The Sisters* draws upon elements from the physical world—goats, flowers, children—but it depicts a world parallel to

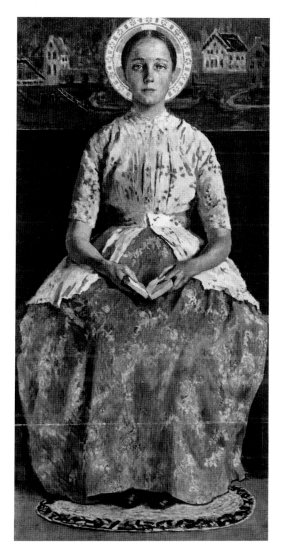

Fig. 25. *Sainte-Gudule*, c. 1897, oil on canvas, 57 × 30¼ inches, private collection.

the real one. This sense of a separate and self-sufficient reality, intrinsic to Symbolist painting, is conveyed by the hieratic presentation, simplified form, and flat, unmodulated color, and by the disquieting gaze of the younger child. Moreover, the calculated placement of the goats directly above the wide-eyed toddler (neither she nor her sister carries a staff to indicate they are tending those goats!) is reflective of symbolic rather than naturalistic intentions.

Melchers's conception of the goats as symbols of guilelessness was probably based on specifically Dutch Symbolist prototypes such as Matthijs Maris's *Woman with Child and Kid* (mid-1860s, Gemeentemuseum, The Hague) or Antoon Derkinderen's *Paul, Bessy en Arthur Tutein Nolthenius* (1894, Dordrechts Museum, Dordrecht). Thus, Melchers's *The Sisters* implies that the little girl is still in the paradisiacal state, innocent and reliant on the protection of her older sister, like her animal equivalents. This impression is accentuated by the child's doll, innocent gaze, and drooping black stocking.

H. E. M. Braakhuis and J. Van der Vliet, in their analysis of Matthijs Maris's work, stated that "the goat sometimes appears to be interchangeable with a traditional symbol of transience, namely the butterfly."[109] That Melchers's intention in

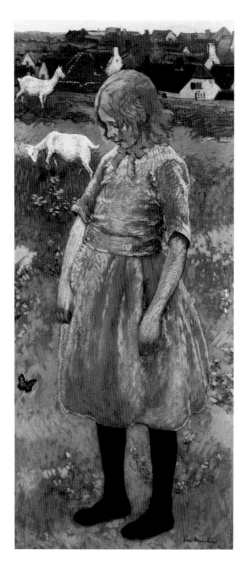

Fig. 26. *The Butterfly*, n.d., gouache on canvas, 52 × 23¹/₂ inches, Belmont, The Gari Melchers Memorial Gallery.

The Sisters was the "blissful state in which child and animal are on equal terms" is confirmed by his related treatment entitled *The Butterfly* (fig. 26), which depicts the older sister with an uncaptured butterfly in the place of the younger child.[110] In *The Sisters* the toddler replaces the butterfly, but the goats remain as symbols of the Eden of childhood.

Melchers's characterization of the younger child, in particular, suggests his interest in the French artist and illustrator Maurice Boutet de Monvel.[111] The Frenchman frequently depicted staring, expressionless children dressed in decoratively patterned clothing and posed as if "chez le photographe." In fact, when Melchers exhibited *The Sisters* in Liège six years later, the critic of the *Gazette de Liège* remarked on the painting's strong resemblance to the work of Boutet de Monvel; a similar observation was made by the *Boston Herald* in 1908.[112]

But *The Sisters* also reflects Melchers's response to *japonisme*. (His collection of some forty woodblocks by artists of the Ukiyo-e School is owned by Belmont.)[113] *La Ligue artistique*, for example, characterized the painting as "rouge et vert: japonisme et simplisme."[114] The *Bien public* called the two children, "fleurs japonaises acclimatées en Hollande." The reviewer continued: "Melchers a beaucoup

emprunté en effet, aux artistes japonais, notamment leurs teintes plates, leurs exquisités de coloration."[115] Indeed, the vertical format of this painting, its insistent foreground, flat landscape background, unmodulated bold colors, brash two-dimensionality, and ambiguous foreground space all evince Melchers's intense interest in Japanese art. (His receptivity to *japonisme*, in fact, may have been determined by his earlier interest in Bastien-Lepage.) Melchers's recourse to these oriental devices accentuated the Symbolist intentions of the painting: unmixed colors were expunged of prior references, and the extremely shallow pictorial space invoked a separate reality as did the ambiguous foreground upon which the children appear to hover. Finally, Melchers used a highly absorbent canvas, which heightened the painting's sense of unreality.[116]

SAINTE-GUDULE

A Symbolist aesthetic also informed Melchers's other entry to the Ghent Salon of 1899, *Sainte-Gudule* (fig. 25), a representation of the patron saint of Brussels. According to legend, she would rise in the middle of the night to worship at the church of Morselle, guiding her steps with a lantern. Satan frequently extinguished the flame, but the prayers of the saint always rekindled it.[117] Like many Symbolist treatments of saints by French artists such as Edmond Aman-Jean, Louis Welden Hawkins, and Lucien Lévy-Dhurmer, Melchers's work omitted traditional iconography; the lantern, which usually accompanied Sainte-Gudule, is absent. The meaning of the painting, thus, lies not in its illustration of a specific historical event but in its universal metaphor, as articulately stated by J. Brenchley: "... the expression of youth, and stubborn unquestioning faith sought and found; not a saint to everybody, only to those who have eyes to see, and a heart to feel for themselves."[118] It is not surprising, then, that for many years and until very recently, the identity of the saint went unrecognized: an old German illustration was captioned simply "Madonna."[119]

Works such as *Sainte-Gudule* patently contradict the frequent characterization of Melchers as an observer and "not a subjective or imaginative artist."[120] On the contrary, Melchers alerts the spectator, as he did in *The Sisters*, that *Sainte-Gudule* is not a "transcript from nature, but that behind [the] picture lies another order of meaning."[121] Religious sentiment is evoked by a strictly hieratic presentation, and by simplification. These stylistic devices recall works such as Aman-Jean's *Sainte-Geneviève* (1885, Musée des Beaux-Arts, Brest) or Lévy-Dhurmer's *Our Lady of Penmarch* (1896, coll. M. Michel Perinet, Paris). Like these Symbolist painters, Melchers may have appropriated these devices from Italian Renaissance painting, which enjoyed great popularity in Paris in the mid-1890s. His admiration for Botticelli in particular was recorded by J. Brenchley: "He was the first man to apply for permission to copy the Botticelli frescoes when they were put up in the Louvre."[122] "Botticelli," wrote Edward Lucie-Smith in his study of Symbolism, "was one of the great influences upon Symbolist art of the nineteenth century."[123]

Reviews of Melchers's *Sainte-Gudule* were generally favorable. One Belgian critic praised its "modernisme sincère." *La Ligue artistique* asked if it was "une

nouvelle modernisation mystique." *La Chronique* called Melchers "un peintre biblique."[124] But *L'Indépendant de Gand* remarked that *Sainte-Gudule* "est très réussi comme figure géometrique ... mais rien donne le caractère de sainteté."[125] *L'Art moderne*, which singled out but a few "oeuvres attrayantes" by American painters, admired Melchers's color harmonies and his accurate drawing.[126] This acknowledgment by Belgium's leading avant-garde journal is especially noteworthy; it was the first time that it found Melchers's work progressive enough to merit attention.

THE KISS AND LITTLE CONSTANCE

Melchers's progressiveness also appealed to Ghent's Royal Society, which presumably solicited his participation in the Quadrennial of 1902. He submitted, as before, two paintings: *The Kiss* (fig. 27) and *Little Constance* (c. 1900, unlocated), a portrait of the daughter of James Creelman, which was not for sale (Melchers asked 6,000 francs for *The Kiss*).[127]

Analysis of these two works is hampered by the fact that they are presently unlocated. Nevertheless, old black and white photographs and contemporary accounts are helpful, if not fully adequate, in illuminating Melchers's connection with the 1902 Salon. As in 1899, Melchers chose his paintings judiciously. Although one is a portrait and the other an ideal figure work, both paintings treat the theme of childhood. *The Kiss* probes the intense relationship between mother and child, while *Little Constance*, described as "the very flower and freshness of childhood caught in the very act of its rosy and restless allure," elaborated the artist's conceit.[128] But the coloristic and stylistic harmony that united Melchers's entries in 1899 was not apparent; thus, the two paintings were hung separately. *Little Constance* was shown in room 21, alongside pastel-colored Impressionist works by George Buysse, Jean-François Raffaelli, and Walter MacEwen, who exhibited *The Secret* (c. 1902, Virginia Museum of Fine Arts, Richmond). The color scheme of *Little Constance*, which relied on pink and white, harmonized with related hues in MacEwen's work.[129]

If *The Secret* may be considered *juste milieu* by its allegiance to accurate drawing, Melchers's *Little Constance* was decidedly painterly. In fact, this portrait may be an early example of Melchers's renewed involvement with Impressionism in the early twentieth century.[130] The *Journal de Gand* called it a "portrait très impressioniste," and Karel Lybaert found the work a "zeer prettige schilderij," but no more than a study or sketch.[131]

In contrast, *The Kiss* (hung in room 6) reflected Melchers's earlier attraction to precise draughtsmanship. The painting's coloring was described by Charles Lewis Hind: "Mr. Melchers shows his love of color in the sleeve of the baby's dress, lines of black on bright red, and the green swaddling band."[132] Its bold color scheme thus harmonized with Alexander Harrison's adjacent *Iris Lunaire* (unlocated), which depicted a fiery red moon against a blue-green sea.[133]

The brash colors of *The Kiss* also bespeak the *japonisme* that characterized *The Sisters*. Its conception of motherhood, however, is drawn from Eugène Carrière, the French Symbolist who executed a series of paintings depicting mothers intensely kissing their babies.[134] Melchers's *The Kiss* seems particularly close to

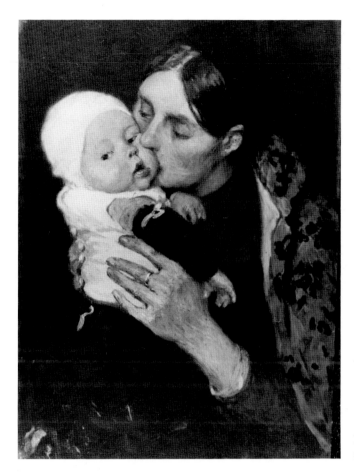

Fig. 27. *The Kiss*, 1896, oil on canvas, size and location unknown.

works like *Mother's Kiss* (c. 1892, Musée d'Orsay, Paris), although Melchers might have been responding to any number of works of this type, which Carrière variously titled *Maternity*, *The Kiss*, or *Tenderness*. That the painting quotes directly from Carrière is demonstrated by its astounding similarity to *The Kiss* (fig. 28) by the Belgian artist Léon Navez, born in Mons in 1900. It is highly unlikely that Navez knew Melchers's painting, but he probably had access to the largest private collection of works by Eugène Carrière, owned by Louis Dévillez of Mons. [135]

Like Carrière, Melchers records more than "sentimental personal emotion"; rather, as in *Sainte-Gudule* or *The Sisters*, he creates a more universal episode, one "implicit," to use the words of Robert Goldwater, "in the whole of human existence." [136] As Charles Lewis Hind remarked:

> There is something almost tragic in the picture called *The Kiss*. There is nothing of the formal family salute about this kiss. This woman is kissing her baby fiercely, with something of the intensity of a savage animal mothering a favorite item of its brood. [137]

Yet Melchers avoided Carrière's monochrome color and mist. As with his earlier emulation of Bastien-Lepage, Melchers attempted to strike a personal note. Hind exaggerated somewhat when he wrote that Melchers "derives from nobody: he need never sign a canvas, and yet you would know its parentage." [138] Still, his overstatement provides a valid insight into Melchers's working methods. Consequently, *The Kiss* was not criticized in the Belgian press for being artistically derivative. On the contrary, *La Libre Critique* praised the work as "un mélange de

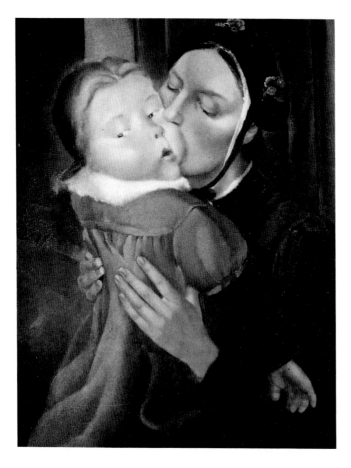

Fig. 28. Léon Navez, *The Kiss*, n.d., size unknown, sold in Brussels, Hôtel de Ventes Horta, 1988.

grandeur et de simplicité." *La Chronique* observed that *The Kiss*, together with *Little Constance*, attracted the attention of connoisseurs. And the *Journal de Gand* stated: "*Le Baiser* arrête toutes les mères: une femme du peuple dévore littéralement son poupon de gros baisers. Bonne toile."[139]

Melchers's entries to Ghent's Quadrennial of 1902, thus, were well received, and most critics—though not all—were cognizant of his American nationality.[140] Although he failed to sell *The Kiss*, according to reports in the local press, his international reputation was once again enhanced.[141] Finally, his solicitation by Ghent's Royal Society might be considered in relation to his involvements with other progressive organizations such as the Munich Secession and London's International Society of Painters, Sculptors, and Gravers.

LATER EXHIBITIONS

After 1902 Melchers's involvement in Belgium was limited to large-scale American displays organized for the Liège Exposition Internationale of 1905 and for the Antwerp Quadrennial of 1908. For the sake of chronological accuracy, however, a discussion of Melchers's participation in collective displays should begin with the Antwerp Exposition Universelle of 1894, the first major exhibition of American art in Belgium.[142] Visitors to the Antwerp show were presented with one hundred works by thirty-eight artists, resident chiefly in Paris.

Antwerp's commitment to such a display was motivated primarily by America's emergence as an artistic presence at the Chicago World's Columbian Exposition of 1893. As Alphonse Hertogs noted in his commentary on the Antwerp Exposition:

> M. Stanislas Haine, vice-président du Comité, n'épargna de son côté ni le temps ni la peine pour amener à l'Exposition le concours d'un grand nombre d'exposants étrangers, notamment des Etats-Unis d'Amérique, qu'il fallait convier à prendre part à notre Exposition, après la grande Exposition de Chicago 1893.[143]

Indeed, the Chicago fair exerted an important and far-reaching influence on the Antwerp Exposition of 1894. The Philadelphia *Press*, for example, cited the impact of Chicago on Antwerp's semicircular arrangement of edifices connected by covered galleries.[144] Visitors who had missed the American fair could experience it through a diorama with views of the Palaces of Transportation, Agriculture, Machines, and Fine Arts. The Belgian exposition also included many attractions already seen in Chicago: the panorama of the Alps, the Cairo street, the Russian and Tunisian villages, and many of the works exhibited in the American fine arts section.[145]

This art display was the direct result of efforts by the Paris-based expatriate Charles Sprague Pearce. Writing on his own initiative but with the support of "several of the American artists residing in Paris," Pearce petitioned the Belgians to allow him to organize an American art section; apparently, he was unaware of the display concurrently being sought by the Belgians through official channels in Washington. On February 11, 1894, Pearce wrote to Stanislas Haine:

> I much wish to be represented if possible and several of the American artists residing in Paris would send if it was known here that we were to have a section. I should be very glad in doing what I can to organize a collection of American works from here if such is desired.[146]

On February 28, Pearce acknowledged receipt of a letter from the Antwerp committee stating that a room would be set aside for American artists (two rooms were finally allotted to the American display).[147] Shortly thereafter, Pearce and Julius Stewart were chosen by the American expatriate community in Paris as delegates to the Antwerp Exposition.

Pearce and Stewart enlisted the support of artists such as Walter Gay, Frank Scott, Frederick Bridgman, Edwin Lord Weeks, William Dannat, Henry Bisbing, James M. Whistler, Walter MacEwen, and Gari Melchers. A survey of American contributions to the Antwerp Exposition reveals a considered variety in medium, technique, and theme. The display presented five sculptures, two etchings, eight watercolors, and eighty-six paintings, including orientalist subjects, American historical themes, landscapes, portraits, peasant paintings, and decorative compositions. Artistic approaches varied from the meticulous style of Edwin Lord Weeks's *The Last Voyage—A Souvenir of the Ganges* (c. 1885, coll. Stuart Pivar) to the more painterly method of James M. Whistler's *Nocturne in Black and Gold: The Fire Wheel* (c. 1872–77, Tate Gallery, London).

A determined search for variety was coupled with an equal determination to mount an impressive American display. Today the American art exhibition appears as an uncommonly rich collection of ambitious and important works. Fully one-quarter of the works exhibited in Antwerp had been shown, it may be recalled, at the Chicago World's Columbian Exposition, where American expatriates quite naturally sought to make an important showing. On February 22, 1894, Pearce wrote to Haine, "I have just received the invoice of works of art returned after the Chicago Exposition—among which many works of importance—it would perhaps be possible to send the entire collection or at least the larger part of it to Antwerp."[148] These works included Walter Gay's *Charity* (1899, coll. Mr. and Mrs. Richard Manney); Walter MacEwen's *The Witches* (c. 1893, William Doyle Galleries, New York, 1984); Julius Stewart's *The Baptism* (1892, Los Angeles County Museum of Art); James M. Whistler's *Nocturne: Blue and Silver* (1870s, Isabella Stewart Gardner Museum, Boston); and three paintings by Gari Melchers: *The Communion* (1889, Cornell University, Ithaca, fig. 29); *The Nativity* (pl. 6; cat. no. 19); and *Portrait of Mrs. George Hitchcock* (c. 1889, private collection), exhibited as *La Brodeuse*. In addition, Melchers sent *The Smoker*, which cannot, at present, be identified with any certainty.[149]

Melchers's selection of these four paintings (final approval of most works may have been up to Pearce and Stewart) was consistent with the thematic and stylistic variety that largely characterized the American fine arts display. *The Smoker* and *The Communion* depicted peasants, as did Walter Gay's *Charity*, Walter MacEwen's *Returning from Work (Holland)* (c. 1891, William Doyle Galleries, New York, 1983), and Frank Scott's *La Lecture* (1892, Indianapolis Museum of Art). In fact, *The Communion* was closely related to *The Sermon*, exhibited in Brussels seven years earlier. A depiction of local townspeople at worship, *The Communion* maintains a similar allegiance to accurate drawing and rigorous structure, while incorporating several Impressionist features. It differs from *The Sermon* in one important respect: it is virtually devoid of narrative concerns. Rather, *The Communion* concentrates on the worshipers' appearance and fervid devotion.

In contrast, *The Nativity* indicates Melchers's modification of Naturalism by Symbolist associations, an aesthetic also espoused in works by Pearce, George M. Reevs, and Edward Grenet. The origin of Melchers's interest in religious painting may be traced back to his training with Gebhardt in Düsseldorf, but *The Nativity* should also be considered in relation to the general vogue for religious paintings in the late nineteenth century among European and American painters: Max Liebermann's *Christ among the Elders* (destroyed); Fritz von Uhde's *Let the Little Children Come unto Me* (1884, Museum der Bildende Künste, Leipzig); Jean Béraud's *Mary Magdalene in the House of the Pharisee* (1891, coll. Walker, Paris); Jean Charles Cazin's *Tobias and the Angel* (1880, Musée des Beaux-Arts, Lille); and Henry Ossawa Tanner's *The Annunciation* (1898, Philadelphia Museum of Art).

Like these artists, Melchers attempted to revitalize a subject drawn from the classical tradition. Thus, Melchers's *The Nativity* conveys spiritual meaning without recourse to traditional religious iconography: there are no adoring angels or

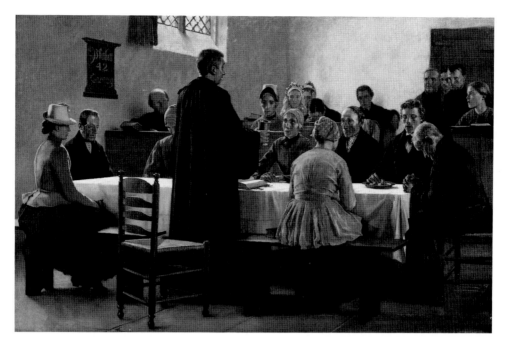

Fig. 29. *The Communion*, c. 1888–89, oil on canvas, sight: 85 × 134 inches, Cornell University, Ithaca, New York.

shepherds, no ox and donkey, and no halo to identify the Madonna. Instead, the painting's pervasive blonde tonalities, relieved by occasional touches of purple, proclaim the miraculous dawn not of a new day, but of a new era.

Finally, Melchers's *Portrait of Mrs. George Hitchcock* is a decorative work primarily concerned with close color harmonies and generalized mood. The painting betrays a debt to Whistler's portraits of the 1860s and 1870s such as *Symphony in White: No. 2* (1864, Tate Gallery, London), exhibited in Antwerp. Melchers's portrait, thus, suggests rather than describes. It is not a character-searching portrait but an excuse for essentially pictorial ends: he carefully opposes the sitter's dark blue dress to the lighter blue screen behind her, enlivening the color scheme with touches of yellow and orange. A recent analysis of this painting proposed that needlework, an "activity appropriate to expectant mothers, was a discreet allusion to pregnancy," and that "on closer inspection, it becomes apparent that Mrs. Hitchcock's dress is actually an elegant maternity outfit."[150] Thus, Melchers's portrayal of Mrs. Hitchcock, who momentarily stops her needlework to gaze into the space beyond the picture frame, may allude to the daydreams and aspirations of a mother-to-be.

The American display, rendered particularly rich by versatile artists such as Gari Melchers, attracted no comment from the Belgian press. A survey of leading Belgian newspapers and journals failed to reveal a single mention of the American art section. But a survey of these publications also revealed severely limited press coverage of most other art displays. This apparent lack of interest by the Belgian press resulted from serious mismanagement of the fine arts exhibition by Antwerp's organizing committee. When the fair opened, *Le Petit Bleu* noted that the "compartiment des Beaux-Arts est loin d'être prêt." *L'Indépendance belge* reported that

the German section was "inaccessible," that of Scandinavia, "impénétrable," that of England "à l'état de formation chaotique," and the exhibition rooms of the United States, "un peu plus avancés."[151] In addition, no catalogue was issued until May 27, three weeks after the opening of the fair. Many displays were still not ready two months after the opening: the Italian section, for example, was not completed until early July.

But the disappointing lack of attention paid by the press should not be viewed as the chief measure of the Belgian critical response. Indeed, a highly favorable attitude was demonstrated by Antwerp's initial plan to purchase five American paintings for the lottery: Weeks's *Study for Mendicants Espagnols* (unlocated); Pearce's *La Veuve* (unlocated); Stewart's *Canale del Erbe* (unlocated); MacEwen's *Returning from Work (Holland)*; and Melchers's *Portrait of Mrs. George Hitchcock*. In a letter dated September 16, 1894, Pearce informed Antwerp's committee that Melchers's painting was not for sale, but he called its attention to *The Smoker*, for which Melchers was asking 3,000 Belgian francs.[152] Owing to a presumed shortage of funds, only MacEwen's painting was acquired; but there was no shortage of honors for the Americans, who left Antwerp with ten medals. Melchers was awarded a medal of honor, a distinction shared only with Walter MacEwen.

If the American fine arts section in Antwerp was owed primarily to the individual initiative of Charles Sprague Pearce, the exhibition in Liège eleven years later reflected a significant collective effort by the Paris Society of American Painters.[153] As in 1894, however, the Belgian commitment to a large-scale American art display was prompted by a recent American world's fair, the Louisiana Purchase Exposition in St. Louis of 1904.[154] For the Liège Exposition Internationale of 1905, organized to celebrate the seventy-fifth anniversary of Belgian independence, the Belgian authorities first issued a formal invitation to the American government, via the Department of State, requesting the participation of American artists. But the American government declined to participate officially, consistent with the traditional hesitancy of Congress to appropriate official funds for international exhibitions. Still, it provided the Belgians with "the most authentic lists obtainable of American artists, sculptors, and art schools ... for their use in bringing announcement of the exhibition to the attention [of those] most deeply interested in the success of the exhibition."[155] Subsequently, the Belgians established contact with the Paris Society of American Painters.

Founded in 1897, this organization was once described as the "arbiter of American art abroad."[156] It sought to advance the interests of American expatriates, resident primarily but not exclusively in Paris, by arranging exhibitions of their works throughout Europe. Gari Melchers was a founding member of the organization, and in 1905, he, together with Walter MacEwen, shared the post of vice-president on the society's Board of Control. For the Liège exhibition, which followed similarly arranged Society shows in Dresden (1901) and in Düsseldorf (1904), the Paris Society of American Painters nominated two delegates, Julius Stewart and Eugene La Chaise, who assembled some ninety-two works by more than fifty American artists, including John Singer Sargent, William Dannat, Frederick Bridgman, Walter Gay, Walter MacEwen, and Gari Melchers. Their

works, occupying three rooms in Liège's newly constructed Palais des Beaux-Arts, had been subject to jurying in Paris by the following members of the society: Eugene La Chaise, Julius Stewart, Henry Bisbing, William Dannat, Charles Sprague Pearce, and Lionel Walden.

Gari Melchers exhibited two paintings: *The Fencing Master* (c. 1900, Detroit Institute of Arts) and *The Sisters* (pl. 10; cat. no. 26), shown earlier at the Ghent Quadrennial of 1899. His choice of these two works suggests a concern for coloristic harmony: the red-color accents in *The Fencing Master* are not inharmonious with the bold orange of the older child's dress in *The Sisters*. A single-figure picture, *The Fencing Master* suggests the impact of European painters such as Edouard Manet, who also treated genre subjects that were at the same time portraits of friends in the artist's circle; apparently, Melchers asked his close friend, the French painter Ernest Noir, to pose for the figure of the fencing instructor.[157] Melchers's selection of the sportive subject may reflect the general enthusiasm in France for physical exercise at the turn of the century.[158] More specifically, *The Fencing Master* recalls a now unlocated painting of the same title by Julius Stewart, executed around 1886.[159] Annette Stott wrote that Melchers depicted "a moment when the fencing instructor has finished one bout and stands waiting for the next pupil.... The master's expectant attitude creates a dialogue between the canvas and the viewer ... as if to invite him to take up arms."[160] It was precisely this provocative pose that displeased the *Gazette de Liège*, which called *The Fencing Master* "bien déplaisant," while the *Gazette de Charleroi* found the figure, "supérieurement campé," as did the critic of *La Meuse*.[161]

The Antwerp Quadrennial of 1908 also benefited from the efforts of the Paris Society of American Painters, which mounted a special showing of their members' works, displayed separately from those by regular Salon exhibitors. Sixty-four American works were hung by forty-seven artists including Theodore Butler, William Dannat, Frederick Frieseke, George Hitchcock, Frederick Bridgman, and Gari Melchers.

Analysis of this exhibition is hampered by a lack of surviving documentation, but according to the *American Art Annual*, to which the Paris Society regularly submitted reports of their activities, they were formally invited by the Royal Society for the Encouragement of Fine Arts in Antwerp.[162] In contrast to the invitations issued for the Belgian world's fairs of 1894 and 1905, Antwerp's solicitation of a sizable American display for its exhibition of 1908 appears more directly related to the success of American expatriates in the Parisian art arena. In the early decades of the twentieth century, Antwerp sought to revitalize its Salon following Brussels's creation of a Salon de Printemps, which conflicted directly with Antwerp's Quadrennial opening in the late spring. According to the *Handelsblad van Antwerpen*, Antwerp's Salons were reduced in size and importance as a result of the "opslurpingproces van de hoofdstad die, niet tevreden van ook eene Triennale te bezitten, telkens als wij eene tentoonstelling inrichten, haar voorjaar-salon opent."[163] The paper angrily declared that the voracious appetite of a rhinoceros was nothing compared with that of Belgium's capital city. The invitation to the Paris Society of American Painters, thus, may have been designed to

Fig. 30. *Femme à sa toilette*, c. 1908, oil on canvas, dimensions and location unknown.

create renewed interest in Antwerp's official Salon; indeed, Sander Pierron of *L'Indépendance belge* praised Antwerp's decision to include them, referring to the Americans' unqualified success in the Parisian art arena.[164]

One of the society's most renowned members was Gari Melchers, who exhibited *Femme à sa toilette*. Unfortunately, this painting cannot be identified with any certainty, although it may have been his painting of a nude preparing to bathe, formerly owned by the Museum of Weimar and now unlocated (fig. 30).[165] Melchers had treated the subject of the nude as early as 1890, when he exhibited a "little pastel nude" in Chicago.[166] His interest in the subject may be traced back, perhaps, to his training with Jules Joseph Lefebvre, a specialist in academic paintings of the female nude; however, the title of Melchers's painting of 1908 more readily suggests the impact of works by Edgar Degas or Pierre Bonnard.

Melchers's *Femme à sa toilette* received mixed critical reviews in the Belgian press. *Le Nouveau Précurseur* called it repulsive, while *La Métropole* found it superb, if no more than a sketch. Unqualified praise, however, came from Sander Pierron, who wrote: "Une des toiles les plus remarquables ... nu intime et chaste, d'une facture large et toutefois délicate, car elle suggère le frissonnement de la chair."[167]

Melchers's work does not seem to have found a Belgian buyer, although the increased possibilities of patronage provided by such exhibitions were especially attractive to American painters. Melchers might have agreed with Charles Warren Eaton, who offered the following explanation for his participation in the Antwerp Salon of 1908: "I do not see ... why more men do not send work to the foreign exhibitions. It costs some pains and some money, but it is worthwhile.... American art is appreciated abroad and my sales from foreign exhibitions have covered all my expenses connected therewith and more."[168] Indeed, this collective effort by the Paris Society of American Painters resulted in the acquisition of Richard Miller's *The Old Woman* by Antwerp's Koninklijk Museum voor Schone Kunsten,

and works by Charles Gruppe (*A la Plage à Katwijk*) and Elizabeth Nourse (*Dans l'ombre de Penmarch*) were purchased for the lottery.[169]

The Antwerp Quadrennial of 1908 marked Gari Melchers's last appearance in the Belgian art forum, in which he had enjoyed an esteemed position as a foreign *invité* for almost three decades. On the one hand, Melchers's appeal was based on his successful international reputation and widely acceptable *juste milieu* style. On the other hand, Melchers's long-standing involvement in Belgium's domestic and international exhibitions was inextricably linked to his affiliation with the emigrant colony in Paris, to which Belgium primarily turned for its foreign *invités*. Consequently, the Belgian episode in Melchers's varied cosmopolitan career commenced immediately following his debut in the Parisian Salon of 1882 and ended with his relocation to Germany.

Dr. Jennifer A. Martin Bienenstock is the author of The Forgotten Episode: Nineteenth-Century American Art in Belgian Public Collections, *1987. She resides in Brussels, where she is on the faculties of the University of Brussels-Vesalius College and the University of Antwerp-European Studies Program.*

NOTES

All translations, within parentheses and in italics, are by the author.

N.B. The use of foreign-language texts in this article requires special explanation. Its purpose is to convey the nature of Melchers's expatriate identity to the reader. A cosmopolite in every sense of the word, Gari Melchers's fluency in Dutch, French, and German accounted, in large measure, for his success in the European arena.

1. For a preliminary discussion of Melchers's involvement in Belgium, see the author's *The Forgotten Episode: Nineteenth-Century American Art in Belgian Public Collections* (Brussels: American Cultural Center, 1987).
2. Useful general treatments of the Triennials include Maria Biermé, "Les Salons en Belgique de 1811 à 1910," *La Belgique artistique et littéraire*, vol. 20 (1910), pp. 78–90; "Les Expositions d'art à Gand," *Gand artistique*, vol. 1, no. 7 (July 1922), pp. 77–78; and Prosper Claeys, *Les Expositions d'art à Gand, 1792–1892* (Ghent, 1892).
3. Edward Alden Jewell, "Gari Melchers, Noted Artist, Dead," *New York Times*, December 1, 1932, p. 21.
4. Ibid.
5. Jean F. Buyck, "Henry Van De Velde in Perspective," in *Henry Van De Velde: Paintings and Drawings* (Antwerp: Koninklijk Museum voor Schone Kunsten, 1988), p. 43. See also Buyck et al., *Antwerpen 1900: Schilderijen en Tekeningen, 1880–1914* (Antwerp:

Koninklijk Museum voor Schone Kunsten, 1986).
6. Ambo, "Le Salon d'Anvers-XIII," *Journal d'Anvers*, September 29, 1882, p. 1. (*our artistic manifestations must be the most important in the country.*)
7. Ibid.
8. Archives of Flemish Cultural Life, Papers of the Royal Society for the Encouragement of Fine Arts in Antwerp (Koninklijke Maatschappij tot Aanmoediging der Schone Kunsten, Antwerpen; hereafter KMA), letter of Boggs to the Royal Society, folder M1371, item B44. No letters from Dodson or Dana were among the Society's papers for the Triennial of 1882. (*I eagerly accept your invitation to send two pictures.*)
9. Ibid; item B48. In addition there is a letter from Melchers dated October 1882, which reads: "Je vous prie de vouloir expedier mon tableau "La Lettre" à Monsieur Ligabue, encadreur, 97 rue d'Enfer à Paris. Agreèz Monsieur me plus distingue remerciements [*sic*]."
10. Herwig Todts, "Aspecten en tendensen in de laat-19de-eeuwse Antwerpse schilderkunst, 1880–1914" in Buyck et al., *Antwerpen 1900*, unpaged. (*They felt that reality should be rendered in a tangible fashion, and achieved this by emphasizing accuracy, by very deliberate drawing techniques {either by elaborately or selectively underscoring detail} and by use of color, by insisting on the physical presence and on an almost sensual charm of matter and form {by clair obscur and sophisticated lighting tech-*

niques}, and by a consistent choice of typical motives, and characteristic attitudes, gestures, and facial expressions.)

11. On Gebhardt, see Adolf Rosenberg, *E. V. Gebhardt* (Leipzig, 1899) and *Die Düsseldorfer Malerschule*, (Düsseldorf: Kunstmuseum, 1979).

12. On De Keyser's late work, see Todts, "Aspecten en tendensen," unpaged.

13. Michael Quick, *American Expatriate Painters of the Late Nineteenth Century* (Dayton, Ohio: Dayton Art Institute, 1976), p. 111.

14. For a general discussion of this phenomenon, see Anne Mochon, "Fritz Von Uhde and Plein-Air Painting in Munich, 1880–1900" (Ph.D. diss., Yale University, 1973), pp. 53–54.

15. See Germain Bazin, "La Notion d'intérieur dans l'art Néerlandais," *Gazette des beaux-arts*, vol. 39 (January 1952), pp. 5–26; see also Petra Ten Doesschate-Chu, *French Realism and the Dutch Masters: The Influence of Dutch Seventeenth-Century Painting on the Development of French Painting Between 1830 and 1870* (Utrecht, 1974).

16. Gustave Lagye, "Salon d'Anvers-IV," *La Fédération artistique*, vol. 9, no. 47 (September 1882), p. 393.

17. Ibid. *(The* Letter, *pretty Breton interior, luminous and refined, with two happy types of young girls.)*

18. Rotciv Ehcamalf, "Salon d'Anvers, le genre," *Revue artistique*, vol. 5, no. 10 (October 15, 1882), p. 192.

19. Arthur Hoeber, "Gari Melchers," *International Studio*, vol. 31 (March 1907), p. 12.

20. Charles H. Meltzer, "Gari Melchers: A Painter of Realities," *Cosmopolitan*, vol. 55, no. 1 (June 1913), p. 5.

21. I.G., "Le Salon de Bruxelles," *Journal de Bruxelles*, October 1, 1890, pp. 1–2.

22. On the formation of Les XX, see Susan Marie Canning, "A History and Critical Review of the Salons of 'Les Vingt,' 1884–1893" (Ph.D. diss., Pennsylvania State University, 1980); and Jane Block, *Les XX and Belgian Avant-Gardism, 1868–1894* (Ann Arbor, Mich.: UMI Research Press, 1984).

23. Charlotte Wilking, "De Antwerpse Pers Tegenover Het Kunstgebeuren: De 3-Jaarlijkse Salons, 1882–1901" (Master's thesis, University of Ghent [Rijksuniversiteit, Gent], 1981–82), p. 20. Wilking, a student in the history department, adopts a historical rather than an art historical approach. *(The Brussels Triennial was obliged to take this progressive trend into account.)*

24. Montezuma, "My Notebook," *Art Amateur*, vol. 17, no. 5 (October 1887), p. 92.

25. "Salon triennal de Bruxelles," *L'Art moderne*, vol. 7, no. 25 (June 19, 1887), p. 196.

26. Max Waller, "Le Salon de Bruxelles," *La Jeune Belgique*, vol. 6 (1887), p. 322. *(Since Les XX, this is the most interesting exhibition we have had in a long time.)*

27. "La Prochaine Exposition des beaux-arts," *L'Art moderne*, vol. 7, no. 33 (August 14, 1887), p. 258. *(There are no longer injustices toward schools of art: each respects the other. The rule followed was: Good works from all the schools.)*

28. A. J. Wauters, "Le Salon," *La Gazette*, September 1, 1887, pp. 1–2.

29. E.[dgar] B.[aes], "Le Salon triennal de Bruxelles," *La Revue belge*, vol. 3, no. 59 (October 1, 1890), pp. 98–99. Baes reported that Whistler "a été sur le point d'être refusé."

30. Gramadoch, "Avant le Salon," *La Nation*, September 5, 1890, p. 1. *(Vingtistes were shown side by side with academics, and the young side by side with the established.)*

31. Georges Verdavainne, "Salon de Bruxelles-I," *La Fédération artistique*, vol. 17, no. 48 (September 21, 1890), p. 571. *(of pointillism and "comma" brushstroke.)*

32. Montezuma, "My Notebook," p. 92.

33. "Salon triennal de Bruxelles," p. 196. *(severe blows.)*

34. Gustave Lagye, "Salon de Bruxelles," *La Fédération artistique*, vol. 11, no. 46 (September 6, 1884), p. 373.

35. No documentation was found in any archives in Brussels. A few documents addressed to the Royal Society for the Encouragement of Fine Arts in Ghent were found in the Library of the University of Ghent, Manuscript Division, Vliegende Bladen, Beaux-Arts (hereafter RUG-VB), folders IB 164(8), and IB 164(9).

36. On Léon Gauchez, see the author's *The Forgotten Episode*, pp. 26–28. See also Paul Leroi, "Salon de 1886," *L'Art*, vol. 41, no. 2 (1886), pp. 14–20, and vol. 40, no. 1 (1886), pp. 242–53; and Leroi, "The American Salon," *The Magazine of Art*, vol. 9 (1886), pp. 485–90.

37. Information concerning Gauchez's friendship with Buls and Portaels was provided by Léon Zylbergeld, archivist of the city of Brussels, curator of the Communal Museums. Letter to the author dated November 26, 1985.

38. A letter to Melchers at this address, dated October 29, 1886, is conserved at Belmont. Melchers also received mail in Egmond in 1886, so it is likely that the Brussels address was short-term. For this information the author is indebted to Richard S. Reid, former director of Belmont.

39. Melchers's address in 1887 is recorded in *Catalogue, exposition générale des beaux-arts*, Brussels, 1887. The precise occupant may never be known since the records of the commune of Schaerbeek, in which rue Royale Ste-Marie is located, were destroyed in a fire on April 17, 1911.

40. This letter is conserved at Belmont. For a copy, the author is indebted to Joanna D. Catron. *(It is not impossible that I shall come and visit you this summer if you do not leave Egmond. Holland is the country I most want to visit again.)*

41. Leroi, "Salon de 1886," p. 18. *(Holland attracts me above all other countries.)*

42. Ibid. *(a colleague who shares my passion for this country.)*

43. Ibid *(to do something well you must know it thoroughly)*; William S. Feldman, *Hommage à Jules Bastien-Lepage (1848–1884)* (Verdun: Musée de la Princerie, 1984), p. 112.

44. Recent discussions of Naturalism include Gabriel Weisberg, *The Realist Tradition: French Painting and Drawing, 1830–1900*, (Cleveland: Cleveland Museum of Art, 1981); Kenneth McConkey, *Peasantries, Paysanneries: 19th-Century French and British Pictures of Peasants and Field Workers* (Newcastle upon Tyne, England: Polytechnic Art Gallery, 1981); and James Thompson et al., *The Peasant in French 19th-Century Art* (Dublin: Douglas Hyde Gallery, Trinity College, 1980).

45. A. J. Wauters, "Le Salon," *La Gazette*, September

1, 1887, pp. 1–2.

46. Clipping from *La Fédération artistique*, dated 1887 and conserved at Belmont. *(takes from Les XX certain methods without embracing their excesses or exaggerations.)*

47. Albert Boime, *The Academy and French Painting in the Nineteenth Century* (London: Phaidon Press, 1971), p. 17.

48. Leroi, "The American Salon," pp. 486, 488.

49. Joseph G. Dreiss, *Gari Melchers: His Works in the Belmont Collection* (Charlottesville, Va.: University Press of Virginia, 1984), p. 13; and William H. Gerdts's introduction to the same, p. xvii.

50. Linda Nochlin, *Realism* (New York: Penguin Books, 1971), p. 90.

51. Lois M. Fink, "Elizabeth Nourse: Painting the Motif of Humanity," in *Elizabeth Nourse: A Salon Career, 1859–1938* (Washington, D.C.: National Museum of American Art, 1983), p. 124.

52. Leroi, "Salon de 1886," p. 244.

53. "New Publications," *Art Amateur*, vol. 7, no. 5 (October 1882), p. 109. Leroi's admiration for the painting was also noted in "Society of American Artists," *The Art Age*, vol. 5, no. 47 (June 1887), p. 68.

54. Unsigned clipping, dated October 16, 1886, Belmont archives.

55. Hoeber, p. 12. J. Brenchley, "Gari Melchers and His Work," *The Magazine of Art* (February 1900), p. 146; unsigned clipping, New York *Star*, February 9, 1890, conserved at Belmont. For the identification of Brenchley as Mrs. George Hitchcock, see the Archives of American Art, papers of Gari Melchers, letter of Leonard L. Mackall to W. Howe, dated October 10, 1933, roll 1407, frame 1038.

56. Annette Stott, "American Painters Who Worked in The Netherlands, 1880–1914" (Ph.D. diss., Boston University, 1986), pp. 124–25.

57. Achille Chainaye, "Le Salon de Bruxelles-VII," *La Réforme*, September 26, 1887, p. 2. *(From this group of women, seated and meditating in this poor village church, emerges a profound emotion. The attitude of the figures is "simplified" according to the principles of certain sculptures.... Everything, in the execution of this canvas, works toward emotion.)*

58. "Le Salon triennal de Bruxelles," *Journal des beaux-arts et de la littérature*, vol. 29, no. 17 (September 15, 1887), p. 131. *(It is difficult to be sober: Mr. Gari Melchers has known how to be in his Sermon.)*

59. Leslie Lenore Gross, "Melchers' Art From Detroit and Düsseldorf," in *Gari Melchers, 1860–1932: Selections from the Mary Washington College Collection* (Fredericksburg, Va.: Mary Washington College, 1973), p. 9.

60. On Herkomer, see Lee MacCormick Edwards, "Hubert von Herkomer and the Modern Life Subject" (Ph.D. diss., Columbia University, 1984).

61. Stott, "American Painters Who Worked in The Netherlands," saw the bent posture as related to classical mourning figures, p. 125.

62. Unsigned clipping, *La Flandre libérale*, August 13, 1887, conserved at Belmont; A. J. Wauters, "Le Salon-III," *La Gazette*, September 12, 1887, p. 1 *(one of the most original and arresting works of the Salon)*; "Le Salon triennal de Bruxelles," *Journal des beaux-arts et de la littérature*, vol. 29, no. 17 (September 15, 1887), p. 131

(A large and excellent Dutch note which gives us hope for later.)

63. Mecoenas, "Le Salon-IV," *La Chronique*, September 13, 1887, p. 1; Achille Chainaye, "Le Salon de Bruxelles-VII," p. 2. *(of striking truthfulness.)*

64. Max Sulzberger, "L'Exposition triennale des beaux-arts-IV," *L'Etoile belge*, September 5, 1887, p. 2. *(This is art learned by heart, not from what is evident.)* See also L. Vedez, *Journal des arts*, September 16, 1887, Belmont archives.

65. For a copy of this letter, conserved at Belmont, the author is grateful to Joanna D. Catron. Lawrence W. Nichols, assistant curator of the John G. Johnson Archives at the Philadelphia Art Museum informed the author, in a letter of December 4, 1987, that no letters from Melchers are among Johnson's correspondence.

66. "Petite Chronique," *L'Art moderne*, vol. 41, no. 46 (1895), p. 367. *(The Brussels Museum of Modern Art has, until now, had no foreign work.)*

67. Meltzer, "Gari Melchers," p. 5.

68. I.G., "Le Salon de Bruxelles," *Journal de Bruxelles*, October 1, 1890, p. 2. *(The members of the jury have very wisely opened wide the doors of the official sanctuary to young neophastes and especially to certain schismatiques who were, until now, ignored and who had been excommunicated with the indignations of an admirable orthodoxy. Thus, the young and the barbarians have been accepted.)*

69. E.B., "Le Salon triennal de Bruxelles," p. 107. *(This Salon represents the apotheosis of the brush, not for its broadness as in Rubens's time, but for its thickness, its coarseness, and its vigorous handling.)*

70. On Bastien-Lepage, see William S. Feldman, "The Life and Work of Jules Bastien-Lepage" (Ph.D. diss., New York University, 1973).

71. Christian Brinton, *Modern Artists* (New York: Baker and Taylor, 1908), p. 216; Brenchley, "Gari Melchers and His Work," p. 147; E. V. Lucas, "Gari Melchers," *Ladies Home Journal*, vol. 43, no. 12 (December 1926), p. 27.

72. "Correspondence: The Paris Decorative Art Exposition," *Art Amateur*, vol. 7, no. 4 (September 1882), p. 87.

73. Dreiss, *Gari Melchers*, p. 18.

74. For the use of the term, see Weisberg's *The Realist Tradition*, p. 209, n. 5.

75. Georges Verdavainne, "Salon de Bruxelles-II," *La Fédération artistique*, vol. 17, no. 49 (September 28, 1890), p. 583.

76. For further discussion of this painting, see Weisberg's *The Realist Tradition*, p. 196.

77. For this information the author is indebted to Annette Stott. Letter to the author dated December 23, 1987.

78. Kenneth McConkey, *A Painter's Harvest: H. H. La Thanque, 1859–1929* (Oldham Art Gallery, England, 1978), p. 9; Max Waller, "Le Salon de Bruxelles," *La Jeune Belgique*, vol. 6 (1887), p. 324. *(vivid blues of Bastien-Lepage.)*

79. Dreiss, *Gari Melchers*, p. 84, and Stott, *American Painters Who Worked in The Netherlands*, p. 139.

80. "Fine Arts–American Art Association," *The Nation*, vol. 44, no. 1172 (December 15, 1887), p. 491.

81. "L'Exposition générale des beaux-arts," *L'Etoile belge*, September 18, 1890, pp. 1, 2 *(the amusing arrangement of blue, yellow, and green tones)*; "Le Salon de Bruxelles 1890," *L'Indépendance belge*, September 23, 1890, p. 1 *(This screaming blue, which blinds the eyes, is the highlight put in the canvas of Mr. Melchers to draw the attention of the exposition's visitors.)*

82. Lucas, "Gari Melchers," p. 27.

83. E.B., "Le Salon triennal de Bruxelles," p. 98; "L'Exposition générale des beaux-arts," pp. 1, 2 *(made up for the poverty of his subject by charming the eye. His figures are well constructed, but that is all)*; Lucien Solvay, "Le Salon-II," *Le Soir*, September 26, 1890, p. 1; and Charles Ponsonailhe, "Le Salon: Peinture III," *L'Artiste*, vol. 57, no. 2 (1887), p. 121 *(a thousand cubits below his masterpiece of the last Salon, the* Sermon*)*. Similar disappointment was expressed by Paul Leroi, "Salon de 1887," *L'Art*, vol. 43, no. 2 (1887), p. 20.

84. Ergaste, "Le Salon de Gand," *Le Petit Bleu*, August 11, 1899, p. 2. *(as celebrated in French painting as in Belgian painting . . . one could follow perfectly at these triennials the history of contemporary French art.)*

85. Ergaste, "Le Salon de Gand," *Le Petit Bleu*, August 27, 1899, p. 3.

86. G.V.Z., "Le Salon de Gand," *La Gazette*, August 25, 1902, p. 1. *(which reveal the most foreign artists.)*

87. In the author's *The Forgotten Episode*, p. 15, the number of American exhibitors in 1899 was erroneously stated as nine. A greater familiarity with lesser-known American expatriate artists has indicated a somewhat larger number of participants than was first realized. The author is presently preparing an article on American participants in the Ghent Triennials, 1880–1909.

88. University of Ghent, Library, Manuscript Division, Papers of the Royal Society for the Encouragement of Fine Arts in Ghent (Société Royale pour l'Encouragement des Beaux-Arts à Gand; hereafter RUG-SR), folder HSIII 16, dossier Fernand Scribe, letter of Scribe to Delvin, dated May 18, 1895. For her generous assistance with these documents, only recently found in the basement of the University of Ghent, the author would like to thank Sylvia van Petephem.

89. G.S., "Chronique d'art: Au Salon de Gand," *Le XXe Siècle*, August 24, 1899, p. 2. *(does not hesitate to personally increase measures to ensure eminent and captivating competition by traveling to Paris, London, and to Scotland.)*

90. RUG-SR, folder HSIII 16, dossier Fernand Scribe. Sample invitations, with instructions to issue in four languages, may be found in RUG-VB, folder IIB 12. *(to artists I do not know.)*

91. RUG-SR, box IE 128, "Liste des artistes étrangers à inviter au Salon de Gand de 1889." Of ten Americans, only William Howe participated. See also "Invitations spéciales, 1892," unclassified; and box IE 135, "Invitations spéciales, 1895." It is possible that Melchers was invited to exhibit in the Ghent Salon of 1886, but no invitation list for that year could be found.

92. No invitation lists could be found for 1899 and 1902, but there can be no doubt that Melchers was invited. RUG-VB, folder IIB 12, "Tableaux pris à domicile suivant autorisation du Comité," dated Octo-

ber 6, 1902, confirms Melchers's invitation for 1902.

93. RUG-VB, folder IB 36(7), "Liste des tableaux désignés par M. Delvin à la Société nationale des beaux-arts à Paris."

94. Ergaste, "Le Salon de Gand," *Le Petit Bleu*, August 11, 1899, p. 2. *(One encounters here the Champ-de-Mars of this year.)*

95. Karel M. J. Lybaert, *Revolutionnairen en Anti-Revolutionnairen. Critisch Overzicht der XXVIIIe Tentoonstelling van Schoone Kunsten Gehouden in het Nieuw Museum van Ghent* (Ghent, 1902), p. 11. *(A knowledgeable person, who visited our exhibition, would think he was at the exhibiton of the Champ-de-Mars in Paris.)*

96. Ergaste, "Au Salon de Gand," *Le Petit Bleu*, August 31, 1902, p. 5; Lybaert, *Revolutionnairen*, p. 39. Lybaert noted on p. 11 that there were no participants from the exhibition of the Société des Artistes Français.

97. "La Trente-Septième Exposition de Gand-I," *L'Etoile belge*, August 11, 1899, p. 3; Frédéric de Smet, *Réformation des jurys aux triennales* (Ghent, 1907), p. 19.

98. On the debate of the 1860s, see *Rapport de la commission directrice de la société royale pour l'encouragement des beaux-arts à l'assemblée générale des sociétaires, March 20, 1860*. A copy may be found in the University of Ghent, Library; see Gand, Beaux-Arts, Varia. The most accessible history of the debate over centralization appeared in RUG-VB, clipping, folder IE 137, Juan, "Le Prochain Salon de Gand," *La Presse*, August 18, 1906.

99. A. Heins, "A propos des Salons triennaux," *Petite Revue de l'art et de l'archéologie en Flandre*, vol. 2, no. 9 (May 15, 1901), pp. 65–66. For the article Heins referred to, see Levêque, "Les Salons officiels," *La Gazette*, May 6, 1901, p. 1; "Le Salon triennal de Gand-III," *L'Etoile belge*, September 1, 1902, p. 2; RUG-VB, clipping, folder IE 137, Juan. *(The constantly eclectic character of Ghent's Salons and efforts used by the Ghent Society to make known talents still unrecognized.)*

100. See the *règlement* in the Triennial catalogues of 1899 and 1902.

101. "Les Expositions d'art à Gand," *Gand artistique*, vol. 1, no. 7 (July 1922), p. 78. Mention of the society's profitable sales was made in RUG-SR, box IE 143, "Invitation spéciale, 1886."

102. Bienenstock, *The Forgotten Episode*, p. 28.

103. Jean Bar, "Les Artistes belges à l'étranger," *La Chronique*, October 1, 1899, p. 1. According to P.L., "Notes d'art," *La Flandre libérale*, September 22, 1902, reviews of the Salon appeared in the English papers, *The Daily Chronicle* and *The Star*, see RUG-VB, folder IE 137; N.N., "A Provincial Exhibition," *The Nation*, vol. 83, no. 2150 (1906), p. 219.

104. RUG-VB, folder IE 136, "Numéros et prix." The asking price of Melchers's *The Sisters* was 12,000 francs and of *Sainte-Gudule*, 10,000 francs.

105. According to the 1899 catalogue, both works were hung in room 1.

106. Octave Maus, "Le Salon de Gand: Les Peintres étrangers," *L'Art moderne*, vol. 19, no. 41 (October 8, 1899), p. 335. *(two bright compositions, half-decorative, half-documentary, constituting a homogeneous ensemble.)*

107. In 1895, *The Sisters* was exhibited at the Art

Institute of Chicago's annual exhibition. The organizer, Sara Hallowell, preferred the exhibitions of the Champ-de-Mars, see Isabel McDougall, "At the Chicago Art Institute," *The Art Amateur*, vol. 34, no. 1 (December 1895), p. 4.

108. Meltzer, "Gari Melchers." Robert Goldwater, *Symbolism* (New York: Harper and Row, 1979), p. 32. See also *Autour de Lévy-Dhurmer: Visionnaires et intimistes en 1900* (Paris: Grand Palais, 1973); Edward Lucie-Smith, *Symbolist Art* (London: Thames and Hudson, 1972); *Kunstenaren der Idee: Symbolistische Tendenzen in Nederland 1880–1930* (The Hague: Gemeentemuseum, 1978); Robert L. Delevoy, *Symbolists and Symbolism* (New York: Rizzoli, 1978); Charles Eldredge, *American Imagination and Symbolist Painting* (Grey Art Gallery and Study Center, New York University, 1979).

109. "Patterns in the Life and Work of Matthijs Maris," *Simolius*, vol. 10 (1978–79), p. 165.

110. Ibid.

111. For the most recent treatment of Monvel, see *Maurice Boutet de Monvel: Master of French Illustration and Portraiture* (Washington, D.C.: Corcoran Gallery of Art, 1988).

112. XXX, "Au Palais des Beaux-Arts," *Gazette de Liège*, June 6, 1905, p. 1; unsigned clipping, Boston *Herald*, March 22, 1908, Belmont archives.

113. On *japonisme*, the author has relied on Gabriel P. Weisberg et al., *Japonisme: Japanese Influence on French Art 1854–1910* (Cleveland: Cleveland Museum of Art, 1975); Frank Whitford, *Japanese Prints and Western Painters* (London, 1977); and Siegfried Wichmann, *Japonisme: The Japanese Influence on Western Art since 1858* (London, 1981).

114. Noël, "A Gand," *La Ligue artistique*, vol. 6, no. 20 (October 5, 1899), p. 3.

115. RUG-VB, folder IE 136, A.D., "Le Salon de Gand-II," *Bien public*, August 30, 1899. (*Japanese flowers acclimatized in Holland. Melchers has, in fact, borrowed a lot from Japanese artists, notably their flat colors, their exquisite coloration.*)

116. For a discussion of Melchers's use of an absorbent canvas, see clipping, the Jacksonville *Daily Journal*, December 8, 1895, in scrapbooks of the Art Institute of Chicago. For a copy of this article, the author is grateful to Susan G. Godlewski, associate director, Art Institute of Chicago.

117. For the legend of Sainte-Gudule, see Margaret E. Tabor, *The Saints in Art* (London, 1913), p. 55.

118. Brenchley, "Gari Melchers and His Work," p. 148.

119. This illustration is preserved at Belmont.

120. Brinton, *Modern Artists*, p. 224.

121. John Christian in his unpaged introduction to *Symbolists and Decadents* (London, 1977).

122. Brenchley, "Gari Melchers and His Work," p. 147.

123. Lucie-Smith, *Symbolist Art*, p. 12.

124. A.D., "Salon des beaux-arts," *Journal de Gand*, September 12, 1899, p. 1; Noël, "A Gand," p. 3; H., "Le Salon de Gand-II," *La Chronique*, August 26, 1899, p. 2.

125. "Le Salon de Gand-I," *L'Indépendant de Gand*, August 25, 1899, pp. 1, 2 (*very successful as a geometric figure … but nothing conveys the notion of holiness*); RUG-VB, folder IE 136, P.L., "Le Salon de Gand-III," *La Flandre libérale*, August 29, 1899, felt the work was too forced and falsely naive.

126. Maus, "Le Salon de Gand: Les Peintres étrangers," p. 335. (*attractive works.*)

127. RUG-VB, folder IB 12, "Numéros et prix."

128. Charles Lewis Hind, "Gari Melchers," *World's Work*, vol. 15 (April 1908), p. 10093.

129. For the color scheme, see clipping, Boston *Advertiser*, March 7, 1908, Belmont archives.

130. On the impact of Impressionism on Melchers's late work, see William H. Gerdts, *American Impressionism* (New York: Abbeville, 1984), pp. 240–42.

131. "Le Salon des beaux-arts," *Journal de Gand*, October 2, 1902, p. 2; Lybaert, *Revolutionnairen*, p. 77. (*a very pretty painting.*)

132. Hind, "Gari Melchers," p. 10103.

133. Lybaert, *Revolutionnairen*, p. 35.

134. On Carrière, see Robert J. Bantens, "Eugène Carrière: His Work and His Influence" (Ph.D. diss., Pennsylvania State University, 1975); and Andrew J. Stillpass, "Eugène Carrière: Symbolist of Family Life" (Master's thesis, University of Cincinnati, 1974).

135. On Dévillez, see Christiane Piérard, "Emile-Henri-Louis Dévillez," *Biographie nationale* (Brussels), vol. 31, supplement (1961), pp. 252–59.

136. Goldwater, *Symbolism*, p. 160.

137. Hind, "Gari Melchers," p. 10103.

138. Ibid., p. 10104.

139. Georges, "Salon de Gand," *La Libre Critique*, vol. 12, no. 42 (October 26, 1902), p. 379; H., "Le Salon de Gand-II," *La Chronique*, September 5, 1902, pp. 1, 2; "Le Salon des beaux-arts," *Journal de Gand*, September 11, 1902, p. 2. (*The Kiss stops all the mothers: a peasant woman literally devours her baby with big kisses. A good canvas.*)

140. An exception was *Kunst en Leven*, which called him Dutch; see "XXXVIIIᵉ Tentoonstelling te Gent," vol. 1, no. 10 (1902), p. 46.

141. RUG-VB, folder IE 137, A.D., "Chronique artistique," *Bien public*, November 5, 1902.

142. On the American art display at the Exposition Universelle of Antwerp, see the author's "From Yankee Ingenuity to Yankee Artistry: American Artists at the Antwerp World's Fair of 1894," *Museum Magazine*, Antwerp's Koninklijk Museum voor Schone Kunsten, vol. 7 (1988), pp. 36–48. See also the author's *The Forgotten Episode*, pp. 15–18.

143. Alphonse Hertogs, *Exposition universelle d'Anvers 1894. Revue retrospective* (Antwerp, 1896), p. 17. (*M. Stanislas Haine, vice-president of the committee, spared neither time nor trouble to bring about the participation in the exhibition of a great number of foreign exhibitors, especially the United States of America, who had to be invited to take part in our exposition, after the grand exposition of Chicago, 1893.*)

144. Archives of the Ministry of Foreign Affairs, Brussels, "Next International Exhibition," Philadelphia *Press*, July 13, 1893, roll B39, dossier 196.

145. For a more extensive bibliography for the Antwerp Exposition, see the author's "From Yankee Ingenuity to Yankee Artistry," p. 36.

146. KMA, folder M1371, item B167; and National Archives, Washington, D.C., records relating to the Exposition Universelle in Antwerp, 1894, letter from Belgian Legation to Mr. Gresham, Secretary of State, dated November 5, 1893, M99, roll 9.

147. KMA, letter from Pearce to Smekens.

148. Ibid., letter from Pearce to Haine.

149. According to Richard S. Reid, the artist's notes indicate that the work entitled *Smoker* was sold to James Deering. Most of Deering's collection was given to the Art Institute of Chicago, but the museum does not own this painting. Two paintings essaying this subject are *Dutchman with Pipe* (University of Nebraska, Sheldon Art Gallery), and *Man Smoking a Pipe* (Parrish Art Museum, Southampton, New York); it is not certain which of these, if either, was exhibited in Antwerp.

150. Linda Ayres and Jane Myers, *American Paintings, Watercolors, and Drawings from the Collection of Rita and Daniel Fraad* (Fort Worth, Tex.: Amon Carter Museum, 1985), p. 26.

151. "En Province: Anvers, à l'exposition," *Le Petit Bleu*, May 7, 1894, p. 1; "La Province: L'exposition d'Anvers," *L'Indépendance belge*, May 7, 1894, p. 2; and Charles Tardieu, "Anvers, beaux-arts," *L'Indépendance belge*, May 27, 1894, p. 1.

152. KMA, see the annotated list of American works, folder M1371, item B167. In addition, see letters from Pearce to Smekens, dated September 14, 15, 16, 1894, and October 4, 1894.

153. On the Liège Exposition, see *Le Livre d'or de l'exposition universelle et internationale de 1905* (Liège, 1905), 2 vols.; "Exposition de Liège: Liste des oeuvres d'art acquises pour la tombola," *L'Art moderne*, vol. 25, no. 42 (1905), p. 338; *Catalogue général, beaux-arts, exposition de Liège, 1905*; A. Cock and J. Lemmens, *Les Expositions internationales en Belgique de 1885 à 1958* (Brussels, 1958); R.C., "French and American Art at Liège," *Brush and Pencil*, vol. 16 (1905), pp. 98–100; "International Exhibit at Liège," *American Art News*, vol. 3, no. 82 (August 15, 1905), p. 2; and Abel Letalle, *La Peinture à l'exposition internationale de Liège 1905* (Paris, 1907).

154. Papers concerning the Liège Exposition are conserved at the archives of the city of Liège. These papers are currently being classified; however, documents concerning the American section could not, as yet, be consulted. Madame Renardy, archivist, informed the author that plans and catalogues of the St. Louis World's Fair were found among these papers.

155. National Archives, Washington, D.C. Letters from John Hay to Baron Moncheur, dated December 15, 1904, and December 24, 1904. For copies of these letters, the author is grateful to Richard T. Gould of the Diplomatic Branch.

156. On the Paris Society of American Painters, see the author's *The Forgotten Episode*, p. 18.

157. Janice Oresman identified the figure as Noir in *Gari Melchers, 1860–1932, American Painter* (New York: Graham Gallery, 1978). See also Annette Stott, "Gari Melchers," in *Artists of Michigan from the Nineteenth Century*, ed. J. Gray Sweeney (Muskegon, Mich.: Muskegon Museum of Art, 1987), p. 136.

158. Eugen Weber, *France, Fin de Siècle* (Cambridge: Harvard University Press, 1986), pp. 213–33.

159. Stewart's *A Parisian Fencing Master* was illustrated in *Art Amateur*, vol. 15, no. 5 (October 1886), p. 97.

160. Stott, "Gari Melchers," p. 136.

161. "Au Palais des beaux-arts," *Gazette de Liège*, June 6, 1905, p. 1 *(very unpleasant)*; "L'Exposition de Liège," *Gazette de Charleroi*, June 15, 1905, p. 2 *(exceptionally well portrayed)*; Olympe Gilbart, "Les Beaux-Arts à l'exposition: Les Etats-Unis," *La Meuse*, May 27–28, 1905, p. 1.

162. *American Art Annual*, vol. 6 (1908), p. 221.

163. "Driejaarlijksche Tentoonstelling," *Het Handelsblad van Antwerpen*, June 9, 1908, p. 1. *(the process of "slurping up" by the capital which, unsatisfied to have a Triennial as well, opens its spring salon each time we organize an exhibition.)*

164. Sander Pierron, "Le Salon d'Anvers-III," *L'Indépendance belge*, June 26, 1908, p. 3.

165. Joanna D. Catron kindly brought this unlocated painting to the attention of the author.

166. H. H. Monroe, "The Chicago Art Exhibition," *Art Amateur*, vol. 23, no. 5 (October 1890), p. 84.

167. Pencil, "Beaux-Arts," *Le Nouveau Précurseur*, June 16, 1908, p. 2; E.V., "Chronique Artistique," *La Métropole*, May 28, 1908, p. 2; Pierron, "Le Salon d'Anvers-III," p. 3. *(one of the most remarkable canvases ... an intimate and chaste nude, of broad and yet delicate treatment because it suggests the quivering of the flesh.)*

168. Archives of American Art, papers of Edwin C. Shaw, clipping, "The International Exhibition in Antwerp," *New York World*, May 15, 1908, roll 1124, frame 799.

169. For Gruppe and Nourse, see "Beaux-Arts," *Le Matin*, May 31, 1908, p. 4. Concerning Miller's *The Old Woman*, see the author's *The Forgotten Episode*, pp. 58–59.

GARI MELCHERS IN NEW YORK

JOSEPH G. DREISS

▼

Gari Melchers first went abroad as an art student in 1877, and until 1915, when he returned from Germany, he spent only intermittent periods in America. Nevertheless, he maintained an active interest in the New York art world from the beginning of his career. From the 1880s he exhibited regularly in New York museums and galleries, he opened a studio there in 1906, and he affiliated himself with New York art organizations and social clubs.

Melchers first exhibited in New York at the National Academy of Design during the 1880s. A major work, *The Letter* (pl. 1; cat. no. 6), won a place in the academy's 58th Annual Exhibition held during the spring of 1883. It is not surprising that *The Letter* and other works by Melchers were accepted for exhibition. During the mid-1880s, academy juries favored figure painting and, in a reversal of opinion, were increasingly receptive to the work of younger American artists who, like Melchers, had been trained in Paris ateliers.[1] The list of artists elected to membership in the academy during the 1880s included many who shared Melchers's stylistic predilections.

A Cosey Corner (fig. 31), by Francis Millet, an American expatriate who became an academy associate in 1881, was also exhibited there during the 1880s. Comparison of this work with *The Letter* demonstrates the compatibility of Melchers's art with that regularly seen at the academy, but at the same time reveals the uniqueness and strength of Melchers's early style. A forcefully realistic work, *The Letter* portrays peasant women and their humble environment in a forthright, honest manner. Melchers monumentalized the figures but refused to idealize the figures or their setting. Millet's painting, by contrast, is sweetly sentimental, depicting a pretty young maid tucked into the corner of a quaint cottage interior.

Melchers's paintings also won acceptance in the 1886, 1887, and 1892 exhibitions of the Society of American Artists. Since its inception in 1877, the society had actively sought pictures by American artists working abroad.[2] Many of the artists in this association had been taught in Paris by the same teachers as Melchers had, namely Gustave Boulanger and Jules Lefebvre.

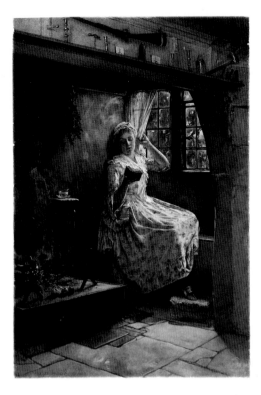

Fig. 31. Francis Davis Millet, *A Cosey Corner*, 1884, oil on canvas, 36¼ × 24¼ inches, The Metropolitan Museum of Art, gift of George I. Feney, 1887 (87.8.3).

Melchers's became an even more active presence on the American art scene during the 1890s. The artist painted two large lunettes for George B. Post's monumentally scaled Manufactures and Liberal Arts Building, erected for the Columbian Exposition of 1893, and two years later, he was commissioned to create a set of murals for the newly constructed Library of Congress building in Washington. Melchers also served on the International Board of Judges of the Columbian Exposition along with William Merritt Chase and Francis Millet.

These prolonged visits to America resulted in a deeper involvement in the New York cultural and social scene during the 1890s. In 1894 Melchers became a member of the Players,[3] a New York social club then located at 16 Gramercy Park in a building renovated by Stanford White. The club, founded by the well-known actor Edwin Booth in 1888, was more than just a theatrical organization and included artists, writers, and other professionals. Besides allowing Melchers to broaden his social contacts in New York, the Players may have brought him more directly in touch with the American Impressionists. J. Alden Weir became a member in 1888; William Merritt Chase and John Twachtman became members in 1889. In the 1890s Edmund Tarbell, Robert Reid, Childe Hassam, and Willard Metcalf joined.[4]

A reminiscence by Clayton Hamilton, who joined the Players in 1903, describes the caliber of its artist members and the flamboyant good spirits of this favorite rendezvous:

> But, to glance back at the round table! Seated there, of course, would be a painter or two; and you could take your pick of almost any of the famous Ten, who had recently seceded from something or other which none of us — not even Royal Cortissoz — can any more remember. But although — or possibly because — they were secessionists, they were all great painters!

Fig. 32. Beaux Arts Building, Charles Rich, architect, c. 1901. View from Sixth Avenue. Photo courtesy of Avery Library, Columbia University, New York.

There was Robert Reid, who looked like one of the great Assyrian bulls in the British Museum; there was Edward Simmons, a nephew of Ralph Waldo Emerson, who, in his early boyhood, used to go on fishing expeditions with Thoreau; there was the burly and self confident J. Alden Weir; there was Willard Metcalf, who, subsequent to his lifelong resolve to ride upon the water-wagon, always told the utter truth about everything whatever, regardless of where the chips might fall. There was Childe Hassam,—a great artist who remained always (although no pun is intended in the comment) a very simple child.[5]

The Players and other social clubs were as essential to New York artists as cafés were to artists in Paris. The clubs were places to meet, to drink, and to discuss art. Melchers, who became head of the art committee in 1931, remained a Players member until his death.

Despite these preliminary forays into the New York art scene, it was not until the mid-1900s that Melchers began to live and work in New York on a consistent basis. He began exhibiting regularly in New York galleries, starting with a portrait show at the Julius Oehme Gallery in 1906, in the hope that his work would become better known to a New York clientele.[6] He became an associate of the National Academy of Design in 1905 and an academician in 1906. In 1908 Christian Brinton alluded to the increased regularity of Melchers's visits to New York, noting that the artist returned from Europe "for a portion of each season."[7]

By May 1906 Melchers had rented a studio in the Beaux Arts Building (fig. 32).[8] The building, also known as the Bryant Park Studios, still stands overlooking Bryant Park on the southeast corner of Sixth Avenue and Fortieth Street. Individual apartments included a large studio and exhibition space with expansive windows facing north.[9] The building typifies the many studio apartments erected

in New York soon after the turn of the century. Others were the Cooperative Studio Building, the Central Park Studios, and the Atelier Building, all of which were built between 1900 and 1910 to provide artists with apartments in which they could live, work, and exhibit their art. Like the Beaux Arts studios, these buildings generally faced a park to take advantage of still remaining open spaces. The studio-apartment not only was popular with artists but became fashionable with prosperous city dwellers, who used the grand interior spaces of the apartments as impressive settings for social entertainments. [10]

The Beaux Arts Building was ideal for Melchers both for its splendid accommodations and for its location. Fifth Avenue, from Thirty-fifth Street to Fifty-seventh Street, was becoming the art center of the city. Many of the important galleries, art organizations, and social clubs that Melchers frequented were found in the vicinity. Cottier and Company, where Melchers had a retrospective exhibition in 1908, was a block from his studio. The Montross Gallery, which held one-man shows of Melchers's work in 1911, 1916, and 1920, was on Fifth Avenue and Forty-fifth Street. The MacBeth Galleries and Knoedler and Company, important outlets for Melchers's work during the 1920s, were also nearby on Fifth Avenue. The Century Association was at 7 West Forty-third Street, an easy four-block walk from the Beaux Arts Building. Furthermore, many of Melchers's artist friends had midtown studios.

Melchers used the view from his studio window in at least five paintings executed over the next few years. *Bryant Park (Twilight)* (pl. 20; cat. no. 39) is one of two works that look down at the park from his window. Against the backdrop of the New York Public Library and Forty-second Street, Melchers portrayed the charm of the snow-covered park, replete with sparkling pinpoints of light that stand out amid the muted atmosphere of early evening. *New York Hippodrome* represents another vista from the studio. Here the view is across the expanse of Bryant Park toward the south side of the Hippodrome, the largest theatrical building in the world when it was built in 1905. [11]

There is good reason to believe that Melchers turned for inspiration to the art of his friend Childe Hassam when faced with the new artistic problem of painting the urban landscape. [12] Hassam's art had long been identified with the city, whether the streets of Boston, Paris, or New York. [13] The close affinity between the artists' depictions of the urban scene can be demonstrated by comparison of Melchers's *Bryant Park (Twilight)* and Hassam's *Winter in Union Square* (fig. 33). Both paintings are set in snow-covered city parks seen from high vantage points. Lavender hues predominate, and generalized atmospheric effects obscure the surrounding buildings.

Other works provide evidence of a continuing connection between the two artists. Around 1910 Hassam and Melchers both explored the theme of a lone contemplative woman by a window in works rendered in an Impressionist style. Melchers's *Snow* (pl. 26; cat. no. 51), exhibited at the Montross Gallery in 1911, depicts a model in a dressing gown posed in front of a window in the Bryant Park studio, the warm intimacy of the studio contrasting with the bright chilly winter scene outside. *New York Window/Twilight* (private collection) is the only other instance of the subject in Melchers's oeuvre. Hassam had begun to paint women

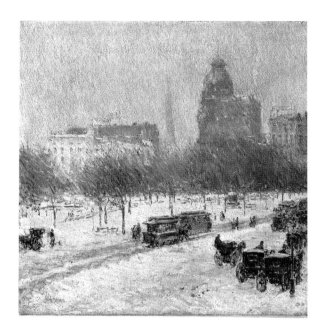

Fig. 33. Childe Hassam, *Winter in Union Square*, c. 1890, oil on canvas, 18¼ × 18 inches, The Metropolitan Museum of Art, gift of Ethelyn McKinney, 1943, in memory of her brother Glenn Ford McKinney (43.116.2).

in diaphanous attire in rear-illuminated interior settings as early as 1910 in works such as *Contre Jour* (Art Institute of Chicago). As the decade progressed, he developed this theme into what came to be called the New York Window series,[14] exemplified by *New York Window* (Corcoran Gallery of Art) and his somewhat later *Tanagra (The Builders, New York)* (fig. 34).

In 1908 Melchers exhibited a number of recently painted New York scenes in a large show held at Cottier and Company. This exhibition of thirty-four works included *New York Hippodrome*, *North River*, and *Bryant Park in Winter* as well as some of Melchers's best-known Dutch paintings, such as *The Delft Horse*, *The China Closet*, and *The Sermon*. Besides the paintings offered for purchase, the exhibition presented works on loan from important collectors and museums. *The Sailor and His Sweetheart* (fig. 5) and *Skaters* were lent by the Carnegie Institute and the Pennsylvania Academy of the Fine Arts respectively. Among the private collectors to lend works were James Deering, Hugh Reisinger, Mrs. Marshall Field, and Julius Stroh.[15]

Melchers's visibility on the New York scene was further enhanced in 1908 by the publication of Christian Brinton's *Modern Artists*. Melchers, along with Arnold Böcklin, Constantin Meunier, Giovanni Segantini, James McNeill Whistler, and John Singer Sargent, was singled out as a personal favorite of Brinton. Brinton would remain one of Melchers's main supporters, writing reviews and articles about the artist through the years. Melchers's portrait of Brinton (Philadelphia Museum of Art), completed by 1910, documents their early professional relationship and collaboration.[16]

In 1909 artistic opportunities in Europe led Melchers to spend more time in Germany and Holland. During that year he was appointed full professor at the Grand Ducal Academy of Fine Arts, Weimar, by the grand duke of Saxe-Weimar-Eisenach, and Melchers and his wife, Corinne, set up residence there on Cranachstrasse. At government expense he was provided with a studio on the second floor,

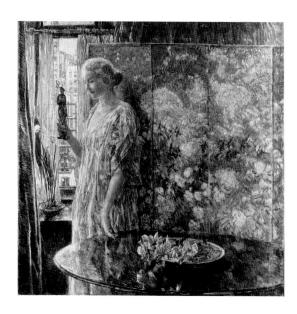

Fig. 34. Childe Hassam, *Tanagra (The Builders, New York)*, 1918, oil on canvas, 58³/₄ × 58³/₄ inches, National Museum of American Art, Smithsonian Institution, gift of John Gellatly.

which was renovated in 1912 according to Melchers's recommendations to provide additional space and better lighting. In spite of Melchers's distinguished position in Weimar, escalating political hostilities forced him to leave Germany in 1915,[17] and by December of that year he was looking for studio space in New York.[18]

During his years abroad Melchers continued to exhibit regularly in New York and remained active in the city's art circles. His association with the Montross Gallery began in 1909, when his work was first included in a group exhibition there. In 1911 the gallery gave him a one-man show; *Madonna* (fig. 14) was purchased from the exhibition for the Metropolitan Museum of Art.[19] For twelve years the gallery would remain the principal New York outlet for Melchers's art. It was also an important link between Melchers and the American Impressionists. The Ten American Painters, the most significant group of American Impressionists, routinely exhibited there during the early years of the century.

The 1911 Montross Gallery exhibition was Melchers's last major one-man show in New York until after he returned to America permanently in 1915. Indeed, between 1911 and 1915 Melchers's presence on the New York scene was limited. The exact date that he gave up the Bryant Park studio is not known, but it was not maintained continually during this four-year interval.

Melchers did visit America in January 1913, after a two-year absence, to serve on the selection jury for an exhibition at the Corcoran Gallery of Art. During an interview with the *New York Times* he spoke of his intention to stay in America for a few months and to travel to Boston, Philadelphia, Detroit, and Washington. He commented on the enormous changes that had occurred in New York during his absence, especially in the Fifth Avenue area, and expressed concern that the rapid rate of architectural change would negatively affect the city's beauty.[20] He returned to America again late in 1913 to receive an honorary degree from the University of Michigan.[21]

Early in 1916 Melchers once again secured a painting studio in the Beaux Arts Building. Later that year he purchased Belmont, an estate in Falmouth, Virginia. Although Melchers would spend considerable time in the Falmouth

area, particularly during the summer months, his professional base during the last seventeen years of his life was New York.

Melchers became deeply involved in the cosmopolitan club life that was so much a part of New York's social milieu during the early years of the century. In 1916 he was invited to join the Coffee House, a social club established by Frank Crowninshield, editor of *Vanity Fair*.[22] Like the Players, the membership list of the Coffee House was filled with names of celebrated artists and art-world chroniclers, including Charles Dana Gibson, Frederick MacMonnies, Paul Manship, and Royal Cortissoz. Cortissoz, an art critic for the *New York Tribune*, was to become Melchers's champion during the 1920s, lauding his work in various reviews. Crowninshield himself, whose involvement with New York art and artists was a complex one, would prove to be a long-time friend of Melchers and an important aid in publicizing his work.

Melchers originally joined the Century Association in 1911, and after his return from Europe in 1915, it became the most important organization in his professional and personal life. From the letters he wrote to his wife at Belmont, it is clear that he frequented the club on an almost daily basis. Melchers had a one-man exhibition there in 1927 and became president of the Century in 1931, an office that he occupied until his death the following year.

The Century has had a long and venerable history as an artistic and literary society. It was an outgrowth of the Sketch Club, a small group of artists and writers who, in 1829, had joined together to foster the visual and literary arts. But so many men sought admission that a new club admitting a hundred members was formed. On January 13, 1847, the Century Association had its first organizational meeting, called by Asher B. Durand and other members of the original Sketch Club.[23] By the time Melchers joined, the club included not only art professionals but scientists, diplomats, journalists, lawyers, executives, and musicians. Prominent artist members during Melchers's tenure included George de Forest Brush, Gifford Beal, Augustus Vincent Tack, and Mahonri Young.[24] Tack painted a portrait of Melchers in 1931 to commemorate his presidency of the association.

The Century clubhouse was then located, as it still is today, at 7 West Forty-third Street, four blocks from Melchers's studio. Designed in Italian Renaissance style by McKim, Mead, and White, the building was completed in 1891 and included a dining room, billiard room, library, and gallery.[25] The gallery was used for exhibitions of the works of member artists and to display an impressive permanent collection of paintings including works by such renowned Centurions as John Frederick Kensett, Eastman Johnson, Asher B. Durand, Frederic Church, William Sidney Mount, and John Vanderlyn.[26]

Melchers's busy social life was paralleled by an active life as an exhibiting artist. He renewed his relationship with the Montross Gallery, holding a one-man show of paintings he had completed in Europe. Melchers's earlier New York shows had frequently combined older realistic figure paintings with portraits and Impressionist works. The 1916 Montross exhibition, however, consisted almost exclusively of works done in an Impressionist manner. Still lifes, landscapes, domestic and church interiors, painted in sparkling color with a loose, impressionistic handling, now predominated.

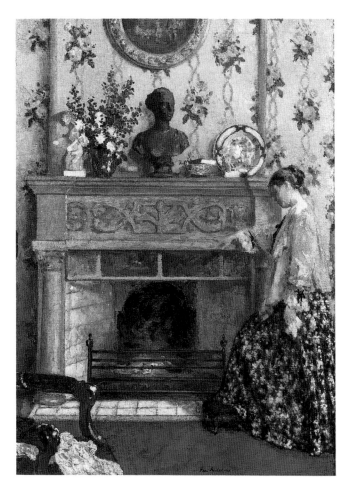

Fig. 35. *The Open Fire*, c. 1912, oil
on canvas, 39 × 28¼ inches,
Belmont, The Gari Melchers
Memorial Gallery.

Interior genre scenes, which the artist had exhibited in New York as early
as 1908, occupied a particularly significant place in this show.[27] Celebrations
of the domestic happiness Melchers enjoyed in the years following his marriage to
Corinne, these interiors suggest the rising social and economic status of the artist.
The works typically represent well-to-do women, sometimes with their maids, in
the sitting room at Schuylenburg, the former home of George Hitchcock in
Egmond aan den Hoef, where Melchers frequently painted after 1904. *The Open
Fire* (fig. 35), shown in the 1916 exhibition, exemplifies the genre. Here an ele-
gantly attired young woman standing before a mantel contemplates a fire. The
focus of the painting is as much the splendor of the upper-class interior, replete
with wallpaper and decorative objects, as it is the figure, whose role is essentially
ornamental. The presence of a mother and infant in some of these genre scenes,
like *The Open Door* (pl. 19; cat. no. 38), adds warmth and narrative interest.
At Home (The Winged Victory) (fig. 18), which was exhibited at the Copley
Society in Boston in 1919, is the most monumental example of the subject
in Melchers's oeuvre.

Given Melchers's rapport with American Impressionist circles in New York,
these paintings can clearly be seen as his interpretation of the theme as it appears
in the work of the Ten and the Boston School. Since before the turn of the century,
artists such as Edmund Tarbell, Joseph DeCamp, Frank Benson, and William
Paxton had been painting women of leisure in elegantly appointed interiors

Fig. 36. William McGregor Paxton, *The Front Parlor*, 1913, oil on canvas,
27 × 22¹/₈ inches, The St. Louis Art Museum, Cora E. Ludwig bequest
by exchange and Edward Mallinckordt, Sr., bequest by exchange.

(fig. 36) to celebrate and idealize the virtues of women and to express their joy
in the brilliant materialistic achievements of nineteenth-century America.

 Still Life (Red Snapper) (fig. 37), also in the 1916 Montross exhibit, is another
instance of the influence of American Impressionism on Melchers and, in particu-
lar, reveals his indebtedness to the art of William Merritt Chase. This was noted
by a reviewer of the 1916 event who remarked that Melchers had painted a
"gorgeous red snapper challenging Mr. Chase on his own ground."[28] Both *Still
Life (Red Snapper)* and Chase's *Fish* (fig. 38), of some years earlier, present the sub-
ject from a close vantage point, and both stress the soft-bodied quality of the fish,
which is thickly painted. Melchers had had professional dealings with Chase as
early as 1890.[29] He attended the sale of Chase's paintings and studio furnishings,
held in May 1917 after the artist's death, and purchased a landscape of Savannah
for the Telfair Academy, as well as a Japanese lacquer screen.[30]

 The 1916 Montross exhibition was a critical reintroduction of Melchers's
work, after a hiatus of about four years, to an American audience. Although he
continued to have one-man exhibitions there until 1919, the Milch Galleries,
beginning with a one-man show in 1921, replaced Montross as his primary New
York gallery. The artist's gradual withdrawal from Montross during the early
1920s may have been in response to the increasingly liberal attitudes of N. E.
Montross, who opened his gallery to the modernists in 1914 and who, along with
Alfred Stieglitz and others, became an enthusiastic supporter of avant-garde art.
In 1919 Childe Hassam, seeking a more conservative representative for his art,
also changed from the Montross to the Milch Galleries.[31]

Fig. 37. *Still Life (Red Snapper)*, c. 1914, oil on canvas, 17¼ × 29¼ inches, Belmont, The Gari Melchers Memorial Gallery.

Fig. 38. William Merritt Chase, *Fish*, before 1910, oil on canvas, 29 × 36 inches, The Metropolitan Museum of Art, gift of Edward G. Kennedy, in memory of William Merritt Chase, 1925 (25.131).

During the postwar period Melchers's commercial visibility in New York was broadened through the inclusion of his work in exhibitions at other prominent galleries. The MacBeth Galleries began exhibiting his work regularly in 1919, and the Anderson and Knoedler Galleries showed his work in various group exhibits during the 1910s and 1920s.

The year 1919 marked the beginning of a new association of artists that was to become particularly important to Melchers in the years to come. In November a group called the American Painters, Sculptors, and Gravers held their first annual exhibition at the Galleries of E. Gimpel and Wildenstein.[32] The following year the name of the group was changed to the New Society of Artists, and Melchers was installed as chairman, an office he held until 1926.

The society was for the most part a conservative group, some of whose members may well have felt threatened by the ascendancy of European modernism during the 1920s. Its roster featured some of the most prominent names in American art of the period. Impressionist artists included Childe Hassam, Frederick

Frieseke, Edmund Tarbell, Elmer Schofield, and Haley Lever. Ashcan painters Robert Henri, George Luks, William Glackens, and Ernest Lawson were members, along with George Bellows. Other distinguished members included painters Leon Kroll, Guy Pene DuBois, Rockwell Kent, and Robert Chandler, and sculptors Stirling Calder, Mahonri Young, John Flanagan, James Earle Fraser, and Paul Manship.

Arthur Loring Paine, in his review of the second annual exhibition of the society, described the nature of the group:

> The basic idea of its organization is refreshingly simple and free from all cant. The forming of this notable group implies no revolt, no artistic propaganda, no brief for this or that kind of art, as against any other kind of art. It is, frankly, a mutual admiration society of honest artistic craftsmen, organized as the result of spontaneous enthusiasm. In the group, we find men who, although they do not so claim, may be said to be the leaders in their various fields of art, however widely separated these fields may be.[33]

Royal Cortissoz remarked in a later review that the group "had something of the significance of a secession" and included men who were "of the progressive, innovative type."[34] A review of the membership, however, suggests that Paine's view of the group is the more accurate one. The New Society of Artists was not so much a revolutionary faction within the New York art world as it was a group of artists who banded together for the sake of promoting their work through lectures, demonstrations, and annual exhibitions.

Melchers acted in a number of different roles as chairman of the society. He was a central figure in organizing many exhibitions and special events, and he also helped to reconcile differences that arose between members. Further, Melchers actively promoted the art of New Society members. During Melchers's tenure, for example, a drawing by Gifford Beal, then vice chairman, was acquired by the Detroit Athletic Club on Melchers's recommendation,[35] and Melchers acted as an intermediary between the MacBeth Galleries and the Corcoran Gallery of Art in the latter's acquisition of Frederick Frieseke's *Dressing Room*.[36]

Melchers's activities in conjunction with the New Society brought him into close personal and professional contact with the Ashcan painters and their circle; Melchers's association with the MacBeth Galleries, which began in 1919, may have been facilitated by his friendship with Ashcan painters who had shown at the gallery for many years. A joint exhibition of the paintings of Gari Melchers and George Luks was held at the Frank K. M. Rehn Galleries in the spring of 1925.[37] A letter from Luks to Melchers in the Belmont archives, which includes an amusing caricature of Joseph Pennell, with whom Luks was at odds at the time, further documents their relationship.[38] Letters from George Bellows in the Belmont archives establish their friendship.[39] In fact, Melchers served on the organizing committee of the George Bellows Memorial Exhibition held at the Metropolitan Museum of Art after Bellows's untimely death in 1925.[40]

Melchers's association with another New Society colleague, Paul Manship, is particularly interesting for a pair of portraits it occasioned. (Manship belonged to the society during Melchers's term as chairman, and he was also a member of the

Fig. 39. Paul Manship, *Gari Melchers*, 1932, plaster, 8½ inches diam., Belmont, The Gari Melchers Memorial Gallery.

Century Association.) In 1932 Manship sculpted a relief in plaster of Melchers (Belmont, fig. 39), who sat for the portrait in February and March during several visits to the sculptor's studio.[41] The relief is a sensitive, realistic study of the aging artist in the last year of his life: the soft flesh beneath the chin and the thinning hair are signs of advanced age, but Manship's crisp and incisive style conveys Melchers's dignity and strength of character. In the same year, Melchers reciprocated with a portrait in profile of Manship (fig. 40). The oil sketch is an admirable example of the painter's late portrait style, which combines the firm contours and solid modeling typical of his early work with a looser, impressionistic handling of paint.[42]

Melchers produced a heterogeneous array of works during the 1920s, representing a variety of styles and subjects, many of which were exhibited at the Milch Galleries in numerous one-man shows held there during the decade. His landscapes and town views of the Fredericksburg and Falmouth areas continued to show the general influence of the American Impressionists he knew, such as Willard Metcalf, Edward Redfield, and Hassam.

Melchers seems to have worked more consistently on large figurative paintings during the 1920s than he had during the previous decade; it is these works that received the most critical attention from the New York press. Perhaps his renewed interest in the figure was sparked by two major mural commissions he executed in the early 1920s for the Detroit Public Library and the Missouri state capitol.

The Old Hunter (location unknown), *The Hunters* (pl. 28; cat. no. 54), and *Native of Virginia* (Belmont) represent Melchers's rural neighbors of Falmouth in much the same way the artist had painted the peasant folk of Egmond thirty years before, although with a brighter palette and a greater emphasis on the decorative possibilities of two-dimensional pictorial design. Melchers's frank and honest portrayal of these simple folk expresses the same determined Realist intention as that which motivated the work of his earlier Dutch period.

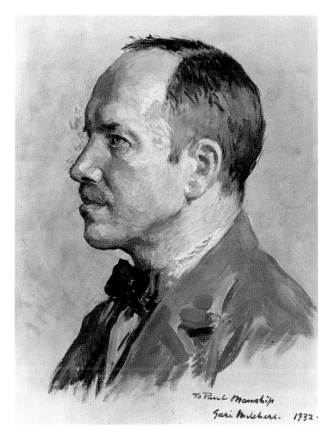

To Paul Manship
Gari Melchers. 1932.

Fig. 40. *Portrait of Paul Manship*, 1932, oil on canvas, 19 × 15 inches, Century Association.

Until his death in 1932 Melchers continued to be professionally and socially engaged in New York art circles. Two large retrospective exhibitions of his work, held at the Anderson Galleries in 1929 and the American Academy of Arts and Letters in 1932, were significant summations of a long and distinguished career.

Dr. Joseph G. Dreiss, chair of the Art Department at Mary Washington College, Fredericksburg, Virginia, is the author of the book Gari Melchers: His Works in the Belmont Collection, *1984.*

NOTES

1. Doreen Bolger Burke, *American Paintings in the Metropolitan Museum of Art. Vol. III. A Catalogue of Works by Artists Born between 1846 and 1864* (New York: Metropolitan Museum of Art, 1980), pp. xxiii–xxiv.

2. Ibid., p. xxiii. It was for the purpose of supporting such artists that the society was originally formed as a protest against the restrictive attitude toward expatriate artists that prevailed at the National Academy of Design during the late 1870s.

3. Henry Wysham Lanier, ed., *The Players' Book: A Half Century of Fact, Feeling, Fun, and Folklore* (New York: The Players, 1938), pp. 97–116.

4. Ibid., pp. 332–75.

5. Ibid., p. 43.

6. Melchers to Rush Hawkins, March 11, 1906, Hawkins letters, XVIII:168, Annmary Brown Memorial, Brown University, Providence.

7. Christian Brinton, *Modern Artists* (New York: Baker and Taylor, 1908), p. 224.

8. Melchers to Rush Hawkins, May 29, 1906, letter

files of General Hawkins, XVIII:179.

9. Robert A. M. Stern, Gregory Gilmartin, and John Montague Massengale, *New York 1900: Metropolitan Architecture and Urbanism 1890–1915* (New York: Rizzoli, 1983), p. 296.

10. Ibid., pp. 294–99.

11. The building was designed by Frederick Thompson, the architect of Coney Island's Luna Park. It was important for its grandiose size and spectacularly elaborate architectural ornamentation and as an important example of the early and extensive use of electric light for architectural display. Ibid., pp. 208–209.

12. The connection between Melchers and Hassam is supported biographically. Hassam himself pointed out that he and Melchers met during their student days in Paris. See Childe Hassam, "Gari Melchers," *Commemorative Tributes of the American Academy of Arts and Letters* (New York: American Academy of Arts and Letters, 1936), pp. 53–66. Donelson F. Hoopes claims that Hassam first made Melchers's acquaintance shortly after the Boston painter arrived in Paris in 1886. See Hoopes, *Childe Hassam* (New York: Watson-Guptill, 1979), p. 13. Hassam's Paris studio, at 11 boulevard Cliché, was close to Melchers's on the rue de Viète. Both painters studied at the Académie Julian and were instructed by Gustave Boulanger and Jules Lefebvre. Both exhibited in the Paris Salon of 1888 and won medals at the Exposition Universelle in Paris in 1889.

13. William H. Gerdts, *American Impressionism* (New York: Abbeville, 1984), p. 98, points out that the close identification of Hassam's art with urban subjects may have prevented his contemporaries from identifying him as an Impressionist, for in America Impressionists were initially thought of as landscape painters.

14. For a discussion of Hassam's New York Window series see Gerdts, *American Impressionism*, pp. 189–190.

15. Cottier and Company, *Gari Melchers* (New York, 1908). In 1913 *The Sailor and His Sweetheart* was sent by exchange to the Freer Gallery of Art.

16. This portrait is discussed in the correspondence between Brinton and Melchers. See Christian Brinton to Melchers, letter file, Belmont archives, 1907.1, 1908.19.

17. Melchers to Rush Hawkins, July 6, 1915, Hawkins letters, XX:96.

18. Melchers to Rush Hawkins, December 31, 1915, Hawkins letters, XX:132.

19. Burke, *American Painters*, p. 380. John White Alexander, Daniel Chester French, and Bryson Burroughs expressed their enthusiasm for and approval of this acquisition in letters written to the museum. Melchers himself wrote in a letter to the Metropolitan: "I cannot help saying it to you again how very much pleased I am that the Metropolitan Museum has become the owner of this picture—for I know it represents me at my very best."

20. Clara T. MacChesney, "Gari Melchers Home, Amazed at New York's Changes," *New York Times*, January 17, 1913.

21. On this second visit, while en route to Ann Arbor to receive the degree, Melchers was stricken with pleurisy and pneumonia, contracted during his transatlantic voyage, and spent three weeks recuperating in a New York hospital.

22. Frank Crowninshield to Melchers, January 8, 1916, Belmont archives.

23. Century Association, *The Century 1847–1946* (New York, 1947), pp. 3–5.

24. Ibid., pp. 92–93.

25. Ibid., p. 56.

26. A. Hyatt Mayor and Mark Davis, *American Art at the Century* (New York: Century Association, 1977).

27. Montross Gallery, *Exhibition of Pictures by Gari Melchers* (New York, 1916).

28. "The Ten and Numerous Other Art Exhibitions: Art at Home and Abroad," *New York Times Magazine*, March 12, 1916, p. 14.

29. They were involved in an exhibition at Reichard and Company. See William Merritt Chase to Melchers, April 8, 1890, Belmont archives.

30. The Japanese screen is still part of the Belmont holdings.

31. Hoopes, *Childe Hassam*, p. 18.

32. *First Annual Exhibition of American Painters, Sculptors, and Gravers* (New York: Galleries of E. Gimpel and Wildenstein, 1919).

33. Arthur Loring Paine, "An Art Show of Unusual Interest," *Vanity Fair*, December 1920.

34. Royal Cortissoz, "A Renewal of the Old Story of Secession," *New York Tribune*, January 9, 1923, p. 7.

35. Gifford Beal to Melchers, March 26, 1924, Belmont archives.

36. Robert G. McIntyre to Melchers, December 21, 1923, Belmont archives.

37. Frank K. M. Rehn Galleries, *Exhibition of Works by Gari Melchers and George Luks* (New York, 1925).

38. George Luks to Melchers, December 18, 1922, Belmont archives.

39. George Bellows to Melchers, November 1922 and October 24, 1923, Belmont archives.

40. Metropolitan Museum of Art, *Memorial Exhibition of the Work of George Bellows* (New York, 1925).

41. Melchers to Corinne Melchers, February 7, 1932; March 19, 1932; and April 9, 1932; Belmont archives.

42. Hyatt and Davis, *American Art at the Century*, p. 104. The relief sculpture is signed "from Paul Manship 1932"; the portrait sketch is inscribed "to Paul Manship." The inscriptions indicate that the artists exchanged the two works as gifts, an assumption confirmed by the fact that the works were originally in each artist's private collection. Melchers's sketch of Manship was given to the Century Association by Manship's estate in 1966.

MELCHERS AND THE TELFAIR ACADEMY: THE EVOLUTION OF A COLLECTION

FEAY SHELLMAN COLEMAN

▼

Gari Melchers was a generous and gregarious gentleman, a man of character, a peacemaker. His outgoing and tolerant personality enabled him to appreciate the fraternal side of art and enriched all his associations. He belonged to a number of art clubs and groups whose goals ranged from promoting the discussion of art to sponsoring exhibitions and forming public collections. On the one hand, his affiliations with the Players and the Century clubs, where he enjoyed the camaraderie of other artists, were essentially social. On the other, his appointments to the boards of the Virginia Arts Commission and the Corcoran Gallery of Art as well as his chairmanships of the Smithsonian Commission to Establish a National Gallery of Art and the New Society of Artists point to a distinguished record of service to the field. Further, he occasionally welcomed curatorial projects such as organizing the American section of the Venice Biennale[1] in 1905 or advising Hugo Reisinger on his choices for the *Austellung Amerikanischer Kunst,* which he arranged for the Berlin Academy in 1910.[2]

Melchers's longest-standing institutional tie was to the Telfair Academy of Arts and Sciences in Savannah, Georgia (fig. 41).[3] His relationship with the art museum ensued through his wife, Corinne. Her maternal uncle, A. R. Lawton, was president of the Telfair in 1905 when the museum's first director, Carl Brandt, died. Lacking funds for a full-time director's salary, the trustees proposed that Melchers serve as their fine arts adviser,[4] with the primary charge of increasing the collection established by Mary Telfair and Carl Brandt.[5] In addition, he would travel to Savannah once or twice a year to meet with the trustees and to make recommendations about museum administration. Melchers accepted the appointment and served officially from 1906 until 1916. He continued to advise the museum informally on acquisitions until the late 1920s.

During the twenty-year period in which Melchers was associated closely with the Telfair, the museum acquired more than seventy works of art.[6] Apparently neither a written collections policy nor stipulations requiring board approval of proposed purchases existed. However, surviving correspondence between Melchers

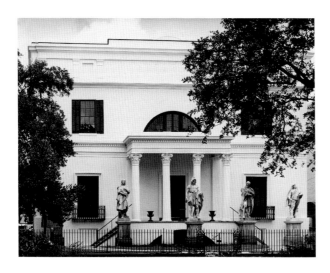

Fig. 41. The Telfair Academy of
Arts and Sciences, Inc., Savannah.

and Lawton suggests that Melchers kept Lawton fully aware of all pending deals
and transactions.

The only constraint on Melchers seems to have been financial. From 1906
until 1916 the trustees budgeted an average of about $1,500 a year for acquisi-
tions. In the spring of 1910 Melchers wrote to Lawton:

> I have the firm conviction that we are doing wonders with our scanty budget, and only
> wish we had more money. Do you see any chance of your rich Savannah friends doing
> something handsome for the Telfair, as you and several gentlemen did a few years ago?
> I remember your saying [that] Mr. _____ or Mr. _____ (I believe it was) had
> wanted to know "why they were not asked at the time to come in." Please give them a
> chance now if you think it wise. I am so anxious to see the museum make a big jump
> this year, and put the place on "war footing" and rearrange the galleries when in
> Savannah next. Do scare up a little more money if you think it can be done.[7]

Although Melchers's letters were usually optimistic and full of enthusiasm for the
Telfair, on one occasion he wrote to Lawton that:

> My position in many of these Telfair transactions, where I deal directly with the
> painter, has been rather that of a damn mean cus [*sic*] who sails a little too close to the
> wind and I fear the Telfair will have to, in the future come nearer the actual market
> prices of pictures or go without them.[8]

The collection of paintings selected for the Telfair was international in scope.
Most of the paintings were secured from artists in Germany, France, and the
United States, with a sprinkling from the Low Countries and England. When
Melchers did not obtain works directly from the artist, he often bought them at
large annual exhibitions. After 1915, when Melchers settled permanently in
America, he frequently dealt with New York galleries including MacBeth,
Montross, Anderson, and Grand Central.

Melchers's approach to painting and collecting reflects the philosophy of the
juste milieu. Many artists, most especially Americans converging on Europe, had
worked doggedly to acquire academic training. Once attaining this goal, they
were reluctant to abandon completely the accomplishment it represented. Simul-
taneously, they found innovation compelling and sought to participate in the

creation of a new vision. In summarizing Melchers's career, the *New York Times* art critic Edward Alden Jewell related a process of reconciliation. It is decidedly identifiable in Melchers's oeuvre and in the work of artists represented in the Telfair collection:

> Although classifiable as an academician, Gari Melchers was too alert and adventurous to stand altogether at odds with what we loosely term "modern art." In no sense actually a modernist, he yet argued in paint a sympathetic appreciation of the fact that living art can never afford to shut the door upon fresh search and significant discovery.[9]

The group of artworks chosen by Melchers for the Telfair stands as a memorial to his taste and times. A study of the artists, their works, and the process of selection gauges Melchers's own life and art. Although most of his acquisitions for the Telfair were painted between 1890 and 1910 and are more pertinent to his interests at that time, at least one painting exemplifying each of the major emphases in his own artistic development can be found in the Telfair collection.

RELIGIOUS AND DUTCH MOTIFS

By the time Melchers began his work for the Telfair in 1906, his early absorption with Dutch peasants and religious subjects had waned, which may explain why biblical themes are scarcely seen in the Telfair collection. Nothing acquired for the Telfair parallels the monumental naturalism of Melchers's large compositions of Dutch fisherfolk and their devotions. However, two small oil paintings—*Head of a Young Woman* by Eduard von Gebhardt (fig. 42) and *Head of Saint John the Baptist* by Puvis de Chavannes—recall Melchers's debt in his religious work to these artists. Since the paintings are similar in size, subject, and treatment, Melchers probably envisioned exhibiting them as a pair in homage to his mentors.[10]

As an impressionable student of Gebhardt at Düsseldorf, Melchers retained many aspects of his master's art. He embraced Gebhardt's practice of creating a *tableau vivant* of individualistic, unidealized peasant models for his religious compositions. Although *Head of a Young Woman* manifests no obvious scriptural source, it is most likely a study for a peasant figure in a larger painting.[11] Moreover, the painting is characteristic of Gebhardt's realism verging on naturalism, which deeply influenced Melchers's early work. The provenance of *Head of a Young Woman* added to its cachet. Melchers acquired it from the estate sale of the collection of his old and dear friend Hugo Reisinger.

Precepts taken from Symbolism and the art of Puvis de Chavannes are apparent in Melchers's own murals and religious paintings executed between 1890 and 1904. Melchers adopted elements of Puvis's technique by introducing chalky tints to his palette and composing designs with little depth. The Symbolists dedicated themselves to creating art with spiritual content, and their philosophy revalidated Melchers's well-established partiality for subjects based on scripture. It is at least interesting and perhaps significant that Melchers selected one of Puvis's religious subjects for the Telfair collection.[12] In *Head of Saint John the Baptist*, Puvis showed his subject in a three-quarter view against a dark background. Subtly posed, the

Fig. 42. Eduard von Gebhardt, *Head of a Young Woman*, oil on canvas, 15³/₈ × 12¹/₄ inches, Telfair Academy, purchase, 1916.

saint's head inclines downward, the eyes are cast up and look back over his shoulder, as if to suggest that his own path foreshadows the crucifixion of Christ. The facial type relates generally to Melchers's *Christ with Halo* (fig. 43)—high cheekbones, pronounced brow, thin nose, dark eyes, and dark hair. The painting also calls to mind Melchers's fascination with the three-quarter view of the human head. His own collection included a Puvis drawing, *Head of a Woman*, in which the tilt of the head is similar to that in *Head of Saint John the Baptist*.

Two of Melchers's purchases, *The Overflow* and *Church Interior, Saint Anne Sluis* (fig. 44), show churches but lack biblical or didactic comment. The former is a gouache by George Boughton, the artist whose 1885 book *Sketching Rambles in Holland* helped to popularize The Netherlands as a painter's haven. *Church Interior, Saint Anne Sluis* by Albert Engstfeld continues the Dutch custom of painting church interiors. Earlier masters from Emanuel de Witte to Johannes Bosboom portrayed large urban churches and cathedrals. In contrast, Engstfeld, with the close scrutiny of a Realist, focused on the architectural details of the humble quarters of a peasant congregation. By manipulating perspective he was able to incorporate the quaint Dutch features of the building, from the flat ceiling, hexagonal pulpit canopy, and chandelier to the closed stalls, red chairs, and slate floor. Although architecture was a secondary interest of Melchers, he portrayed similar panoramas of church interiors in paintings such as *The Offertory (Interior of a Church)* (private collection), *The Christening* (Belmont), and *The Wedding* (fig. 13).

Throughout his life Melchers was inevitably drawn to Holland and to the work of artists who responded to the country's unique qualities of light and life. Thanks to Melchers, the Telfair owns the Engstfeld and six other paintings depicting Dutch or peasant themes. Four are scenes drawn from the lives of working-class women. Quiet, everyday pursuits—sewing, knitting while tending a flock,

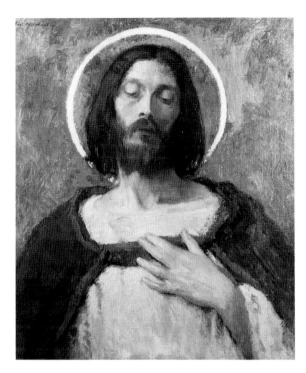

Fig. 43. *Christ with Halo*, n.d., oil on canvas, 28³/₈ × 23³/₈ inches, The Cleveland Museum of Art, bequest of Mrs. Henry A. Everett for the Dorothy Burnham Everett Memorial Collection (38.39).

Fig. 44. Albert Engstfeld, *Church Interior, Saint Anne Sluis*, oil on canvas, 24⁵/₈ × 22¹/₂ inches, Telfair Academy, purchase, 1912.

pausing in the midst of marketing, or eating an apple—occupy each subject. Hardly potential causes célèbres for Social Realists, these women are reasonably comfortable working people whose antecedents were the models for Vermeer and de Hooch.

Like Melchers's painting *The Letter* (pl. 1; cat. no. 6), both *Interior, with a Woman Sewing* (fig. 45) by François Bonvin and *Apfelessendes Mädchen* (fig. 46) by Gotthardt Kuehl rely on the compositional devices of seventeenth-century Dutch genre painting. The skillful interplay of rectangles, backlighting from an open window or door, and still-life groupings of lowly kitchen objects are fundamental to the design of all three paintings.

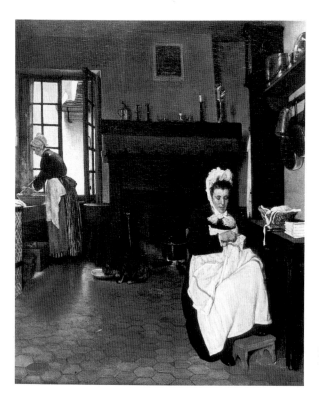

Fig. 45. François Bonvin, *Interior, with a Woman Sewing*, 1880, oil on canvas, 22 × 18 inches, Telfair Academy, purchase, 1911.

Although he completed *Interior, with a Woman Sewing* just two years before Melchers painted *The Letter*, Bonvin belonged to the previous epoch. Melchers's generation appreciated Bonvin as a forerunner who gained acceptance at the Salon for small-scale domestic realism inspired by Jean-Baptiste-Siméon Chardin and seventeenth-century Dutch genre painters. Bonvin did paint bona fide Dutch subjects, although *Interior, with a Woman Sewing* was executed in the artist's kitchen in a suburb of Paris. But its inspiration is Dutch, and it is representative of Bonvin's oeuvre. In a letter to A. R. Lawton, Melchers commented that he "was glad to see a Bonvin in the National Gallery, London, and one in the Rijks Museum, Amsterdam. Neither one is in my opinion as fine an example as the one in the Telfair Gallery."[13]

In contrast to Bonvin, the quintessential Parisian, Gotthardt Kuehl belonged to the coterie of German Realists identified with Max Liebermann. Writing in 1901, Liebermann explained how the painters of the Hague School lured the Germans to Holland:

About thirty years ago the Dutch made their debut as a group in the Glaspalast in Munich and created a tremendous sensation among the artists, who constitute the only public in Munich. What struck us was the painterly culture. Any young man of any energy made the pilgrimage to Holland, bringing back with him a wooden shoe, a white cap and a long clay pipe; the Dutch window with its little leaded lights became the fashion. The revival that German painting underwent in the eighties of the last century was owed not least to the influence of the Dutch.[14]

Kuehl visited Holland often during the 1870s and 1880s. He also periodically returned to his birthplace, Lübeck, which, like Holland, presented the artist

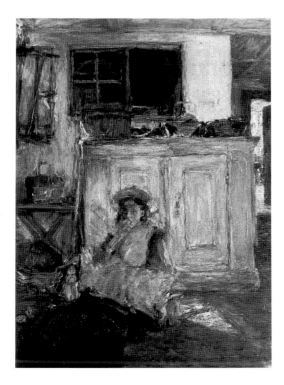

Fig. 46. Gotthardt Kuehl, *Apfelessendes Mädchen*,
c. 1900–10, oil on panel, 24 × 19 inches,
Telfair Academy, purchase, 1912.

with vignettes of traditional life that made excellent subject matter. Thus, the
possibility exists that Kuehl, like Bonvin, was not in Holland when he painted
this "Dutch" subject. Nevertheless, *Apfelessendes Mädchen* bears some hallmarks
that link Kuehl both to Melchers[15] and to Liebermann's circle. One is the use of
dark colors combined with painterly brushstrokes resembling the French Impres-
sionist technique. Another is the "Dutch" subject that evinces a benign view of
working people and the institutional life of the poor. Compare *Apfelessendes Mäd-
chen* to Melchers's *The China Closet* (pl. 16; cat. no. 34) or *The Open Door* (pl. 19;
cat. no. 38) and the parallels become apparent.

A second pair of peasant subjects, *Amsterdam* (fig. 47) by Hans Herrmann
and *Pasturage in the Dunes* (fig. 48) by Raphael Lewisohn, reinforces Melchers's
connections to the German artists who painted in Holland and Brittany. Herr-
mann and Melchers met during their student days in Düsseldorf. Beginning in
1883 they spent time together in Egmond and remained friends despite the
politics of World War I. Several small works by Herrmann in the collection at Bel-
mont commemorate that friendship. Although he continued his painting journeys
to Holland, Herrmann made Berlin his permanent home from 1886. In 1892 he
joined with Liebermann in forming a group of progressive artists called The
Eleven, which evolved into the Berlin Secession. Herrmann's subject and his
loose, painterly application of dark pigments predict his ties to both Liebermann
and Melchers.

Pasturage in the Dunes takes up a theme common to Melchers and other
painters of peasants in Holland and northern France. Melchers's canvases *In Hol-
land* (pl. 3; cat. no. 12), *Moss and Sand* (pl. 4; cat. no. 13), and *The Goatherd*
(Belmont) show peasant women working on the dunes. In each instance, the artist
places the subject against the high horizon line of the dunes. Melchers's brushwork

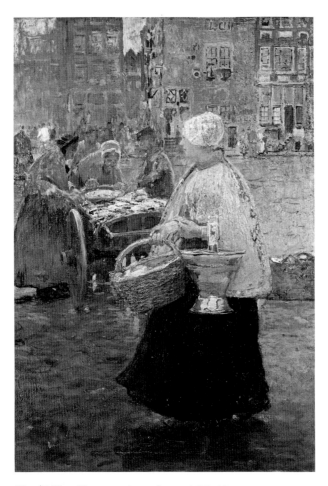

Fig. 47. Hans Hermann, *Amsterdam*, c. 1900–10, oil on canvas, 36¹/₂ × 26¹/₂ inches, Telfair Academy, purchase, 1910.

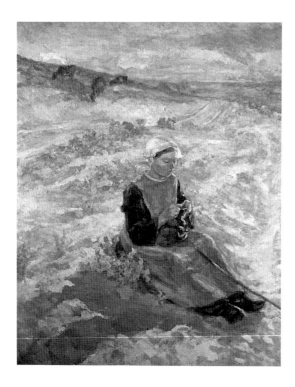

Fig. 48. Raphael Lewisohn, *Pasturage in the Dunes*, 1905, oil on canvas, 45⁵/₈ × 35¹/₄ inches, Telfair Academy, purchase, 1907.

became progressively looser and more painterly every time he returned to the subject; the figure in *The Goatherd* is merely a sketchy summary. By contrast, in *Pasturage in the Dunes* Lewisohn borrowed Jules Bastien-Lepage's device of delineating a particularized figure against an amorphous background. Freely painting in tints of lavender, turquoise, pink, orange, and yellow, Lewisohn washed the dunes in the colors of a spellbinding sunset.

GENRE AND LEISURE

Genre endured as a consequential theme in Melchers's art even though his early specialty in peasant subjects gave way around the turn of the century to a new focus on middle-class women and domestic interiors. A group of paintings in the Telfair collection reflects this trend.

Pictures like *Intimate* (fig. 49) established Julius L. Stewart as a painter of fashionable Parisians. This painting, which Stewart exhibited in the Salon of 1897 as *At Home*, was a gift to the Telfair from the artist's estate. Melchers explained to A. R. Lawton:

> Jules [*sic*] Stewart, the American painter said in Paris last winter—and in his will designated Jean Beraud, Walter MacEwen, and myself to make a selection among his pictures to be presented to museums in this country. I am writing ... so as to learn if Telfair Academy would welcome one of Stewart's best canvases should it be decided to offer you one. (I will see that this is done.) In [my] opinion you ought to put yourself down as welcoming this gift. Stewart was a man of very large means, and paid no attention whatever toward the side of selling his work, and also was a very rare exhibitor in this country. [16]

Perhaps chosen as a counterpart to the lady reclining in the foreground of *Intimate*, Frederick Frieseke's *The Hammock* (fig. 50) also shows a lady in repose. [17] Painted in France and shipped to New York at the beginning of World War I, *The Hammock* received its first public scrutiny in an exhibition at the MacBeth Galleries in January 1916. The painting stood out among the works in the exhibition for critical notice, mostly pejorative. To one commentator the paint looked as if "some creamy substance, variously tinted, had been whipped into foam upon the surface." [18] Although American critics were not ready to accept the degree of abstraction in Frieseke's brushwork and interpretation of light, Melchers had no hesitation in recommending that the Telfair acquire *The Hammock*. Melchers was always mindful of upgrading the collection while respecting the limitations of the Telfair's pocketbook. He suggested, therefore, that the museum trade Frieseke's *Marcelle*, an acquisition made a few years earlier, and add a small sum to acquire *The Hammock*. Happily, MacBeth worked out a bargain with the museum so that the Telfair could keep both paintings. [19]

From artists of the older generation who had been active during the Second Empire, Melchers selected works by Alfred Stevens and James-Jacques-Joseph Tissot. Both had won wide recognition for vividly rendering fashionable ladies and closely observing details of their rich surroundings. For the Telfair, however,

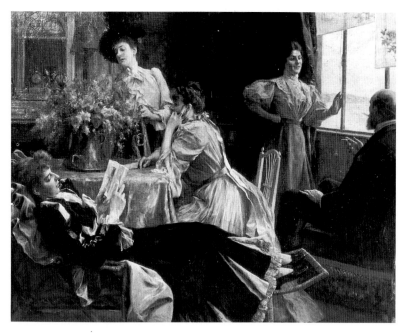

Fig. 49. Julius L. Stewart, *Intimate*, 1897, oil on panel, 31³/₈ × 39³/₈ inches, Telfair Academy, gift of the estate of Julius L. Stewart.

Melchers chose pictures that merely hinted at rather than reiterated the subject matter and technique of their authors' most typical canvases.

Far from the luxuriant dwellings of the Second Empire in both space and time, Stevens painted *Regatta Day at Menton* out-of-doors. A fashionable lady is present, but she is part of the scenery, her status that of a logo, like the artist's monogram at the lower left. Land, sea, and sky dominate the painting.

The racing theme introduced in the Stevens painting is repeated in two sketches by Tissot donated to the Telfair by Melchers in 1926. Each is a study of a young woman: one leans on what seems to be the rail of a yacht; the other gazes through a pair of binoculars. All three images restate Melchers's bias for the face shown in profile.

As if to underscore the internationalism in turn-of-the-century painting, Melchers added scenes by two Germans and a Frenchman of the upper class at play. One, *Calme Blanc* by Raoul du Gardier, perpetuates the yachting theme. The other, *Tennis in den Dunen* by Ernst Oppler,[20] memorializes a different leisure sport.

The Frenchman Gaston La Touche set *View of the Eiffel Tower from the Trocadéro* in Le Nôtre's park at Saint-Cloud. Here again the artist conveys an affirmative view of life in which the middle class enjoys a fête champêtre in a park once reserved for royalty but now open to all. The Eiffel Tower, symbol of nineteenth-century technology and industrialization, is but a tiny detail in the composition. Melchers's own paintings of modern life focused on domestic tranquility rather than on leisure, but his early twentieth-century works also embody a sanguine view of life.

A few more genre examples are located in open-air settings. A 1907 purchase, *Le Déjeuner sous les bois* (fig. 51) by Alfred Smith, closely approximates

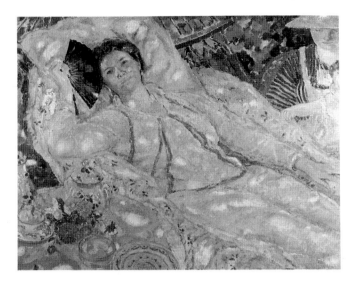

Fig. 50. Frederick Frieseke, *The Hammock*, c. 1915, oil on canvas, 38½ × 51½ inches, Telfair Academy, purchase, 1917.

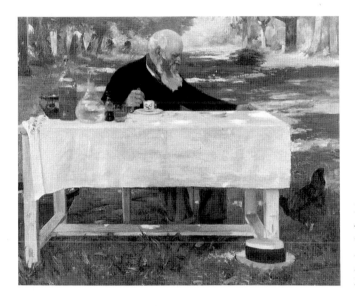

Fig. 51. Alfred Smith, *Le Déjeuner sous les bois*, 1903, oil on canvas, 47½ × 59½ inches, Telfair Academy, gift of George J. Baldwin, Alexander R. Lawton, William W. Mackall, J. Florance Minis, 1907.

Melchers's *In the Arbor* (private collection). The two painters placed figures at tables with white cloths, dotted the canvases with flecks of mottled sunlight, and created impressionistic still lifes that recall the still life on the bar in Manet's *Un Bar aux Folies-Bergère*.

Although he never returned to the Social Realism seen in his early paintings influenced by Düsseldorf and the Hague School, Melchers considered it a valid aim of art. Two acquisitions allude to that viewpoint. *De Gauwdief (The Pickpocket)* by the Dutch Symbolist Jan T. Toorup (fig. 52) and *Calico Sellers* by Jerome Myers contain social commentary. Painted in 1884, *De Gauwdief* is one of Toorup's rare early Realist works. Unfortunately we have no details of Melchers's acquisition of the work, but it may have occurred while Toorup's daughter resided in a town bordering on Egmond. Particulars about Melchers's purchase of *Calico Sellers* also are lacking.

In 1921 Melchers obtained *The Flower Woman* by the Washington painter Felicie Waldo Howell. This outdoor genre scene finds counterparts in Melchers's

Fig. 52. Jan T. Toorup, *De Gauwdief (The Pickpocket)*, 1884, oil on canvas,
35½ × 63 inches, Telfair Academy, purchase, 1915.

own work of the same period. His views of rural Virginia such as *Commerce Street*
(Belmont), *Nelson Berry's Store* (Belmont), and *Saint George's Church* (cat. no. 50)
reveal a similar attraction to chalky tints, a row of buildings compressing the
action into the foreground, and small-town or rural subjects.

FIGURES AND PORTRAITURE

Among the figures and portraits that Melchers selected for the Telfair are two full-
length female figures, one by his good friend Walter MacEwen, the other by Jean-
François Raffaelli. Melchers might have envisioned the two works as foils to one
another; one is viewed from the back, the other from the front. Both artists were
distinguished in their exhibition records and critical reception. Although best
known for his Dutch subjects, MacEwen painted several costume pieces, including
The Belle of 1810 (fig. 53), in which a young woman is seen from the back, her face
reflected in a mirror. Her satin dress is the center of interest. *The Belle of 1810* was
exhibited in Munich, Berlin, and Düsseldorf before MacEwen sold it to the Telfair.

Like MacEwen's painting, *La Demoiselle d'honneur* (fig. 54) was one of a group
of exhibition pieces. Raffaelli exhibited a similar figure in a white dressing gown,
A Young Girl with Blue-bottle Plants, at the Salon of 1899. *La Demoiselle d'honneur*
debuted at the Salon in 1901 and appeared at the Venice Biennale in 1903.[21]
Critics registered their approval of the painting, even calling it "a new symphony
in white, marvelous for its grace and charm."[22] Melchers's own paintings *At Home
(The Winged Victory)* (fig. 18) and *Portrait of Mrs. Gari Melchers* (pl. 17; cat. no.
35) show a parallel interest in the portrayal of silks and elaborate period costume.

During his years as an expatriate, and even after he returned to the United
States, both wanderlust and career requirements seem to have fueled Melchers's
desire for frequent migrations. It was not unusual for the artist to scout likely
acquisitions for the Telfair in exhibitions he visited on his travels. Sometimes he

Fig. 53. Walter MacEwen, *The Belle of 1810*, c. 1900, oil on canvas, 45⁵/₈ × 35¹/₄ inches, Telfair Academy, purchase, 1907.

Fig. 54. Jean-François Raffaelli, *La Demoiselle d'honneur*, c. 1901, oil on canvas, 99 × 45³/₈ inches, Telfair Academy, purchase, 1910.

purchased paintings on the spot, but he often bided his time until he could make a direct plea to the artist on the Telfair's behalf. Melchers conveyed his reaction to Robert Henri's *La Madrileñita* (fig. 55) in a letter written to A. R. Lawton:

> When I was passing through Detroit last summer, a collective exhibition of the work of Robert Henry [*sic*] was shown at [the] Detroit Museum. There was a picture there called "Madrilenita" a Spanish girl which particularly tickled my fancy, and I felt it would be a fine addition to the Telfair collection. He is a remarkably fine painter—one of our very best.
>
> Last night I had the occasion to meet Henri and brought up this particular matter, he will let you have it for $1,500.... I strongly urge that you buy it for Telfair.[23]

The Spanish theme seems to have stayed with Melchers. When the opportunity presented itself, he painted *Portrait of Mrs. John W. Garrett in Spanish Costume* (Belmont). Melchers completed the uncommissioned portrait in December 1925.

Fig. 55. Robert Henri, *La Madrileñita*, c. 1910, oil on canvas,
40⁷/₈ × 33 inches, Telfair Academy, purchase, 1919.

In the next year Melchers presented to the Telfair a small ink wash drawing,
In the Café, by Constantin Guys. The subject is a woman who stands with the erect
posture of a dancer, her right hand on her hip, mirroring *La Madrileñita*. Like the
artists of Henri's Philadelphia circle, Guys labored as an artist-journalist, record-
ing the happenings of contemporary city life. In "Un Peintre de la vie moderne,"[24]
Baudelaire ranked Guys as the premier painter of contemporary life because of his
ability to capture the essence of a subject with the swish of a brush.

Melchers's European reputation helped him to win American patrons for
commissioned portraits. Painted in 1908, *Portrait of President Theodore Roosevelt*
(fig. 56) stands at the peak of Melchers's career as a portraitist. Melchers portrayed
the President in informal clothing, thereby underscoring his vitality. It is possible
that he took a cue from Alfred-Philippe Roll's *Felix Faure and His Grandson* (fig.
57), which Melchers had selected for the Telfair in 1907. Although intended as a
preliminary study of Faure, president of the French Republic, for the mammoth
Pose de la première pierre du pont Alexandre III, Roll exhibited the canvas as a
finished work. The critic L. Roger-Miles praised Roll's warm and intimate por-
trayal of Faure, a man known for his formality.[25] The tender relationship between
grandfather and grandson probably attracted Melchers, who was intrigued by the
intimacy of mothers and infants.

Roll, famous as a Salon Realist, enjoyed a long career as a muralist and por-
traitist of public officials. Melchers may have wanted a painting for the Telfair that
was more typical of Roll's semi-official status, for he acquired *Admiral Krantz*,
explaining to A. R. Lawton:

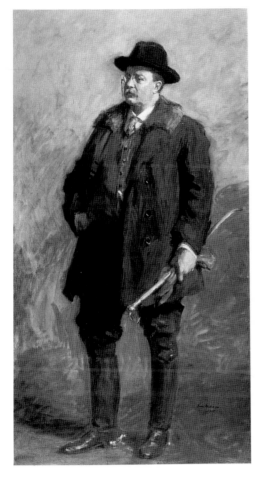

Fig. 56. *Portrait of President Theodore Roosevelt*, 1908, oil on canvas, 83 × 43½ inches, Freer Gallery of Art, Smithsonian Institution, Washington, D.C.

Fig. 57. Alfred-Philippe Roll, *Felix Faure and His Grandson*, c. 1895–99, oil on canvas, 26⅜ × 31 inches, Telfair Academy, gift of George J. Baldwin, Alexander R. Lawton, William W. Mackall, J. Florance Minis, 1907.

I wanted a Roll, for the study head of "Faure" was hardly enough, and furthermore I wanted one [of] some ten or more years ago. I hesitated a long time between a comparatively important canvas which he would let us have for 6,000 francs and this rather small canvas for 5,000 of just the "Admiral's" head and shoulders painted aboard the Flagship Toulon in '89, against a blue sky, which Roll has always considered one of his very best "Morceau de Peinture." Finally I wrote to Roll from Weimar to decide and he answered and advised the "Admiral Krantz." It is a magnificent and big thing.[26]

Melchers purchased *Boy's Head* by Charles W. Hawthorne from the widow of an artist in 1921. As with *Felix Faure and His Grandson*, Melchers chose a portrait sketch that displays virtuoso brushwork in the service of a rapid and disarmingly handsome character study.

There are two portraits of artists in the Telfair collection. One, *George Hitchcock* (fig. 58), recollects the friendship of three expatriate Americans: Hitchcock, Melchers, and James Shannon, who spent summer holidays together painting in Holland. Shannon was known for his society portraits, which were often compared to Sargent's. Like Sargent, who left his stylish sitters behind during the summer so that he could travel and paint watercolors, Shannon retreated to Holland where

Fig. 58. James Jebusa Shannon, *George Hitchcock*, 1891, oil on canvas, 51 × 34⅞ inches, Telfair Academy, purchase, 1909.

he painted family and friends. The floral surroundings allude to Hitchcock's favorite subject, and it has been suggested that the glint of sunlight on the palette refers to Hitchcock's nickname, the "Painter of Sunlight."[27] To complete his homage to his old friend, Melchers also purchased a pure landscape, *Early Spring in Holland*, by Hitchcock.[28]

The sitter for *Jeune Homme avec chemise rose* by Olga Boznanska was the Polish painter Eugen Dabrowski. It seems that the painting had no personal association for Melchers. Although he had been watching Boznanska's work for a long time, Melchers wrote to Lawton that "I never met her until the day I called by appointment to buy this picture, which after talking very poor and cracking up the Museum, was sold at the modest sum of 1,000 francs."[29]

In Melchers's own work, portraits and figures were much more numerous than were nudes, but they do occur. In 1910, when his own interest in the nude was increasing, he bought two for the Telfair: *Marcelle* by Frederick Frieseke (fig. 59) and *La Toilette d'Herminie* by Henri Caro-Delvaille. Both artists were abandoning temporarily their main theme, the contemporary woman, in favor of the nude. Caro-Delvaille was impelled to paint a series of nudes by a study of Titian and the Elgin marbles, which he saw in 1902. *La Toilette d'Herminie*, a stylistic descendant of nudes of impeccable classical pedigree such as the *Aphrodite of Milo* and Titian's *Venus Anadyomene*, may have inspired Melchers's *Nude Figure against Yellow Background* (Belmont). The assumption that Caro-Delvaille's nude influenced Melchers is reinforced by an enthusiastic letter dashed off in the flush of victory:

Fig. 59. Frederick Frieseke, *Marcelle*,
c. 1905–1908, oil on canvas, 32¼ × 25¾
inches, Telfair Academy, purchase, 1910.

I have succeeded today, after much persuasion, to buy the *finest nude* painted anywhere
in the last years, by Caro-Delvaille, a three-quarter length which was shown at the
Salon three or four years ago, price 6,000 francs. He just simply did not want to part
with it, and only today at a luncheon party did he give in. I told him the Savannah
Museum was the most promising in our glorious country, as in the last few years they
had acquired a Roll, Puvis de Chavannes, La Touche, Aman-Jean, several Besnards,
Raffaellis, and that sort of thing, all of which you know is true.[30]

As is so often the case with Melchers's acquisitions, he seems to have had a comparison in mind when he purchased *La Toilette d'Herminie* and *Marcelle*. Both models are redheads seen in mirrored reflections. Herminie stands, facing the viewer, her back visible in the mirror; Marcelle sits, her back toward the viewer, her face reflected.

Marcelle was also a carefully considered acquisition. According to a letter he sent to Lawton, Melchers had followed *Marcelle* from its debut at the Salon in 1908 to a prize-winning appearance at the Corcoran in 1908–1909, then on to exhibitions at the Carnegie in 1909 and the Berlin Academy in 1910. He finally purchased the canvas in 1910.[31]

MURALS AND LANDSCAPES

Melchers's Paris years, beginning in 1881, coincided with a surge in municipal building programs. He knew many of the artists who were making their reputations as they won competitions and commissions to decorate buildings from the Hotel de Ville to the Petit Palais in the Beaux Arts revival style. Back home,

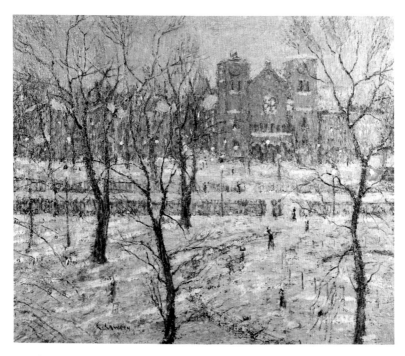

Fig. 60. Ernest Lawson, *Stuyvesant Square in Winter*, c. 1900–1905, oil on canvas, 25 1/8 × 30 1/8 inches, Telfair Academy, purchase, 1907.

Melchers executed murals for two of the outstanding monuments of the American Renaissance: the Chicago World's Columbian Exposition in 1893 and the Library of Congress in 1895. That he admired and sought examples of the French muralists' work for the Telfair comes as no surprise.[32] His purchases were a study for *La Travail*[33] by Henri Martin and *Three Decorative Panels* by Albert Besnard.

Like many of Melchers's selections, the study for *La Travail* and *Three Decorative Panels* enhance one another by their contrasts. Martin created *La Travail* for a solemn tribunal in the Palais de Justice, and its Symbolist themes, pointillist technique, and monumental scale identify his successful style. On the other hand, Besnard's commission was to decorate a domestic space, one of the showcase rooms installed for the 1895 opening of Siegfried Bing's L'Art Nouveau Bing.[34] The Telfair panels are three of a group that originally numbered eleven, in addition to a circular ceiling painting.[35] A Prix de Rome winner, Besnard held more closely to traditional academic handling of form than Martin. Besnard's considerable stature as a draughtsman was grounded at least partially in his portrayal of horses such as the two in the largest of the Telfair panels.

Although Melchers's acquisitions reflect many interests and ideas, his comments on the Besnard panels illustrate that aesthetic quality remained his first concern:

> The Besnard decorative panels I bought from an exhibition of his works in Paris, and did not deal with him, although we have known each other for many years. After carefully looking over the two Salons, it occurred to me the wise thing to only buy, as much as possible, pictures by men who have the biggest reputation and have been able to hold it year after year. Besnard, who is 60 years or more, is the most brilliant figure

Fig. 61. Childe Hassam, *Brooklyn Bridge in Winter*, 1904, oil on canvas,
30 × 34¹/₁₆ inches, Telfair Academy, purchase, 1907.

in France today. When I say brilliant, I mean the greatest "virtuose," and we needed
him very badly in our museum.[36]

Melchers turned to landscape and cityscape during some lengthy visits to the
United States between 1905 and 1909. Painted around 1906–1907, *Bryant Park
(Twilight)* (pl. 20; cat. no. 39) offers indications of an emerging leitmotif in both
Melchers's landscapes and those he purchased for the Telfair. Common features
shared by most paintings in this group are a high vantage point and high horizon,
atmospheric treatment of an urban landscape, winter subject, gray tonality, and
broken brushwork. Taken together, these elements crystallize into a softened,
quiet interpretation of a city landscape. Melchers purchased Ernest Lawson's
Stuyvesant Square in Winter (fig. 60) for the Telfair in 1907, about the time he
painted *Bryant Park (Twilight)*. The paintings are such close counterparts that
Melchers's inspiration must have come from Lawson.

Melchers chose two more interpretations of a similar subject for the Telfair to
complement the canvas by Lawson. Mist obscures form so thoroughly in George
Sauter's *Frost und Nebel* that the painting verges on being an abstract arrangement
of gray tones. Melchers added Joseph Pennell's untitled watercolor of London,
which demonstrates how the fluidity of the medium can suggest an almost pal-
pable wetness.

Rounding out the cityscapes are three views of the busy waterways around
New York City: *Brooklyn Bridge in Winter* (fig. 61) by Childe Hassam, *Ice Boats on
the Hudson* (fig. 62) by Henry Golden Dearth, and *Snow-capped River* by George
Bellows.[37] Melchers knew these artists personally. Again, similar images appear
in Melchers's paintings of the same date, for example, in *Hudson River* (cat. no. 40)
and *The Wharves, New York* (Belmont). His paintings of the Hudson are closest in

Fig. 62. Henry Golden Dearth, *Ice Boats on the Hudson*, c. 1890–1900, oil on canvas, 18 × 29¹/₈ inches, Telfair Academy, gift of Gari Melchers, 1908.

spirit to Dearth's work, which he presented to the Telfair in 1908. Melchers purchased *Brooklyn Bridge in Winter* from a Hassam show at the Montross Gallery. Among the twenty-five works in the exhibition, *Brooklyn Bridge in Winter* stood out in a reviewer's mind:

> There is something spectral, unsubstantial, something of the dream architecture of Piranesi in the spidery line of the Brooklyn Bridge when a ghostly mist has begun to eat away its massive towers, its sweeping cables and its solid arch. Hassam has caught the rhythmic music, the same sense of mystery.[38]

Most of the landscapes among Melchers's acquisitions were painted by Americans. Yet he did purchase some European interpretations of gray winter days along the river banks of France: *The Harbor* by Emile Vernier, *Bordeaux, vu du pont, journée d'hiver*[39] by Alfred Smith, and *La Seine à Billancourt* by Jean-François Raffaelli. At the peak of his interest in Social Realism, Raffaelli moved to Asnières, an industrial suburb of Paris. There he lived among the poor and the pitiful who peopled his canvases. Two landscapes painted nearby, *La Seine à Billancourt* and *View of the Seine* (in Melchers's personal collection), reveal only flickerings—a tug, a barge, a crane, smokestacks—of the shabby industrial nature of the place. Their appeal for Melchers was Raffaelli's subtle control of the narrow gradations of color with which he suggested sky, land, and river.

Besides the cool, misty landscapes that refresh visitors stepping from Savannah's summer heat into the galleries of the Telfair, Melchers bought a group of sunny vistas. These canvases capture the quality of light in their country of origin. From the brush of George Hitchcock came *Early Spring in Holland* (fig. 63), which perfectly visualizes his written description of Holland's appeal for artists:

Fig. 63. George Hitchcock, *Early Spring in Holland*, c. 1890–1905, oil on canvas, 35⅞ × 51⅛ inches, Telfair Academy, purchase, 1907.

> That which in other lands is a cold gray, uninteresting, often repellent, here becomes an indefinable harmony, containing a depth and richness or pearly brilliancy, opalescent, sad—an infinite variety, each effect apparently more beautiful than the last. The result of this luminous gray atmosphere is to transform everything, to change the bugbear of "commonplace" into mystery, and through its many gradations to give as many charming motives.[40]

In the pearly colors of the pastel tulips, the silvery gray willows, and the muted, grayish blue sky, Hitchcock has expressed the unique atmosphere of The Netherlands.[41]

From the quiet harmony of Hitchcock's Holland, one moves to the brilliant, shimmering heat of siesta time in the south of France in Henri Martin's *Puy l'Évêque*. Martin launched his career as a muralist with the seemingly contradictory combination of pointillist technique with Symbolist theme. However, he could comfortably express the gossamer appearance of a summer afternoon in his native province.

Two American landscapes summarize the spring and fall seen from opposite sides of Long Island Sound. A spring wind blows clouds across the Connecticut sky in *Buttercup Field* by Willard Metcalf. On the other shore of the sound, William Merritt Chase's model enjoys the last warmth of the sun under the saturated blue of the still, autumnal sky in his pastel *October*.

In each of these paintings, showing a specific time and place, the impressionistic technique of broken brushwork is employed in the service of optical realism. However, one of Melchers's final acquisitions for the Telfair emphasizes yet another

phenomenon. From the realistic landscapes of his Impressionist colleagues, Melchers turned to the *Storm Swept Landscape* of Van Dearing Perrine. With bright, nondescriptive color Perrine expressed not the strict appearance but the sensation of a storm. With the acquisition of *Storm Swept Landscape* Melchers implicitly acknowledged Perrine's statement:

> I believe also that what is done by nature is done by [the] mind which will best serve the human need. This need today is slowly pressing toward a new art; an abstract art of color and light, one in which the deflections of sunbeams may play subservient to the dreams of man.[42]

Melchers's faithful service to the Telfair endowed the museum with a unique heritage—a collection that is a visual articulation of his life in art. Further, Melchers's acquisitions infuse the Telfair's galleries with an atmosphere of harmony, beauty, and affirmation. Today the Telfair is a vital regional museum that cherishes its rich past while it builds for the future.

Feay Shellman Coleman is research curator at the Telfair Academy of Arts and Sciences, Inc., and the author of a number of studies of late nineteenth-century American art.

NOTES

The author gratefully acknowledges the assistance of a John J. McCloy Fellowship in Art and a Georgia Council for the Arts Research Grant in the preparation of this essay. Thanks are also due to my colleagues at the Telfair Academy, especially Elizabeth Scott Shatto and Pamela D. King, for their exceptional support.

1. Melchers chose the following American colleagues to participate with him in the Venice Biennale of 1905: Colin Campbell Cooper, William Dannat, Frederick Frieseke, Walter Gay, George Hitchcock, H. J. Johnston, Walter MacEwen, E. R. Miller, J. J. Shannon, Julius Stewart, Eugen Vail, Henry Van der Weyden, Lionel Walden, and James A. M. Whistler.

2. Joseph G. Dreiss, *Gari Melchers: His Works in the Belmont Collection* (Charlottesville, Va.: University Press of Virginia, 1984), p. 44.

3. The Telfair Academy of Arts and Sciences in Savannah, Georgia, was established as a museum through the 1875 legacy of Mary Telfair, who bequeathed her family home and an endowment to the institution. After a prolonged legal challenge, the courts upheld Miss Telfair's will. Under the guidance of the museum's first director, Carl Brandt, the family mansion was transformed into a museum. Brandt continued as director until his death in 1905.

4. The precise details of how the arrangement between Telfair and Melchers came about are unknown. A hand-ful of personal letters between Melchers and A. R. Lawton are among the few surviving primary documents relating to Melchers's work for Telfair.

5. Telfair family heirlooms formed the nucleus of the museum collection. Carl Brandt's most significant additions to the holdings of the Telfair were a group of European (mostly German) Salon paintings, a collection of plaster casts of antique sculpture, and a large number of prints and reproductions of great works of art.

6. For a complete list see Appendix, Works of Art Acquired for the Telfair Academy on the Recommendation of or by Gift of Gari Melchers.

7. Melchers, transcript of a letter to A. R. Lawton, May 5, 1910, Telfair archives. The names in the text were omitted in the transcript used by the author. It is not known if Melchers omitted them in the original letter or if the transcriber deleted them.

8. Melchers, transcript of a letter to A. R. Lawton, July 11, 1920, Telfair archives.

9. Edward Alden Jewell, "Ever Youthful in Art," *New York Times*, December 1, 1932.

10. Although we know that Melchers advised Telfair on the arrangement of galleries, no photographic records of his installations have survived.

11. If Gebhardt's *Head of a Young Woman* is a study, it is not the only preliminary work in the collection. Melchers purchased several other studies for the Telfair:

Tête d'une fillette and a study for *La Travail* by Henri Martin, *Felix Faure and His Grandson* by Alfred Philippe Roll, *Sketch for the Portrait of a Lady* by J. J. Shannon, and two untitled sketches of women by James-Jacques-Joseph Tissot.

12. Melchers purchased *Head of Saint John the Baptist* in 1909 for $300. Telfair records do not identify the provenance of the painting, so it is impossible to verify whether Melchers purchased the work directly from his friend Puvis.

13. Melchers, transcript of a letter to A. R. Lawton, July 17, 1919, Telfair archives.

14. S. Fischer, *Max Liebermann, Die Phantasie in der Malerei; Schriften und Reden* (Frankfurt am Main, 1978), pp. 83–84, quoted in *The Hague School, Dutch Masters of the Nineteenth Century* (London, 1983), pp. 120–21.

15. It has not been possible to document an acquaintanceship between Melchers and Kuehl. However, there is circumstantial evidence that they knew one another: both were students in Germany before settling in Paris and Holland in the 1880s, and Kuehl took a post at the Dresden Academy in 1895; in 1897, he established the Dresden International Exhibition to replace the annual exhibition of the academy. Melchers participated in the exhibition at Dresden in 1897, 1901, and 1910. In a friendly letter (Belmont archives) of October 30, 1901, H. Preller asked Melchers if he would be interested in joining him and Kuehl at the Dresden Academy.

16. Melchers, transcript of a letter to A. R. Lawton, July 17, 1919, Telfair archives.

17. The theme of mother and child is the single major interest in his own art that Melchers did not introduce into the Telfair collection. *The Hammock* is the only acquisition made by Melchers for Telfair that includes a mother and child.

18. "Carlson and Frieseke Exhibit," *American*, January 10, 1916.

19. R. W. MacBeth, transcript of a letter to A. R. Lawton, March 18, 1917, Telfair archives.

20. Early in their careers Ernst Oppler and Gotthardt Kuehl followed Max Liebermann in depicting life in institutions such as orphanages and homes for the elderly. Like Liebermann, they eschewed the bleakness of the workhouse, choosing instead to convey a sense of communal harmony and social progress. From a benign view of the poor, each artist moved on to portray the contemporary middle class.

21. Artists exhibited impressive figures anticipating that a warm critical reception would generate portrait commissions. Raffaelli's *La Demoiselle d'honneur* is a case in point. The long, rectangular format for the full-length figure, the subject's seated pose, white dress, and bouquet of daisies are all repeated in the composition of his portrait of *Mademoiselle Galop* (Bury Street Gallery, London, 1980).

22. Gustave Coquiot, "Jean-François Raffaelli," *Gazette des Beaux-Arts*, vol. 5, series 4, no. 1 (1911), p. 142.

23. Melchers, transcript of a letter to A. R. Lawton, October 24, 1919, Telfair archives.

24. Charles Baudelaire, "Un Peintre de la vie mo-

derne," *Le Figaro*, November 26 and 28, December 3, 1863.

25. L. Roger-Miles, *Alfred Roll* (Paris: A. Lahure, 1904), p. 119.

26. Melchers, transcript of a letter to A. R. Lawton, May 29, 1910, Telfair archives.

27. Annette Stott, *American Painters Who Worked in the Netherlands, 1880–1914* (Ph.D. diss., Boston University, 1986), p. 156.

28. Melchers purchased the paintings by Shannon and Hitchcock from Hitchcock's former wife, Henriette.

29. Melchers, transcript of a letter to A. R. Lawton, May 29, 1910, Telfair archives.

30. Melchers, transcript of a letter to A. R. Lawton, May 5, 1910, Telfair archives. It is not clear to which "Salon" Melchers here refers. The painting was exhibited at the Venice Biennale in 1909. One of the conditions of the sale was that Caro-Delvaille would paint a copy of *La Toilette d'Herminie* before shipping the canvas to America. (Henri Caro-Delvaille, letter to Melchers, n.d., Archives of American Art, Gari Melchers Papers, microfilm roll #1407, frames 501–502.)

31. The Luxembourg Museum acquired Frieseke's *Devant la glace*, a full-length standing nude whose face is reflected in a mirror. Frieseke used the same model who appears in *Marcelle*. It has not been confirmed that Melchers knew about the Luxembourg purchase, but he followed the art world so closely that there is a good chance he did know that the painting he was purchasing for Telfair had a near duplicate in France's museum of contemporary art.

32. In addition to the murals and decorations in the Telfair collection, Melchers also selected easel paintings by artists who won commissions for murals, such as Frank Brangwyn, Caro-Delvaille, Frieseke, du Gardier, Gebhardt, Puvis de Chavannes, Raffaelli, and Roll.

33. Telfair records indicate that the study for *La Travail* was "damaged beyond repair by water." There is no photograph of the work.

34. Coincidental events point to the probability that Melchers knew the origin of the Besnard panels: at a time when Melchers was trying to help Henry van de Velde through a difficult period, he suggested Christian Brinton might write an article on van de Velde for an American magazine. As background for Brinton, Melchers asked that van de Velde send him materials about the room he had installed at L'Art Nouveau Bing, which Melchers had seen. See Dreiss, *Gari Melchers*, p. 45. Bing sent installations, including works by van de Velde and Besnard's panels, to the 1897 Dresden International Exhibition. Melchers also sent works to the show and may have seen the Besnard panels in Dresden.

35. Telfair records do not refer to the history of the panels. Their provenance was identified by the author from contemporary photographs reproduced in G. M. [Gabriel Mourey], "Studio Talk," *The Studio*, vol. 7 (1896), p. 180, and in Gabriel P. Weisberg, *Art Nouveau Bing, Paris Style 1900* (New York: Harry N. Abrams, 1986), pp. 70, 131.

36. Melchers, transcript of a letter to A. R. Lawton,

May 3, 1910, Telfair archives. Melchers also registered his admiration of Besnard by including his watercolor *Woman's Head* in his own collection.

37. By selecting a snowy view of the Hudson, Melchers followed the suit of the Pennsylvania Academy of the Fine Arts, which purchased a similar river view, *North River*, about 1909. This was Bellows's first major sale to a museum. Two more of Bellows's vistas of the Hudson found their way into museums: *Floating Ice*, acquired by Gertrude V. Whitney, eventually went to the Whitney Museum and *Up the Hudson* was given by Hugo Reisinger to the Metropolitan Museum of Art in 1911, the same year that Melchers acquired *Snow-capped River* for Telfair.

38. "Around the Galleries," *The Sun*, December 17, 1906.

39. Smith showed this painting at the Venice Biennale in 1905, the year that Melchers organized the American section of the exhibition.

40. George Hitchcock, "The Picturesque Quality of Holland," *Scribner's Magazine*, vol. 2, no. 2 (August 1887), p. 160.

41. One of the Hitchcocks in Melchers's own collection is a small watercolor, *Two Ladies in a Field of Tulips*, that is very close in color harmony and composition to *Early Spring in Holland*.

42. Montclair Art Museum, *Van Dearing Perrine, Painter of Light and Color: A Retrospective Exhibition 1908–1951* (Montclair, New Jersey, 1965), n.p.

APPENDIX

Works of Art Acquired for the Telfair Academy on the Recommendation of or by Gift of Gari Melchers
All dimensions are given in inches; height precedes width.

Edmund Aman-Jean (1860–1936), French
The Feather Boa, 1897
Oil on canvas, 36^1/$_2$ × 28^{15}/$_{16}$
Purchase, 1907

Gifford Beal (1879–1956), American
By the Water's Edge, 1922
Ink and wash on paper, sight: 6^7/$_8$ × 12^1/$_4$
Purchase, 1926

New York, 1916
Watercolor and gouache on paper, sight: 13^3/$_4$ × 19^1/$_2$
Purchase, 1924

The Path of Light
Oil on canvas, 20^1/$_8$ × 30^1/$_8$
Purchase, 1925

George Bellows (1882–1925), American
The Irish Fair
Lithograph on paper, 20^7/$_8$ × 19
Purchase, 1923

Snow-capped River, c. 1910
Oil on canvas, 45^1/$_4$ × 63^1/$_4$
Purchase, 1911*

Albert Besnard (1849–1934), French
Three Decorative Panels, c. 1895
Oil on canvas, 122^1/$_4$ × 26^1/$_2$, 122^1/$_4$ × 28^1/$_4$, 113^{15}/$_{16}$ × 51^3/$_4$
Purchase, 1910; deaccessioned c. 1972
Gift of Beatrice Hood Stroup, 1984 and 1986

François Bonvin (1817–87), French
Interior, with a Woman Sewing, 1880
Oil on canvas, 22 × 18
Purchase, 1911

George Boughton (1834–1905), English
Early Cottage Interior
Watercolor and gouache over charcoal on paper, sight:
9^3/$_8$ × 6^3/$_8$
Purchase, 1907

The Overflow
Watercolor and gouache over charcoal on paper, sight:
8^7/$_{16}$ × 11^7/$_8$
Purchase, 1907

The Skipper Garden, St. Ives
Watercolor and gouache on brown paper, sight:
11^{15}/$_{16}$ × 17^3/$_4$
Purchase, 1907

Olga Boznanska (1865–1942), Polish
Jeune Homme avec chemise rose, 1898
Oil on illustration board, 35^1/$_2$ × 30
Purchase, 1910*

Frank Brangwyn (1867–1956), English
Spanish Fisherman, 1895
Oil on canvas, 40^1/$_2$ × 50
Purchase, 1911

Alexander Stirling Calder (1870–1945), American
Scratching Her Heel
Bronze, 11^3/$_4$ high, including base
Purchase, 1921

Henri Caro-Delvaille (1876–1928), French
La Toilette d'Herminie, 1906
Oil on canvas, 58^1/$_4$ × 41^3/$_4$
Purchase, 1910*

William Merritt Chase (1849–1916), American
October
Pastel on primed, lightweight canvas,
sight: 16^7/$_8$ × 23^3/$_{16}$
Purchase, 1917

Charles Daubigny (1817–78), French
Farm Yard Scene
Ink on paper, sight: 8^3/$_8$ × 13^1/$_4$
Gift of Gari Melchers, 1926

Henry Golden Dearth (1864–1918), American
Ice Boats on the Hudson, c. 1890–1900
Oil on canvas, 18 × 29¹/₈
Gift of Gari Melchers, 1908

Albert Engstfeld (1876–?), German
Church Interior, Saint Anne Sluis
Oil on canvas, 24⁵/₈ × 22¹/₂
Purchase, 1912

Frederick Frieseke (1874–1939), American
Marcelle, c. 1905–1908
Oil on canvas, 32¹/₄ × 25³/₄
Purchase, 1910*

The Hammock, c. 1915
Oil on canvas, 38¹/₂ × 51¹/₂
Purchase, 1917

Raoul du Gardier (1871–1952), German
Calme Blanc, c. 1905–1908
Oil on canvas, 55³/₄ × 78
Purchase, 1909

Eduard von Gebhardt (1838–1925), German
Head of a Young Woman
Oil on canvas, 15³/₈ × 12¹/₄
Purchase, 1916⁺

Constantin Guys (1805–92), French
In the Café
Ink wash over graphite on paper, 11 × 8¹/₂
Gift of Gari Melchers, 1926

Theodor Hagen (1842–1919), German
Abend in den Feldern, c. 1895
Oil on canvas, 23³/₈ × 34
Purchase, 1912

Childe Hassam (1859–1935), American
Brooklyn Bridge in Winter, 1904
Oil on canvas, 30 × 34¹/₁₆
Purchase, 1907

Charles W. Hawthorne (1872–1930), American
Boy's Head
Oil on canvas, 21⁷/₈ × 18
Purchase, 1921

Robert Henri (1865–1929), American
La Madrileñita, c. 1910
Oil on canvas, 40⁷/₈ × 33
Purchase, 1919*

Hans Herrmann (1858–1942), German
Amsterdam, c. 1900–10
Oil on canvas, 36¹/₂ × 26¹/₂
Purchase, 1910*

George Hitchcock (1850–1913), American
Early Spring in Holland, c. 1890–1905
Oil on canvas, 35⁷/₈ × 51¹/₈
Purchase (from Henriette [Hitchcock] Lewis-Hind), 1907
Blue Door
Watercolor and gouache over graphite on paper, sight:
12⁷/₈ × 9⁵/₈
Gift of Gari Melchers, 1911

Cottage Doorway
Watercolor and gouache over graphite on paper, sight:
12⁷/₈ × 9⁵/₈
Gift of Gari Melchers, 1911

Felicie Waldo Howell (1897–1956), American
The Flower Woman
Gouache on paper, 14¹/₁₆ × 12³/₁₆
Purchase, 1921

Gotthardt Kuehl (1850–1915), German
Apfelessendes Mädchen, c. 1900–10
Oil on panel, 24 × 19
Purchase, 1912

Gaston La Touche (1854–1913), French
Ballet Dancers
Pastel on canvas, 29³/₄ × 31¹/₂
Purchase, 1907*

View of the Eiffel Tower from the Trocadero
Oil on canvas, 29¹/₂ × 31¹/₂
Purchase, 1914

Ernest Lawson (1873–1939), Canadian
Stuyvesant Square in Winter, c. 1900–1905
Oil on canvas, 25¹/₈ × 30¹/₈
Purchase, 1907

Hayley Lever (1876–1958), American,
born Australia
Gloucester
Oil on canvas, 25¹/₂ × 30³/₈
Purchase, 1924

Harbor
Oil on paper, 12¹/₄ × 16
Purchase, 1924

Landscape
Watercolor over graphite on paper, sight:
9¹/₈ × 12¹⁵/₁₆
Purchase, 1924

Raphael Lewisohn (1863–1923), German
Pasturage in the Dunes, 1905
Oil on canvas, 45⁵/₈ × 35¹/₄
Purchase, 1907

Jonas Lie (1880–1940), American, born Norway
Sunlight
Medium and dimensions unavailable
Purchase, 1926; exchanged, 1931

Walter MacEwen (1860–1943), American
Belle of 1810, c. 1900
Oil on canvas, 45⁵/₈ × 35¹/₄
Purchase, 1907*

Henri-Jean Guillaume Martin (1860–1943), French
Puy l'Evêque
Oil on canvas, 33¹/₂ × 42³/₁₆
Purchase, 1914

Tête d'une fillette
Oil on panel, 21¹¹/₁₆ × 17¹/₂
Purchase, 1914

Study for *La Travail*
Oil (support unknown), 29¹/₂ × 9¹/₂
Purchase, 1914*; location unknown

Willard Leroy Metcalf (1858–1925), American
Buttercup Field
Oil on canvas, 26¹/₈ × 29¹/₈
Purchase, 1926

Jerome Myers (1867–1940), American
Calico Sellers, 1909
Oil on canvas, 16 × 22
Purchase, 1921

Ernest Noir (1864–1931), French
View of Paris, 1908
Oil on canvas, 65 × 194¹/₂
Purchase, 1909*

Ernst Oppler (1867–1923), German
Tennis in den Dunen, 1909
Oil on canvas, 17¹³/₁₆ × 21³/₄
Purchase, 1916⁺

Joseph Pennell (1860–1926), American
Untitled (cityscape), 1914
Watercolor and gouache on paper, sight: 8³/₁₆ × 10³/₈
Purchase, 1924

Van Dearing Perrine (1869–1955), American
Storm-swept Landscape
Pastel on black paper, sight: 11¹¹/₁₆ × 13⁷/₈
Purchase, 1926

Pierre Puvis de Chavannes (1824–98), French
Head of Saint John the Baptist
Oil on canvas, 23 × 22
Purchase, 1909; deaccessioned 1975

Edmund T. Quinn (1868–1929), American
Self-portrait, 1925
Pencil on paper, sight: 8³/₄ × 6¹/₂
Purchase, 1926

Jean-François Raffaelli (1850–1924), French
La Demoiselle d'honneur, c. 1901
Oil on canvas, 99 × 45³/₈
Purchase, 1910*
La Seine à Billancourt
Oil on canvas, 20¹/₈ × 29¹/₄
Purchase, 1910*

Edward Redfield (1869–1965), American
The Brook in Winter
Oil on canvas, 36¹/₂ × 60¹/₂
Purchase, 1907; exchanged for *Center Bridge in Winter*, 1920
Center Bridge in Winter, c. 1910–20
Oil on canvas, 37¹/₄ × 50¹/₂
Purchase and exchange of *The Brook in Winter*, 1920*

Alfred-Philippe Roll (1846–1919), French
Felix Faure and His Grandson, c. 1895–99
Oil on canvas, 26³/₈ × 31
Gift of George J. Baldwin, Alexander R. Lawton, William W. Mackall, and J. Florance Minis, 1907*
Admiral Krantz, c. 1889
Oil on canvas, 29 × 23¹/₁₆
Purchase, 1910*

George Sauter (1866–1935), German
Frost und Nebel, 1907
Oil on canvas, 24¹/₄ × 32¹/₂
Purchase, 1916⁺

James Jebusa Shannon (1862–1923), American
Sketch for a Portrait of a Lady
Oil on board, sight: 28¹/₈ × 14⁷/₈
Gift of George J. Baldwin, Alexander R. Lawton, William W. Mackall, and J. Florance Minis, 1907
George Hitchcock, c. 1891
Oil on canvas, 51 × 34⁷/₈
Purchase (from Henriette [Hitchcock] Lewis-Hind), 1909

Alfred Smith (1854–1936), French
Le Déjeuner sous les bois, 1903
Oil on canvas, 47¹/₂ × 59¹/₂
Gift of George J. Baldwin, Alexander R. Lawton, William W. Mackall, and J. Florance Minis, 1907
Bordeaux, vu du pont, journée d'hiver, 1904
Oil on canvas, 59¹/₄ × 87¹/₄
Purchase, 1908*

Alfred Emile Leopold Stevens (1823–1906), Belgian
Regatta Day at Menton, 1894
Oil on canvas, 32¹/₄ × 26
Purchase, 1916⁺

Julius L. Stewart (1855–1919), American
Venetian Girl, 1909
Oil on canvas, 25³/₈ × 20¹¹/₁₆
Purchase, 1910
Intimate, 1897
Oil on panel, 31³/₈ × 39³/₈
Gift of the estate of Julius L. Stewart

James-Jacques-Joseph Tissot (1836–1902), French
Untitled (sketches of two women)
Ink and gouache over graphite on paper, left: 10¹/₈ × 6; right: 10¹/₈ × 11
Gift of Gari Melchers, 1926

Jan T. Toorop (1858–1928), Dutch
De Gauwdief (The Pickpocket), 1884
Oil on canvas, 35¹/₂ × 63
Purchase, 1915

Emile Louis Vernier (1829–87), French
The Harbor, c. 1880
Oil on canvas, 16⁹/₁₆ × 27¹/₂
Purchase, 1907

Charles Herbert Woodbury (1864–1940), American
A Northeaster
Watercolor over graphite on paper, sight: 16¹/₂ × 20¹/₂
Purchase, 1907

Mahonri Young (1877–1957), American
Rolling His Own, 1924
Bronze, 12¹/₂ high
Purchase, 1925

* Purchased from the artist
⁺ Purchased from the estate of Hugo Reisinger

BELMONT: THE GARI MELCHERS MEMORIAL GALLERY

RICHARD S. REID

▼

When Gari Melchers left Europe to return permanently to America in 1915, he established himself in a studio in New York City and sought a rural retreat that would inspire his creative work. He found that retreat in 1916 in Belmont, a small estate in Falmouth on the north bank of the Rappahannock River across from Fredericksburg, Virginia. During the last sixteen years of his life, Melchers lived and painted at Belmont when not working at his New York studio.

Gari and Corinne, his beloved wife, created at Belmont a warm home of which they were justly proud. Both were active in local affairs and eventually served their adopted state by promoting a greater appreciation for the fine arts. Melchers left Belmont to Corinne when he died in 1932, and she, in turn, deeded the estate to the commonwealth of Virginia, to which it reverted on her death in 1955. In recent years, according to the desires of its donor, Belmont has evolved into a memorial museum representing the work of Gari Melchers and his way of life in the 1920s.

Corinne Lawton Mackall, born in Savannah in 1880, was the daughter of Leonard L. Mackall, of Baltimore and Calvert County, Maryland, and Louisa Lawton Mackall of Savannah. In 1902, then an art student at the Maryland Institute of Art in Baltimore, Corinne accompanied her mother and younger brother to Europe to tour museums and to further her art education in Paris. On board the S.S. *Aller*, en route from New York to Naples, Corinne met Gari Melchers. Their shipboard romance continued during the summer at Egmond aan Zee, where Corinne took art lessons from George Hitchcock. In October Corinne and her family left Egmond for Paris—where she eventually enrolled at the Académie Julian—but Melchers pursued her, and on December 28 the two became engaged.[1] In April 1903, at Saint Brelades Church on the Isle of Jersey, they were married, just a year after they had met. After a honeymoon in Paris, Berlin, and Düsseldorf, the newlyweds set up housekeeping in Egmond aan den Hoef, in a rented farm cottage on School Street, which they would purchase in 1906 (fig. 69).

Corinne Mackall was never optimistic about her own abilities as an artist. Perhaps with excessive modesty, she confided to her diary in 1902 that George

Hitchcock was much too flattering in his criticism of her efforts.[2] Although Corinne gave up her painting lessons after she married, in the 1920s she once again took up her brush and palette. Her efforts were rewarded by acceptance in the 1923 Corcoran Gallery of Art Biennial Exhibition of Area Artists.

As a newlywed living in a foreign country, Corinne quickly learned Dutch in order to direct her servants, deal with tradesmen, and take part in the social life of Egmond. On occasion she joined Gari in Paris, meeting his fellow artists and patrons. She wrote to her mother in 1904, "Friday Gari's old countesse [sic] had us in her box at the opera to see a new piece.... Besides us there were present the Chief Justice of France and some ... Russian creature."[3] When they moved to Germany in 1909 Corinne learned German, and they entertained officials of the court of the grand duke of Saxe-Weimar-Eisenach and members of the Weimar art community.

Gari and Corinne were a devoted couple. In a letter to his fiancée just before their marriage, Gari wrote, "Hopkinson Smith [the American artist] once said 'it takes two to paint a picture, one to paint it and the other fellow to hit him over the head with a club when it's time to stop' and in the future you will have to be that other fellow."[4] As a model for Gari, Corinne appeared in a Dutch Brabant costume in *La Brabançonne* (fig. 16), in an elaborate blue satin dress in a bust-length portrait (pl. 17; cat. no. 35), and in a full-length portrait (Detroit Athletic Club) painted in 1904–1905. It is Corinne who is seated, embroidering, in *Penelope* (pl. 21; cat. no. 42), and she is the seated figure in *At Home* (also called *The Winged Victory*) (fig. 18). Although many of these works were painted in the first decade of their marriage, Corinne continued to pose for Melchers after they moved to Belmont; he painted her in the drawing room in *Young Woman Sewing* (pl. 25; cat. no. 48), and in one of his 1923 mural decorations for the Missouri state capitol, she posed for the figure of Susan Blow, the pioneering founder of kindergartens in Missouri. Besides modeling for Melchers, Corinne performed numerous tasks related to his painting. She sewed costumes for his mural paintings, worked in the studio squaring canvases, took care of child models, acted as chauffeur for local posers, and helped him to write the introduction for John Beatty's book, *The Relation of Art to Nature*.[5]

The only sadness in their marriage was that they could not have children. In Egmond Corinne had organized Christmas parties for the children of the town, and at Belmont she held annual Easter egg hunts. Melchers showed a deep appreciation for motherhood and tender feelings for infants, achieving a wide reputation for his mother and child paintings, which he created as early as the 1890s and for the rest of his career. He also painted commissioned portraits of young children in both Europe and America.

Gari and Corinne returned to the United States from Europe in the summer of 1915, when the war made it difficult for him to continue as a professor of painting at the Grand Ducal Academy of Fine Arts in Weimar. Arriving in New York late in August, the couple traveled to Detroit where they stayed for a few months. There Gari settled the estate of his widowed mother, who had died while the two were en route home. Eventually, he rented a New York studio in the Beaux Arts

Building at 80 West Fortieth Street, opposite the New York Public Library and Bryant Park.

Seeking a home in a more hospitable climate than that of New York, and feeling the need for a rural retreat, Melchers followed a recommendation of a Detroit friend, Frank Baldwin, then serving as chairman of the American Institute of Architects and living in Fredericksburg. Baldwin told Melchers about Belmont, an estate on the Rappahannock River that had been developed around a house built in the late eighteenth century. Although somewhat dilapidated, the Georgian mansion, with its high-ceilinged rooms, had possibilities. In September 1916 Gari and Corinne purchased Belmont, their first and only home in America.

The couple set out to improve their new home to the extent permitted by the uncertainty of their finances during the war. They had the house rewired and installed a modern heating plant. After the war, with his income bolstered by commissions from murals for the Detroit Public Library and the Missouri state capitol, more improvements were made. A sun porch was added, and this pleasant room became the focus of their daily living during warm weather. A large two-story European-style barn was built, about which Melchers wrote to Corinne, "It must be as big as a country church."[6]

In 1923 Melchers built the fieldstone studio in which he would paint until his death in 1932 (fig. 64). Designed by a Detroit friend, the architect John Donaldson, the studio consisted of a large workroom with a north window, a gallery room, and a storage room. The building was enlarged soon after its completion and again after Melchers's death to allow for additional exhibition space. A sandstone gazebo was built in 1932, after Corinne was inspired by one she had seen on a visit to Mount Vernon.

Until 1922 Belmont was furnished largely with furniture inherited from Gari and Corinne's families, and by purchases made in New York, Washington D.C., and Fredericksburg. Gari had begun collecting furniture and china for their Egmond home even before they were married, and the two continued to acquire rare antiques during their residences and travels abroad.[7] The furnishings of their former home in Egmond and of the rented house in Weimar had been placed in storage in 1915, where they remained until Gari and Corinne retrieved them in 1922. With these additions Corinne was able to decorate the house in a manner that displayed their collections and reflected her eclectic taste.

The paintings hung at Belmont in the 1920s included a large work in the dining room, *A Market Scene in Haarlem*, by the Flemish painter Frans Snyders, purchased by Melchers in New York in the early 1920s. Other paintings in the collection included an exquisite small still life by the Dutch artist Balthasar van der Ast, and a Gainsborough-like portrait by that artist's nephew, Gainsborough Dupont. Berthe Morisot was represented by a charming small painting from 1877 of a boating party at Argenteuil. Other Dutch painters collected by Melchers included the Hague School artists Jozef Israëls, Anton Mauve, and Johannes Bosboom. Melchers also acquired a large number of late eighteenth-century and

Fig. 64. Belmont, the house and fieldstone studio in spring.

early nineteenth-century Japanese woodblock prints in Paris as well as three posters by Toulouse-Lautrec.

While living in Europe, Melchers purchased paintings for the Telfair Academy of Arts and Sciences in Savannah, and assisted American collectors such as Mrs. Potter Palmer, General Rush Hawkins, who was to create the Annmary Brown Memorial Library at Brown University, and Mrs. Edward C. Walker, who left a number of works to the Corcoran Gallery of Art. During these forays into the European art markets, Melchers bought works for his own collection from his contemporaries, including the Americans George Hitchcock and Walter MacEwen and the French artists Puvis de Chavannes and Gustave Boulanger, one of his teachers at the Académie Julian. German artists collected by Melchers included two former classmates at Düsseldorf, Fritz Strobentz and Heinrich Heimes, and the court painter to von Hindenburg, Hugo Vogel.

Corinne Melchers's collection of porcelain and china assembled at Belmont contained some exceptional pieces, such as early Wedgwood, Chinese export ware, Staffordshire and Leedsware, and Delftware. She had inherited several miniatures painted on ivory, including two painted by Raphaelle Peale.[8]

With their possessions installed, Belmont took on the appearance of a small museum, but retained a comfortable, homelike atmosphere. In 1928 the popular national magazine *Town and Country* devoted a five-page pictorial article to their collection.[9]

Melchers led a busy social life in New York. His work there was concentrated on portraits of the well-to-do and famous with occasional uncommissioned works. An academician of the National Academy of Design and a member of the American Academy of Arts and Letters, he was also active in his social clubs, the Century, the Links, and the Coffee House. As chairman for many years of the New Society of Artists, he presided over annual exhibitions and many social functions. He enjoyed the opera and theater, and when presented to the famous singer Dame Nellie Melba, he wrote to Corinne, "I told her that I had the pleasure of seeing her at her debut at the Théâtre de la Monnaire [*sic*] in Bruxelles—and she

Fig. 65. Gari and Corinne Melchers at Belmont, c. 1921.

said 'please don't say how long ago' and was most cordial to me."[10] Corinne joined Gari in New York for important exhibition openings and for social events. She was a member of the Metropolitan Club, and because Gari's studio apartment was short of sleeping space, the club became her home away from home in New York.

Despite his active artistic and social life in New York, Melchers retained his love for and interest in Belmont as a home, a place to work, and a working farm (fig. 65). He supervised the construction of his new studio in 1923 and essayed the role of gentleman farmer, tending his favorite strawberry beds and prize turkeys.[11] In 1922 Melchers was host at Belmont to Vice President Coolidge and in the following year to Britain's former Prime Minister Lloyd George, during their visits to Fredericksburg.

At Belmont Melchers worked on portrait commissions and genre paintings of the area and its residents. *Saint George's Church* (cat. no. 50), *Commerce Street*, *Nelson Berry's Store*, *Early Spring Landscape* (pl. 23; cat. no. 45), *Stafford Heights*, and *In Old Virginia* (all Belmont) made these scenes familiar to gallerygoers throughout America. The loose brushwork and vital local color of these later paintings would enhance Melchers's position as an American Impressionist.

In addition to his paintings of Corinne, Melchers depicted a number of area residents. *Native of Virginia* shows Mrs. Annie DeShields of Garrisonville, one of his favorite models, in her work clothes with a grub hoe in hand, standing beside her harvested garden produce. Melchers's caretaker, Mason Dillon, posed for characters in the murals for the Detroit Public Library and for two hunting pictures, *The Hunters* (pl. 28; cat. no. 54) and *Pot Hunters*, and modeled in the local genre scene *Tonsorial Parlor* (Belmont), painted late in Melchers's career.

Melchers also resumed his series of mother and child paintings. Julia Payne, a Falmouth neighbor, and her first son, Ivan, posed for several of these, including *Julia and Ivan* (Belmont) and *Mother and Child* (National Museum of American Art). His painting *Madonna of the Rappahannock* (cat. no. 53) combined the theme of maternity with the local landscape of the Rappahannock River Valley as it appears from Belmont.

Melchers's residence in Virginia enabled him to serve on commissions in Washington and Richmond. In 1923 he succeeded Daniel Chester French as the chairman of the Smithsonian Commission to Establish a National Gallery of Art, presently the National Museum of American Art. In this capacity he was instrumental in securing for the nation the extensive collection of antiquities and American art accumulated by John Gellatly. Melchers also worked closely with his friend C. Powell Minnegerode, director of the Corcoran Gallery of Art, advising on technical matters and on purchases. He used a studio in the Corcoran Gallery when he painted a portrait of Andrew Mellon, then Secretary of the Treasury. In 1932 Melchers became a trustee of the Corcoran. As a member of the Virginia Arts Commission, Melchers became involved in the 1932 redecoration of the Virginia capitol and the completion of its statuary hall.

Returning home from an exhausting stay in New York, where he had supervised the hanging of a large retrospective exhibition of his work at the American Academy of Arts and Letters, Melchers became ill and died on November 30, 1932. His death was mourned by family and friends in America and in Europe and noted in a three-column obituary in the *New York Times*.[12]

From the time of their marriage in 1903, Corinne Melchers had been the artist's devoted helpmate. On Gari's death she protected his reputation and perpetuated his memory in the art world and in the art markets that were then turning to abstract painting. As executrix of his estate, she closed his New York studio, bringing the greater part of his work to Belmont. She continued to sell his paintings whenever possible and on at least one occasion bought one back at auction. In the 1930s Corinne lent paintings for memorial exhibitions held in Baltimore, Grand Rapids, Pittsburgh, Richmond, Savannah, and Washington, D.C. She took great pride in sharing with appreciative visitors to Belmont the large collection of Melchers's paintings displayed in the artist's studio.

Corinne completed Melchers's unfinished term on the Virginia Arts Commission, serving actively during the organization of the Virginia Museum of Fine Arts. On the opening of the museum in 1935, she became a trustee and served faithfully in that capacity—particularly on the accessions committee—until the early 1950s, when failing health limited her activities.

The Virginia Museum's memorial exhibition in 1938 led to Mrs. Melchers's determination to deed the Belmont estate and its collection to the museum as a gift. This was first discussed with the director of the Virginia Museum, the late Thomas Colt. With the enthusiastic concurrence of family, friends, and the recipients, a deeded gift of Belmont to the commonwealth of Virginia was accepted by the Virginia General Assembly in 1942, allowing Mrs. Melchers a life interest and occupancy of the estate.[13] According to her will, Belmont was to become a public memorial to her late husband, administered for the state by the Virginia Museum of Fine Arts, a state-supported institution.

After Corinne Melchers died in 1955, a committee for Belmont was established by the board of the museum, and plans were initiated for opening the house and studio to the public on a limited basis. In 1957 a survey of the condition of the main house found that considerable repairs would be needed before the house could be opened. The Belmont committee considered that the supervision of such

work would be beyond the capacity of the limited museum staff; furthermore, the governor had set a ceiling on the amount of state funds to be spent on the house. Thus, when the chancellor of Mary Washington College in Fredericksburg, a branch of the University of Virginia, offered to administer Belmont and to carry out necessary repairs, steps were taken to effect the transfer from the trustees of the museum to the Board of Visitors of the University of Virginia, which was completed by appropriate legislation and by court approval in 1960.[14] The major repairs to the house were made during the intervening period.

During the 1960s Belmont was not available to the general public; in 1974 the Board of Visitors of Mary Washington College, dissatisfied with the situation, directed the newly appointed college president to take steps to open the house and studio on a limited basis. In mid-1975 a full-time director was appointed, and in October of that year Belmont was opened to the public regularly for the first time, some twenty years after the death of Corinne Melchers.

Activities at the museum were increasingly professionalized. Volunteers from local communities were trained to serve as docents, a painting conservation program was implemented, improved security systems were installed in the studio and main house, cataloguing was begun on the collections of Melchers's works and on the works of other artists at Belmont, an inventory of the household furnishings was made, and an educational program of special exhibits, lectures, and films was developed.

Corinne Melchers's will provided that a permanent collection of Melchers's paintings, together with certain portfolios, sketches, and drawings, should be retained at Belmont. After a permanent collection was designated by the Board of Visitors of the college in 1976, a limited number of Melchers's paintings and drawings were offered for sale in 1977–78 to relieve crowded storage conditions and to reduce conservation costs. The proceeds were added to the endowment that had been established by Corinne Melchers. As a result of the sale, offered in part at Belmont and through the Graham Gallery in New York, public awareness of and interest in the work of Gari Melchers increased measurably.

In 1983 a second full-time museum professional was appointed to provide an improved educational program and to continue the important and demanding task of cataloguing the collections. In 1985 Belmont was granted accreditation by the American Association of Museums. Currently a comprehensive preservation project is under way to stabilize the structure of the main house, to redecorate and conserve the interior of the house and its furnishings, and to install climate control and further protect the collections.

With its programs and exhibits Belmont has become a valued educational institution within the local community. It also attracts visitors to Fredericksburg, bringing to the area those special tourists—scholars, students, art collectors, and art lovers—who are particularly interested in Gari Melchers's art. The collections of fine and decorative arts and the correspondence of the artist and his wife have been used by art history students from around the nation and have become an important adjunct to Mary Washington College's Art Department and its Center for Historic Preservation.

Belmont serves today as a memorial to Gari Melchers, presenting the 1920s life-style of this successful artist and his devoted wife. Finally, Belmont serves as a permanent reminder of the generosity of its donor and principal benefactor, Corinne Melchers.

Richard S. Reid is the former director of Belmont, The Gari Melchers Memorial Gallery, and editor of Gari Melchers: His Works in the Belmont Collection, *1984.*

NOTES

1. Letter, Corinne Mackall to Mrs. Louisa Mackall, January 3, 1903, Belmont archives.

2. Diary, Corinne Mackall, 1902, Belmont archives.

3. Letter, Corinne Melchers to Louisa Mackall, April 26, 1904, Belmont archives.

4. Letter, Melchers to Corinne Mackall, 1903, Belmont archives. F. Hopkinson Smith was an American artist and lecturer on art subjects. Born in 1838, he was of the generation preceding Melchers, but the two shared exhibitions in the early 1900s and were fellow members of the American Academy of Arts and Letters.

5. John W. Beatty, *The Relation of Art to Nature*, introduction by Gari Melchers (New York: W. E. Rudge, 1922). Diary entries by Corinne Melchers for December 29, 1921, and January 3, 1922, mention work on the Beatty introduction, which she and Gari finished together. Belmont archives.

6. Letter, Melchers to Corinne Melchers, 1918, Belmont archives.

7. The house in Egmond was completely furnished when they rented in Weimar in 1909. For that residence Corinne found pieces she considered suitable to Gari's position as a professor of painting. She purchased an inlaid German cabinet said to have belonged to a grand duke of Saxe-Weimar-Eisenach, as well as several chairs and chests in the Biedermeier style. In Weimar Corinne found an old Dutch secretary. She wrote about it to her mother in 1909: "I must do a great deal more sitting at my beautiful new desk. It's a beauty, and has a thousand drawers and pigeonholes, so I can't have any excuse for misplacing things" (Belmont archives). She hired a furniture maker to make two four-poster canopy beds with an urn motif on the headboards and posters, and embellished her dining room with an old pedestal table, two matching armchairs, and ten unmatched nineteenth-century side chairs. All this—and more—was moved to Belmont late in 1922.

8. *An Exhibition of Virginia Miniatures, December 3, 1941–January 5, 1942* (Richmond: Virginia Museum of Fine Arts), p. 26.

9. Augusta Owen Patterson, "The Virginia Home of Mr. Gari Melchers," *Town and Country,* June 15, 1928, p. 45.

10. Letter, Melchers to Corinne Melchers, January 17, 1918, Belmont archives.

11. Taped interview with George Payne, Falmouth, Virginia, February 25, 1977, by Daphne Forbes, Mary Washington College. Belmont archives.

12. Nicholas Murray Butler and Robert Underwood Johnson, president and secretary, respectively, of the American Academy of Arts and Letters in their cable to Mrs. Melchers said, "His fame, so well proclaimed by the present exhibition in our galleries, will be cherished and his loss deplored." Cass Gilbert, the architect, wrote, "Melchers's ... position in the arts has been recognized in Europe and in America for many years as preeminent. He was a man of ... a genial and generous nature, ... broad in his views and sympathetic, particularly in regard to the work of other artists." Artist John Sloan wrote, "There was a man who, in his work, was as young as ever....The youthful vigor of discovery was apparent in all the work he had been doing recently." Childe Hassam said, "The sudden death of my old friend and confrere ... ends a friendship of fifty years— we met in Paris in our student days—and a half century of modern art history. He was always the sound craftsman and a firm believer in an academic training—I use this term in the best sense—and the study of the masters, old and new." Edward Alden Jewell, "Gari Melchers, Noted Artist, Dead," *New York Times,* December 1, 1932.

13. Virginia Senate Bill No. 217, February 19, 1942.

14. Circuit Court, City of Richmond, Deed Book 125, p. 235. Agreement No. 138, July 29, 1960. Agreement between Board of Trustees of the Virginia Museum of Fine Arts and The Rector and Visitors of the University of Virginia.

Egmond Remembers Gari Melchers

RONALD VAN VLEUTEN

▼

Three villages, all sharing the name Egmond, lie clustered along the shore of the North Sea. All are ancient: Egmond Binnen (inner) and Egmond aan Zee (on the sea) are a thousand years old; Egmond aan den Hoef (on the hoof) originated in the Middle Ages around a castle that ranked among the largest in the country. Through the centuries little changed in the villages. The people were poor, dependent on farming and fishing for a meager living; poaching and plundering shipwrecks, although illegal, made occasional additions to a family's income.

In the early 1880s the villagers began to see great changes. Tourists came, and hotels were built. Egmond aan Zee developed into a seashore resort (fig. 66). Above all, artists were attracted to the area, and their presence made an impact on the residents. An American painter, George Hitchcock, arrived in Egmond in 1884. He fell in love with its colors, its light, and, as he said, its "pictorial element"—the sea, with its "chiefest charm," the atmosphere. Hitchcock was the forerunner of an American artist colony that grew there.

Until April 1979 I had known little about the early artists who had settled in Egmond. I knew George Hitchcock had lived in our house, Schuylenburg (fig. 67), in which he also had his studio, and that he had given painting lessons as well as exuberant parties. I also knew that among the earliest arrivals was Gari Melchers, who came in 1884 and for most of the next twenty-five years maintained a home and studio in Egmond.

It all began with a phone call from Lucas Hikke, sexton of the Protestant church in Egmond aan den Hoef. He asked whether I had ever heard of an American painter named Melchers who had lived in my house. He went on to explain that an American couple had stopped by his door to ask about Melchers. They were photographers and were collecting information about the painter for the Gari Melchers Memorial Gallery in Virginia. Could they come and see me? Although I didn't think I could be of much assistance, I said they were nonetheless welcome.

Minutes later Theresa and Don Schlachter stood before me, holding out a brochure. It contained black and white reproductions of paintings, one of which showed two women in front of a fireplace and mantel (fig. 18). To our surprise,

Fig. 66. Egmond aan Zee, 1895.

Fig. 67. Schuylenburg, c. 1900, Egmond aan den Hoef, The Netherlands,
former home of George Hitchcock.

they were posed in our living room. The photo was the beginning of what was to
be a long journey of discovery.

Melchers had never lived in Schuylenburg—of that I was sure, but the story
begins there. When Hitchcock bought the property in 1891, it was the first time
in over two hundred years that it had been sold out of my family. Not until 1934
did my grandfather buy back the house. In the 1960s, when my father moved
into the house, it was his intention to research the years in which Hitchcock had
lived there. Among his files I found a note: "Find out more about Hitchcock and
Melchers." It was this file of papers, clippings, and other documents that my wife
remembered and brought out when we spent an evening with the Schlachters.

Gari Melchers arrived soon after Hitchcock had settled in the village, and
for a time the two artists shared a studio and living quarters on the top of a dune
(fig. 68). Melchers also stayed at the Bult inn and used its "blue room" as a stu-
dio. When Hitchcock bought Schuylenburg, both artists worked there as well.
After their marriage in 1903, Gari and Corinne Melchers settled into a beautiful
old farmhouse in School Street, where he established his own studio (fig. 69).

Fig. 68. Melchers and Hitchcock at their studio on the dunes,
Egmond aan Zee, 1884.

In all anecdotes but one Melchers is described as an extremely kind and generous man who made many friends in the village. The exception is a story about Melchers's confrontation with a sailor in front of the Bult inn, where Melchers had set up his equipment. Leaving a painting on its easel, he went indoors for a few minutes. Soon after, some boys discovered the painting and were inspired to add a few touches of their own to the canvas. Taking in the disaster as soon as he came out, Melchers vented his rage on the first person he saw—a husky sailor who had nothing to do with the prank. Melchers was soon made aware of his mistake.

That both Melchers and his wife were remembered with affection long after they left Egmond, and indeed, long after Melchers's death, is exemplified by a visit to Mrs. Melchers at Belmont in 1941 made by Captain Blaauboer, a native of the Egmonds. She showed him her home and her husband's paintings, in which the captain recognized many friends and neighbors of his youth. Blaauboer later wrote to his father, telling how deeply moved he had been on seeing so many familiar faces so far from home. Reading the detailed descriptions of the paintings, with the names of the models and the comments of Corinne Melchers, led us to an idea: the Schlachters, after a visit to Paris, would return to Egmond, and in the meantime we would try to trace some of the people who would still remember Melchers and might even have posed for him.

The result was overwhelming: thanks to the enthusiastic participation of many people, Theresa and Don Schlachter were able to see and speak with more people than either they or we had dared to hope. There was, for example, Piet Rozing, who as a young man drove Melchers in a tilbury from the inn to the studio at Schuylenburg and back again in the evening. Seated next to Piet on the box

Fig. 69. School Street residence of Gari and
Corinne Melchers, Egmond aan den Hoef.

sat a shy peasant girl who served as a model, clutching a bouquet of flowers in her
little hands. Old Freek de Goede remembered that the compensation for children
who modeled was a chocolate bar. And there was Willem Wittebrood, who still
lived by himself in the old family farmhouse. He too recalled Melchers, and was
still grateful to him for his gift of a good-as-new suit when Melchers came to say
good-bye more than sixty years ago.

This "oral history" procedure generated far more information than we had
anticipated. We decided to organize an exhibition that would comprise recollec-
tions of Egmond and its people, and photographs of paintings made by Melchers
during his Egmond years, with as many Egmond models as possible. The Schlach-
ters sent prints of the photos they had taken and Richard S. Reid, then director of
Belmont, provided us with additional illustrations and documentary material.

The exhibition, a resounding success, was held in the Egmond community
hall in 1980. More than six hundred attended, and we were able to tape a great
deal of information—names, histories, and anecdotes. The exhibition catalogue's
introduction was devoted to Gari Melchers, with emphasis on his Egmond period.
Visitors, especially the older ones, crowded into the exhibition and held lively dis-
cussions over who was who. Memories were stirred, and favorite places described.
The Egmond of yesterday and the Egmonders of two or three generations ago came
to life once again.

The artists had had little need to search for acceptable locations or models.
The Protestant church, next to the old castle ruins and a favorite site of Melchers,
was just across the village street and opposite the Bult inn. For *The Wedding* (fig.
13), for instance, Melchers had only to ask Mrs. Bult to play the bride and one of
the neighbors, Jan Schuit, to be the groom. We learned that although Melchers
was usually accurate in his painting, he did take artistic license, which was criti-
cized by some viewers at the exhibition. In *The Sermon* (pl. 2; cat. no. 11), painted
in the Protestant church of Egmond Binnen, the women were considered to be
underdressed because some were wearing only a lace cap instead of the bonnet that

was an obligatory part of Sunday dress. In another painting, *In Holland* (pl. 3; cat. no. 12), a woman carrying a yoke and milk buckets is wearing her best clothes, and this was deemed "preposterous." On the other hand, the blue interior of the buckets might seem too bright, but we were told this color was correct — it was intended to keep the flies away. Another woman bears a *kriel* on her back, a basket used to carry potatoes from the fields, dry wood from the dunes, or the wreckers' loot.

The casting of models for parts in a painting was not always without difficulty. Albert Wijker, who posed for several of Melchers's paintings, was asked to be the model for Christ in *The Last Supper* (fig. 8). Wijker felt obliged to refuse on the grounds that, as a poacher, he was not worthy to pose for the Christ figure. "Fine," said Melchers, "then you can be Judas!"

During the exhibition we heard many stories — sad, poignant, funny, and surprising. But all gave evidence of the affection and respect that everyone felt for Gari and Corinne Melchers. Gari was nicknamed Malle Melsie; Malle means odd or funny, but it was spoken with affection. Nor did the Melcherses forget their friends in Egmond after they returned to the United States. Their interest can be seen in Gari's paintings, in the diaries and letters of Corinne, and in her relief packages sent to Egmond immediately after the Second World War. In the old Bult inn, where the blue room is still intact, there hangs a portrait of Grandma Sijtje which Melchers gave to the family to mark his long friendship with them.

So the memory of the artist is preserved in Egmond — Gari Melchers, who lived among the Egmonders longer than all other American artists, and who was the most beloved.

Ronald van Vleuten, formerly a lecturer on marketing and public relations at the Reinwardt Academy of Museology in Leiden, is a freelance marketing consultant for museums.

CATALOGUE OF THE EXHIBITION

JOANNA D. CATRON

1. WINTER LANDSCAPE WITH FIGURES, 1876

Oil on wood panel, 14 × 24
Signed and dated lower right: *J. G. Melchers./1876*
Belmont 1798

PROVENANCE
Gift to Belmont from John W. Stroh, nephew of the artist, 1977

EXHIBITION HISTORY
1876 Detroit. Detroit Art Association, *First Exhibition*, February

Melchers was just sixteen when he painted this winter scene. Although little is known about the art instruction he received from his father, undoubtedly he studied classical and Old Master works through plaster casts and engravings.

Melchers used stock motifs—figures, wagons, cottages, and trees—to define a receding space, a standard compositional device that suggests *Winter Landscape with Figures* was copied after a European engraving.

All catalogue dimensions are in inches; height precedes width.

Joanna D. Catron, assistant director at Belmont, The Gari Melchers Memorial Gallery, is currently preparing a catalogue raisonné of the artist's work.

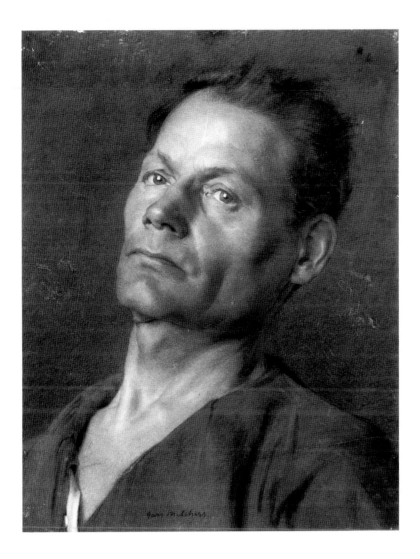

2. MAN'S HEAD, c. 1879

Charcoal and pencil on paper, 17½ × 14⅛
Signed lower center: *Gari Melchers*
Mrs. John W. Stroh

PROVENANCE
The artist's wife to Mr. and Mrs. John W. Stroh

EXHIBITION HISTORY
1932 New York. American Academy of Arts and Letters, *Exhibition of Paintings by Gari Melchers*,
November 10–May 1, 1933
1938 Richmond. Virginia Museum of Fine Arts, *Gari Melchers: A Memorial Exhibition of His Work*,
January 17–February 28
1960 Detroit. Detroit Institute of Arts, *Gari Melchers: A Centenary Exhibition*, February 16–
March 13

The first objective of Düsseldorf training was the production of solidly modeled, highly
finished drawings after nature. Legend has it that over the door to his first studio Melchers
nailed a sign bearing the inscription Waar en Klaar (True and Clear). The precisely realistic
Man's Head perfectly embodies that personal credo and the Düsseldorf tradition in general.

3. HEAD OF A BOY, c. 1880

Charcoal and stump on paper, 16¼ × 13
Signed lower left: *G. Melchers*.
The Corcoran Gallery of Art, Washington, D.C., museum purchase

PROVENANCE
Purchased from the artist

EXHIBITION HISTORY
1908 New York. Cottier and Company, *Gari Melchers*, January 28–February 21
1938 Baltimore. Baltimore Museum of Art, *The Last 100 Years in American Prints and Drawings*, n.d.
1949 Washington, D.C. Watkins Gallery, American University, *American Portraits*, March 6–April 13
1983 Washington, D.C. Corcoran Gallery of Art, *American Master Drawings from the Collection*, March 11–April 24

Head of a Boy, with its carefully controlled modeling and strict profile, is stylistically linked to a number of Melchers's student productions, suggesting a circa 1880 date.

Shown at the Museum of Fine Arts, St. Petersburg, the Detroit Institute of Arts, and the Virginia Museum of Fine Arts, Richmond.

4. MALE NUDE MODEL, 1881

Charcoal on paper, 24³/₈ × 17¹/₄
Signed and dated verso: *Melchers, eme/eleve de M. Lef. et Boulanger*
Belmont 265

PROVENANCE
Belmont, The Gari Melchers Memorial Gallery

Male Nude Model was Melchers's entry for the first part, "Drawing after Nature," of his entrance exam to the Ecole des Beaux-Arts. The inscription on the reverse of the picture indicates that he was one of at least two students to represent the Académie Julian under the tutelage of the famous Salon painters Jules Lefebvre and Gustave Boulanger.

5. KNEELING MONK IN A CHURCH, 1882

Oil on wood panel, 14 × 9¼
Signed and dated lower left: *Gari J. Melchers -82*
Belmont 980

PROVENANCE
Belmont, The Gari Melchers Memorial Gallery

EXHIBITION HISTORY
1983 Fredericksburg. Belmont, The Gari Melchers Memorial Gallery, *Gari Melchers, The Student Years*, November 30–January 30, 1984

Melchers spent the summer of 1882 painting in Italy with two fellow students from the Académie Julian. *Kneeling Monk in a Church* was produced while the young artist was staying in the Trappist monastery at Casamari.

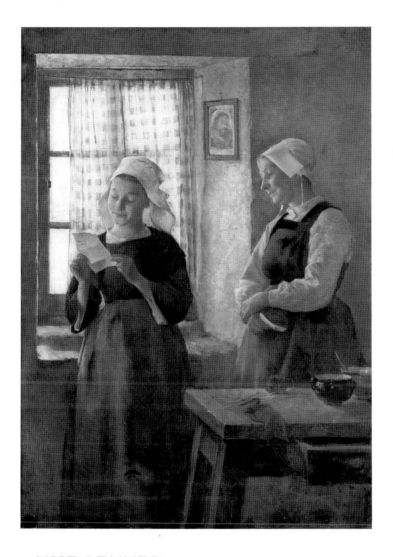

6. THE LETTER, 1882

Oil on canvas, 37¹/₄ × 26³/₈
Signed and dated lower right: *Gari J. Melchers./Paris. 1882*
The Corcoran Gallery of Art, Washington, D.C., Edward C. and Mary Walker Collection, 1937
Plate 1

PROVENANCE
The artist to Edward C. and Mary Walker (?)

EXHIBITION HISTORY
1882 Paris. *Salon de la Société des Artistes Français*, n.d.
 Antwerp. *Salon Triennal d'Anvers*, August 13–early October
1883 New York. National Academy of Design, *58th Annual Exhibition*, April 2–May 12
 Detroit. *Detroit Art Loan Exhibition,* September
1905 Detroit. Detroit Museum of Arts. *Exhibition of Paintings Lent by E. Chandler Walker*, April
1918 Washington, D.C. Corcoran Gallery of Art, *Paintings by Gari Melchers*, February 2–March 3
1919 Chicago. Art Institute of Chicago, *Paintings by Gari Melchers*, April 4–May 1
1923 Baltimore. Baltimore Museum of Art, *Paintings by Gari Melchers*, April 10–May 5
1930 Buffalo. Buffalo Fine Arts Academy/Albright Art Gallery, *Retrospective Exhibition of Paintings
 Representative of the Life Work of Gari Melchers*, February 2–March 2
 Rochester. Memorial Art Gallery of the University of Rochester, *Gari Melchers, N.A., Thomas
 J. Mitchell, and Thirty Cleveland Artists*, March–April
 Dayton. Dayton Art Institute, *Exhibition of Paintings by Gari Melchers*, April 15–May 15

1933 Washington, D.C. Corcoran Gallery of Art, *Memorial Exhibition of Paintings, Drawings, and Etchings by Gari Melchers*, October 21–December 3

1938 Richmond. Virginia Museum of Fine Arts, *Gari Melchers: A Memorial Exhibition of His Work*, January 17–February 28

1976 Dayton. Dayton Art Institute, *American Expatriate Painters of the Late-Nineteenth Century*, December 4–January 16, 1977

1977 Philadelphia. Pennsylvania Academy of the Fine Arts, *American Expatriate Painters of the Late-Nineteenth Century*, February 4–March 20

Los Angeles. Los Angeles County Museum of Art, *American Expatriate Painters of the Late-Nineteenth Century*, April 12–May 29

1982 Washington, D.C. Federal Reserve Board, *The Hague School and Its American Legacy*, April 19–June 11

West Palm Beach, Florida. Norton Gallery and School of Art, *The Hague School and Its American Legacy*, July 9–August

At the age of twenty-two, Melchers achieved international recognition when *The Letter* was accepted into the prestigious Paris Salon. The sound academic training he had received at Düsseldorf amply prepared him for his first Salon entry. Düsseldorf students were well grounded in the seventeenth-century Dutch tradition, and they frequently made group excursions to Holland to sketch and to study the Old Masters. Jan Vermeer was particularly revered, and Melchers's depiction of two peasant women standing at a sunlit interior window is strongly reminiscent of that master.

Shown only at the Virginia Museum of Fine Arts, Richmond.

7. PORTRAIT OF HELEN LOTHROP PRALL, 1884

Oil on canvas, 48¼ × 36¼
Signed and dated upper right: *Gari J. Melchers. 84.*
The Detroit Institute of Arts, bequest of Helen Lothrop Prall

EXHIBITION HISTORY
1960 Detroit. Detroit Institute of Arts, *Gari Melchers: A Centenary Exhibition*, February 16–
March 13

On a trip home to Detroit in 1883, which coincided with the end of his formal European
training, Melchers painted the first portraits of his professional career, including a small
painting of his mother (cat. no. 8) and a more ambitious three-quarter-length portrait of a
young Detroit native, Helen Lothrop. The Lothrop portrait, sensitive and elegant in con-
ception, may have been commissioned to mark her coming of age. Miss Lothrop's mother
was also painted by Melchers (Detroit Historical Museum) and, very likely, so was her
sister, Anne Lothrop (as suggested by the Belmont archives). The Lothrops' father,
George Van Ness Lothrop, was a member of the Detroit Museum of Art's first board of
trustees. The Detroit Institute of Arts, as it was later called, became Melchers's major
institutional patron.

8. PORTRAIT OF MRS. JULIUS MELCHERS, 1884

Oil on canvas board, 14 × 9⅞
Signed and dated upper right: *Gari J. Melchers '84*
Belmont 1736

PROVENANCE
Belmont, The Gari Melchers Memorial Gallery

EXHIBITION HISTORY
1977 Fredericksburg. Belmont, The Gari Melchers Memorial Gallery, *Portraits by Gari Melchers*,
February–June

Melchers painted his mother while on a return visit to his native Detroit. Even at this early
stage in his career, he ably conveyed the personality of his sitter. The somber palette and
solid modeling of the subject's features speak of strength, while a softness about the brush-
work suggests Melchers's filial devotion.

9. THE SICK CHILD, 1884

Watercolor on cardboard, 12^{1}/$_{2}$ × 16^{3}/$_{4}$
Signed and dated lower center: *J. G. Melchers./Egmond 84.*
Belmont 1302

PROVENANCE
Belmont, The Gari Melchers Memorial Gallery

EXHIBITION HISTORY
1888 Boston. Saint Botolph Club, *Paintings by Gari Melchers,* March
1890 New York. Reichard and Company, *Prize Fund Exhibition*, February
 Chicago. Inter-State Industrial Exposition, *18th Annual Art Exhibition*, September
1927 New York. Milch Galleries, *Exhibition of Works by Gari Melchers*, November 28–December 24
1928 Chicago. Art Institute of Chicago, *8th International Exhibition of Watercolors, Pastels, Drawings and Miniatures*, March 29–May 6
1929 New York. Anderson Galleries, *Paintings and Drawings by Gari Melchers*, January 1–26
1938 Richmond. Virginia Museum of Fine Arts, *Gari Melchers: A Memorial Exhibition of His Work*, January 17–February 28
1984 Fredericksburg. Belmont, The Gari Melchers Memorial Gallery, *Gari Melchers in Holland*, March 6–May 2
1985 Fredericksburg. Belmont, The Gari Melchers Memorial Gallery, *Children: Twenty Paintings, Drawings, and Prints by Gari Melchers*, November 1–January 6, 1986

Not long after settling in The Netherlands, Melchers came under the influence of the popular Hague School artists. This native group of painters stimulated a revival in traditional Dutch subjects, particularly landscape and peasant life. Qualities that typify their work, namely, intimate scale, an overall dark tonality, and a sad or sentimental mood, are the stylistic sources for pictures like *The Sick Child* and *Volendam Interior* (cat. no. 16).

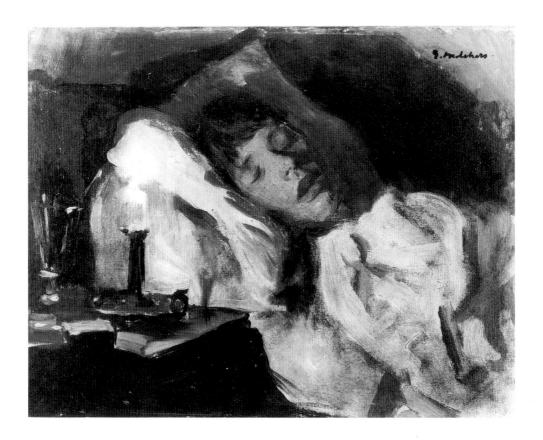

10. CANDLELIGHT (SLEEPING GIRL), c. 1885

Oil on canvas mounted on board, 10½ × 13¾
Signed upper right: *G. Melchers*
Belmont 1297

PROVENANCE
Belmont, The Gari Melchers Memorial Gallery

EXHIBITION HISTORY
1927 New York. Milch Galleries, *Exhibition of Works by Gari Melchers*, November 28–December 24
1929 New York. Anderson Galleries, *Paintings and Drawings by Gari Melchers*, January 1–26
1984 Fredericksburg. Belmont, The Gari Melchers Memorial Gallery, *Gari Melchers in Holland*, March 6–May 2
1985 Fredericksburg. Belmont, The Gari Melchers Memorial Gallery, *Children: Twenty Paintings, Drawings, and Prints by Gari Melchers*, November 1–January 6, 1986

The subject of the sleeping child was a popular one in late nineteenth-century painting, and in this instance it offered Melchers an ideal opportunity to study the effects of artificial illumination. The artist later experimented with the image in a series of etchings.

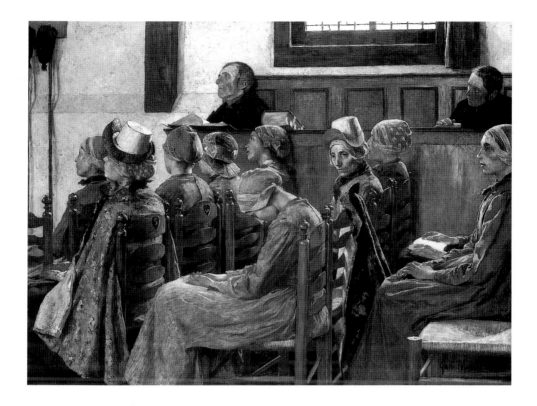

11. THE SERMON, 1886

Oil on canvas, $62^5/_8 \times 86^1/_2$
Signed lower right: *Gari Melchers.*
National Museum of American Art, Smithsonian Institution, Washington, D.C.,
bequest of Henry Ward Ranger through the National Academy of Design
Plate 2

PROVENANCE
The artist to Potter Palmer
Palmer to the Milch Galleries and the artist in 1930
National Academy of Design, H. W. Ranger Fund, 1931

EXHIBITION HISTORY
1886 Paris. *Salon de la Société des Artistes Français*, n.d.
 Amsterdam. *Tentoonstelling van Kunstwerken van Levende Meesters*, n.d.
1887 Brussels. *Salon Triennal de Bruxelles*, September 1–November 1
1888 Munich. *3. Internationale Kunst-Ausstellung*, n.d.
1889 Paris. *Exposition Universelle*, United States Fine Arts Section, n.d.
1890 New York. Reichard and Company, *Prize Fund Exhibition*, February
 Chicago. Inter-State Industrial Exposition, *18th Annual Art Exhibition*, September
1893 Chicago. World's Columbian Exposition, *International Exhibition of Art*, May 1–October 30
 Philadelphia. Pennsylvania Academy of the Fine Arts, *63rd Annual Exhibition*,
 December 18–February 24, 1894
1895 Berlin. *Grosse Berliner Kunst-Ausstellung*, n.d.
1908 New York. Cottier and Company, *Gari Melchers*, January 28–February 21
1912 Berlin. *Grosse Berliner Kunst-Ausstellung*, April–June
1919 Boston. Copley Society, *Loan Exhibition of Paintings by Gari Melchers*, November 12–29
 Chicago. Art Institute of Chicago, *Paintings by Gari Melchers*, April 4–May 1
1927 Detroit. Detroit Institute of Arts, *Retrospective Exhibition of Paintings by Gari Melchers*, October
 New York. Milch Galleries, *Exhibition of Works by Gari Melchers*, November 28–December 24

1928　Dallas. Dallas Art Association, *Second Intimate Exhibition*, January 13–23

New York. Brooklyn Museum of Art, *9th Annual Exhibition of Paintings by the New Society of Artists*, November 19–January 1, 1929

1930　New York. Macbeth Gallery, *Thirty Paintings by Thirty Artists: 18th Annual Exhibition*, February 4–17

Rochester. Memorial Art Gallery of the University of Rochester, *Gari Melchers, N.A., Thomas J. Mitchell, and Thirty Cleveland Artists*, March–April

1931　Washington, D.C. Corcoran Gallery of Art, extended loan from the National Academy of Design according to the Henry Ward Ranger bequest (through 1944)

1933　Washington, D.C. Corcoran Gallery of Art, *Memorial Exhibition of Paintings, Drawings, and Etchings by Gari Melchers*, October 21–December 3

1958　New York. National Academy of Design, *Ranger Centennial Exhibition and Traveling Show*, September 25–October 12

Washington, D.C. Smithsonian Institution, National Collection of Fine Arts, *Ranger Centennial Exhibition and Traveling Show*, December 2–January 8, 1959

1959　Charlotte, North Carolina. Mint Museum of Art, *Ranger Centennial Exhibition and Traveling Show*, January 12–February 8

Bradenton, Florida. Art League of Manatee County, *Ranger Centennial Exhibition and Traveling Show*, February 22–March 13

MEDALS

Honorable Mention, *Salon de la Société des Artistes Français,* Paris 1886

First-Class Gold Medal, *Tentoonstelling van Kunstwerken van Levende Meesters,* Amsterdam, 1886

First-Class Gold Medal, *3. Internationale Kunst-Ausstellung,* Munich, 1888

Grand Prize, American Painting, *Exposition Universelle,* Paris, 1889

An early group of large canvases portraying Dutch peasants at worship has come to be regarded as one of Melchers's most successful endeavors. The finest example is *The Sermon*, which earned the twenty-six-year-old artist his first international decoration, an honorable mention at the Paris Salon of 1886. In subsequent competitions the picture received two gold medals and the grand prize for American painting at the 1889 Paris Exposition Universelle, an honor shared with another expatriate, John Singer Sargent.

The Sermon's setting is a Protestant Dutch Reformed Church, not far from Melchers's lodgings, where local villagers attending a Sunday morning service are pictured in a variety of attitudes. Critics of the day applauded the painting for its technical mastery and expressive power. (For a detailed discussion, see Stott, above, pp. 55–56, and Bienenstock, above, pp. 80–89.)

12. IN HOLLAND, 1887

Oil on canvas, 109 × 77¾
Signed lower left: *Gari Melchers*
Belmont 1550
Plate 3

PROVENANCE
Belmont, The Gari Melchers Memorial Gallery

EXHIBITION HISTORY

1887 Paris. *Salon de la Société des Artistes Français*, n.d.
 Chicago. Inter-State Industrial Exposition, *15th Annual Exhibition,* September
 New York. American Art Association, American Art Galleries, December

1888 Boston. Saint Botolph Club, *Paintings by Gari Melchers*, March
 New York. Reichard and Company, *Prize Fund Exhibition*, autumn

1890 Philadelphia. Pennsylvania Academy of the Fine Arts, *60th Annual Exhibition*,
 January 30–March 6
 Brussels. *Salon Triennal de Bruxelles*, September 15–November 15

1891 Munich. *Jährliche Kunst-Ausstellung Königliche Glaspalast*, August 6

1894 St. Louis. No information available.

1912 Berlin. *Grosse Berliner Kunst-Ausstellung*, April–June

1932 New York. American Academy of Arts and Letters, *Exhibition of Paintings by Gari Melchers*,
 November 10–May 1, 1933

1933 Washington, D.C. Corcoran Gallery of Art, *Memorial Exhibition of Paintings, Drawings, and
 Etchings by Gari Melchers*, October 21–December 3

1934 Pittsburgh. Museum of Art, Carnegie Institute, *Gari Melchers Memorial Exhibition*,
 January 11–February 18

1938 Richmond. Virginia Museum of Fine Arts, *Gari Melchers: A Memorial Exhibition of His Work*,
 January 17–February 28

1984 Fredericksburg. Belmont, The Gari Melchers Memorial Gallery, *Gari Melchers in Holland*,
 March 6–May 2

Although *In Holland* was not as successful in the Salon of 1887 as was *The Sermon* the previous year, its monumental scale certainly guaranteed notice. Perhaps it was the lack of critical praise that caused Melchers to make several alterations, the most notable being the addition of a windmill and other structures at the top of the picture, as well as an overall heightening of color. The original composition is evident in Melchers's etching of the same title (fig. 24).

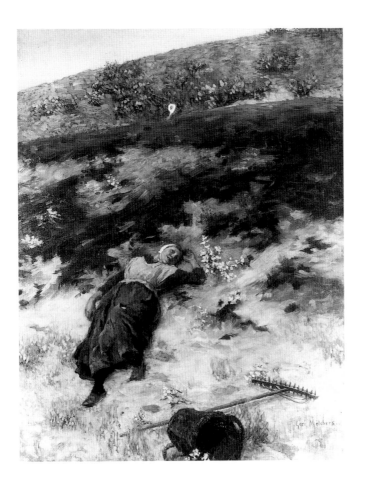

13. **MOSS AND SAND**, 1887

Oil on canvas, 44 × 33
Signed lower right: *Gari Melchers.*
Belmont 1702
Plate 4

PROVENANCE
Belmont, The Gari Melchers Memorial Gallery

EXHIBITION HISTORY
1887 New York. Reichard and Company, *Prize Fund Exhibition*, n.d.
1888 Boston. Saint Botolph Club, *Paintings by Gari Melchers*, March
 Chicago. Inter-State Industrial Exposition, *16th Annual Art Exhibition*, September
1938 Richmond. Virginia Museum of Fine Arts, *Gari Melchers: A Memorial Exhibition of His Work*,
 January 17–February 28
1962 New York. Century Association, *Exhibition of Works by Gari Melchers*, January 10–March 5
1984 Fredericksburg. Belmont, The Gari Melchers Memorial Gallery, *Gari Melchers in Holland*,
 March 6–May 2
1987 Greenville, South Carolina. Greenville County Museum of Art, *Gari Melchers*,
 September 29–November 15

From the time of his arrival in North Holland in 1884, Melchers found continuous inspiration in the local inhabitants and coastal countryside. The dunes surrounding his brick studio, for example, served as the setting for a series of figurative landscapes, of which *Moss and Sand* is one. The picture's high horizon and sharply tilted pictorial space, its dark, earthy tones, and poetic mood are characteristic features of the series.

14. PORTRAIT OF THOMAS PITTS, 1887

Oil on panel, 40¹/₂ × 31¹/₂
Signed and dated lower right: *Gari Melchers/Detroit 1887*
The Detroit Institute of Arts, Founders Society purchase, Gibbs-Williams Fund, 1958

EXHIBITION HISTORY
1888 Boston. Saint Botolph Club, *Paintings by Gari Melchers*, March
1949 Detroit. Detroit Institute of Arts, *Detroit Artists Before 1900*, June 7–
July 3
1960 Detroit. Detroit Institute of Arts, *Gari Melchers: A Centenary Exhibition*,
February 16–March 13

Melchers received a number of early portrait commissions from the prominent Pitts family of Detroit. This is one of several portraits of Thomas Pitts, successor to the family's lumber business and fortune. Melchers's depiction of this dapper, well-educated member of the city's elite impressed a Detroit *Evening Journal* critic, who on March 7, 1888, wrote:

> Mr. Melchers has painted a wonderfully good portrait of Thomas Pitts. In a straight-backed chair, dressed in a velvet smoking jacket and a high-cut white waistcoat, with a red scarf, Mr. Pitts sits smoking, a French novel opened on his knee. It is not simply that the clothes are perfect in every detail, but that the man dominates the clothes. That he is faultlessly dressed is a matter of course. How could he be otherwise? That the artist has been able to express so much with such simplicity is an achievement.

15. THE CHOIRMASTER, 1888–91

Oil on canvas, 49 × 68
Signed center left: *Gari Melchers*
Belmont 1739

PROVENANCE
Sold by William S. Kimball, Rochester, New York, to Mrs. Gari Melchers (?),
American Art Galleries sale, 1924
Belmont, The Gari Melchers Memorial Gallery

EXHIBITION HISTORY
1891 Paris. *Salon de la Société Nationale des Beaux-Arts*, n.d.
1924 New York. American Art Galleries, *Oil Paintings from the Collection of the Late William Kimball*,
 January 23–24
1932 New York. American Academy of Arts and Letters, *Exhibition of Paintings by Gari Melchers*,
 November 10–May 1, 1933
1933 Washington, D.C. Corcoran Gallery of Art, *Memorial Exhibition of Paintings, Drawings, and
 Etchings by Gari Melchers*, October 21–December 3
1934 Savannah. Telfair Academy of Arts and Sciences, Inc., *Memorial Exhibition of Paintings by Gari
 Melchers*, March 2–April 2
1984 Fredericksburg. Belmont, The Gari Melchers Memorial Gallery, *Gari Melchers in Holland*,
 March 6–May 2

The Choirmaster is related to Melchers's more successful large-scale church interiors of the late
1880s, *The Sermon* (pl. 2; cat. no. 11) and *The Communion* (Cornell University, fig. 29). In all
three, his narration of the simple, godly Dutch peasant is both frank, sometimes brutally so,
and charming.

16. VOLENDAM INTERIOR, 1889

Oil on canvas, 16 × 21½
Signed and dated lower right: *G. Melchers*.
Verso before relining: *Volendam Interior/Gari Melchers 1889*
Belmont 1338

PROVENANCE
Belmont, The Gari Melchers Memorial Gallery

EXHIBITION HISTORY
1984 Fredericksburg. Belmont, The Gari Melchers Memorial Gallery, *Gari Melchers in Holland*,
 March 6–May 2
1987 Greenville, South Carolina. Greenville County Museum of Art, *Gari Melchers*,
 September 29–November 15

In subject matter and style *Volendam Interior* reveals the influence of the Hague School artists
and can be related to *The Sick Child* (cat. no. 9), a work painted five years earlier.

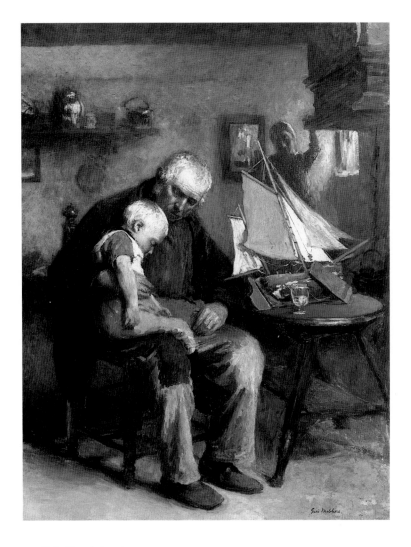

17. OLD AND YOUNG, c. 1890

Oil on canvas, 43³/₈ × 33¹/₂
Signed lower right: *Gari Melchers.*
Mr. and Mrs. Robert G. Beck, Newport News, Virginia
Plate 5

PROVENANCE
Belmont, The Gari Melchers Memorial Gallery to Mr. Beck, 1978

EXHIBITION HISTORY
1978 New York. Graham Gallery, *Gari Melchers (1860–1932), American Painter*, September 26–
October 28

Following the lead of the Hague School painters, Melchers's Dutch subjects deal with the
traditional themes of work, worship, and family life. The touching *Old and Young* not only
pays homage to the sanctity of family but to the sea and the livelihood it provided to genera-
tions of Hollanders.

The setting is Melchers's studio on the North Sea dunes. Photographs in the Belmont
archives show Melchers at work before the two models.

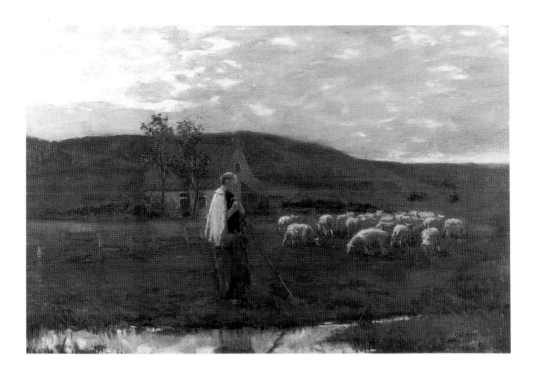

18. THE SHEPHERDESS, c. 1890

Oil on canvas, 20³/₄ × 30³/₄
Signed lower right: *Gari Melchers*.
Mrs. John W. Stroh

PROVENANCE
The artist to his brother-in-law, Julius Stroh
By descent through the Stroh family

EXHIBITION HISTORY
1890 New York. Reichard and Company, *Prize Fund Exhibition*, February

At a time when the unspoiled beauty of the countryside was increasingly threatened by modern industry, a surviving pastoral tradition in North Holland attracted countless artists, including Melchers. In *The Shepherdess* he captured an evocative glimpse of this vanishing way of life.

19. THE NATIVITY, c. 1891

Oil on canvas, 35¹/₂ × 43¹/₂
Signed lower left: *Gari Melchers*.
Belmont 1606
Plate 6

PROVENANCE
Belmont, The Gari Melchers Memorial Gallery

EXHIBITION HISTORY
1891 Paris. *Salon de la Société Nationale des Beaux-Arts*, n.d.
1892 Philadelphia. Pennsylvania Academy of the Fine Arts, *62nd Annual Exhibition*, January 21–March 5
1893 Chicago. World's Columbian Exposition, *International Exhibition of Art*, May 1–October 30
1894 Antwerp. *Exposition Universelle*, May 5–November 5
1900 Berlin. *Grosse Berliner Kunst-Ausstellung*, May 5–September 16
1930 Buffalo. Buffalo Fine Arts Academy/Albright Art Gallery, *Retrospective Exhibition of Paintings Representative of the Life Work of Gari Melchers*, February 2–March 2
Dayton. Dayton Art Institute, *Exhibition of Paintings by Gari Melchers*, April 15–May 15
1978 New York. Graham Gallery, *Gari Melchers (1860–1932), American Painter*, September 26–October 28
1983 Fredericksburg. Belmont, The Gari Melchers Memorial Gallery, *Mother and Child: Paintings by Gari Melchers*, April 15–May 16
1987 Greenville, South Carolina. Greenville County Museum of Art, *Gari Melchers*, September 29–November 15

MEDALS
Medal of Honor, *Exposition Universelle,* Antwerp, 1894

The Nativity was the first of several biblical subjects with which Melchers began experimenting in the early 1890s. None appear to have been commissioned, but more likely were the outcome of his training under the religious painter Eduard von Gebhardt, his early interest in church subjects, and the current vogue for biblical themes.

In the place of traditional manger iconography, such as adoring angels, shepherds, and oxen, Melchers utilized mood-creating color and an aura of light about the Infant's head to convey a sense of the supernatural.

20. MOTHER AND CHILD WITH ORANGE, c. 1892

Oil on canvas, 29 × 19½
Signed lower center: *Gari Melchers*.
Belmont 1704
Plate 7

PROVENANCE
The artist to Max Wilke, Berlin exhibition, 1898
Sotheby's to Mrs. Melchers (?), 1950

EXHIBITION HISTORY
1897 Munich. *7. Internationale Kunst-Ausstellung*, n.d.
　　　 Pittsburgh. Museum of Art, Carnegie Institute, *2nd Annual International Exhibition of
　　　 Paintings,* November 4–January 1, 1898
1898 Berlin. No information available.
1900 Berlin. *Grosse Berliner Kunst-Ausstellung*, May 5–September 16
1926 Buffalo. Buffalo Fine Arts Academy/Albright Art Gallery, *20th Annual Exhibition of Selected
　　　 Paintings by American Artists*, April 25–June 21
1983 Fredericksburg. Belmont, The Gari Melchers Memorial Gallery, *Mother and Child: Paintings
　　　 by Gari Melchers*, April 15–May 16
1984 Fredericksburg. Belmont, The Gari Melchers Memorial Gallery, *Gari Melchers in Holland*,
　　　 March 6–May 2
1985 Fredericksburg. Belmont, The Gari Melchers Memorial
　　　 Gallery, *Children: Twenty Paintings, Drawings, and Prints by Gari Melchers*, November 1–
　　　 January 6, 1986

A lifelong preoccupation of Melchers, and one with which he is often associated, is the
theme of motherhood. For their wholesome, old world appeal, he favored Dutch peasants as
subjects: one of the finest examples is *Mother and Child with Orange*. Melchers consistently
resisted the temptation to interpret the theme with overbearing sweetness. Instead, he con-
veyed the beauty of the bond between mother and child with directness and naturalism. In
traditional Dutch pictures of the Madonna and Child, the orange replaces the apple as the
fruit of the Tree of Knowledge and, therefore, alludes to the infant as the Redeemer of man-
kind from original sin. The German artist Hugo Vogel, a close friend of Melchers, employed
an orange in exactly the same manner in his *Mother and Child*, a painting that was exhibited
with Melchers's *Mother and Child with Orange* in 1900 in Berlin.

　　Melchers's later mother and child paintings carried more obvious religious overtones,
including the use of a halo, the appellation "Madonna," and liberal allusions to Renaissance
sources.

21. Study for THE ARTS OF WAR, 1893

Oil on canvas, 21 1/2 × 36
Signed and dated: *The Arts of War Gari Melchers. XCIII*
Mr. and Mrs. Peter Heydon, Ann Arbor, Michigan

PROVENANCE
Acquired by the Heydons through a Boston dealer

It is not clear how Melchers won his first mural commission, the decorations for the Manufactures and Liberal Arts Building of the 1893 World's Columbian Exposition. Immediately apparent, however, is the artist's departure from factual realism toward a more austere monumentalism. Many have conjectured that Melchers's close association with the French muralist Pierre Puvis de Chavannes was responsible in part for this change. The two lunettes were later acquired by the University of Michigan, Ann Arbor, and installed in the reference reading room of the graduate library, where they remain today.

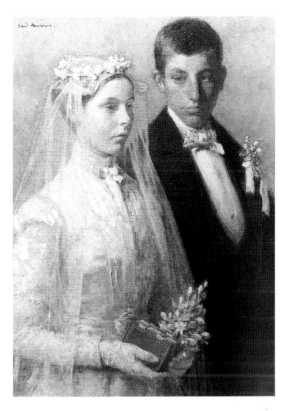

22. MARRIAGE, c. 1893

Oil on canvas, 33½ × 23¾
Signed upper left: *Gari Melchers.*
Minneapolis Institute of Arts, gift of the
Martin B. Koon Memorial Collection

EXHIBITION HISTORY

1893 Chicago. World's Columbian Exposition, *International Exhibition of Art*, May 1–October 30

1897 Munich. *7. Internationale Kunst-Ausstellung*, n.d.

1901 Dresden. *4. Internationale Kunst-Ausstellung*, n.d.

1902 Chicago. Art Institute of Chicago, *15th Annual Exhibition of Oil Paintings and Sculpture by American Artists*, October 28–December 7

1907 Philadelphia. Pennsylvania Academy of the Fine Arts, *102nd Annual Exhibition*, January 21–February 24
 Pittsburgh. Museum of Art, Carnegie Institute, *11th Annual Exhibition*, April 11–June 13

1908 New York. Cottier and Company, *Gari Melchers*, January 28–February 21
 Boston. Saint Botolph Club, *Paintings by Gari Melchers*, March 8–26
 Providence. Museum of Art, Rhode Island School of Design, *An Exhibition of Paintings by Gari Melchers*, March 31–April 13

1918 Washington, D.C. Corcoran Gallery of Art, *Paintings by Gari Melchers*, February 2–March 3

1919 Chicago. Art Institute of Chicago, *Paintings by Gari Melchers*, April 4–May 1
 Boston. Copley Society, *Loan Exhibition of Paintings by Gari Melchers*, November 12–29

1923 Baltimore. Baltimore Museum of Art, *Paintings by Gari Melchers*, April 10–May 5

1927 Detroit. Detroit Institute of Arts, *Retrospective Exhibition of Paintings by Gari Melchers*, October

1930 Buffalo. Buffalo Fine Arts Academy/Albright Art Gallery, *Retrospective Exhibition of Paintings Representative of the Life Work of Gari Melchers*, February 2–March 2

1965 Minneapolis. Farmers and Mechanics Bank, June 7–30

1976 Minneapolis. Minneapolis Institute of Arts, *Bicentennial Exhibition*, n.d.

MEDALS

First-Class Gold Medal, *4. Internationale Kunst-Ausstellung,* Dresden, 1901

Melchers executed a number of paintings and sketches dealing with marriage for which Anna Dekker, his young Dutch cook, modeled. Here she appears in three-quarter view with her attentive groom by her side (see also *The Bride*, pl. 15; cat. no. 31).

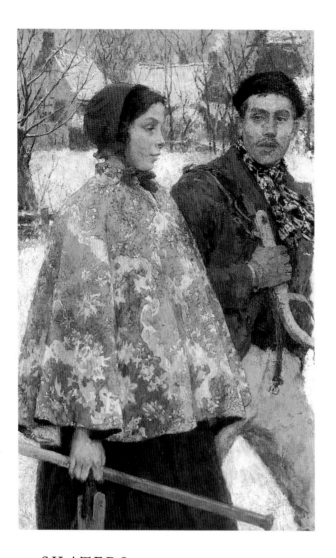

23. SKATERS, c. 1893

Oil on canvas, 43³/₁₆ × 27⁷/₁₆
Signed lower center: *Gari Melchers.*
Pennsylvania Academy of the Fine Arts, Philadelphia, Joseph E. Temple Fund
Plate 8

PROVENANCE
The artist to the Pennsylvania Academy of the Fine Arts, 1901

EXHIBITION HISTORY
1893 Dresden. No information available.
　　　Hamburg. No information available.
　　　Philadelphia. Art Club of Philadelphia, *5th Annual Exhibition of Oil Paintings and Sculpture*,
　　　November 23–December 31
　　　Chicago. World's Columbian Exposition, *International Exhibition of Art*, May 1–October 30
1894 Paris. *Salon de la Société Nationale des Beaux-Arts*, n.d.
1895 Munich. No information available.
1897 Copenhagen. No information available.
1900 Chicago. Art Institute of Chicago, *13th Annual Exhibition of Oil Paintings and Sculpture by
　　　American Artists*, October 30–December 9
1901 Philadelphia. Pennsylvania Academy of the Fine Arts, *70th Annual Exhibition of Pictures*,
　　　January 14–February 23
　　　Buffalo. *Pan-American Exposition*, n.d.

1905 Buffalo. Buffalo Fine Arts Academy/Albright Art Gallery, *Inaugural Loan Exhibition*, May 31–July 1

1907 Philadelphia. Pennsylvania Academy of the Fine Arts, *102nd Annual Exhibition*, January 21–February 24

Pittsburgh. Museum of Art, Carnegie Institute, *11th Annual Exhibition*, April 11–June 13

1908 New York. Cottier and Company, *Gari Melchers*, January 28–February 21

Boston. Saint Botolph Club, *Paintings by Gari Melchers*, March 8–26

1910 Weimar. Grossherzogliches Museum, Karlsplatz, *Exhibition of Paintings by Gari Melchers*, February 11

1912 Baltimore. Peabody Galleries, *Exhibition of American Art*, March

1915 San Francisco. Panama Pacific International Exposition, February 20–December 4

1918 Washington, D.C. Corcoran Gallery of Art, *Paintings by Gari Melchers*, February 2–March 3

1919 Chicago. Art Institute of Chicago, *Paintings by Gari Melchers*, April 4–May 1

Boston. Copley Society, *Loan Exhibition of Paintings by Gari Melchers*, November 12–29

1923 Baltimore. Baltimore Museum of Art, *Paintings by Gari Melchers*, April 10–May 5

1927 Detroit. Detroit Institute of Arts, *Retrospective Exhibition of Paintings by Gari Melchers*, October

1929 New York. Anderson Galleries, *Paintings and Drawings by Gari Melchers*, January 1–26

1930 Buffalo. Buffalo Fine Arts Academy/Albright Art Gallery, *Retrospective Exhibition of Paintings Representative of the Life Work of Gari Melchers*, February 2–March 2

Rochester. Memorial Art Gallery of the University of Rochester, *Gari Melchers, N.A., Thomas J. Mitchell, and Thirty Cleveland Artists*, March–April

Dayton. Dayton Art Institute, *Exhibition of Paintings by Gari Melchers*, April 15–May 15

1933 Washington, D.C. Corcoran Gallery of Art, *Memorial Exhibition of Paintings, Drawings, and Etchings by Gari Melchers*, October 21–December 3

1934 Savannah. Telfair Academy of Arts and Sciences, Inc., *Memorial Exhibition of Paintings by Gari Melchers*, March 2–April 1

1938 Richmond. Virginia Museum of Fine Arts, *Gari Melchers: A Memorial Exhibition of His Work*, January 17–February 28

1975 London. United States Ambassador's residence (through 1976)

1976 Dayton. Dayton Art Institute, *American Expatriate Painters of the Late-Nineteenth Century*, December 4–January 16, 1977

1977 Philadelphia. Pennsylvania Academy of the Fine Arts, *American Expatriate Painters of the Late-Nineteenth Century*, February 4–March 20

Los Angeles. Los Angeles County Museum of Art, *American Expatriate Painters of the Late-Nineteenth Century*, April 12–May 29

1981 Washington, D.C. The White House (through 1987)

MEDALS

Gold Medal, Panama Pacific International Exposition, San Francisco, 1915

Over time Melchers's preoccupation with Dutch peasant life shifted from anecdotal toward decorative concerns. The appeal of *Skaters*, for example, has less to do with narrative than with color, pattern, and texture.

The model, Anna Dekker (see *The Bride*, pl. 15; cat. no. 31, and *Marriage*, cat. no. 22), wearing a violet cape, was photographed on the dunes and in the artist's seaside studio. Most likely Melchers provided the cape, as it was his habit to collect costumes and bric-a-brac to beautify and authenticate his pictures. So pleased was he with the decorative effects of the cape that he used it again in later years.

24. PORTRAIT OF JULIUS MELCHERS, 1894

Oil on wood panel, 14 × 9⁷/₈
Unsigned
Belmont 1737

PROVENANCE
Belmont, The Gari Melchers Memorial Gallery

EXHIBITION HISTORY
1977 Fredericksburg. Belmont, The Gari Melchers Memorial Gallery, *Portraits by Gari Melchers*,
 February–June

Melchers produced this painting as a pendant to one of his mother painted ten years earlier
(cat. no. 8), and he was careful to match the likeness of his father with the low-key, aca-
demic style of his youth. The elder Melchers, a sculptor best remembered for his wooden
cigar-store Indians, numbered among his students the architect Albert Kahn and the
painter Julius Rolshoven, in addition to his son.

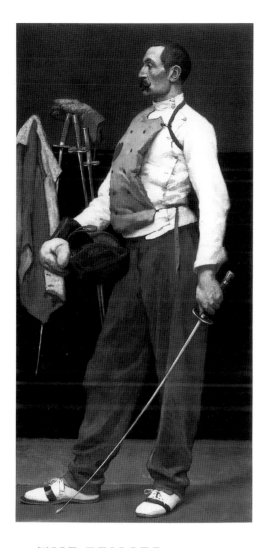

25. THE FENCER, c. 1895

Oil on canvas, 80⁷/₈ × 39¹/₄
Signed upper left: *Gari Melchers.*
Belmont 1683
Plate 9

PROVENANCE
Belmont, The Gari Melchers Memorial Gallery

EXHIBITION HISTORY
1897 Pittsburgh. Museum of Art, Carnegie Institute, *2nd Annual International Exhibition of Paintings*, November 4–January 1, 1898
1900 Berlin. *Grosse Berliner Kunst-Ausstellung,* May 5–September 16
1902 Philadelphia. Pennsylvania Academy of the Fine Arts, *71st Annual Exhibition*, January 20–March 1
1906 Paris. *Salon de la Société Nationale des Beaux-Arts*, n.d.
1910 Weimar. Grossherzogliches Museum, Karlsplatz, *Exhibition of Paintings by Gari Melchers,* February 11
1921 New York. Milch Galleries, *Paintings by Gari Melchers*, March 14–April 9
1927 Pittsburgh. Museum of Art, Carnegie Institute, *26th International Exhibition of Paintings*, October 13–December 4
1928 New York. Brooklyn Museum, *The 26th Annual Carnegie Exhibition*, January 14–February 19
1929 New York. Anderson Galleries, *Paintings and Drawings by Gari Melchers*, January 1–26

1930 Buffalo. Buffalo Fine Arts Academy/Albright Art Gallery, *Retrospective Exhibition of Paintings Representative of the Life Work of Gari Melchers*, February 2–March 2

Rochester. Memorial Art Gallery of the University of Rochester, *Gari Melchers, N.A., Thomas J. Mitchell, and Thirty Cleveland Artists*, March–April

Dayton. Dayton Art Institute, *Exhibition of Paintings by Gari Melchers*, April 15–May 15

1932 Venice. *XVIIIª Esposizione Biennale Internazionale d'Arte*, n.d.

1933 Washington, D.C. Corcoran Gallery of Art, *Memorial Exhibition of Paintings, Drawings, and Etchings by Gari Melchers*, October 21–December 3

1934 Savannah. Telfair Academy of Arts and Sciences, Inc., *Memorial Exhibition of Paintings by Gari Melchers*, March 2–April 1

1938 Richmond. Virginia Museum of Fine Arts, *Gari Melchers: A Memorial Exhibition of His Work*, January 17–February 28

1939 New York. National Academy of Design, *Special Exhibition*, May 8–July 25

1962 New York. Century Association, *Exhibition of Works by Gari Melchers*, January 10–March 5

1987 Chadds Ford, Pennsylvania. Brandywine River Museum and Conservancy, *In Pursuit of Sport*, September 12–November 22

For commissioned portraits Melchers generally adhered to formal academic principles; otherwise he freely experimented with composition and elaborated on details of setting. In anonymous occupational portraits such as *The Fencer*, the identity of the subject was less important than the picture's overall design. In fact, the model is presumed to be Ernest Noir, a French painter, who also posed for a related version, *The Fencing Master* (Detroit Institute of Arts). One cannot help drawing parallels between the bold composition of *The Fencer* and the single, standing figures of Manet.

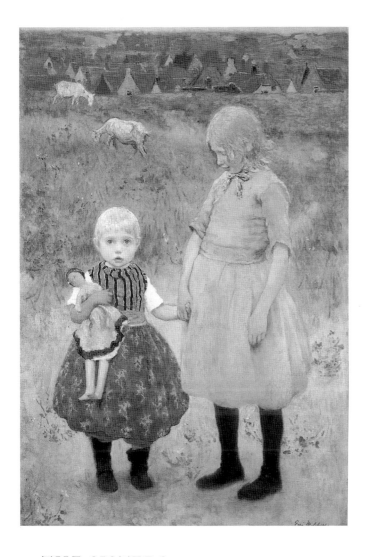

26. THE SISTERS, c. 1895

Oil on canvas, 59¼ × 39⅝
Signed lower right: *Gari Melchers*.
National Gallery of Art, Washington, D.C., gift of Curt H. Reisinger, 1957
Plate 10

PROVENANCE
The artist to Hugo Reisinger
By descent through the family to Curt H. Reisinger

EXHIBITION HISTORY
1895 Paris. *Salon de la Société Nationale des Beaux-Arts*, n.d.
 Chicago. Art Institute of Chicago, *8th Annual Exhibition of Oil Paintings and Sculpture by American Artists*, October 22–December 8
 Philadelphia. Pennsylvania Academy of the Fine Arts, *65th Annual Exhibition of Pictures*, December 23–February 22, 1896
1896 Berlin. *Internationale Kunst-Ausstellung*, May 3–September 30
1897 Pittsburgh. Museum of Art, Carnegie Institute, *2nd Annual International Exhibition of Paintings*, November 4–January 1, 1898
1898 Vienna. *Jubeljahr Kunst-Ausstellung*, n.d.
1899 Ghent. *Salon Triennal de Gand*, August 13–October 8
1900 Paris. *Exposition Universelle*, United States Fine Arts Section, n.d.
 Berlin. *Grosse Berliner Kunst-Ausstellung*, May 5–September 16
 Chicago. Art Institute of Chicago, *13th Annual Exhibition of Oil Paintings and Sculptures by American Artists*, October 30–December 9

1901 Dresden. *4. Internationale Kunst-Ausstellung*, n.d.

1902 Karlsruhe. No information available.

1903 Venice. *5th Esposizione Internazionale*, n.d.

1904 St. Louis. Louisiana Purchase Exposition, n.d.

1905 Liège. *Exposition Internationale*, April–November

1908 New York. Cottier and Company, *Gari Melchers*, January 28–February 21
 Boston. Saint Botolph Club, *Paintings by Gari Melchers*, March 8–26
 Providence. Museum of Art, Rhode Island School of Design, *An Exhibition of Paintings by Gari Melchers*, March 31–April 13

1918 Washington, D.C. Corcoran Gallery of Art, *Paintings by Gari Melchers*, February 2–March 3

1919 Boston. Copley Society, *Loan Exhibition of Paintings by Gari Melchers*, November 12–29

1923 Baltimore. Baltimore Museum of Art, *Paintings by Gari Melchers*, April 10–May 5

1927 New York. Century Association, *A Representative Collection of the Works of Gari Melchers*, February
 Detroit. Detroit Institute of Arts, *Retrospective Exhibition of Paintings by Gari Melchers*, October

1929 New York. Anderson Galleries, *Paintings and Drawings by Gari Melchers*, January 1–26

1930 Buffalo. Buffalo Fine Arts Academy/Albright Art Gallery, *Retrospective Exhibition of Paintings Representative of the Life Work of Gari Melchers*, February 2–March 2
 Rochester. Memorial Art Gallery of the University of Rochester, *Gari Melchers, N.A., Thomas J. Mitchell, and Thirty Cleveland Artists*, March–April

1932 New York. American Academy of Arts and Letters, *Exhibition of Paintings by Gari Melchers*, November 10–May 1, 1933

1934 Pittsburgh. Museum of Art, Carnegie Institute, *Gari Melchers Memorial Exhibition*, January 11–February 18

1938 Richmond. Virginia Museum of Fine Arts, *Gari Melchers: A Memorial Exhibition of His Work*, January 17–February 28

1970 Washington, D.C. Blair House (through March 1984)

MEDALS

First-Class Gold Medal, *4. Internationale Kunst-Ausstellung,* Dresden, 1901

Because of his sympathetic approach to Dutch subjects in paintings like *The Sisters*, Melchers was often mistaken for a native Dutchman. His picturesque view of life in The Netherlands and, in particular, his charming flaxen-haired youths, lent these images an appeal that won him favorable reviews.

The artist was in the habit of lifting elements from one painting to another. So captivated was he with the models for *The Sisters* that he duplicated one or the other in *The Family* (Berlin, Staatliche Museum), *The Doll* (private collection), and Belmont's *The Butterfly (Little Girl)* (fig. 26).

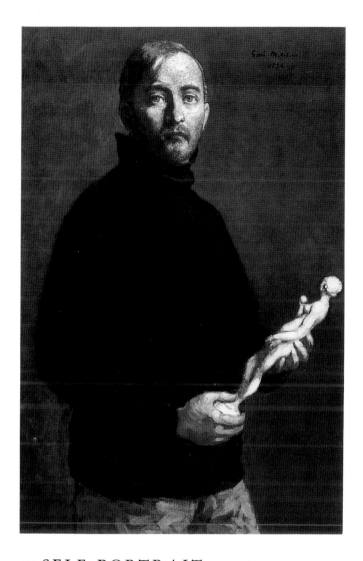

27. SELF-PORTRAIT, 1896

Oil on canvas, 37⁷/₈ × 26¹/₈
Signed and dated upper right: *Gari Melchers/1896.*
Belmont 1278
Plate 11

PROVENANCE
Belmont, The Gari Melchers Memorial Gallery

EXHIBITION HISTORY
1977 Fredericksburg. Belmont, The Gari Melchers Memorial Gallery, *Portraits by Gari Melchers,*
February–June
1987 Muskegon. Muskegon Museum of Art, *Artists of Michigan from the 19th Century,*
September 17–November 1
Detroit. Detroit Historical Museum, *Artists of Michigan from the 19th Century,* November 12–
January 28, 1988

Painted at the height of his career, this self-portrait reveals a self-possessed and intelligent
man in casual clothing. The statuette of Eve suggests the art of creation itself but may be an
oblique reference to Melchers's profession and to his sculptor father.

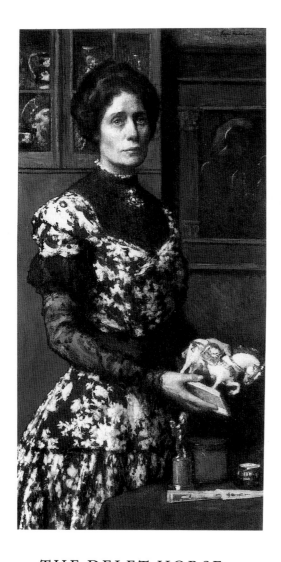

28. THE DELFT HORSE, c. 1900

Oil on canvas, 44¼ × 22¼
Signed upper right: *Gari Melchers.*
Belmont 1594
Plate 12

PROVENANCE
Belmont, The Gari Melchers Memorial Gallery

EXHIBITION HISTORY
1901 Chicago. Art Institute of Chicago, *14th Annual Exhibition of Oil Paintings and Sculpture by American Artists*, October 29–December 8
1902 Paris. *Salon de la Société Nationale des Beaux-Arts*, n.d.
1907 Philadelphia. Pennsylvania Academy of the Fine Arts, *102nd Annual Exhibition,* January 21–February 24
Pittsburgh. Museum of Art, Carnegie Institute, *11th Annual Exhibition*, April 11–June 13
1908 New York. Cottier and Company, *Gari Melchers*, January 28–February 21
Boston. Saint Botolph Club, *Paintings by Gari Melchers*, March 8–26
Providence. Museum of Art, Rhode Island School of Design, *An Exhibition of Paintings by Gari Melchers*, March 31–April 13
1912 Berlin. *Grosse Berliner Kunst-Ausstellung*, April–June

1932 New York. American Academy of Arts and Letters, *Exhibition of Paintings by Gari Melchers*, November 10–May 1, 1933

1933 Washington, D.C. Corcoran Gallery of Art, *Memorial Exhibition of Paintings, Drawings, and Etchings by Gari Melchers*, October 21–December 3

1934 Pittsburgh. Museum of Art, Carnegie Institute, *Gari Melchers Memorial Exhibition*, January 11–February 18

Columbus, Ohio. Gallery of Fine Arts, *Exhibition of Paintings by Gari Melchers*, May 1–31

1935 Baltimore. Baltimore Museum of Art, *Memorial Exhibition of Gari Melchers*, March

1938 Richmond. Virginia Museum of Fine Arts, *Gari Melchers: A Memorial Exhibition of His Work*, January 17–February 28

1977 Fredericksburg. Belmont, The Gari Melchers Memorial Gallery, *Portraits by Gari Melchers*, February–June

Pictures like *The Delft Horse* and *Portrait of Mrs. George Hitchcock* (also called *The Embroideress*, private collection), without doubt two of the most expert of Melchers's career, helped to establish him as a premier portrait artist. Melchers's preoccupation with Henriette Hitchcock is not surprising, for photographs in the Belmont archives attest her striking classical beauty. Calling attention to her face with spotlighting and firmly developed modeling, Melchers captured both a true likeness and a sense of intriguing personality.

Hitchcock's rather sorrowful aspect has often fascinated admirers of the picture; in fact, Melchers originally painted her as slightly younger and less disconsolate than here. The date of the artist's alterations is unknown, but in 1904 George Hitchcock abandoned Henriette and soon after married a student, Cecil Jay. Henriette married Charles Lewis Hind, the British author (see *The Sun Porch*, pl. 27; cat. no. 52) in 1907. Following Hind's death in 1927, she authored the first monograph on Gari Melchers.

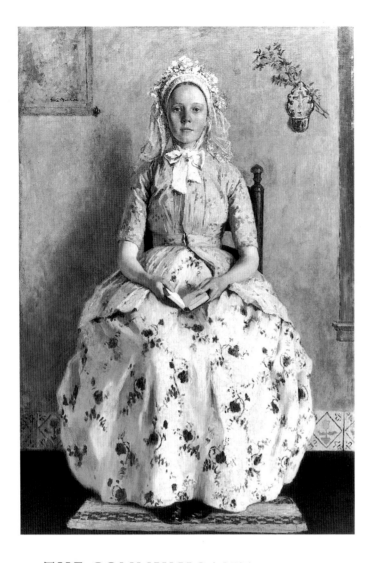

29. THE COMMUNICANT, c. 1900

Oil on canvas, 63¼ × 43
Signed upper left: *Gari Melchers*
The Detroit Institute of Arts, bequest of Mr. and Mrs. Charles M. Swift, 1969
Plate 13

PROVENANCE
The artist to the Swifts

EXHIBITION HISTORY
1900 Chicago. Art Institute of Chicago, *13th Annual Exhibition of Oil Paintings and Sculpture by American Artists*, October 30–December 9

1901 Dresden. *4. Internationale Kunst-Ausstellung*, n.d.

1904 St. Louis. Louisiana Purchase Exposition, n.d.

1907 Philadelphia. Pennsylvania Academy of the Fine Arts, *102nd Annual Exhibition*, January 21–February 24

1916 Buffalo. Buffalo Fine Arts Academy/Albright Art Gallery, *Paintings Selected from the Permanent Collection of the Detroit Museum of Art*, January 9–30

1925 Washington, D.C. Corcoran Gallery of Art, *Centennial Exhibition of the National Academy of Design, 1825–1925*, October 17–November 15
New York. Grand Central Art Galleries, *Centennial Exhibition of the National Academy of Design, 1825–1925*, December 1–January 3, 1926

1926 Philadelphia. Pennsylvania Academy of the Fine Arts, *121st Annual Exhibition*, January 31–
 March 21
1927 Detroit. Detroit Institute of Arts, *Retrospective Exhibition of Paintings by Gari Melchers*, October
1929 New York. Anderson Galleries, *Paintings and Drawings by Gari Melchers*, January 1–26
1930 Buffalo. Buffalo Fine Arts Academy/Albright Art Gallery, *Retrospective Exhibition of Paintings
 Representative of the Life Work of Gari Melchers*, February 2–March 2
 Rochester. Memorial Art Gallery of the University of Rochester, *Gari Melchers, N.A., Thomas
 J. Mitchell, and Thirty Cleveland Artists*, March–April
1932 New York. American Academy of Arts and Letters, *Exhibition of Paintings by Gari Melchers*,
 November 10–May 1, 1933
1934 Pittsburgh. Museum of Art, Carnegie Institute, *Gari Melchers Memorial Exhibition*,
 January 11–February 18
 Columbus, Ohio. Gallery of Fine Arts, *Exhibition of Paintings by Gari Melchers*, May 1–31
1938 Richmond. Virginia Museum of Fine Arts, *Gari Melchers: A Memorial Exhibition of His Work*,
 January 17–February 18

MEDALS
First-Class Gold Medal, *4. Internationale Kunst-Ausstellung,* Dresden, 1901

Like his American colleague in Holland, George Hitchcock, Melchers came to be associated
with the iconography of the modern Dutch Madonna. In the late 1890s, however, he formu-
lated a distinctive female type in the "spiritual communicant." *The Communicant, Sainte-
Gudule* (fig. 25), and *Palm Sunday* (location unknown) are monumentally scaled works pic-
turing young women in traditional Dutch costume, enthroned, iconlike, before a shallow
stage decorated with murals, tapestries, Delft tiles, and fonts. Melchers's admiration for the
religious art of fifteenth and sixteenth century Italy is apparent here (and is documented in
the archives at Belmont). Moreover, the magnificent gilt frame on the Detroit picture was
adapted from ornate Renaissance altarpieces, further enhancing the spiritual significance of
The Communicant. This practice was employed by another American painter of modern spir-
itual beauty, Abbott Handerson Thayer (1849–1921).

 The model is Petronella van der Brugh, who sat for the painting at the age of sixteen.

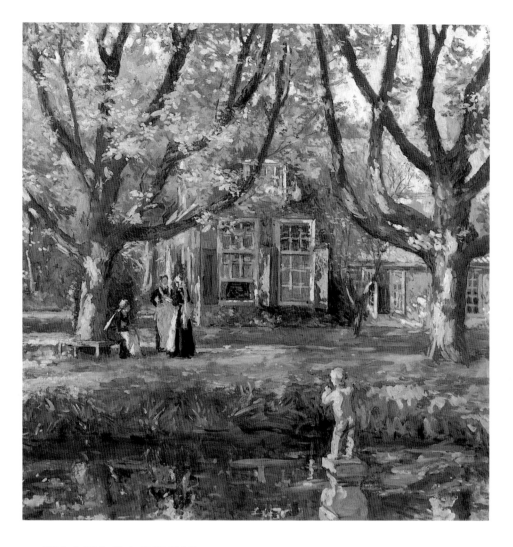

30. IN MY GARDEN, c. 1903

Oil on canvas, 41 × 40
Signed lower left: *Gari Melchers*
The Butler Institute of American Art, Youngstown, Ohio, purchase, 1922
Plate 14

PROVENANCE
Once owned by Edward A. Faust
J. J. Gillespie and Company, Pittsburgh, to the Butler Institute of American Art

EXHIBITION HISTORY
1911 New York. Montross Gallery, *Exhibition of Works by Gari Melchers*, March 1–15
 Buffalo. Buffalo Fine Arts Academy/Albright Art Gallery, *6th Annual Exhibition of Selected
 Paintings by American Artists*, May 12–August 28
1912 Worcester. Worcester Art Museum, *15th Annual Exhibition of Oil Paintings*, June 7–
 September 15
1914 Providence. Museum of Art, Rhode Island School of Design, *Exhibition of Works by Twenty-one
 American Painters*, October 25–November 23
1919 Chicago. Art Institute of Chicago, *Paintings by Gari Melchers*, April 10–May 5
 Boston. Copley Society, *Loan Exhibition of Paintings by Gari Melchers*, November 12–29
1922 Pittsburgh. Museum of Art, Carnegie Institute, *Exhibition of Art and Science in Gardens*,
 June 18–July 31
1923 Baltimore. Baltimore Museum of Art, *Paintings by Gari Melchers*, April 10–May 5

1927 New York. Milch Galleries, *Exhibition of Works by Gari Melchers*, November 28–December 24
1930 Buffalo. Buffalo Fine Arts Academy/Albright Art Gallery, *Retrospective Exhibition of Paintings Representative of the Life Work of Gari Melchers*, February 2–March 2
 Rochester. Memorial Art Gallery of the University of Rochester, *Gari Melchers, N.A., Thomas J. Mitchell, and Thirty Cleveland Artists*, March–April
1934 Pittsburgh. Museum of Art, Carnegie Institute, *Gari Melchers Memorial Exhibition*, January 11–February 18
1938 Richmond. Virginia Museum of Fine Arts, *Gari Melchers: A Memorial Exhibition of His Work*, January 17–February 28
1963 New York. American Federation of Arts, *American Impressionists: Two Generations*, October–May 1964
1983 Canton. Canton Art Institute, *Impressionism: An American View*, February 20–April 3
 Greensburg, Pennsylvania. Westmoreland County Museum of Art, *Impressionism: An American View*, April 16–May 22
 Youngstown, Ohio. Butler Institute of American Art, *Impressionism: An American View*, June 5–July 17

By 1900 Melchers no longer painted the dunes and canals of Holland exclusively. *In My Garden* was the first of several intimate garden scenes in which he explored intense color and the impressionistic effects of sunlight.

The garden behind Schuylenburg, the home of painter George Hitchcock, served as the setting. A favorite retreat of Melchers, it is the subject of at least two other pictures, *The Lily Pond* (private collection) and *House under the Trees* (location unknown). A picture-postcard of Schuylenburg in the Belmont archives (fig. 67) verifies the topographical accuracy of the artist's picture, down to the giant shade trees and the statue of the cherub in the pond. Years later, the cherub was given to Melchers and his wife, who placed it prominently in their garden in Belmont.

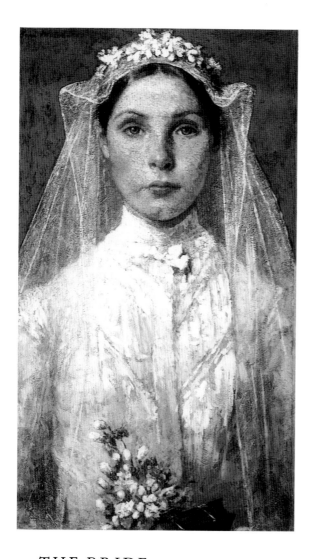

31. THE BRIDE, 1903

Oil on wood panel, 21¼ × 12⅛
Signed upper left: *Gari Melchers*
Belmont 1259
Plate 15

PROVENANCE
Belmont, The Gari Melchers Memorial Gallery

EXHIBITION HISTORY
1903 Berlin. *Grosse Berliner Kunst-Ausstellung*, May 2–October 4
1904 Philadelphia. Pennsylvania Academy of the Fine Arts, *73rd Annual Exhibition*, January 25–March 5
 Düsseldorf. *Fine Arts and Horticultural Exhibition*, n.d.
1907 Philadelphia. Pennsylvania Academy of the Fine Arts, *102nd Annual Exhibition*, January 21–February 24
 Pittsburgh. Museum of Art, Carnegie Institute, *11th Annual Exhibition*, April 11–June 13
1908 New York. Cottier and Company, *Gari Melchers*, January 28–February 21
 Boston. Saint Botolph Club, *Paintings by Gari Melchers*, March 8–26
 Providence. Museum of Art, Rhode Island School of Design, *An Exhibition of Paintings by Gari Melchers*, March 31–April 13
1910 Weimar. Grossherzogliches Museum, Karlsplatz, *Exhibition of Paintings by Gari Melchers*, February 11

1911 New York. Montross Gallery, *Exhibition of Works by Gari Melchers*, March 1–15
1927 Detroit. Detroit Institute of Arts, *Retrospective Exhibition of Paintings by Gari Melchers*, October
New York. Milch Galleries, *Exhibition of Works by Gari Melchers*, November 28–December 24
1931 New York. Milch Galleries, *Paintings and Drawings by Gari Melchers*, March 2–28
1934 Savannah. Telfair Academy of Arts and Sciences, Inc., *Memorial Exhibition of Paintings by Gari Melchers*, March 2–April 1
1938 Richmond. Virginia Museum of Fine Arts, *Gari Melchers: A Memorial Exhibition of His Work*, January 17–February 28
1978 New York. Graham Gallery, *Gari Melchers (1860–1932), American Painter*, September 26–October 28
1984 Fredericksburg. Belmont, The Gari Melchers Memorial Gallery, *Gari Melchers in Holland*, March 6–May 2

The Bride is one of a series of paintings dealing with marriage, a theme Melchers took up in the early 1890s and explored from a variety of aspects. In *The Wedding* (Detroit Institute of Arts, fig. 13), for example, Melchers depicted a specific setting and cast of characters, while in Belmont's version he sacrificed narrative detail in favor of simplicity of design and symbolic mood.

Old reproductions in Belmont's archives disclose the picture's original green background and an inscription in the upper-right corner: "Paris 1903." (It is worth noting that in April of 1903 Melchers married Corinne Mackall.) Anna Dekker, the artist's Dutch cook, served as the model in this and the related pictures *Marriage* (cat. no. 22), *Married* (Belmont), and *Wedded* (location unknown).

32. UNPRETENTIOUS GARDEN, 1903–1909

Oil on canvas, 33³/₄ × 40¹/₄
Signed lower right: *G. Melchers.*
Telfair Academy of Arts and Sciences, Inc., Savannah, museum purchase,
Button Gwinnett Autograph Fund, 1916

PROVENANCE
The artist to the Telfair Academy of Arts and Sciences, 1916

EXHIBITION HISTORY
1916 New York. Montross Gallery, *Exhibition of Pictures by Gari Melchers*, March 7–April 1
1918 Washington, D.C. Corcoran Gallery of Art, *Paintings by Gari Melchers*, February 2–March 3
1919 Chicago. Art Institute of Chicago, *Paintings by Gari Melchers*, April 4–May 1
 Boston. Copley Society, *Loan Exhibition of Paintings by Gari Melchers*, November 12–29
1922 Pittsburgh. Museum of Art, Carnegie Institute, *An Exhibition of Art and Science in Gardens*,
 June 18–July 31
1923 Baltimore. Baltimore Museum of Art, *Paintings by Gari Melchers*, April 10–May 5
1934 Savannah. Telfair Academy of Arts and Sciences, Inc., *Memorial Exhibition of Paintings by Gari
 Melchers*, March 2–April 1
1938 Richmond. Virginia Museum of Fine Arts, *Gari Melchers: A Memorial Exhibition of His Work*,
 January 17–February 28
1963 Columbus, Georgia. Museum of Arts and Crafts, *American Traditionalists of the 20th Century*,
 February

Like *The Open Door* (pl. 19; cat. no. 38), *Unpretentious Garden* reflects not only the current
vogue for the subject of women but the domestic tranquility of Melchers's personal life. The
artist continued his investigations into the coloristic effects of Impressionism in this garden
setting at the rear of Melchers's house on School Street in Egmond aan den Hoef.

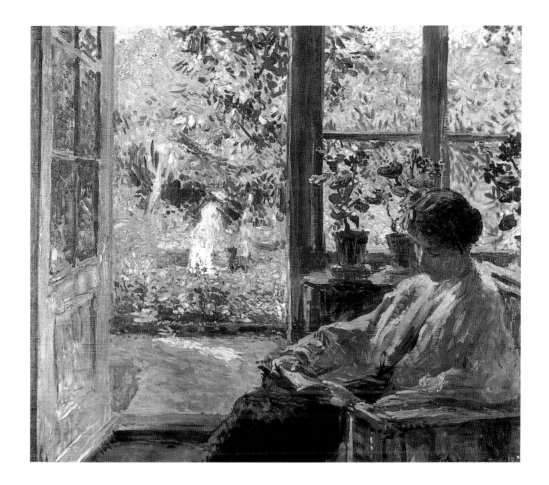

33. WOMAN READING BY A WINDOW, 1903–10
Oil on canvas, 25¹/₂ × 30
Signed lower right: *G. Melchers*
Mr. and Mrs. J. Bretan

PROVENANCE
Vincent D. Cliff, Detroit, in the 1920s, to his grandchild
Sotheby Parke Bernet Inc. to present owner

EXHIBITION HISTORY
1916 Syracuse. Syracuse Museum of Fine Arts, *Paintings by Gari Melchers*, October 1–November 1
 Washington, D.C. Corcoran Gallery of Art, *6th Annual Exhibition of Oil Paintings by
 Contemporary American Artists*, December 17–January 21, 1917

Painted around the same time as *Unpretentious Garden* (cat. no. 32), *Woman Reading by a
Window* is a view of Melchers's garden from the rear of his house at Egmond aan den Hoef.

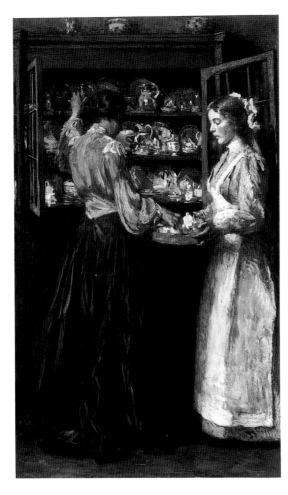

34. THE CHINA CLOSET, 1904–1905

Oil on canvas, 50 × 30
Signed lower right: *Gari Melchers.*
Belmont 1671
Plate 16

PROVENANCE
Belmont, The Gari Melchers Memorial Gallery

EXHIBITION HISTORY
1908 New York. Cottier and Company, *Gari Melchers*, January 28–February 21
Boston. Saint Botolph Club, *Paintings by Gari Melchers*, March 8–26
Pittsburgh. Museum of Art, Carnegie Institute, *12th Annual Exhibition*, April 30–June 30
Pittsburgh. Museum of Art, Carnegie Institute, *Summer Loan Exhibition*, August 13–
October 13
1929 New York. Anderson Galleries, *Paintings and Drawings by Gari Melchers*, January 1–26
1931 New York. Milch Galleries, *Paintings and Drawings by Gari Melchers*, March 2–28
1933 Washington, D.C. Corcoran Gallery of Art, *Memorial Exhibition of Paintings, Drawings, and
Etchings by Gari Melchers*, October 21–December 3
1934 Pittsburgh. Museum of Art, Carnegie Institute, *Gari Melchers Memorial Exhibition*,
January 11–February 18
1938 Richmond. Virginia Museum of Fine Arts, *Gari Melchers: A Memorial Exhibition of His Work*,
January 17–February 28
1981 Newport News, Virginia. Peninsula Fine Arts Center, *Gari Melchers: A Loan Exhibition*,
September 8–October 4
1984 Fredericksburg. Belmont, The Gari Melchers Memorial Gallery, *Gari Melchers in Holland*,
March 6–May 2
1986 Yonkers, New York. Hudson River Museum of Westchester, *Domestic Bliss: Family Life in
American Painting, 1840–1910*, May 18–July 14
Rochester. Margaret W. Strong Museum, *Domestic Bliss: Family Life in American Painting,
1840–1910*, August 17–November 30

The China Closet reflects Melchers's growing fondness for the subject of bourgeois life; the
painting's rich chromatic effects and the decorative quality of light on reflective surfaces
make it consistent with contemporary French taste. The models are Mrs. George Hitchcock
and her Dutch maid, Kierie Blok.

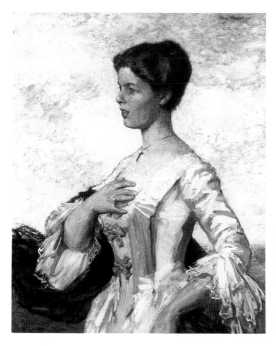

35. PORTRAIT OF MRS. GARI MELCHERS, 1905

Oil on canvas, 35³/4 × 28¹/2
Signed upper right: *Gari Melchers.*
Belmont 1701
Plate 17

PROVENANCE
Belmont, The Gari Melchers Memorial Gallery

EXHIBITION HISTORY
1907 Pittsburgh. Museum of Art, Carnegie Institute, *11th Annual Exhibition*, April 11–June 13
 Chicago. Art Institute of Chicago, *20th Annual Exhibition of Oil Paintings and Sculpture by American Artists*, October 22–December 1
1910 Weimar. Grossherzogliches Museum, Karlsplatz, *Exhibition of Paintings by Gari Melchers*, February 11
1928 Washington, D.C. Corcoran Gallery of Art, *Special Exhibition of Paintings by Gari Melchers and Edward W. Redfield*, March 3–April 8
1929 New York. Anderson Galleries, *Paintings and Drawings by Gari Melchers*, January 1–26
1930 Buffalo. Buffalo Fine Arts Academy/Albright Art Gallery, *Retrospective Exhibition of Paintings Representative of the Life Work of Gari Melchers*, February 2–March 2
 Dayton. Dayton Art Institute, *Exhibition of Paintings by Gari Melchers*, April 15–May 15
1932 New York. American Academy of Arts and Letters, *Exhibition of Paintings by Gari Melchers*, November 10–May 1, 1933
1933 Washington, D.C. Corcoran Gallery of Art, *Memorial Exhibition of Paintings, Drawings, and Etchings by Gari Melchers*, October 21–December 3
1934 Savannah. Telfair Academy of Arts and Sciences, Inc., *Memorial Exhibition of Paintings by Gari Melchers*, March 2–April 1
 Columbus, Ohio. Gallery of Fine Arts, *Exhibition of Paintings by Gari Melchers*, May 1–31
1935 Baltimore. Baltimore Museum of Art, *Memorial Exhibition of Gari Melchers*, March
 Grand Rapids. Grand Rapids Art Gallery, *A Memorial Exhibition: Gari Melchers*, October 1–31
1937 Raleigh, North Carolina. State Art Society of North Carolina, January 8–12
 Baltimore. Baltimore Museum of Art, October
1977 Fredericksburg. Belmont, The Gari Melchers Memorial Gallery, *Portraits by Gari Melchers*, February–June

Melchers met the young Baltimore art student Corinne Mackall on a trip to Europe in 1902. He persuaded her to study in Holland that summer, and after a brief courtship, the two were married in 1903. Almost immediately the new Mrs. Melchers began posing for her husband.

A comparison of this portrait with an old reproduction in the Belmont archives discloses a number of changes. Melchers reworked the face and garment and painted out two trees on either side of the figure.

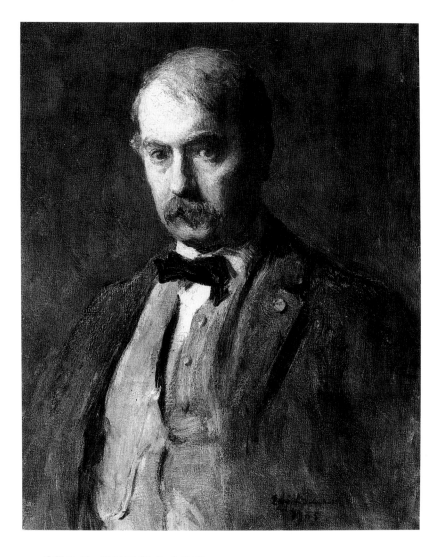

36. SELF-PORTRAIT, 1905

Oil on canvas, 31¼ × 25½
Signed lower right: *Gari Melchers./1905*
National Academy of Design, New York

EXHIBITION HISTORY
1983 New York. National Academy of Design, *Artists by Themselves: Artists' Portraits from the
National Academy of Design*, November 3–January 1, 1984, traveled

Candidates elected to the National Academy of Design must submit a self-portrait to qualify
for associate status, which Melchers attained in 1905 with this painting. Compared to the
likeness painted nine years earlier (pl. 11; cat. no. 27), the academy's version is more intro-
spective and stylistically conservative. No longer playing the confident individualist,
Melchers here portrayed himself as an established gentleman.

To qualify for academician, candidates are required to make a gift of a representative
example of their work to the academy. These membership prerequisites are the sole means by
which the academy amasses its collection. Melchers was made an academician in 1906.

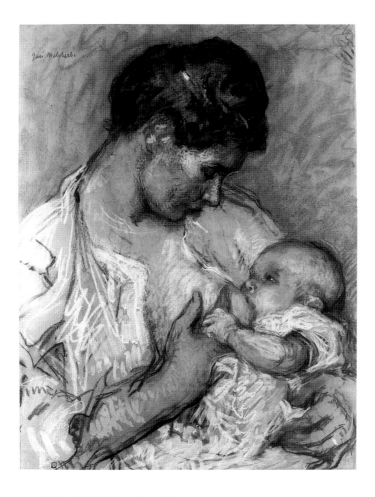

37. MOTHER AND CHILD, c. 1905–1908

Watercolor, charcoal, and pastel on paper mounted on board, 24 × 18¹/₄
Signed upper left: *Gari Melchers*.
Belmont 1688
Plate 18

PROVENANCE
Belmont, The Gari Melchers Memorial Gallery

EXHIBITION HISTORY
1938 Richmond. Virginia Museum of Fine Arts, *Gari Melchers: A Memorial Exhibition of His Work*,
 January 17–February 28
1983 Fredericksburg. Belmont, The Gari Melchers Memorial Gallery, *Mother and Child: Paintings
 by Gari Melchers*, April 15–May 16
1984 Fredericksburg. Belmont, The Gari Melchers Memorial Gallery, *Gari Melchers in Holland*,
 March 6–May 2
1985 Fredericksburg. Belmont, The Gari Melchers Memorial Gallery, *Children: Twenty Paintings,
 Drawings, and Prints by Gari Melchers*, November 1–January 6, 1986

The traditional role of women was particularly exalted at the turn of the century and was
reflected in the art of the time. Especially popular were images suggestive of a universal
mother and child. Reminiscent of the work of Mary Cassatt, *Mother and Child* bears
Melchers's personal stamp: an expert pastel technique. With a minimum of outline and an
expressive use of carefully placed color, he conveyed a sense of pulsating life and warm love.
Melchers's Dutch cook, Anna Dekker, who posed for *The Bride* (pl. 15; cat. no. 31) and
Marriage (cat. no. 22), modeled for the figure of the mother.

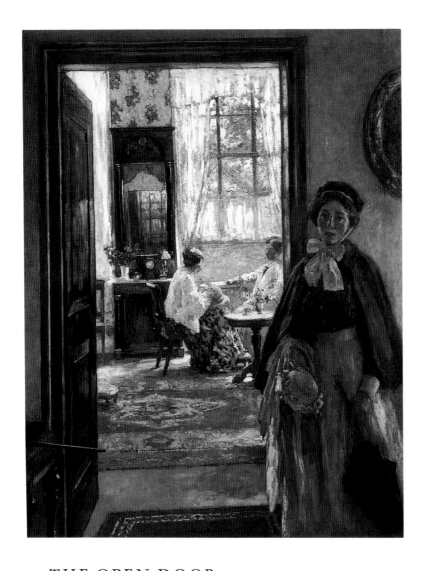

38. THE OPEN DOOR, c. 1905–10

Oil on canvas, 63 × 49½
Signed lower center: *Gari Melchers.*
Belmont 1714
Plate 19

PROVENANCE
Belmont, The Gari Melchers Memorial Gallery

EXHIBITION HISTORY
1912 Berlin. *Grosse Berliner Kunst-Ausstellung*, April–June
1914 Pittsburgh. Museum of Art, Carnegie Institute, *18th Annual Exhibition*, April 30–June 30
 St. Louis. St. Louis Art Museum, *9th Annual Exhibition of Selected Paintings by American Artists*, September–November
1915 San Francisco. Panama Pacific International Exposition, February 20–December 4
1916 New York. Montross Gallery, *Exhibition of Pictures by Gari Melchers*, March 7–April 1
1917 Detroit. Detroit Museum of Art, *3rd Annual Exhibition of Paintings by American Artists*, April 9–May 30
 Toledo. Toledo Museum of Art, *Annual Summer Exhibition: Paintings by American Artists*, June–August
1918 Washington, D.C. Corcoran Gallery of Art, *Paintings by Gari Melchers*, February 2–March 3
1920 New York. M. Knoedler and Company, *13th Annual Summer Exhibition of Paintings by American Artists*, n.d.

1921 Cincinnati. Cincinnati Art Museum, *28th Annual Exhibition of American Art*, May 28–
July 31

1929 Providence. Museum of Art, Rhode Island School of Design, *Fall Exhibition of Contemporary
American Paintings*, October 8–November 3

1930 Buffalo. Buffalo Fine Arts Academy/Albright Art Gallery, *Retrospective Exhibition of Paintings
Representative of the Life Work of Gari Melchers*, February 2–March 2

Rochester. Memorial Art Gallery of the University of Rochester, *Gari Melchers, N.A., Thomas
J. Mitchell, and Thirty Cleveland Artists*, March–April

Dayton. Dayton Art Institute, *Exhibition of Paintings by Gari Melchers*, April 15–May 15

1933 Washington, D.C. Corcoran Gallery of Art, *Memorial Exhibition of Paintings, Drawings, and
Etchings by Gari Melchers*, October 21–December 3

1934 Pittsburgh. Museum of Art, Carnegie Institute, *Gari Melchers Memorial Exhibition*, January
11–February 11

Columbus, Ohio. Gallery of Fine Arts, *Exhibition of Paintings by Gari Melchers*, May 1–31

1935 Baltimore. Baltimore Museum of Art, *A Memorial Exhibition of Gari Melchers*, March

1983 Fredericksburg. Belmont, The Gari Melchers Memorial Gallery, *Mother and Child: Paintings
by Gari Melchers*, April 15–May 16

1984 Fredericksburg. Belmont, The Gari Melchers Memorial Gallery, *Gari Melchers in Holland*,
March 6–May 2

MEDALS
Gold Medal, Panama Pacific International Exposition, San Francisco, 1915

Women in affluent interiors was a favorite theme of many turn-of-the-century painters.
Melchers did not demonstrate an interest in this genre until around the time of his marriage
in 1903. The happy state of his domestic affairs, coupled with his international success,
undoubtedly contributed to the tenor of these pictures, which were his brightest and most
decorative to date.

The Open Door is set in the parlor at Schuylenburg, the home of Melchers's American col-
league in Holland, George Hitchcock. Ironically, it was Hitchcock's abandonment of his
wife Henriette for a young art student that made it possible for Melchers to use the house as
a backdrop for these cheerful, homey interiors.

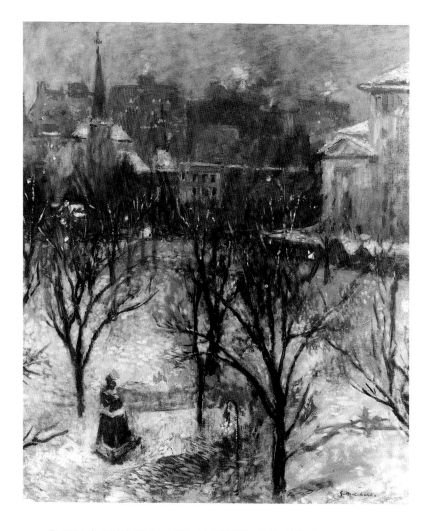

39. BRYANT PARK (TWILIGHT), c. 1906–1907

Oil on canvas, 34¹/₈ × 29¹/₂
Signed lower right: *G. Melchers.*
Belmont 1226
Plate 20

PROVENANCE
Belmont, The Gari Melchers Memorial Gallery

EXHIBITION HISTORY
1908 New York. Cottier and Company, *Gari Melchers,* January 28–February 21
 Providence. Museum of Art, Rhode Island School of Design, *An Exhibition of Paintings by
 Gari Melchers,* March 31–April 13
1910 Weimar. Grossherzogliches Museum, Karlsplatz, *Exhibition of Paintings by Gari Melchers,*
 February 11
1911 New York. Montross Gallery, *Exhibition of Works by Gari Melchers,* March 1–15
1938 Richmond. Virginia Museum of Fine Arts, *Gari Melchers: A Memorial Exhibition of His Work,*
 January 17–February 28

Between 1905 and 1909 important exhibitions and portrait commissions, like that for Presi-
dent Theodore Roosevelt, kept Melchers in the United States for extended periods. Having
made New York City his base, Melchers rented a studio in the Beaux Arts Building, facing
Bryant Park and the New York Public Library. The view from his window inspired his first
known urban subjects, two of which are included here, *Bryant Park (Twilight)* and *Snow*
(pl. 26; cat. no. 51).

40. HUDSON RIVER, c. 1907

Oil on canvas, 15$^{1}/_{2}$ × 23$^{1}/_{2}$
Signed lower right: *G. Melchers.*
Belmont 1203

PROVENANCE
Belmont, The Gari Melchers Memorial Gallery

EXHIBITION HISTORY
1987 Greenville, South Carolina. Greenville County Museum of Art, *Gari Melchers*, September
29–November 15

Here, as in his depictions of city streets and parks, Melchers employed a high vantage point.
Instead of the quiet of urban views muffled by snow, however, he suggests the dynamism of
the waterfront through the repeated use of smoke clouds billowing from stacks on buildings
and boats.

41. PORTRAIT OF JULIUS STROH, c. 1908

Oil on canvas, 43³/₄ × 30¹/₂
Signed lower right: *Gari Melchers.*
The Stroh Companies, Inc.

PROVENANCE
The artist to his brother-in-law, Julius Stroh
The Stroh Brewery Company, 1939

EXHIBITION HISTORY
1908 New York. Cottier and Company, *Gari Melchers*, January 28–February 21
1960 Detroit. Detroit Institute of Arts, *Gari Melchers: A Centenary Exhibition*, February 16–
 March 13

Julius Stroh was the second child and son of Detroit brewery founder Bernard Stroh. He
acted as secretary and treasurer of the family business until 1908, when his older brother,
Bernard, passed the presidency to him because of ill health. It was at this time that Stroh
posed for Melchers. Stroh was married to Melchers's sister, Hettie, and the personal associa-
tion between the two is reflected in this sensitive and insightful portrait. Stroh is clearly
portrayed as an earnest personality, an astute businessman, and a man of privilege.

 Stroh, an ardent supporter and patron of Melchers, acquired several of his brother-in-law's
finest works.

42. PENELOPE, 1910

Oil on canvas, 54¹/₂ × 50⁷/₈
Signed lower right: *Gari Melchers.*
The Corcoran Gallery of Art, Washington, D.C.,
Museum Purchase Gallery Fund, 1911
Plate 21

PROVENANCE
Purchased from the artist

EXHIBITION HISTORY

1910 Washington, D.C. Corcoran Gallery of Art, *3rd Annual Exhibition of Oil Paintings by Contemporary American Artists*, December 13–January 22, 1911

1911 New York. Montross Gallery, *Exhibition of Works by Gari Melchers*, March 1–15

1912 Philadelphia. Pennsylvania Academy of the Fine Arts, *107th Annual Exhibition*, February 4–March 24

1918 Washington, D.C. Corcoran Gallery of Art, *Paintings by Gari Melchers*, February 2–March 3

1927 Detroit. Detroit Institute of Arts, *Retrospective Exhibition of Paintings by Gari Melchers*, October

1930 Buffalo. Buffalo Fine Arts Academy/Albright Art Gallery, *Retrospective Exhibition of Paintings Representative of the Life Work of Gari Melchers*, February 2–March 2

1934 Savannah. Telfair Academy of Arts and Sciences, Inc., *Memorial Exhibition of Paintings by Gari Melchers*, March 2–April 1

1950 Norfolk, Virginia. Museum of Arts and Sciences, summer loan, June 15–November

1963 Knoxville, Tennessee. Dulin Gallery of Art, *A Century and a Half of American Painting*, April 3–May 13

1987 Muskegon. Muskegon Museum of Art, *Artists of Michigan from the 19th Century*, September 17–November 1

1987 Detroit. Detroit Historical Museum, *Artists of Michigan from the 19th Century*, November 12–January 28, 1988

MEDALS
Second William A. Clark Prize and Corcoran Silver Medal, *3rd Annual Exhibition of Oil Paintings by Contemporary American Artists,* Corcoran Gallery of Art, 1910

The sight of his beautiful young wife working over her tambour frame possibly inspired Melchers to paint this modern-day Penelope. In Homer's epic the *Odyssey*, Penelope, who awaits Odysseus' return, promises to marry only when her weaving has been completed. She keeps her suitors at bay by unraveling her work each night.

The distinctive rose-garland wallpaper identifies the setting as Schuylenburg, the home of American painter George Hitchcock (see *The Open Door*, pl. 19; cat. no. 38). The girl sorting threads is Mrs. Hitchcock's Dutch maid, Kierie Blok.

43. TORSO, after 1910

Pastel on paper, 14 × 13
Signed upper left: *G. Melchers.*
Private collection

PROVENANCE
Belmont, The Gari Melchers Memorial Gallery to a private collection, 1977

EXHIBITION HISTORY
1931 New York. Milch Galleries, *Paintings and Drawings by Gari Melchers*, March 2–28
1933 Washington, D.C. Corcoran Gallery of Art, *Memorial Exhibition of Paintings, Drawings, and Etchings by Gari Melchers*, October 21–December 3
1934 Pittsburgh. Museum of Art, Carnegie Institute, *Gari Melchers Memorial Exhibition*, January 11–February 18
1938 Richmond. Virginia Museum of Fine Arts, *Gari Melchers: A Memorial Exhibition of His Work*, January 17–February 28
1977 Fredericksburg. Belmont, The Gari Melchers Memorial Gallery, *Gari Melchers, 1860–1932*, November 19–December 11

Of all Melchers's efforts, none are so genuinely charged with life as are his pastels. Despite a minimum of descriptive detail, pictures like *Torso* and *Mother and Child* (pl. 18; cat. no. 37) derive their vitality from a quivering shorthand technique and expressive manipulation of color.

44. THE WARTBURG, NO. 1, c. 1912

Oil tempera on paper mounted on board, 35 × 25¹/₂
Signed lower right: *G. Melchers*.
Belmont 1593
Plate 22

PROVENANCE
Belmont, The Gari Melchers Memorial Gallery

Between 1909 and 1914 Melchers served, at the invitation of the grand duke of Saxe-
Weimar-Eisenach, as professor of art at the Grand Ducal Academy of Fine Arts in Weimar,
Germany. Surprisingly, he painted little of the country while residing there, with the excep-
tion of a few winterscapes and a series of sketches in oil tempera depicting old Wartburg
Castle. *The Wartburg, No. 1,* with its abbreviated brushwork, limited tonal range, and veiled
atmospheric effects, continues the investigation into landscape that Melchers began in Man-
hattan years before (see *Bryant Park (Twilight)*, pl. 20; cat. no. 39).

 Wartburg Castle held historical as well as visual appeal. Martin Luther took refuge there
after being condemned by the Diet of Worms in 1521 for his controversial religious views.
During his ten-month sanctuary, Luther translated the Bible from Latin into German.

45. EARLY SPRING LANDSCAPE, c. 1918

Oil on canvas, 17³/₄ × 21
Signed lower right: *G. Melchers.*
Belmont 1347
Plate 23

PROVENANCE
Belmont, The Gari Melchers Memorial Gallery

EXHIBITION HISTORY
1919 Boston. Copley Society, *Loan Exhibition of Paintings by Gari Melchers*, November 12–29
1920 New York. Montross Gallery, *Exhibition of Pictures by Gari Melchers: Figures and Landscapes*,
 January 10–31
1921 New York. Milch Galleries, *Paintings by Gari Melchers*, March 14–April 9
1927 New York. Milch Galleries, *Exhibition of Works by Gari Melchers*, November 28–December 24
1928 Dallas. Dallas Art Association, *Second Intimate Exhibition*, January 13–23
1977 Fredericksburg. Belmont, The Gari Melchers Memorial Gallery, *Gari Melchers in Virginia*,
 October 15–November 14
1983 Fredericksburg. Belmont, The Gari Melchers Memorial Gallery, *Our Town*, October 14–
 November 14

In 1916 Gari and Corinne Melchers settled permanently in Virginia. For five to six months
of the year the artist painted and relaxed in the company of his wife at Belmont, their estate
in Falmouth. The remainder of the year he was occupied with portrait commissions and
other duties in New York. The picturesque rural countryside surrounding his Virginia prop-
erty was just the respite he craved after a winter in the city. With paint box and easel in tow,
Melchers soon established himself as a regular fixture of the neighborhood. As *Early Spring
Landscape* attests, he discovered charm and beauty in every corner of the village. The land-
scapes of this period are characterized by a heavy application of bright, broken color, with
careful attention paid to the effects of season and climate.

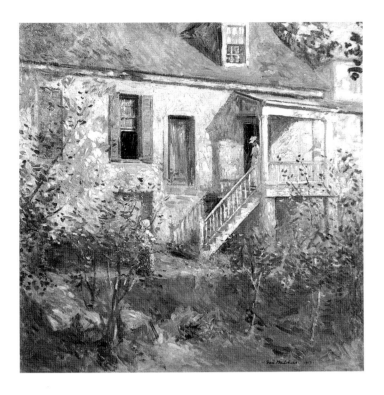

46. HOUSE WITH A PORCH, 1919

Oil on canvas, 31¼ × 31⅝
Signed lower right and dated: *Gari Melchers. 1919*
Mr. and Mrs. Peter W. Stroh

PROVENANCE
Belmont, The Gari Melchers Memorial Gallery to the Strohs, 1977

EXHIBITION HISTORY
1920 New York. Montross Gallery, *Exhibition of Pictures by Gari Melchers: Figures and Landscapes*,
 January 10–31
 Detroit. Detroit Institute of Arts, *6th Annual Exhibition of Selected Paintings by American
 Artists*, April 20–May 31
1925 New York. Frank Rehn Galleries, *Exhibition of Work by Gari Melchers and George Luks*, April–
 May 18
1933 Washington, D.C. Corcoran Gallery of Art, *Memorial Exhibition of Paintings, Drawings, and
 Etchings by Gari Melchers*, October 21–December 3
1934 Pittsburgh. Museum of Art, Carnegie Institute, *Gari Melchers Memorial Exhibition*,
 January 11–February 18
 Columbus, Ohio. Gallery of Fine Arts, *Exhibition of Paintings by Gari Melchers*, May 1–31
1935 Baltimore. Baltimore Museum of Art, *Memorial Exhibition of Gari Melchers*, March
 Grand Rapids. Grand Rapids Art Gallery, *A Memorial Exhibition: Gari Melchers*,
 October 1–31
1938 Richmond. Virginia Museum of Fine Arts, *Gari Melchers: A Memorial Exhibition of His Work*,
 January 17–February 28
1977 Fredericksburg. Belmont, The Gari Melchers Memorial Gallery, *Gari Melchers, 1860–1932*,
 November 19–December 11

House with a Porch pictures the fieldstone bakery Melchers purchased in 1918 to function as
one of three Virginia studios. It was here that he completed important mural commissions
for the Detroit Public Library and the Missouri state capitol.

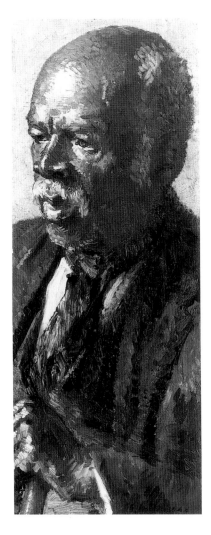

47. UNCLE JIM, c. 1919
Oil on panel, 19¹/₄ × 8¹/₈
Signed lower right: *G. Melchers*.
Verso upper center: *Uncle Jim/Gari Melchers*.
Belmont 1573
Plate 24

PROVENANCE
Belmont, The Gari Melchers Memorial Gallery

EXHIBITION HISTORY
1920 New York. Montross Gallery, *Exhibition of Pictures by Gari Melchers: Figures and Landscapes*,
 January 10–31
1925 New York. Frank Rehn Galleries, *Exhibitions of Work by Gari Melchers and George Luks*, April–
 May 18
1934 Savannah. Telfair Academy of Arts and Sciences, Inc., *Memorial Exhibition of Paintings by Gari
 Melchers*, March 2–April 1
1977 Fredericksburg. Belmont, The Gari Melchers Memorial Gallery, *Gari Melchers in Virginia*,
 October 15–November 14
1983 Fredericksburg. Belmont, The Gari Melchers Memorial Gallery, *Our Town*, October 14–
 November 14

This uncomplicated depiction of James Rowser, whose daughter occasionally worked for
Melchers, is as penetrating and vital as any portrait produced by the artist. Its strength is
derived in part from its severely restrictive format and the animated play of facial highlights
against a dramatic green background.

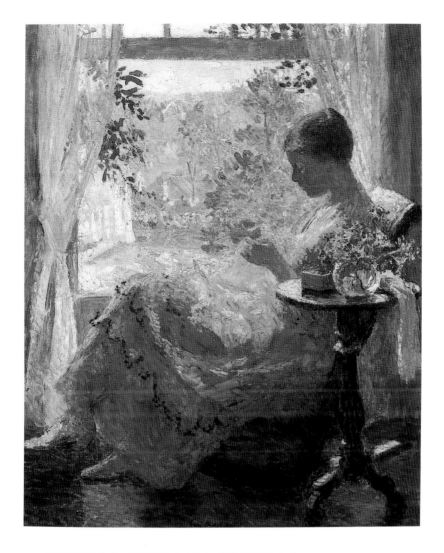

48. YOUNG WOMAN SEWING, 1919

Oil on canvas, 34¼ × 29¼
Signed lower center: *Gari Melchers.*
Belmont 1460
Plate 25

PROVENANCE
Belmont, The Gari Melchers Memorial Gallery

EXHIBITION HISTORY
1929 New York. Anderson Galleries, *Paintings and Drawings by Gari Melchers,* January 1–26.
1974 Fredericksburg. Chimneys Museum (through 1981)
1982 Stockholm. American Embassy Residence (through 1985)
1986 Jacksonville, Florida. Cummer Gallery of Art, *Transitions in American Impressionism,*
 October 23–January 11, 1987

William H. Gerdts has called this painting "a classic example of domesticated American
Impressionism" (*American Impressionism*, New York: Abbeville Press, 1984, p. 309).
Melchers's wife, Corinne, is shown seated at a window of their Virginia home. Photographs
of a lost preparatory oil sketch reveal that the vase of flowers on the side table was an
afterthought.

49. MORNING HAZE, c. 1920

Oil on canvas, 12³/₈ × 17
Signed lower right: *G. Melchers.*
Belmont 1315

PROVENANCE
Belmont, The Gari Melchers Memorial Gallery

EXHIBITION HISTORY
1983 Fredericksburg. Belmont, The Gari Melchers Memorial Gallery, *Our Town*, October 14–
 November 14

The Rappahannock River, a prominent feature of Melchers's Virginia neighborhood, became
the subject of a number of his pictures, including *Morning Haze*. The artist went on frequent
sketching expeditions on the river by rowboat. By carefully manipulating light and atmos-
phere, he conveyed a romantic, dreamlike impression of this southern river at dawn.

50. SAINT GEORGE'S CHURCH, c. 1920

Oil on canvas, 33 × 32¼
Signed lower left: *Gari Melchers.*
Belmont 1456

PROVENANCE
Belmont, The Gari Melchers Memorial Gallery

EXHIBITION HISTORY
1920 New York. Montross Gallery, *Exhibition of Pictures by Gari Melchers: Figures and Landscapes*,
January 10–31
Detroit. Detroit Institute of Arts, *6th Annual Exhibition of Selected Paintings by American
Artists*, April 20–May 31
1922 New York. M. Knoedler and Company, *15th Annual Summer Exhibition of Paintings by
American Artists*, n.d.
1927 New York. Milch Galleries, *Exhibition of Works by Gari Melchers*, November 28–December 24
Detroit. Detroit Institute of Arts, *Retrospective Exhibition of Paintings by Gari Melchers*, October
1928 Dallas. Dallas Art Association, *Second Intimate Exhibition*, January 13–23
1930 Buffalo. Buffalo Fine Arts Academy/Albright Art Gallery, *Retrospective Exhibition of Paintings
Representative of the Life Work of Gari Melchers*, February 2–March 2
Rochester. Memorial Art Gallery of the University of Rochester, *Gari Melchers, N.A., Thomas
J. Mitchell, and Thirty Cleveland Artists*, March–April
Dayton. Dayton Art Institute, *Exhibition of Paintings by Gari Melchers*, April 15–May 15
1932 Lincoln, Nebraska. Nebraska Art Association, *42nd Annual Exhibition of Paintings*,
February 11–March 13
New York. American Academy of Arts and Letters, *Exhibition of Paintings by Gari Melchers*,
November 10–May 1, 1933
1933 Washington, D.C. Corcoran Gallery of Art, *Memorial Exhibition of Paintings, Drawings, and
Etchings by Gari Melchers*, October 21–December 3
1934 Pittsburgh. Museum of Art, Carnegie Institute, *Gari Melchers Memorial Exhibition*,
January 11–February 18
1938 Richmond. Virginia Museum of Fine Arts, *Gari Melchers: A Memorial Exhibition of His Work*,
January 17–February 28
1977 Fredericksburg. Belmont, The Gari Melchers Memorial Gallery, *Gari Melchers in Virginia*,
October 15–November 14
1983 Fredericksburg. Belmont, The Gari Melchers Memorial Gallery, *Our Town*, October 14–
November 14

Melchers's fascination with the quality and character of small-town life persisted throughout
his career. At his home in Virginia he discovered the same quiet dignity and simple beauty
that captivated him in coastal Holland. Windmills, however, were now supplanted by
church steeples and picket fences, and his Impressionist technique grew brighter and more
delicate.

51. SNOW, 1921

Oil on canvas, 43 × 31¹/8
Signed and dated lower right: *Gari Melchers./1921.*
Belmont 1403
Plate 26

PROVENANCE
Belmont, The Gari Melchers Memorial Gallery

EXHIBITION HISTORY
1921 New York. Milch Galleries, *Paintings by Gari Melchers*, March 14–April 9
1922 New York. Milch Galleries, *Gari Melchers*, January 28–February 16
1926 New York. New Society of Artists, *8th Annual Exhibition*, November 15–December 4
1927 New York. Milch Galleries, *Exhibition of Works by Gari Melchers*, November 28–December 24
1929 New York. Anderson Galleries, *Paintings and Drawings by Gari Melchers*, January 1–26
1930 Buffalo. Buffalo Fine Arts Academy/Albright Art Gallery, *Retrospective Exhibition of Paintings Representative of the Life Work of Gari Melchers*, February 2–March 2
1931 Pittsburgh. Museum of Art, Carnegie Institute, *30th International Exhibition of Paintings*, October 15–December 6
1932 Philadelphia. Pennsylvania Academy of the Fine Arts, *127th Annual Exhibition*, January 24–March 13
New York. American Academy and Institute of Arts and Letters, *Exhibition of Paintings by Gari Melchers*, November 10–May 1, 1933

Pentimenti around the face suggest that Melchers may have reworked this painting and dated it a decade later, a practice not uncommon for the artist. Despite its 1921 date, *Snow* stylistically relates to the Bryant Park series of circa 1907; an unidentified work titled *Snow* was exhibited in New York, Buffalo, and Chicago in 1911 and 1912.

Another version of this painting exists in a private collection.

52. THE SUN PORCH, c. 1921

Oil on canvas, 28 × 18
Signed lower left: *G. Melchers*
Belmont 1735
Plate 27

PROVENANCE
Belmont, The Gari Melchers Memorial Gallery

EXHIBITION HISTORY
1921 New York. Milch Galleries, *Paintings by Gari Melchers*, March 14–April 9
1928 New York. Brooklyn Museum, *9th Annual Exhibition of Paintings and Sculpture by the New Society of Artists*, November 19–January 1, 1929
1977 Fredericksburg. Belmont, The Gari Melchers Memorial Gallery, *Gari Melchers in Virginia*, October 15–November 14

In *The Sun Porch* Melchers placed a figure reading by a window, employing a composition similar to one first used in *The Letter* (pl. 1; cat. no. 6). *The Sun Porch* pictures the British author and critic Charles Lewis Hind seated in the solarium at Belmont. (Hind was the husband of the former Mrs. George Hitchcock.) Executed in an extremely loose hand, the artist's principal concern was with recreating the jewellike coloristic effects of natural lighting.

53. MADONNA OF THE RAPPAHANNOCK, 1923

Oil on canvas, 39³/₄ × 37³/₄
Signed and dated lower center: *Gari Melchers. 1923*
Virginia Museum of Fine Arts, Richmond, gift of John Barton Payne, 1935

PROVENANCE
The artist to John Barton Payne

EXHIBITION HISTORY
1923 Washington, D.C. Corcoran Gallery of Art, *9th Exhibition of Contemporary American Oil
 Paintings*, December 16–January 20, 1924
1928 Washington, D.C. Corcoran Gallery of Art, *Special Exhibition of Paintings by Gari Melchers and
 Edward W. Redfield*, March 3–April 8
1930 Buffalo. Buffalo Fine Arts Academy/Albright Art Gallery, *Retrospective Exhibition of Paintings
 Representative of the Life Work of Gari Melchers*, February 2–March 2
1933 Cleveland. Cleveland Museum of Art, *International Exhibition of 1933*, March 10–April 9
1934 Pittsburgh. Museum of Art, Carnegie Institute, *Gari Melchers Memorial Exhibition*,
 January 11–February 18
1938 Richmond. Virginia Museum of Fine Arts, *Gari Melchers: A Memorial Exhibition of His Work*,
 January 17–February 28
1962 New York. Century Association, *Exhibition of Works by Gari Melchers*, January 10–March 5
1977 Fredericksburg. Belmont, The Gari Melchers Memorial Gallery, *Gari Melchers in Virginia*,
 October 15–November 14

Melchers's fondness for the mother and child theme never waned. Only the nationality of his
models changed. Upon his return to the United States in 1915, he replaced Dutch peasant
mothers with contemporary American women. In *Madonna of the Rappahannock* he recreated
the countryside around Belmont and the river it overlooks. The models were Eva Fritter and
her infant ward, neighbors of the artist, who also posed for related pictures in the Belmont
collection. The picture's ornately gilded frame and halo are somewhat incongruous in this
modern context but are devices the artist occasionally employed to convey spiritual beauty in
the commonplace.

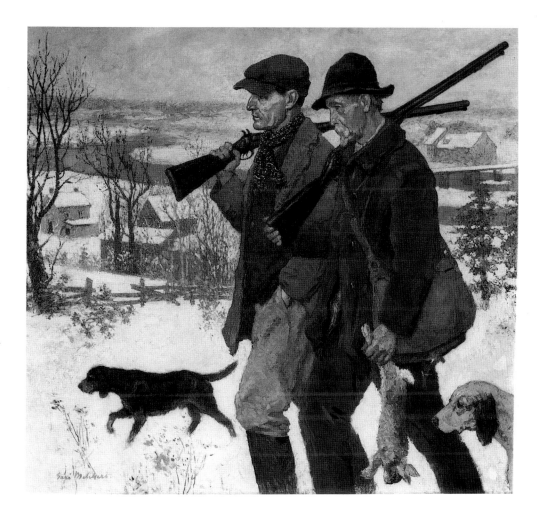

54. THE HUNTERS, c. 1925

Oil on canvas, 53³/₈ × 59¹/₄
Signed lower left: *Gari Melchers.*
Mr. and Mrs. Robert G. Beck, Newport News, Virginia
Plate 28

PROVENANCE
Belmont, The Gari Melchers Memorial Gallery to the Becks

EXHIBITION HISTORY
1926 Washington, D.C. Corcoran Gallery of Art, *10th Annual Exhibition of Contemporary American Oil Painting*, April 4–May 16
Toledo. Toledo Museum of Art, *14th Annual Exhibition of Selected Paintings by American Artists*, June–August
1927 New York. Century Association, *A Representative Collection of the Works of Gari Melchers*, February
Pittsburgh. Museum of Art, Carnegie Institute, *26th International Exhibition of Paintings*, October 13–December 4
1928 New York. Brooklyn Museum, *The 26th Annual Carnegie Exhibition*, January 14–February 19
1930 Buffalo. Buffalo Fine Arts Academy/Albright Art Gallery, *Retrospective Exhibition of Paintings Representative of the Life Work of Gari Melchers*, February 2–March 2
Rochester. Memorial Art Gallery of the University of Rochester, *Gari Melchers, N.A., Thomas J. Mitchell, and Thirty Cleveland Artists*, March–April
Dayton. Dayton Art Institute, *Exhibition of Paintings by Gari Melchers*, April 15–May 15
1932 New York. American Academy of Arts and Letters, *Exhibition of Paintings by Gari Melchers*, November 10–May 1, 1933

1933 Washington, D.C. Corcoran Gallery of Art, *Memorial Exhibition of Paintings, Drawings, and Etchings by Gari Melchers*, October 21–December 3

1934 Savannah. Telfair Academy of Arts and Sciences, Inc., *Memorial Exhibition of Paintings by Gari Melchers*, March 2–April 1

1937 Raleigh, North Carolina. State Art Society of North Carolina, January 8–12

1938 Richmond. Virginia Museum of Fine Arts, *Gari Melchers: A Memorial Exhibition of His Work*, January 17–February 28

1962 New York. Century Association, *Exhibition of Works by Gari Melchers*, January 10–March 5

1977 Fredericksburg. Belmont, The Gari Melchers Memorial Gallery, *Gari Melchers in Virginia*, October 15–November 14

Fredericksburg. Belmont, The Gari Melchers Memorial Gallery, *Gari Melchers, 1860–1932*, November 19–December 11 .

1983 Richmond. Virginia Museum of Fine Arts, *Painting in the South: 1564–1980*, September 14–November 27

1984 Birmingham, Alabama. Birmingham Museum of Art, *Painting in the South: 1564–1980*, January 8–March 4

New York. National Academy of Design, *Painting in the South: 1564–1980*, April 12–May 27

Jackson. Mississippi Museum of Art, *Painting in the South: 1564–1980*, June 24–August 26

Louisville, Kentucky. J. B. Speed Art Museum, *Painting in the South: 1564–1980*, September 16–November 11

New Orleans. New Orleans Museum of Art, *Painting in the South: 1564–1980*, December 9–February 3, 1985

1987 Muskegon. Muskegon Museum of Art, *Artists of Michigan from the 19th Century*, September 17–November 1

Detroit. Detroit Historical Museum, *Artists of Michigan from the 19th Century*, November 12–January 28, 1988

MEDALS
Popular Prize, *26th International Exhibition of Paintings*, Museum of Art, Carnegie Institute, 1927

Melchers long admired the masters of Northern European painting and over the years amassed hundreds of postcard reproductions. Two facsimiles in his possession were Pieter Brueghel's *Hunters in the Snow* and *Dark Day*, paintings that bear striking parallels to this work. Aside from the related subject, all three share a similar compositional format. Hunters or workmen accompanied by dogs occupy the foreground of each painting. The eye follows a zigzag of rain-soaked tree trunks and winding rivers, under threatening skies, into the background space.

While Brueghel's panoramic views were imaginary, Melchers accurately portrayed the view from the heights of Belmont and the Rappahannock River as it flowed southeast. The huntsmen have been identified as Melchers's groundsman, Mason Dillon, and Dillon's father-in-law, Mr. Gibbs.

55. SCHOOL (ADAM'S RUN), 1925

Gouache on paper, 18³/₈ × 23¹/₄
Signed and dated lower left: *Gari Melchers/Adam's Run, S.C./1925*
Belmont 1542

PROVENANCE
Belmont, The Gari Melchers Memorial Gallery

EXHIBITION HISTORY
1938 Richmond. Virginia Museum of Fine Arts, *Gari Melchers: A Memorial Exhibition of His Work*,
January 17–February 28

Melchers and his wife frequently traveled south to visit family. Occasionally these automobile
trips provided him with a fresh perspective on an old theme. In 1925 a stopover in rural
Adam's Run, South Carolina, afforded him just such an opportunity. The concept and
design for the schoolroom at Adam's Run is rooted in early pictures like *The Choirmaster*
(cat. no. 15) and *The Sermon* (pl. 2; cat. no. 11).

56. STILL LIFE, c. 1925

Oil on canvas, 22¼ × 18⅛
Signed upper right: *G. Melchers.*
The Honorable J. Granger Macfarlane, Roanoke, Virginia

PROVENANCE
Knoke Galleries, Marietta, Georgia, to Jordan Volpe Gallery, New York

It was not until the last decade of his life that Melchers developed an interest in still life, perhaps as a relief from the more demanding requirements of mural painting, landscape, and portraiture. Without exception, Melchers's still lifes exhibit exuberant color and energetic handling of paint.

Melchers employed still life in figure paintings as well, in much the same manner as Childe Hassam (see Dreiss, above, pp. 114–15). A vase of flowers is prominently positioned in *Snow* (pl. 26; cat. no 51) and in *Young Woman Sewing* (pl. 25; cat. no. 48).

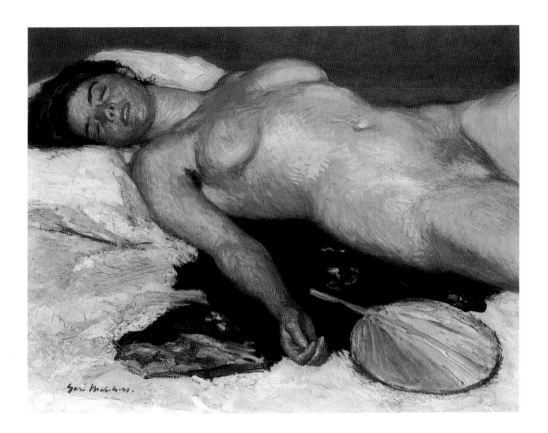

57. LASSITUDE, c. 1925–31

Oil on canvas, 36 × 29
Signed lower left: *Gari Melchers*.
Belmont 1572
Plate 29

PROVENANCE
Belmont, The Gari Melchers Memorial Gallery

EXHIBITION HISTORY
1933 Washington, D.C. Corcoran Gallery of Art, *Memorial Exhibition of Paintings, Drawings, and Etchings by Gari Melchers*, October 21–December 3
1934 Pittsburgh. Museum of Art, Carnegie Institute, *Gari Melchers Memorial Exhibition*, January 11–February 18
1980 Fredericksburg. Belmont, The Gari Melchers Memorial Gallery, *Nudes by Gari Melchers*, November 7–December 4

Although Melchers painted nudes throughout his career, in later life he turned to this subject with great frequency and enthusiasm. Compared with earlier examples, the late nudes are generally far larger in scale. Painted in a high-key palette, the figures are shown provocatively at close range and are erotic in mood.

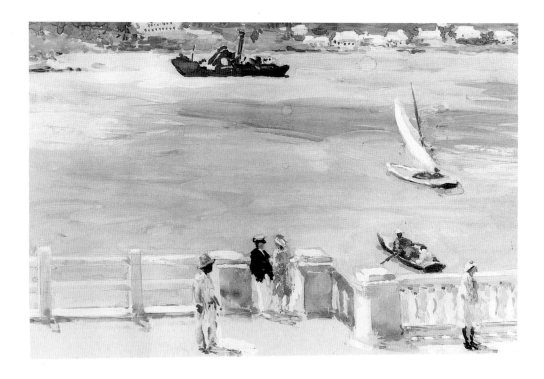

58. THE LANDING (BERMUDA), 1927

Gouache on paper mounted on board, 9¹/₂ × 14¹/₂
Signed and dated lower left: *G. Melchers. 1927*
Belmont 1175

PROVENANCE
Belmont, The Gari Melchers Memorial Gallery

EXHIBITION HISTORY
1927 Detroit. Detroit Institute of Arts, *Retrospective Exhibition of Paintings by Gari Melchers*, October
1928 Dallas. Dallas Art Association, *Second Intimate Exhibition*, January 13–23
 Washington, D.C. Corcoran Gallery of Art, *Special Exhibition of Paintings by Gari Melchers and Edward W. Redfield*, March 3–April 8
1933 Washington, D.C. Corcoran Gallery of Art, *Memorial Exhibition of Paintings, Drawings, and Etchings by Gari Melchers*, October 21–December 3
1934 Pittsburgh. Museum of Art, Carnegie Institute, *Gari Melchers Memorial Exhibition*, January 11–February 18
1938 Richmond. Virginia Museum of Fine Arts, *Gari Melchers: A Memorial Exhibition of His Work*, January 17–February 28

On several occasions throughout the 1920s Melchers wintered at the Bermuda home of his patron Charles Blair MacDonald, a stockbroker and designer of golf courses. As with Winslow Homer, the picturesque harbors, attractive natives, and intense sunlight of the island proved irresistible to Melchers, who produced countless impressions in a variety of media and styles.

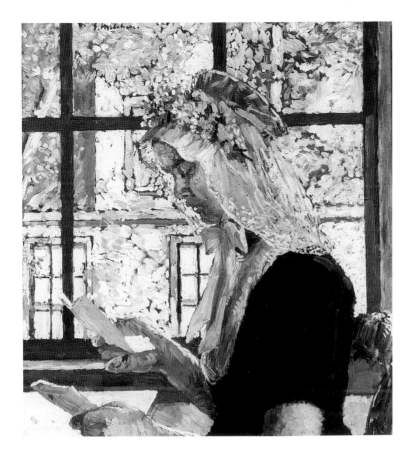

59. THE LACE CAP, 1932

Oil on paper mounted on composition board, 19¼ × 17¼
Signed upper left: *G. Melchers.*
Belmont 1299
Plate 30

PROVENANCE
Belmont, The Gari Melchers Memorial Gallery

EXHIBITION HISTORY
1938 Richmond. Virginia Museum of Fine Arts, *Gari Melchers: A Memorial Exhibition of His Work*,
 January 17–February 28
1945 New York. Cosmopolitan Club, February 21–March 3
1981 Newport News, Virginia. Peninsula Fine Arts Center, *Gari Melchers: A Loan Exhibition*,
 September 8–October 4

It is noteworthy that *The Lace Cap*, the last painting Melchers completed before his death,
deals with the same subject as *The Letter* (pl. 1; cat. no. 6), his first picture to be accepted
into the Paris Salon. A comparison of the two reveals the marked stylistic disparity between
his early and late works. His style evolved from a dark, academic factualism to a brighter,
looser impressionistic technique.

 Melchers's love affair with things Dutch never diminished. *The Lace Cap* was painted in
Virginia but is based on sketches produced while visiting Holland in 1932. (Passport stamps
and a ship passage booklet attest that Melchers, in the year of his death, made a last trip to
Holland and Germany.)

1860 August 11, born in Detroit, to Julius Melchers, sculptor, and Marie Bangetor

1877 Enters Royal Academy of Art, Düsseldorf

1881 Enters Ecole des Beaux-Arts and Académie Julian, Paris

1882 Debuts in the Salons of Paris and Antwerp

1884 Establishes a studio in Egmond aan Zee, Holland, with the American expatriate painter
 George Hitchcock

1886 Honorable Mention, *Salon de la Société des Artistes Français,* Paris, for *The Sermon*
 First-Class Gold Medal, *Tentoonstelling van Kunstwerken van Levende Meesters,* Amsterdam,
 for *The Sermon*

1888 First-Class Gold Medal, *3. Internationale Kunst-Ausstellung,* Munich, for *The Sermon*
 Third-Class Gold Medal, *Salon de la Société des Artistes Français,* Paris, for *The Pilots*

1889 Grand Prize, American Painting, *Exposition Universelle,* Paris, for *The Communion;*
 The Sermon; Audrey, The Shepherd Lass; and *The Pilots*

1891 First Prize, *4th Annual Exhibition of Oil Paintings and Sculpture by American Artists,* Art
 Institute of Chicago, for *The Pilots*
 Medal of Honor, *Internationale Kunst-Ausstellung,* Berlin

1892 Gold Medal, Philadelphia Art Club, for *The Pilots*
 Order of Saint Michael of Bavaria, 4th Class

1893 Member, International Jury of Award, World's Columbian Exposition, Chicago

1894 Medal of Honor, *Exposition Universelle,* Antwerp, for *The Nativity*

1895 Chevalier of the Legion of Honor, France
 Knight of the Order of Saint Michael of Bavaria

1896 Temple Gold Medal, *65th Annual Exhibition,* Pennsylvania Academy of the Fine Arts,
 for *The Family*

1897 Bronze Medal, *Internationale Kunst-Ausstellung,* Dresden
 Founding Member, Paris Society of American Painters

1898 First-Class Gold Medal, *Jubeljahr Kunst-Ausstellung,* Vienna, for *The Fencing Master*
 Elected to National Institute of Arts and Letters

1900 First-Class Medal, *Salon de la Société des Artistes Français,* Paris, for service on the
 jury of selection
 Occupies an entire gallery in the *Grosse Berliner Kunst-Ausstellung*

1901 First-Class Gold Medal, *4. Internationale Kunst-Ausstellung,* Dresden, for *Marriage, The Sisters,*
 and *The Communicant*
 First-Class Gold Medal, *Pan-American Exposition,* Buffalo
 Member in Ordinary, Royal Academy, Berlin

1902 Royal Order of Saint Michael of Bavaria

1903 April 14, Marries Corinne Lawton Mackall

1904 Gold Medal, Louisiana Purchase Exposition, St. Louis, for service on the selection committee
Officer of the Legion of Honor, France

1905 Associate, National Academy of Design, New York

1906 Academician, National Academy of Design, New York

1907 Officer, Royal Prussian Order of the Red Eagle

1908 Member, Royal Society of the Arts, Brussels
Member, Institute of France

1909 Appointed professor of art, Grand Ducal Academy of Fine Arts, Weimar

1910 Second William A. Clark Prize and Corcoran Silver Medal, *3rd Annual Exhibition of Oil Paintings by Contemporary American Artists,* Corcoran Gallery of Art, for *Penelope*

1911 Officer, Grand Ducal Order of the White Falcon, Saxony
Member, International Society of Painters, Sculptors, and Gravers, London
Member, Royal Society of Austrian Painters
Member, Munich Secession
Member, Century Association, New York

1913 Honorary Doctor of Laws, University of Michigan

1915 Gold Medal, Panama Pacific International Exposition, San Francisco, for *Skaters,* and
The Open Door
Leaves Weimar and Egmond and returns to the United States

1916 Settles in Falmouth, Virginia
Member, American Academy of Arts and Letters, New York
Member, Coffee House, New York

1920 President, New Society of Artists, until 1926

1921 Appointed to Smithsonian Commission to Establish a National Gallery of Art

1923 Chairman, Smithsonian Commission to Establish a National Gallery of Art

1926 Gold Medal, Philadelphia Sesquicentennial Exposition, for *MacPherson and MacDonald*

1927 Popular Prize, *26th International Exhibition of Paintings,* Museum of Art, Carnegie Institute,
for *The Hunters*

1928 Popular Prize, *11th Exhibition of Contemporary American Painting,* Corcoran Gallery of Art, for
The Native of Virginia

1930 Appointed to the Virginia Arts Commission

1931 Gold Medal, Maryland Art Institute, for *The Native of Virginia*
Elected to Board of Trustees, Corcoran Gallery of Art
President, Century Association

1932 Gold Medal, National Institute of Arts and Letters, New York
November 30, dies at Belmont, Falmouth, Virginia

SELECTED BIBLIOGRAPHY

Bienenstock, Jennifer A. M. *The Forgotten Episode: Nineteenth-Century American Art in Belgian Public Collections*. Brussels: The American Cultural Center, 1987.

————. "From Yankee Ingenuity to Yankee Artistry: American Artists at the Antwerp World's Fair of 1894." *Museum Magazine* (Antwerp), vol. 7 (1988), pp. 36–48.

Blaugrund, Annette, et al. *Paris 1889: American Artists at the Universal Exposition*. Philadelphia: Pennsylvania Academy of the Fine Arts; New York: Harry N. Abrams, 1989.

Brenchley, J. "Gari Melchers and His Work." *The Magazine of Art*, February 1900, pp. 145–51.

Brinton, Christian. "The Art of Gari Melchers." *Harper's Magazine*, vol. 114 (February 1907), pp. 430–39.

————. "Gari Melchers: An Estimate of the Man and His Art." *Vanity Fair*, July 1921, pp. 37, 78.

————. *Modern Artists*. New York: Baker and Taylor, 1908.

Brooklyn Museum. *The American Renaissance, 1876–1917*. New York, 1979.

Buffalo Fine Arts Academy and Albright Art Gallery. *Retrospective Exhibition of Paintings Representative of the Life Work of Gari Melchers, N.A.* Buffalo, 1930.

Burke, Mary Alice. *Elizabeth Nourse, 1859–1938: A Salon Career*. Washington, D.C.: National Museum of American Art, Smithsonian Institution, 1983.

Burroughs, Clyde H. *Exhibition of Paintings by Gari Melchers*. Detroit: Detroit Institute of Arts, 1927.

Caffin, Charles H. *The Story of American Painting*, New York: Frederick A. Stokes, 1907.

Carnegie Institute of Art. *Gari Melchers Memorial Exhibition*. Pittsburgh, 1933.

Child, Theodore. "American Artists at the Paris Exhibition." *Harper's New Monthly Magazine*, September 1889, pp. 489, 508–10.

Corcoran Gallery of Art. *Memorial Exhibition of Paintings, Drawings, and Etchings by Gari Melchers*. Washington, D.C., 1933.

Cortissoz, Royal. *Exhibition of Paintings by Gari Melchers*. New York: American Academy of Arts and Letters, 1932.

————. "Gari Melchers." In *Dictionary of American Biography*, vol. 12. New York: Charles Scribner's Sons, 1933.

————. "Some Notable Shows Begin the New Year." *New York Herald Tribune*, January 6, 1929, p. 10.

Detroit Institute of Arts. *The Quest for Unity: American Art between World's Fairs, 1876–1893*. Detroit, 1983.

Dewhurst, Kurt C., Betty MacDowell, and Marsha MacDowell. "The Art of Julius and Gari Melchers." *The Magazine Antiques*, April 1984, pp. 862–73.

Donaldson, Bruce. *Gari Melchers: A Memorial Exhibition of His Work*. Richmond: Virginia Museum of Fine Arts, 1938.

Dreiss, Joseph G. *Gari Melchers: His Works in the Belmont Collection*. Charlottesville, Va.: University Press of Virginia, 1984.

Fraser, W. Lewis. "Decorative Painting at the World's Fair: The Work of Gari Melchers and Walter MacEwen." *Century Illustrated Monthly Magazine*, vol. 46 (May 1893), pp. 14–21.

"Gari Melchers Dies: American Painter Was 72." *New York Herald Tribune*, December 1, 1932.

"Gari Melchers, Famed Detroit Artist, Is Dead." *Detroit Free Press*, December 1, 1932.

Gerdts, William H. *American Impressionism*. New York: Abbeville Press, 1984.

Goley, Mary Anne. *The Hague School and Its American Legacy*. Washington, D.C.: Board of Governors of the Federal Reserve Board, 1982.

Greenville County Museum of Art. *Impressionism and the South*. Greenville, North Carolina, 1988.

Hassam, Childe. "Gari Melchers." *Commemorative Tributes of the American Academy of Arts and Letters*. New York: American Academy of Arts and Letters, 1938, pp. 284–91.

Hind, Charles Lewis. "Artists Who Matter." *International Interpreter*, June 1922, p. 275.

————. "Gari Melchers." *World's Work*, vol. 15 (April 1908), pp. 10092–105.

Hoeber, Arthur. "Gari Melchers." *International Studio*, vol. 31 (March 1907), pp. xi–xviii.

Hudson River Museum of Westchester. *Domestic Bliss: Family Life in American Painting, 1840–1910*. Yonkers, N.Y.: 1986.

Jackman, Rilla Evelyn. *American Arts*. Chicago: Rand McNally, 1928.

Jewell, Edward Alden. "Gari Melchers, Noted Artist, Dead." *New York Times*, December 1, 1932, p. 21.

Kroeber, Hans Timotheus. "Gari Melchers." *Westermanns Monatshefte*, April 1912, pp. 185–96.

Laurvik, J. Nilsen. "Gari Melchers, Painter." *International Studio*, vol. 48 (December 1912), pp. 27–30.

Leroi, Paul. "Salon de 1886." *L'Art*, July 1886, pp. 16–20.

Lewis-Hind, Henriette. *Gari Melchers, Painter*. New York: W.E. Rudge, 1928.

Lucas, E. V. "Gari Melchers." *Ladies Home Journal*, vol. 43, no. 12 (December 1926), p. 27.

MacChesney, Clara T. "Gari Melchers Home, Amazed at New York's Changes." *New York Times*, January 17, 1913.

———. "Gari Melchers Gratified by Art Outlook Here." *New York Times*, March 26, 1916.

Marling, Karal Ann. *Looking Back: A Perspective on the 1913 Inaugural Exhibition*. Rochester, N.Y.: Memorial Art Gallery of the University of Rochester, 1988.

Mechlin, Leila. "Notes on Art and Artists." *Washington Star*, February 3, 1918.

Melchers, Gari. Introduction to *The Relation of Art to Nature*, by John W. Beatty. New York: W. E. Rudge, 1922.

Meltzer, Charles H. "Gari Melchers: A Painter of Realities." *Cosmopolitan*, vol. 55 (June 1913), pp. 5–9.

Mesman, George. "Julius Garibaldi Melchers at Egmond: A Discussion of His Religious Art." Master's thesis, City University of New York, 1983.

Milius, Helen Covey. "The Artist Who Got Away from Wooden Indians." *Commonwealth*, April 1959, pp. 28–32.

Monroe, Harriet. "The Paintings of Gari Melchers." *House Beautiful*, January 1902, pp. 92–98.

Narodny, Ivan. *American Artists*. New York: Roerich Museum Press, 1929.

Oresman, Janice. *Gari Melchers (1860–1932): American Painter*. New York: Graham Gallery, 1978.

———. "Gari Melchers' Portraits of Mrs. Hitchcock." *Archives of American Art Journal*, vol. 20 (1980), pp. 19–24.

Piper, Adaline. "Gari Melchers." *The Magazine of Art*, vol. 15 (February 1924), pp. 79–85.

Pisano, Ronald G. *Idle Hours: Americans at Leisure, 1865–1914*. Boston: Little, Brown, 1988.

Quick, Michael. *American Expatriate Painters of the Late Nineteenth Century*. Dayton, Ohio: Dayton Art Institute, 1976.

Reid, Richard S. "Gari Melchers: An American Artist in Virginia." *Virginia Cavalcade*, vol. 28 (Spring 1979), pp. 154–67.

Saint-Gaudens, Homer. *The American Artist and His Times*. New York: Dodd, Mead, 1941.

Shellman, Feay. "Aspects of Late-Nineteenth Century and Early-Twentieth Century Painting as Reflected by Gari Melchers in His Capacity as an American Painter and Collector, 1906–1916." Master's thesis, University of Georgia, 1976.

Stott, Annette. "American Painters Who Worked in The Netherlands, 1880–1914." Ph.D. diss., Boston University, 1986.

———. "Dutch Utopia: Paintings by Antimodern American Artists of the Nineteenth Century." *Smithsonian Studies in American Art*, vol. 3 (Spring 1989), pp. 47–61.

Sully, Julia. "Painting *Last Supper* Made under Odd Conditions." *Richmond News Leader*, March 14, 1936, p. 9.

Sweeney, J. Gray, ed. *Artists of Michigan from the Nineteenth Century*. Muskegon, Mich.: Muskegon Museum of Art, 1987.

Teall, Gardner. "The Art of Gari Melchers." *Hearst's*, vol. 30 (September 1910), pp. 170–72.

Vaughan, Malcolm. "Painter of Modern Madonnas." *New York Herald Tribune*, December 30, 1928, pp. 16–18.

Virginia Museum of Fine Arts. *Painting in the South: 1564–1980*. Richmond, Va.: 1983.

Watson, Joyce L. "Melchers' Portraits at Michigan: Three Examples of American *Juste-Milieu*." Master's thesis, University of Michigan, 1982.

Photo credits: In most cases photographs have been supplied by the lenders. Additional acknowledgment is due to the following:

Plates: Tim Chambers, Virginia, 28; Peter Harholdt, Maryland, 3–4, 6–7, 9–10, 12, 15–20, 22–27, 29–30.
Catalogue numbers: Tim Chambers, Virginia, 54; Peter Harholdt, Maryland, 1, 4–5, 8–10, 12–13, 15–16, 19–20, 24–25, 27–28, 31, 34–35, 37–40, 43–45, 47–52, 55, 57–59; Vince Miller, Roanoke, Virginia, 56; The Telfair Academy of Arts and Sciences, Inc., Savannah, Georgia, 32.
Figures: Aberdeen Art Gallery and Museum, Scotland, 6; The Annmary Brown Memorial, Brown University, Providence, Rhode Island, 7, 16; Art Institute of Chicago, 15; Avery Library, Columbia University, New York, 32; Berbling Kunsthalle, Hamburg, 3; Belmont, The Gari Melchers Memorial Gallery, Fredericksburg, Virginia, 8, 18, 20–21, 24, 26, 35, 37, 39, 64–69; Christie's, 2; Geoffrey Clements and The Century Association, 40; Cleveland Museum of Art, 43; Cornell University, Ithaca, New York, 29; Detroit Institute of Arts, 13; Düsseldorf Royal Academy of Art, 1; Flint Institute of Arts, 17; Freer Gallery of Art, Smithsonian Institution, Washington, D.C., 5, 56; Frye Art Museum, Seattle, 4; Gemeentemuseum, The Hague, 10; Peter Harholdt, Maryland, 9, 20, 26, 30; Lady Lever Art Gallery, Port Sunlight, England, 22; Metropolitan Museum of Art, New York, 14, 31, 33, 38; National Museum of American Art, Smithsonian Institution, Washington, D.C., 34; Rijksmuseum Vincent van Gogh/Vincent van Gogh Foundation, Amsterdam, 23; Theresa Schlachter, 20; Städelsches Kunstinstitut und Städtische Galerie, Frankfurt am Main, 11; St. Louis Art Museum, 36; Telfair Academy of Arts and Sciences, Inc., Savannah, 41–42, 44–55, 57–63; Toledo Museum of Art, 12.